The Eye of War

The Eye of War

Introduction by JOHN KEEGAN

Essays by PHILLIP KNIGHTLEY

Pictures edited by SARAH JACKSON & ANNABEL MERULLO

Design and art direction by DAVID ROWLEY

WEIDENFELD & NICOLSON

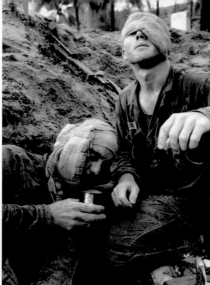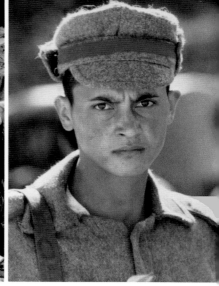

Contents

Introduction by John Keegan

THE VOICE OF WAR has long been heard and the literature of war is almost as old as organized warfare itself. The vision of war proved more difficult to fix, in any form as convincing as, say, Homer achieved in words three thousand years ago. Some Assyrian and Pharaonic bas-reliefs, some Hellenic mosaics, some Roman statuary convey the reality of combat, but the effect is necessarily static. The same is true of painted mediaeval manuscript illuminations of warfare. Whether English and French fighting the Hundred Years' War or the Knights of King Arthur, the warriors are stereotypes, not real people.

Not until the revolution in graphic art achieved at the Renaissance did the artist's depiction of fighting begin to suggest action, danger and suffering. The Renaissance masters and their successors generally failed, even so, to break out of conventional barriers. Their warrior types were heroic, their battle scenes set-pieces. They often drew on the traditions of other artistic schools to capture the viewer's attention. Thus, for example, Singleton Copley's *Death of General Wolfe*, one of the most celebrated and influential 18th-century portrayals of a battlefield event, was deliberately modelled on the arrangement of figures in 15th-century Italian images of Christ's Deposition. The poses of individual figures in this and other paintings often derive from those in classical statuary. It is highly arresting but obviously not true to life.

The earliest attempts at documentary depiction of battle did not begin until the wars of the French Revolution and Napoleonic Empire, when the regime's official artists, particularly Le Gros, Lejeune and Carle and Horace Vernet, began to construct large canvases that attempted to show the whole panorama of battlefield action. These included recognizable portraits of the main actors, convincing images of ordinary soldiers as individuals, tactical technique and actual episodes in the manoeuvre of units and exchange of fire. What the French did for warfare on land, a growing school of British naval painters, including Nicholas Pocock, tried to do also for warfare at sea.

The impulse to convey the reality of warfare in paint was to persist and to animate such talented artists as Detaille in France, Menzel in Germany and Lady Butler in England. Detaille and Menzel found much of their material in the history of the Franco-Prussian War of 1870–1, Lady Butler in the epic of Wellington's campaigns, the Crimea and Victorian Britain's imperial conquests. All three, the leading exponents of their nation's military art, were already struggling against a new and potentially superior competitor, the photographer.

Photography was first devoted to portraiture and landscape, but it did not take long for enterprising practitioners to glimpse the possibility of using it to bring news images to the public. War was always news, and so very quickly after the invention of wet-plate photography, which could be used, if with difficulty, away from the studio, photographers began to take their apparatus to theatres of war. The first-ever 'war' photograph is a daguerreotype of American cavalry in a Mexican street taken during the American-Mexican War, which started in 1846. There were also a few photographs taken during Britain's Second Burmese War, 1852–3. But the first photographer to achieve fame was Roger Fenton, whose images of the Crimea retain their beauty and immediacy to this day, as well as their verisimilitude.

Visiting the harbour of Balaclava in 2001, I found it instantly recognizable from the photographs taken by Fenton 150 years earlier. The first photographer to take pictures of war dead was Felice Beato, in the Third Opium War fought by the French and British against China in 1860. Surgeon D. Rennie reported: 'Thirteen Chinese were lying in one group round a gun. Signore Beato was here in great excitement, characterizing the group as "beautiful", and begging that it might not be interfered with until perpetuated by his photographic apparatus.'

Fenton's equivalent in the United States was Mathew Brady, who may be recognized as the first professional war photographer. Fenton strove to achieve artistic effect. Brady was interested in documentation, although on occasion he was not above moving weaponry or rearranging bodies to get them in shot. He organized a team of photographers to record the activities of the Union army in the American Civil War and equipped it with travelling dark rooms that were often at the scene almost as soon as it was possible for an observer to set foot on the battlefield. He did not shrink from realism, photographing individual dead bodies and fields of corpses, producing black-and-white plates that portray the gruesomeness of war's aftereffects as starkly as anything caught by a modern cameraman. The American essayist Oliver Wendell Holmes said of the pictures taken of the dead by Brady's photographers Alexander Gardner and James F. Gibson at Antietam in 1862, 'Let him who wishes to know what war is look at this series of pictures.' The *New York Times* said: 'Mr Brady has done something to bring home to us the terrible reality and earnestness of war. If he has not brought the bodies and laid them in our door-yards and along the streets, they (the photographs) had done something very like it.'

Wet-plate photography was, however, intrinsically static. The apparatus was delicate and exposure times long. It could not match the demand for 'real-time' image-making, for which, paradoxically, it had stimulated the appetite. As it was replaced by the dry-plate and then by cameras using celluloid 'film', war photographers strove to get ever closer to the scene and moment of action. By the outbreak of the First World War, professionals who had the nerve to take the necessary risks were equipped to take real 'action' photographs; so, too, were amateurs. The miniaturization of cameras, such as the 'box Brownie' and the even more compact 'pocket' models, enabled combatants to snap scenes in the heat of combat. Examples of their work have survived in the photographic records kept by officers of the 1st Cameronians and the 11th Hussars of the part played by the British Expeditionary Force during the opening stages of the war in August–November 1914.

Such photography attracted the disapproval of the high command, which feared that, if film fell into the hands of the enemy, it might reveal damaging intelligence. Private photography, like diary-keeping, was therefore forbidden. As a result, there are almost no private photographs of any episode of the First World War from any front. An event of the greatest historical importance, involving perhaps twenty-five million young men, many of whom owned cameras in private life and took 'snaps' of holiday, family and everyday life as a matter of course, yielded no photographic record at all, except that captured by the

official photographers, who were subject to the strictest censorship. There are good photographs from the Western Front and elsewhere – and a number of them will be found in this book – but by and large, the photographic archive of the Great War is extraordinarily dull and repetitive.

That is not true of the painted and drawn record, from Britain at least. Because of an imaginative decision to employ leading British artists as official 'war artists', who were financially supported on condition that their output became the property of the state, British public galleries, in particular the Imperial War Museum, possess a magnificent collection of the best British painting of the first half of the 20th century (the scheme was revived for the Second World War), by such artists as the Nash brothers, Eric Kennington, Anthony Gross, Eric Ravilious, Henry Moore and many other masters of the period.

The code of photographic censorship also prevailed during the Second World War. It was relaxed, however, by indirect means. Cinema, which had become in the inter-war years the most important medium of popular culture, was recognized by all combatant governments during 1939–45 to be a powerful agent of propaganda for the war effort. But its footage in some ways escaped the censorship that stills photographs were under. Britain and Germany formed official war cinema units. In the United States Hollywood was, effectively, enlisted as a medium of patriotic effort. The output varied in quality.

The British made a large number of both official documentaries and semi-official feature films. The Germans concentrated on documentaries but their output was large and several hundred cameramen, encouraged to film in the front line, were killed in action. Hollywood chose to harness the feature film to the war effort, but in a highly imaginative way; the leading Hollywood director John Huston filmed Japanese air attacks on Midway Island in the Pacific, in Technicolor, on 4 June 1942, while another director, Billy Wilder, flew combat missions to record the reality of the strategic bombing offensive against Germany.

Goebbels' propaganda ministry, as well as teaching photographers always to take 'attacking' troops going from left to right, because the Russian enemy was in the East, decreed that German dead were never to appear in shot. In 1943 the Nazi propaganda effort reached a climax, with 15,000 reporters filming, photographing and writing about German victories in the East, just when the front was collapsing there. In September 1943 President Roosevelt was persuaded to lift the ban on pictures of dead US soldiers, so as not to encourage the public's cynicism about all published photographs. Shortly after, *Life* magazine published a picture of Marine corpses on Buna Beach in the Pacific. Maggots could be clearly seen on one of the bodies.

Cinema's defeat of censorship had an effect, not long delayed, on still photography at the battlefront. While the coverage of the fighting in Korea (1950–3) was subjected to Second World War rules, they could not be applied to the many other conflicts that broke out in that war's aftermath, particularly the Chinese Civil War of 1946–9 and the French War in Indochina, 1946–54. The Indochinese war was to yield some of the most graphic images of the post-censorship era, many taken by the photographer

Robert Capa, whose life epitomizes that of the modern war photographer. He achieved fame first as a photographer of the Spanish Civil War; his image of a Republican soldier at the moment of death remains one of the most famous war photographs ever taken (even though it is not perhaps what it purports to be). As an official American photographer of the Second World War, he managed to bring back from Omaha Beach the most frequently reproduced film of the D-Day landings. Finally, as a freelance, he recorded a series of highly arresting images of the French-Vietnamese conflict, before he was killed in the course of his search for photographic reality.

By the time that the Americans had fully embarked on their Vietnamese War in 1965, television had come of age. The generals did not realize the impact this would have on the electorate back home, bringing moving pictures of war into everyone's living rooms, and camera crews were allowed what seems now an amazingly free rein. This attitude fed through to the stills photographers, now of course equipped with faster film and compact cameras of great sophistication, easily able to take sequences of shots at speed in colour as well as in black-and-white. They got everywhere, hitching lifts on helicopters, living and often dying wherever the Marines and infantry were fighting. The statistics say it all – 133 photographers, as opposed to 45 reporters, were killed in the various wars in Indochina. Many were freelancers, prepared to take insane risks to get the ultimate combat shot, and they paid the price. In the first few years there was still a measure of self-censorship practised by newspapers and magazines, but once the My Lai massacre story and pictures were published at the end of 1969 – a year after the event – much changed.

War photography is an inherently dangerous calling. Casualties among war photographers regularly exceed those suffered in infantry units. The risks, however, do not deter. There seems to be an inexhaustible supply of young men, and now young women, who are ready to expose themselves to acute forms of danger in order to supply the public with 'real-time' images of what the urge to combat, by state and increasingly non-state organizations, portends. War photography began simply as a means of placing on visual record some aspect of war's reality. During the 20th century it acquired an ideological dimension, many war photographers seeking to define war, particularly the war of states against popular and so-called 'liberation' movements, as unjustifiable exercises of power by the strong against the weak. More recently, as liberationalism has lost its allure as a political creed, war photography has at times, in the hands of some practitioners, seemed to become merely another element in the media's pursuit of the sensational for its own sake. This book serves as a reminder of what it has been, and can be, at its best. And by combining outstanding images with first-hand eyewitness accounts, often written by the fighters, the victims and the photographers themselves, it gets as close as one can on the page to the crude, cruel, bloody and horrible business that is war. Seeking to record that reality pictorially may have failed to deter humankind from resorting to violence, and will continue to fail to do so, but the record itself is here, to be seen and read.

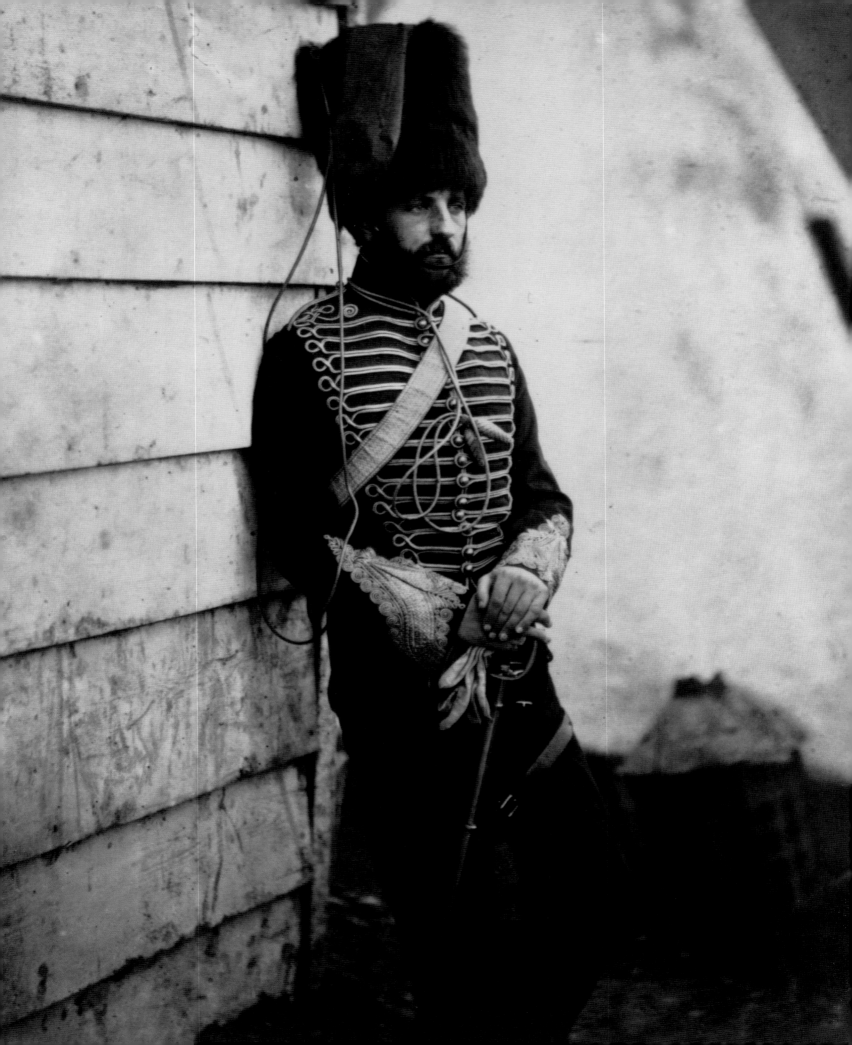

I. | The Camera Goes to War 1855 – 65

CRIMEAN WAR, INDIAN MUTINY, THIRD OPIUM WAR, AMERICAN CIVIL WAR

GENERALS USED IN EFFECT to report their own wars — Wellington on Waterloo, for instance — because the only newspaper coverage was in the form of extracts from official dispatches sent back by commanders in the field. But with the rapid growth of newspaper readers in the 19th century, editors began to realize that this would no longer work. They tried using junior officers as part-time war correspondents but most were too busy fighting to do more than keep a diary and then send it back. 'The idea of a newspaper correspondent keeping a journal of a siege until the affair is over has driven me wild,' complained the manager of *The Times* of London. So when Britain and France declared war on Russia in 1854, *The Times* decided to send its best reporter, an Irishman called William Howard Russell, to accompany British forces to the Crimea, where they were to attack the Black Sea city of Sevastopol. The war was popular — the British hated Czarist absolutism and Russia's ambition to expand its empire — and *The Times* wanted to win new readers. Russell was appalled at what he encountered. The British Army had not fought since Wellington beat Napoleon nearly forty years earlier. The general staff was dominated by noble blood. The expedition's leader was Lord Raglan who was sixty-five and had never commanded so much as a battalion in the field. His officers brought a French chef, Kaffir servants, their favourite horses and wine, their shotguns, dogs and, in some cases, their wives.

Much went wrong — the disastrous Charge of the Light Brigade, the lack of medical facilities for the wounded, the disease, the unnecessary casualties, totally inadequate food, clothing or accommodation. Russell wrote about it all, *The Times* printed most of it, and, in January 1855, the government succumbed over criticism of the campaign. Many of the military hated Russell for his role in bringing down the government and a former Secretary for War wrote that he hoped the army would lynch him. At this stage someone in the British establishment, probably Queen Victoria's husband, Prince Albert, realized that to restore public confidence some form of counter-propaganda was necessary. What better could it be than the newly discovered medium that never lied — the camera? So Roger Fenton, one of the founders of the Royal Photographic Society, who had often photographed the royal family, was encouraged to go out to the Crimea to record what was happening there. Fenton established the axiom that although in most cases the camera does not lie directly, it can lie brilliantly by omission. His photographs portray a war where everything looks ship-shape and everyone content. Although he saw the half-buried skeletons of those who had died at the Charge of the Light Brigade, he did not bother to unpack his camera. This was not the sort of photograph he had been sent to take.

No such inhibitions worried Felice Beato, who recorded the final days of the Indian Mutiny that had broken out in 1857. Indian sepoys revolted against British rule, massacring their officers and families. The British put down the mutiny and punished the mutineers without mercy. Some were tied to the mouths of cannons and blown away; others were hanged, some from makeshift gallows, others from trees, one after another, until there were no more branches available. Exactly what Beato was doing there is hard to establish but no doubt there was a ready audience for visual evidence of revenge.

The camera was present, too, during the third Opium War against China in 1860. Britain and France attacked China to force her to keep open her ports to opium produced in British India so that Britain could

pay for its imports of Chinese tea, porcelain and silk. The cumbersome camera techniques of the time did not allow action photographs but pictures of the aftermath of battles testified to their fury and horror.

By the time the American Civil War started in 1861, the war correspondent had created such a demand for news of battle that five hundred journalists went off to report for the North alone. The issues were momentous – the southern states claimed the right to secede from the Union while the North fought to maintain it, with slave emancipation a secondary issue. It is understandable then that the *New York Herald* put sixty-three men into the field and spent nearly $1 million covering the conflict.

The telegraph was widely available for the first time, so reporting of the Civil War was not only more extensive than for any previous war but also more immediate – except in the South, where most newspapers were weeklies with small circulations. For the first time it was possible for most of the American public to read what happened yesterday rather than someone's opinion on what had happened last week. Unfortunately, the majority of the Northern correspondents were ignorant, dishonest and unethical and the dispatches they wrote were frequently inaccurate, often invented, partisan and inflammatory.

This would have been a marvellous opportunity for the camera to act as a check on faked eye-witness accounts and conjectures built on imagination. But the technology of the day failed to meet demand. The entrepreneur Matthew Brady sent his photographers Timothy O'Sullivan and Alexander Gardner with the Northern armies into battle and produced a comprehensive pictorial account of the war. Their choice of subject, composition and technical skill with bulky equipment and unreliable chemicals remain to this day a testament to their dedication and professionalism.

But no newspaper was able to use these or any other photographs, because they lacked the equipment and technique for making half-tone blocks, the system used until recently for reproducing photographs in print. Instead, the war artist flourished, and, although some became caught up in the production of fake or exaggerated reporting that afflicted many correspondents, most produced detailed and accurate records of the battles they witnessed.

Illustrated weeklies, such as *Harper's* and Frank Leslie's *Illustrated Weekly*, flourished, the latter alone employing some eighty artists and publishing in four years more than 4000 sketches and drawings of 'battles, sieges, bombardments, stormings, and other scenes incidental to war'.

War artists continued to dominate a new series of wars that flared up in distant parts of the world as the colonial powers fought to maintain and expand their rule. But the camera had arrived and its development, although slow and spasmodic, was now unstoppable.

William Howard Russell of *The Times* describes Balaclava harbour in the Crimea, through which all supplies for the British forces came.

I was never more astonished in my life than when on the morning of Tuesday I halted on the top of one of the numerous hills of which this portion of the Crimea is composed, and looking down saw under my feet a little pond, closely compressed by the sides of high rocky mountains; on it floated some six or seven English shops, for which exit seemed quite hopeless. The bay is like a highland tarn, some half mile in length from the sea and varies from 250 to 120 yards in breadth. The shores are so steep and precipitous that they shut out as it were the expanse of the harbour, and make it appear much smaller than it really is. Towards the sea the cliffs close up and completely overlap the narrow channel which leads to the haven, so that it is quite invisible ... During the first three weeks of our stay in the Crimea we lost as many of cholera as perished at the battle of Alma. The town (of Balaclava) was in a filthy, revolting state. Lord Raglan ordered it to be cleansed, but there was no one to obey the order, and consequently no one attended to it.

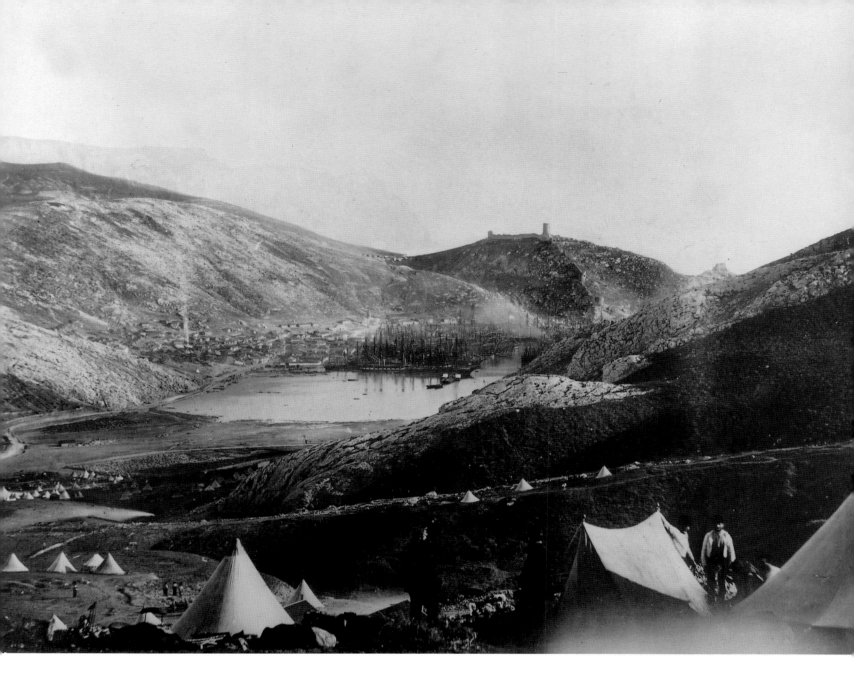

Crimean War

The harbour at Balaclava, with the old Genoese fort on the hill behind, photographed by Roger Fenton, the first war photographer, in the spring of 1855. Fenton was sent to the Crimea with the blessing of the British War Office to capture a positive image of the war. He spent fewer than four months there, producing 360 photographs, which present a substantial documentary record of the participants and landscapes of war. But he also had the strict instruction, 'No Dead Bodies'.

Roger Fenton

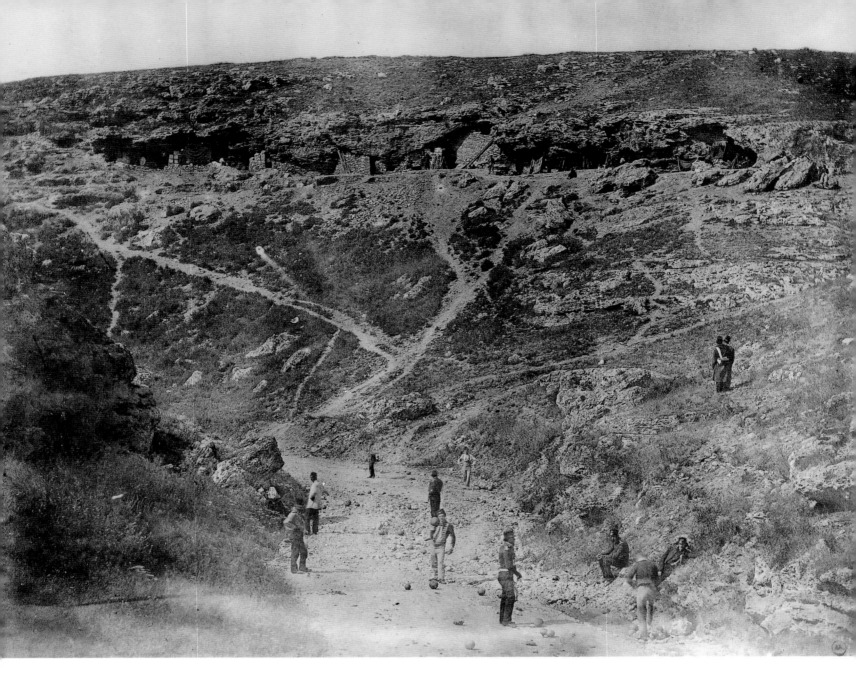

William Howard Russell of *The Times* writing of conditions in the Crimea in spring 1855.

Again, as regarded food and shelter, our men were better off every day than they were the day before. From hunger, unwholesome food and comparative nakedness, the camp was plunged into a sea of comforters, mufflers, flannel shirts, tracts, soups, preserved meats, potted game and spirits; but it was, unfortunately, just in proportion as they did not want them that comforts and even luxuries were showered upon them.

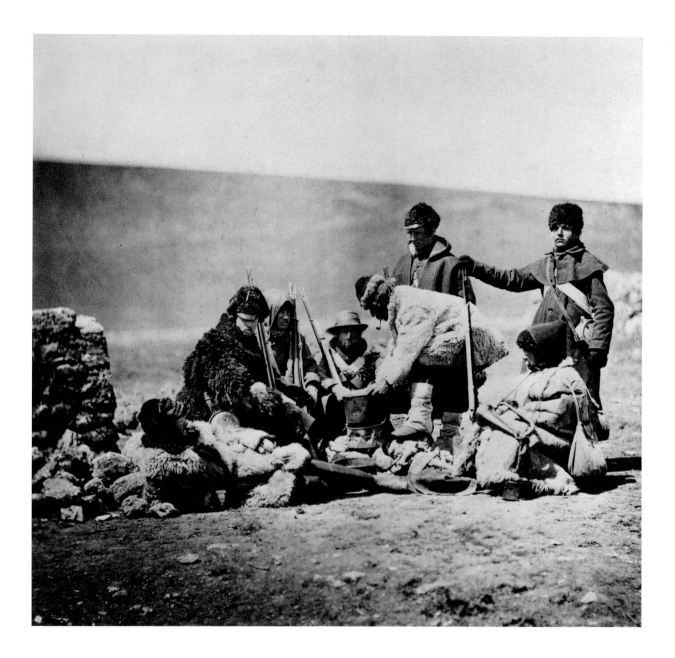

The Worontzoff Ravine, described by
William Howard Russell as '... so exposed
to the enemy fire that it has been called
"The Valley of Death"'. British soldiers are
playing bowls with Russian cannon balls
on the road through the ravine.

James Robertson

British troops pose in the bright sunshine
of spring 1855 in their warm winter
clothing, most of which arrived too late
to be of use in the bitter snows of the
previous winter. Roger Fenton presumably
took this photograph to counter criticism
of the totally inadequate clothing that the
troops had in 1854.

Roger Fenton

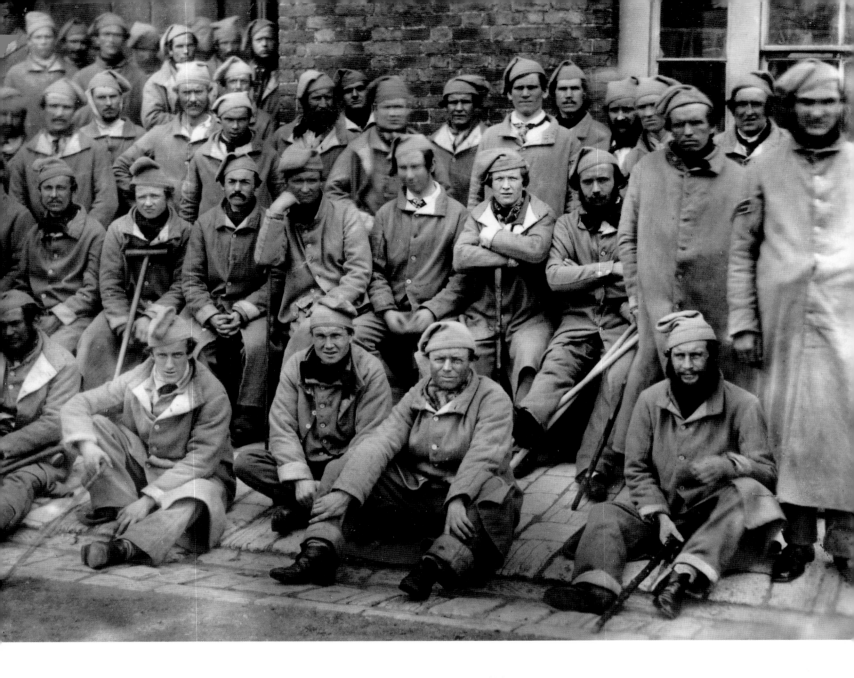

Florence Nightingale on conditions at Scutari Hospital outside Constantinople after the battle of Inkerman on
5 November 1854, in a letter to Queen Victoria.

We have now four miles of beds of not 18 inches apart ... the
dysentery cases have died at the rate of one in two ... These poor
fellows bear pain of mutilation with an un-shrinking heroism that
is really superhuman or die or are cut up without a complaint ...
I think we have not an average of 3 limbs to a man ... One poor
fellow, exhausted with haemorrhage, had his leg amputated as a
last hope and dies ten minutes after the surgeon has left him.
Almost before the breath has left his body it is sewn up in its
blanket and carried away and buried the same day — we have no
room for corpses in the ward.

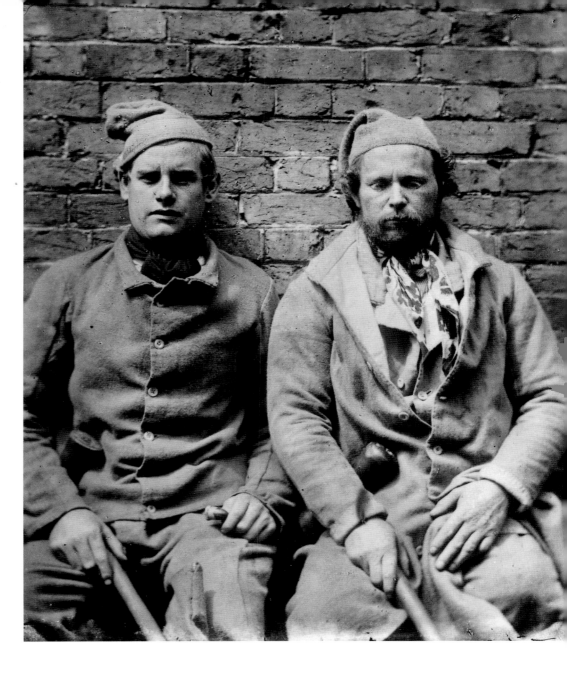

A group of wounded soldiers back from the Crimea, convalescing at Brompton Barracks, Chatham, where they were inspected by Queen Victoria and Prince Albert in April 1856. The Queen's sympathy for the soldiers was matched by her admiration for Florence Nightingale. She noted in her journal: 'I envy her being able to do so much good and look after the noble heroes whose behaviour is admirable.'

Cornelius Jabez Hughes

John Dowels of the 55th Foot, who lost his leg at the battle of Alma at the start of the war, and Robert Evans of the 1st Light Dragoons, who lost his taking part in the Charge of the Light Brigade at the battle of Balaclava in October 1854. The Queen paid for a significant number of artificial limbs personally and offered to find employment for some of the soldiers. According to her secretary Colonel Phipps, 'The Queen can never do enough for these poor men.'

Cornelius Jabez Hughes

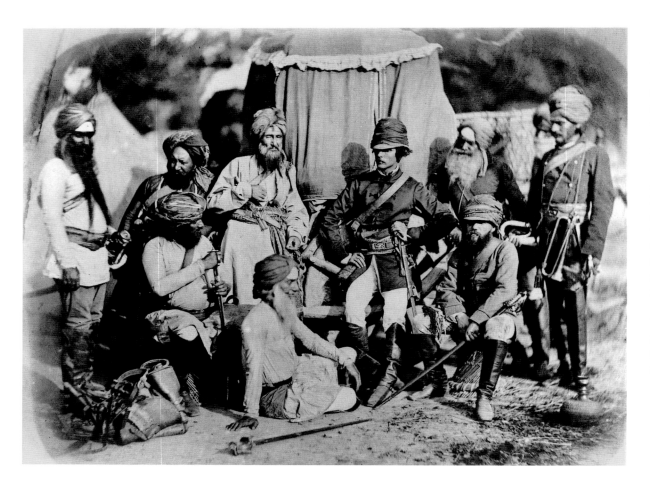

Indian Mutiny
British and native officers of Hodson's Horse photographed soon after the final storming and recapture of Lucknow from the Indian mutineers on 9 March 1858. William Hodson, who had raised this irregular body of cavalry, had died in the assault and the seated officer may well be Major Henry Daly, his successor as CO.
Felice Beato

The execution of Indian mutineers by the British after a summary trial.
Felice Beato

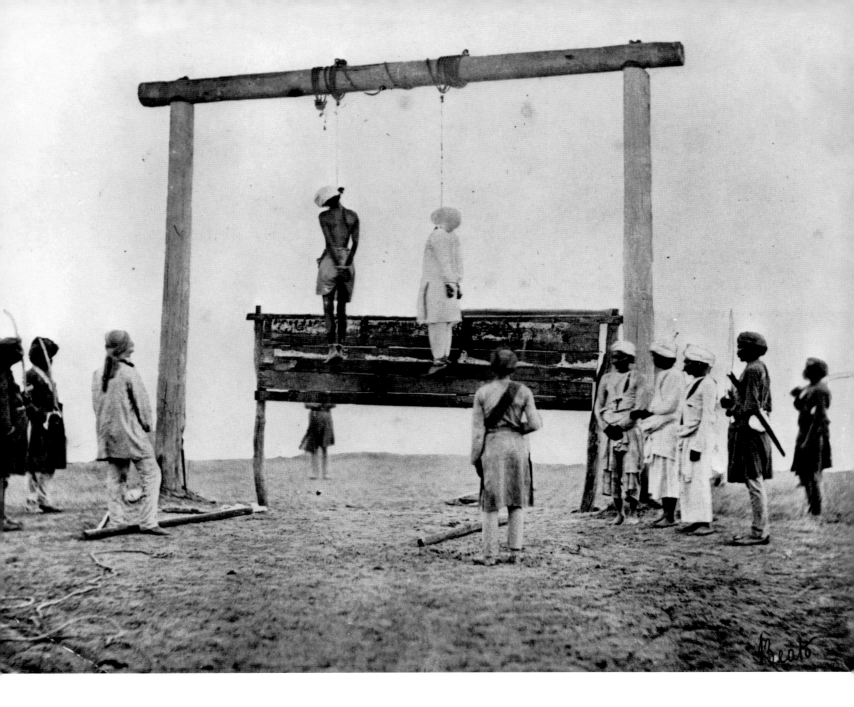

Corporal William Forbes-Mitchell of the 93rd (Sutherland) Highlanders on British retribution during the Indian Mutiny.

The commissioner held his court in what had formerly been a police
station. I cannot say what form of trial the prisoners underwent, or
what evidence was recorded against them. I merely know that they
were marched up in batches, and shortly after marched back again to
a large tree, which stood in the centre of the square, and hanged
thereon. This went on from about three o'clock in the afternoon till
daylight the following morning, when it was reported that there was
no more room on the tree ... there were one hundred and thirty men
hanging from its branches. A grim spectacle indeed!

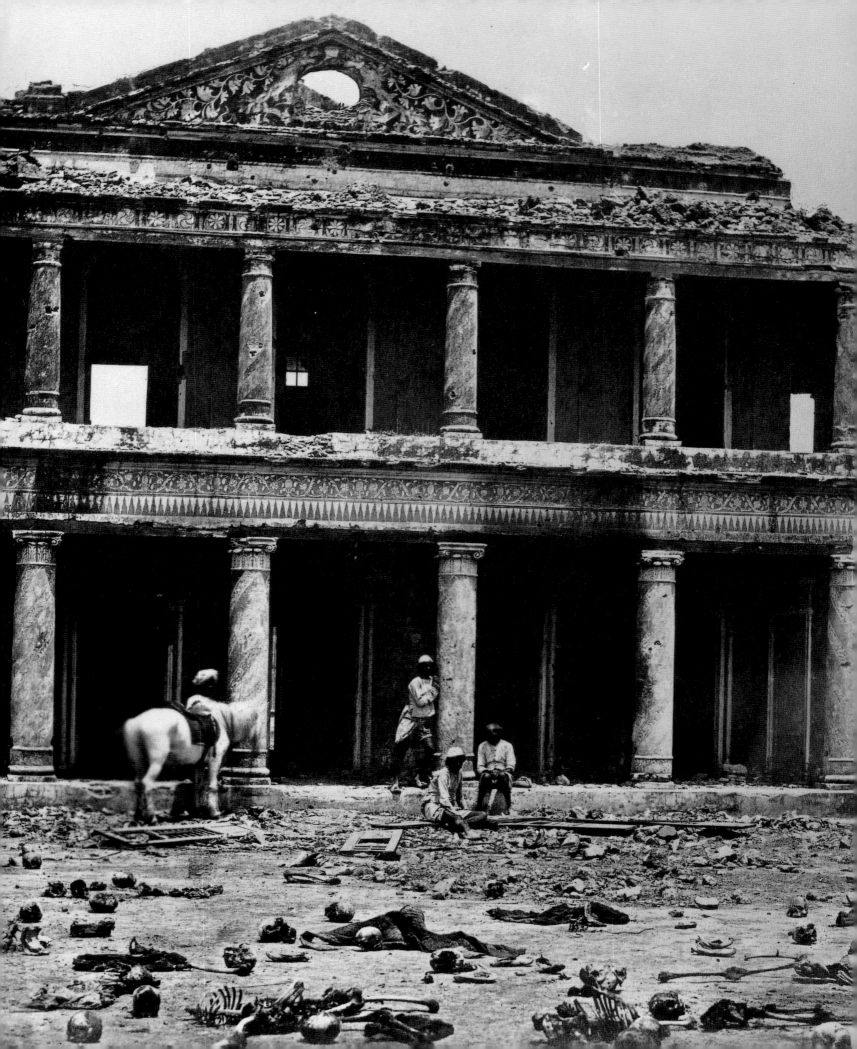

The Secundrabagh Palace on the outskirts
of Lucknow in India, shortly after the final
fall of the city to the British in March
1858. The skulls, ribcages and bones of
Indian mutineers killed when the building
was first recaptured by Scottish Highland
and Sikh troops the previous November
lie scattered in the foreground, probably
dug up by dogs. Historians believe the
photographer, Felice Beato, rearranged
the mutineers' skeletons in the courtyard
for dramatic effect.

Felice Beato

Corporal William Forbes-Mitchell of the 93rd (Sutherland) Highlanders recounts an incident immediately after the first assault on the palace
in November 1857.

In the centre of the inner court of the Secundrabagh there was a large pipal
[fig] tree with a very bushy top, round the foot of which were set a number of
jars full of cool water. When the slaughter was almost over, many of our men
went under the tree for the sake of its shade, and to quench their burning
thirst with a draught of the cool water from the jars. A number however lay
dead under this tree, both of the 53rd and 93rd, and the many bodies lying
in that particular spot attracted the notice of Captain Dawson. After having
carefully examined the wounds, he noticed that in every case the men had
evidently been shot from above. He thereupon stepped out from beneath the tree,
and called to the Quaker Wallace [who] had his rifle loaded ... He fired, and
down fell a body dressed in a tight-fitting red jacket and tight-fitting rose-
coloured silk trousers; and the breast of the jacket bursting open with the
fall, showed that the wearer was a woman. She was armed with a pair of heavy
old-pattern cavalry pistols, one of which was in her belt still loaded, and
her pouch was still about half full of ammunition, while from her perch in the
tree, which had been carefully prepared before the attack, she had killed more
than half a dozen men.

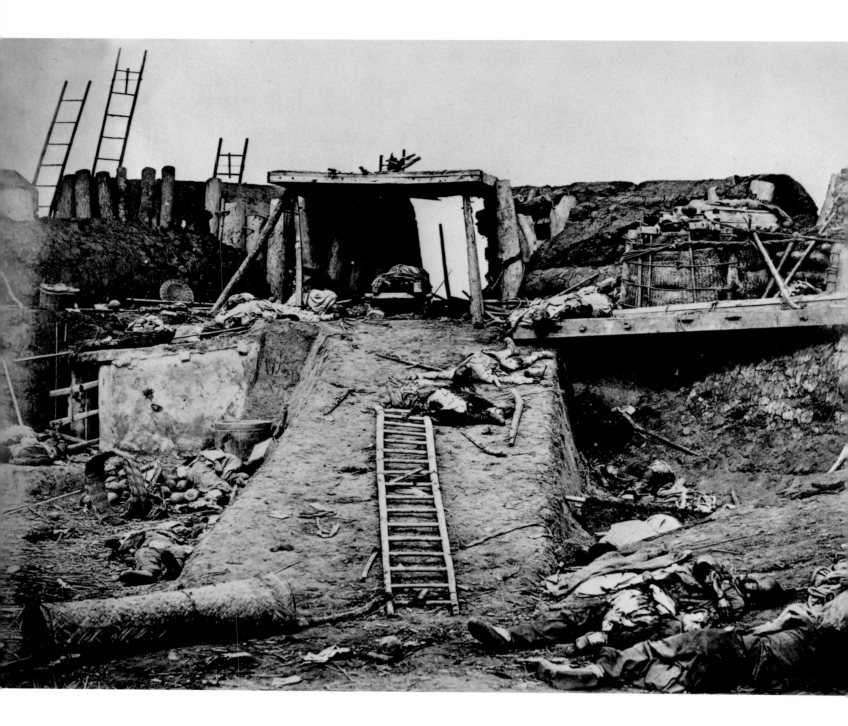

Third Opium War

Inside one of the Taku Forts after it had
fallen. This and other photographs taken
by the Italian Felice Beato were the first
ever to show war dead. Beato begged the
soldiers not to move the 'deada mansa'
until he had recorded the scene.

Felice Beato

Colonel Garnet Wolseley (who in 1895 became Commander-in-Chief of the British Army) describes the storming of the Taku Forts in 1860 by an Anglo-French force during the Third Opium War against China. The forts guarded the entrance to the Peiho River, the first stage of the route to Peking. This was the first occasion in warfare that breech-loading artillery was used.

There was a rattling discharge of arrows, bolts from crossbows, jingalls firing handfuls of slugs from the work itself, but also a flanking fire of round shot, thrown with accuracy from the correspondingly placed fort on the south bank ... [The French had succeeded in getting up three or four ladders.] Up, rung after rung of the ladder the French crept warily, until at length, with a bound, the first man jumped upon the parapet and waved the tricolor of this nation, whilst every one joined in his maddening cheer, amidst the wild clamour of which his spirit passed away from him to another, and let us hope, a better world. He fell, shot through the heart, in the proudest position in which a soldier can die — who could wish for a nobler death? Almost simultaneously with this event, young Chaplain, an ensign of the 67th Regiment, succeeded in reaching the top of the parapet, partly pushed and helped by the men along with him; he carried the Queen's colour of his regiment, which he let float out proudly into the breeze; it was a splendid sight to see.

Ensign Chaplain and a small party who followed the colours, rushed up the ramp leading to the high cavalier earthwork which formed the principal feature of the fort, and cleared it with the bayonet of all the Chinese there; in doing this that gallant young officer received more than one wound ... Never did the interior of any place testify more plainly to the noble manner in which it had been defended.

William Howard Russell of *The Times* witnesses the start of the rout of the Northerners at the end of the first Battle of Bull Run (Manassas) in July 1861.

I perceived several wagons coming from the direction of the battlefield, the drivers of which were endeavouring to force their horses past the ammunition carts going in the contrary direction near the bridge ... My first impression was that the wagons were returning for fresh supplies of ammunition. But every moment the crowd increased; drivers and men cried out with the most vehement gestures, 'Turn back! Turn back! We are whipped.'

American Civil War

Union (Northern) Cavalry on the edge of the Bull Run river early in 1862. The Confederates (Southern) won victories here in 1861 and again in August 1862

The great Southern General, Stonewall Jackson, was mortally wounded by 'friendly fire' as he defeated a Northern army at Chancellorsville in May 1863. The Reverend James P. Smith remembers.

As he rode near to the Confederate troops, just placed in position and ignorant that he was in the front, the left company began firing to the front and two of his party fell from their saddles dead. Spurring his horse across the road to his right, he was met by a second volley from the right company of Pender's North Carolina brigade. Under this volley, when not two rods from the troops, the general received three balls at the same instant ...

The general was placed upon the litter and carefully raised to the shoulder, I myself bearing one corner. A moment after, artillery from the Federal side was opened upon us ... the fright of the men was so great that we were obliged to lay the litter and its burden down upon the road. As the litter-bearers ran to the cover of the trees, I threw myself by the general's side and held him firmly to the ground as he attempted to rise. Over us swept the rapid fire of shot and shell — grape-shot striking fire upon the flinty rock of the road all around us, and sweeping from their feet horses and men of the artillery just moved to the front. (Jackson was eventually got into an ambulance, but died a few days later.)

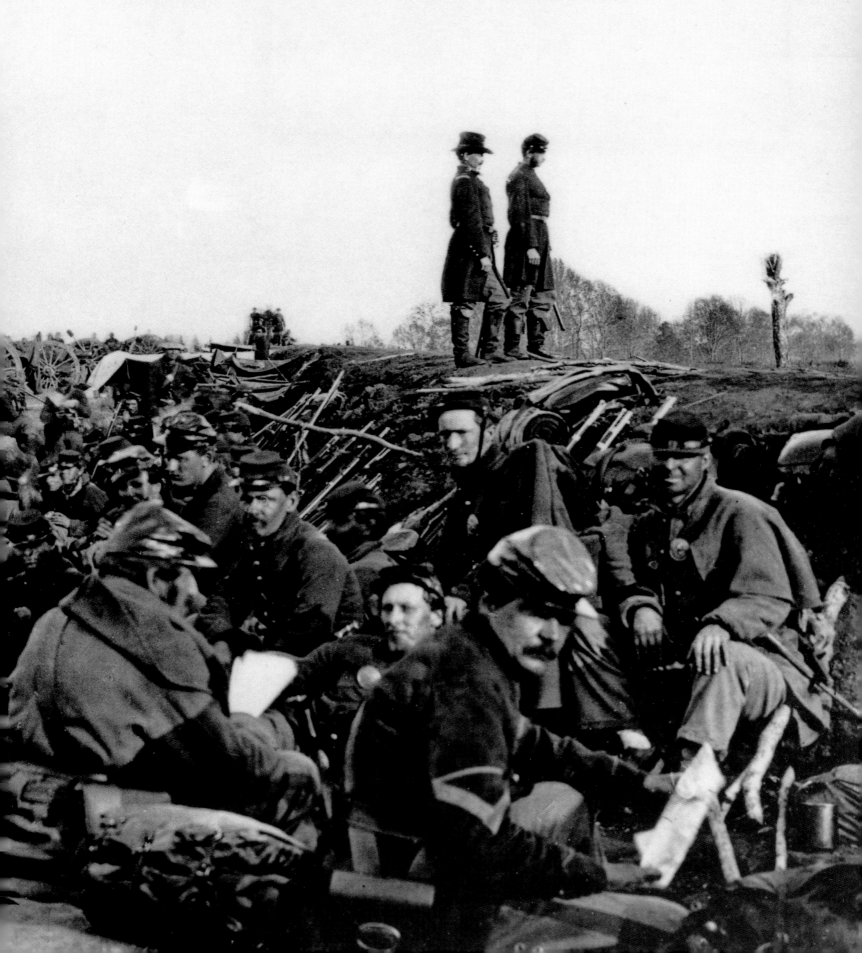

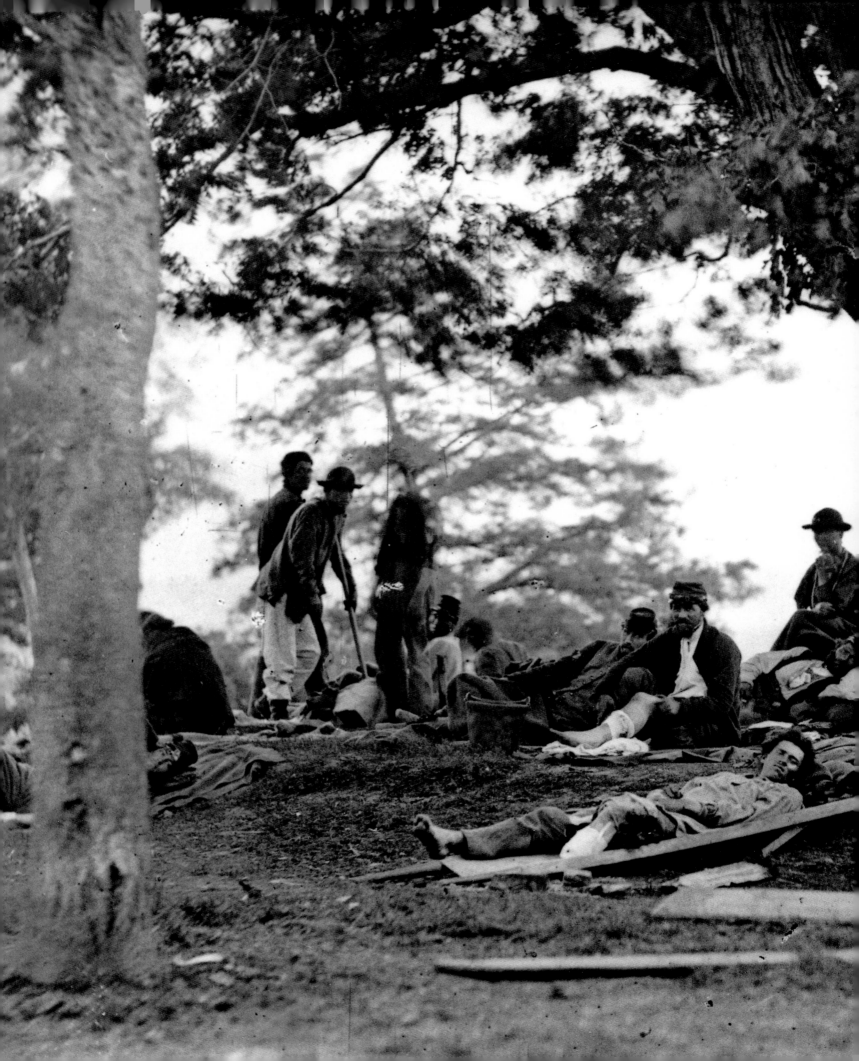

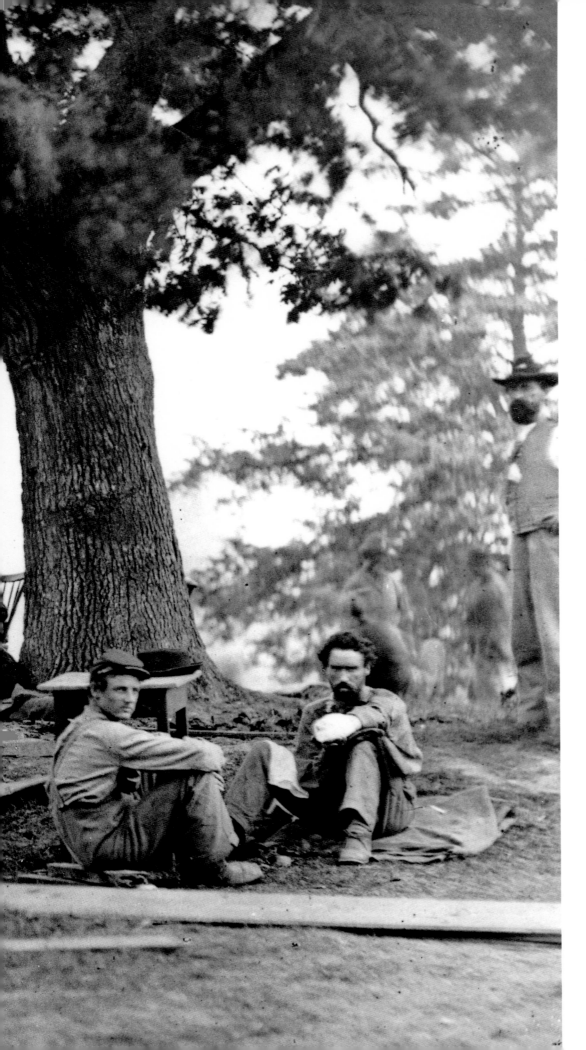

Wounded await treatment in a field hospital after the battle of Chancellorsville, May 1863, where General Stonewall Jackson had been mortally wounded. The figure lying on a stretcher appears to have had his left foot amputated, and the seated figure on the right, his forearm and hand. A chaplain recalled, 'when the strife ceased ... I went back to one of the large depots for the wounded – of hospitals in this wilderness there was none. Here about two thousand wounded had been collected. Such multiplied and accumulated suffering is not often seen!'

Samuel Wilkeson of the *New York Times* wrote what was probably the most poignant piece of the war. Sent to cover the three-day battle at Gettysburg in 1863, he found his eldest son among the 40,000 fallen.

Who can write the history of a battle whose eyes are immovably fastened upon a central figure of transcendingly absorbing interest — the dead body of an oldest born, crushed by a shell in a position where a battery should never have been sent, and abandoned to death in a building where surgeons dared not to stay? ...

Eleven o'clock — twelve o'clock — one o'clock. In the shadow cast by the tiny farmhouse, sixteen by twenty, where General Meade had his headquarters, lay wearied staff officers and tired reporters. There was not wanting to the peacefulness of the scene the singing of a bird, which had a nest in a peach tree within the tiny yard of the whitewashed cottage. In the midst of its warbling a shell screamed over the house, instantly followed by another and another, and in a moment the air was full of the most complete artillery prelude to an infantry battle that was ever exhibited. Every size and form of shell known to British and American gunnery shrieked, moaned, whirled, whistled, and wrathfully fluttered over our ground ... Through the midst of the storm of screaming and exploding shells an ambulance, driven by its frenzied conductor at full speed, presented to all of us the marvellous spectacle of a horse going rapidly on three legs. A hinder one had been shot off at the hock ... During this fire the houses at twenty and thirty feet distant were receiving their death, and soldiers in Federal blue were torn to pieces in the road and died with the peculiar yells that blend the extorted cry of pain with horror and despair. Not an orderly, not an ambulance, not a straggler was to be seen upon the plain swept by this tempest of orchestral death thirty minutes after it commenced.

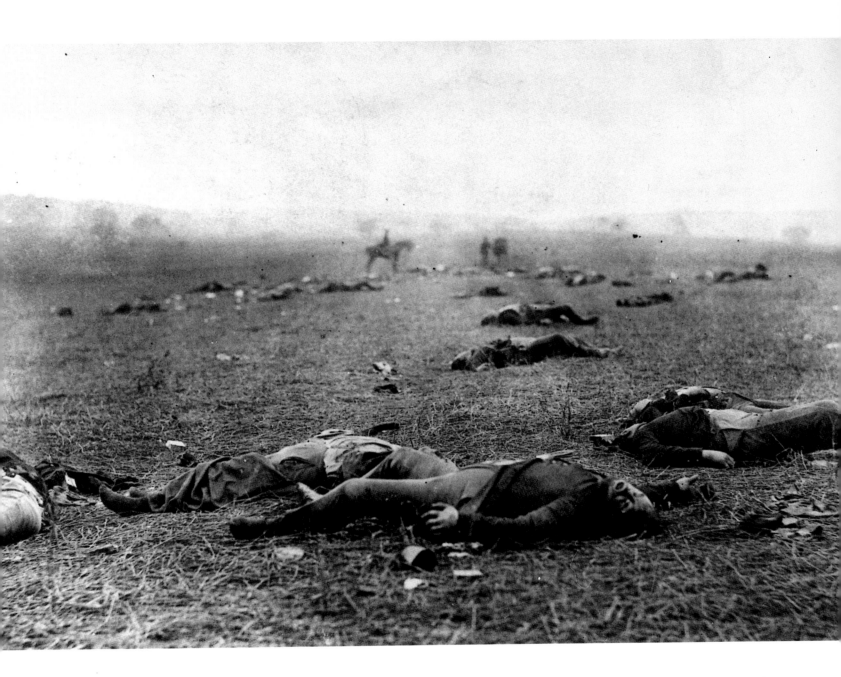

Bloated, sun-blackened Union dead on the battlefield at Gettysburg, July 1863, the watershed encounter of the American Civil War, which lasted three days. The bodies have been stripped of their boots, always in short supply, by retreating Confederates. Classic battlefield images such as this prompted the *New York Times* to write: 'It seems somewhat singular that the same sun that looked down upon the faces of the slain, blistering them, blotting out from the bodies all semblance of humanity ... should have thus caught their features on canvas, and given them perpetuity for ever.'

Timothy O'Sullivan

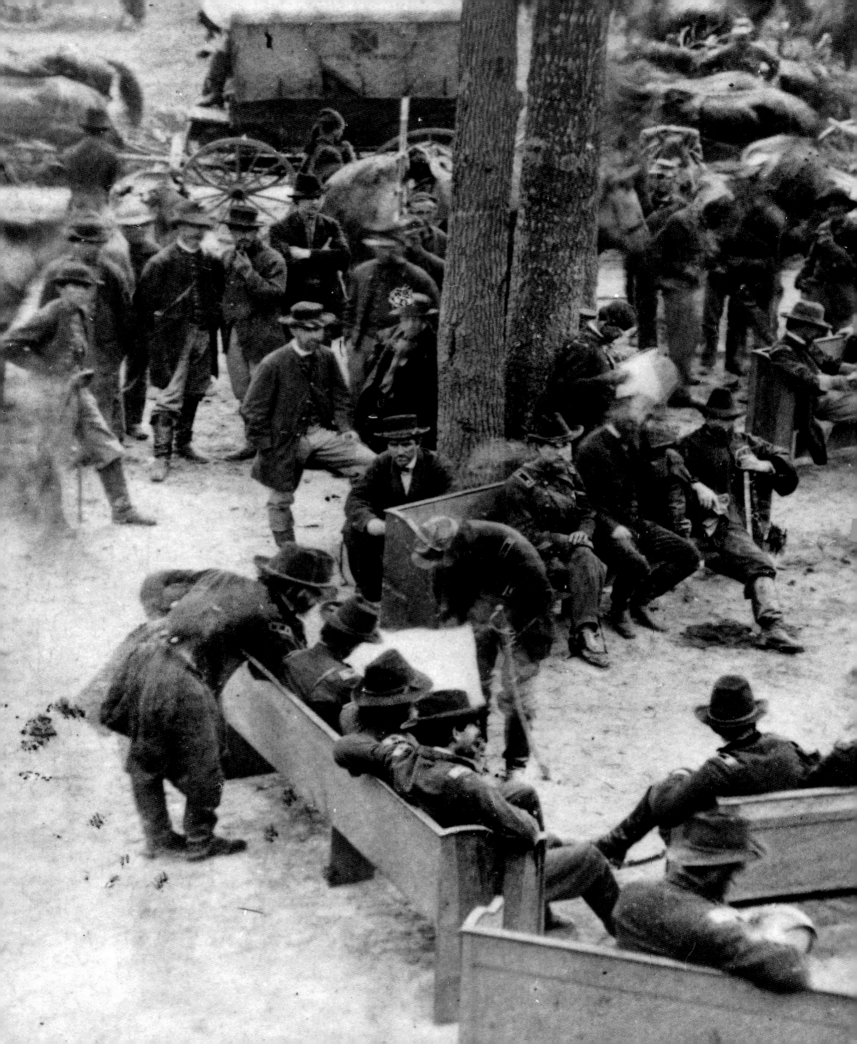

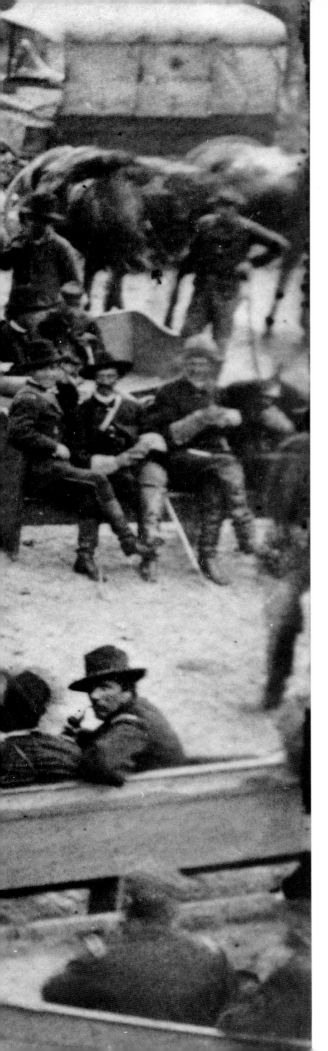

It is well that war is so terrible — we would grow too fond of it.

General Robert E. Lee to Lieutenant-General James Longstreet, Battle of Fredericksburg, 13 December 1862

You just tell me the brand of whiskey Grant drinks; I would like to send a barrel of it to my other Generals.

Abraham Lincoln, November 1863

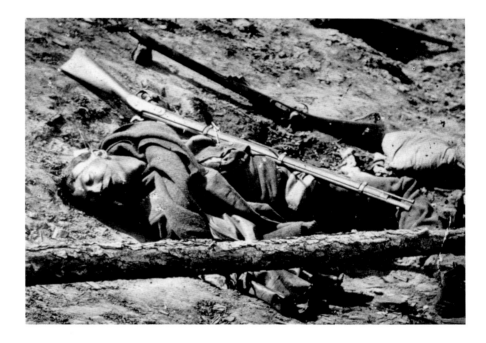

A dead Confederate soldier after the siege of Petersburg at the end of the war, photographed by Alexander Gardner, one of Mathew Brady's photographers. Gardner sometimes, as here, embellished his shots by bringing discarded weapons into the picture. His *Photographic Sketch Book* was the first published collection of photographs of the Civil War.
Alexander Gardner

A Union council of war outside Massaponax Church, Virginia, 21 May 1864. General Ulysses S. Grant, the Union Commander, stands on the left looking over the shoulder of General Meade, who is seated on one of the pews from the church.
Timothy O'Sullivan

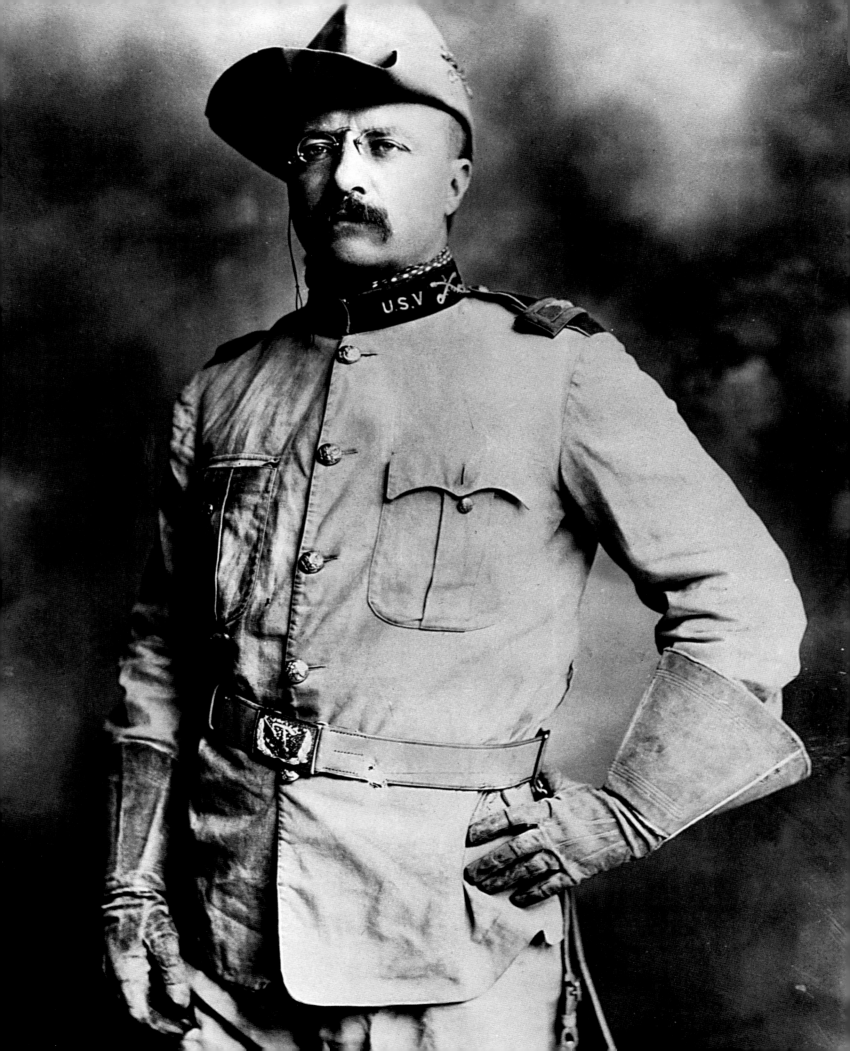

2. Imperial Expansion 1865 – 1900

COLONIAL WARS IN AFRICA, FRONTIER WARS, SPANISH-AMERICAN WAR

THE RISE OF THE POPULAR PRESS, the increasing use of the telegraph and the military's tardy introduction of organized censorship made the latter part of the 19th century a golden age for war reporting. Newspaper expansion in the two major newspaper-reading countries – Britain and the United States of America – was explosive. In Britain the number of newspapers sold doubled between 1880 and 1900, and in the USA increasingly affluent newspaper proprietors now felt they could afford to cover even minor wars in far-distant places.

They also realized that thrilling accounts of battles, slaughter and bravery could be reported as adventure stories with intrepid war correspondents as the heroes. An elite corps of journalists was born, prepared to endure the punishing demands of war reporting for its reward – fame and fortune.

No major events involving violence occurred anywhere in the world, however remote, during this period without at least one of this new breed of correspondent there to report it, draw it or photograph it. They travelled by horse, donkey, camel, sled, steamer and train. They carried letters of credit, gold pieces, *laissez-passers* and often a brace of pistols. They tended to go to bed drunk with their boots and spurs still on and they had little time for social graces. No one suggested that they were non-combatants. One of the Americans, H. M. Stanley, was not above starting his own small wars in Africa so that he could report them. James Creelman of the *New York Journal* led a bayonet charge in Cuba during the Spanish-American War. Five of them died during the Turko-Serbian war and five in the many Sudanese campaigns.

They were not interested in the political background to the wars they covered or the rights and wrongs of the campaigns. There was little explanation or analysis in their reports. They wrote of war as a grand adventure, as one of them put it: 'a search for real romance in the midst of the workaday nineteenth century'. Raw realism and any portrayal of the real horror of battle was out. It is significant that two of the big-name correspondents of this period, Archibald Forbes of the London *Daily News* and Stephen Crane of the *New York Journal*, got their jobs because their editors had been impressed by their *fictional* descriptions of battles.

Most of the wars involved colonial powers imposing their will on tribal forces – the Pathans on the Northwest frontier of India, the Afghans outside Kabul, photographed by the freelance photographer James Burke, and the Dervishes in the Sudan. The outcome was seldom in doubt. Spears, lances, knives and the occasional musket were normally no match for repeating rifles, Maxim machine-guns, trained cavalry and breech-loading artillery manned by disciplined professional soldiers. The native soldiers were slaughtered in their thousands but there are few photographs of piles of black or brown bodies and scant descriptions in the correspondents' reports.

Sometimes wars overlapped and since war correspondents were herd creatures they tended to go to the same war, leaving the others virtually uncovered. The Boxer rebellion in northeastern China, for example, overlapped with the Boer War and was therefore under-reported. The Boxers, members of a secret society called the Righteous Harmony Fists – hence Boxers to Europeans – believed that they had immunity from foreign bullets and in 1900 fell upon all foreigners they could find and massacred them. An international force suppressed the rebellion, killing the Boxers in their thousands. Few wrote about this because for most

correspondents war was an integral part of 19th-century life and they saw their job as describing the adventure and glory of it.

This was especially true of the Spanish-American War in 1898, which ended Spanish rule in Cuba and the Philippines and turned the United States into a colonial power. It is hard to think of another war in which the media played such an active role. The flamboyant Richard Harding Davis had been reporting the Cuban insurgents' struggles for independence from Spain and along with his proprietor, the 'yellow press' baron, William Randolph Hearst, believed that the United States should intervene to help the rebels. They wanted to inflame public opinion against Spain, so Hearst sent the artist Frederic Remington, famous for his portrayal of the Wild West, to convey visually what Davis reported. Remington was not keen on the assignment and, finding things quiet in Cuba, he telegraphed Hearst: 'There is no trouble here. There will be no war. I wish to return.' Hearst replied: 'Please remain. You furnish pictures. I will furnish war.'

His chance to do so came when the American battleship *Maine* blew up in Havana Harbour. It may have been an accident but Hearst, without a particle of proof, blamed Spain and in the wave of patriotic fervour that swept the United States, Hearst finally got his war. Two hundred turned up to cover it, including twenty-five from Hearst's group alone. The group's circulation climbed dizzily as headlines grew larger and larger until they occupied most of the front pages. Correspondents struggled to provide stories and illustrations to match until the *New York Herald* complained that there must be 'a factory out there for manufacturing war news'.

But some of the most exciting stories were true. Future President Theodore Roosevelt, noted for his jingoistic view of life and a believer in America's manifest destiny, raised a group of American volunteers, the Rough Riders, rich Americans who had learned their horsemanship playing polo. When a detachment of American regular troops showed reluctance to attack a Spanish position on San Juan Hill, Roosevelt led his men in a wild, disorderly charge that sent the Spaniards fleeing for their lives.

Not to be outdone, Stephen Crane, the author of the widely read American Civil War novel, *The Red Badge of Courage* and a correspondent for the *New York World*, walked alone into the town of Juana Díaz in Puerto Rico, accepted its surrender from the mayor and then organized a party for its citizens to celebrate their liberation. James Creelman, another Hearst correspondent, was covering an attack on a Spanish blockhouse on the outskirts of Santiago. Pinned down by heavy fire, Creelman seems to have forgotten that he was a correspondent and offered to lead a bayonet charge on the blockhouse. It was a success and Creelman had a front-page story. But before he could begin to write it, he was wounded in the arm and lost consciousness. He came around to find Hearst kneeling beside him, a revolver in his belt and holding a pencil and notebook. He took down Creelman's story. 'I'm sorry you're hurt,' Hearst said, 'but wasn't it a splendid fight. We must beat every paper in the world.'

Captain Tristram Speedy went in search of big game in Abyssinia in 1861–2. When General Sir Robert Napier led an expedition in 1868 to secure the release of various Britons imprisoned by Emperor Theodore of Abyssinia, Speedy accompanied it as interpreter, and here describes what happened when the Anglo-Indian force reached Theodore's stronghold of Magdala.

A body of some two hundred horsemen galloped towards us quivering their lances and shouting their war-cries while here and there silver-mounted shields showed that chiefs of tried value were hastening to strike the final blow against the daring invaders. Rapidly the 4th 'Kings Own' threw out their skirmishers, the artillery and rocket battalions prepared for action, and as our bugles sounded 'Commence firing' the battle began. The effect of our Sniders was terrific, the precision of the mountain howitzers of Penn's battery was marvellous — the enemy fell in heaps, both horse and man, before the awful storm of bullet, shot and shell. At four o'clock in the afternoon a storm of hail followed by heavy rain put an end to the slaughter.

The next two days were spent in negotiation ... We descried five horsemen galloping in circles just below the gate of Magdala. When about a quarter of a mile from them, I could easily distinguish Theodore as one of them, partly from the colour of his favourite charger and partly by his gay apparel. He challenged us to single combat or equal numbers, which of course we could not accept, having strict orders not to fire. After firing a couple of rifle shots the King followed by his Chiefs retired to Magdala.

Shortly after our troops arrived and the Armstrong guns opened fire on the doomed rock — and about 3 o'clock in the afternoon of the 13 April the 33rd Regiment rushed gallantly to the assault and took the Fortress. The four chief men were found dead at the gate and the body of King Theodore was discovered a little higher up, with traces that showed he had taken his own life to avoid falling into our hands alive.

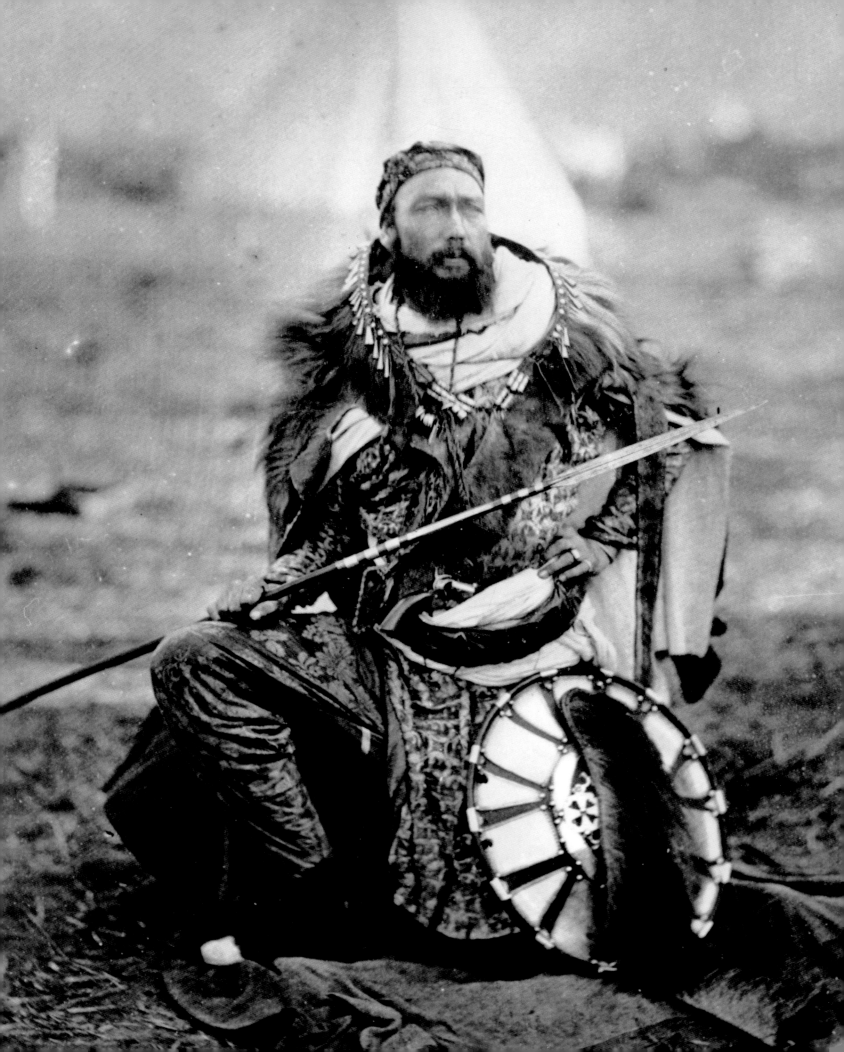

An attempt to get at the essence of warfare on India's North-West Frontier, and to equate the practices of the British with those of the border Afghans and Pathans, by 'Pousse Cailloux', the pseudonym of Lieutenant-Colonel Leonard Bethell of the 8th Gurkha Rifles, a contributor to *Blackwood's Magazine.*

Success or disaster came with equally unexpected suddenness: a rearguard surprised and bunched together in difficult ground; a group of tribesmen caught in a cunning trap of their own devising; an ugly rush with knives on a camp at midnight ... or, the same tribesmen lying out and sniping the camp in the darkness, and the scattered flashes growing inexplicably fewer till the party of barefoot little Gurkhas came in again through the picket-line, their kukris red with the blood of the snipers stalked and slain in silence ... And if they did cut up our dead and wounded, very rarely left out for them to cut, well, didn't we burn their villages and ring-bark their few and precious apricot and mulberry-trees — though making very sure that the village was empty before we burned it? And if they had a rather macabre taste for rifling our fresh-made graves and turning the pitiful contents out to the vultures, didn't we, not seldom, bury in a grave a dummy in a blanket, containing gun-cotton slabs,not a few, and tricky contact-wires, whereby the gravediggers flew to Paradise, their limbs not all together but singly and one by one?

 Orakzai or Afridi, Mohmand or Achakzai, you could meet any of the many clansmen in Peshawar Bazaar, in Kohat, Dera Ismail Khan, or Quetta, each with a useful rifle and a bandolierful of the latest and best smokeless, and you could pass the time of day to each, openly and with a grin. Each and all would, occasion serving, gladly cut your throat, but he wouldn't be rude to you.

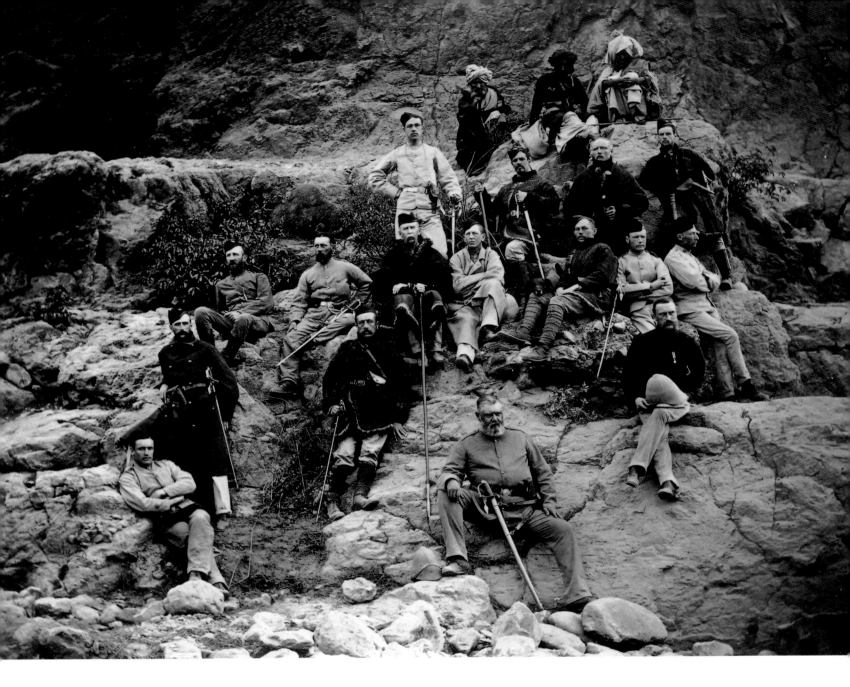

Frontier Wars

Officers of the 51st Light Infantry, part of the Peshawar Valley Field Force, in Afghanistan in 1879. Several of them have supplemented their uniforms with Afghani poshteens, sheepskin coats with the fleece on the inside. Between 1849 and 1877 Britain undertook no fewer than twenty-eight expeditions on the North-West Frontier, to pre-empt plundering raids into the Punjab in India.

John Burke

Howard Hensman was the only journalist in the Second Afghan War in 1879. He describes the Afghan attack on the British fortified camp outside Kabul.

Through the mist at last appeared a dense mass of men waving swords and knives, shouting their war-cry, and firing incessantly as they advanced. The order came at last for our soldiers to open fire, and the Afghans were then so close that the volleys told with murderous effect. Some of the ghazis were shot within 80 yards of our rifles, so patiently was the attack awaited; while thirty bodies were counted afterwards well within 200 yards' range. The attack collapsed as suddenly as it had begun. The Afghans saw what execution men in trenches and behind parapets can do with breech-loaders in their hands, and they took cover behind walls and trees, from whence they expended thousands of cartridges, doing us little damage. Our ammunition was too precious to be needlessly wasted, and only when clusters of men got within range were volleys fired to scatter them.

Part of General Sir Frederick Roberts' cavalry from the Kandahar Field Force, and also horse artillery on the left, parades during the Second Afghan War. Their victory at Kandahar on 1 September 1880 finally settled the campaign. Only then did the British withdraw, having spent an enormous amount of effort to achieve a situation that seemed virtually identical to that at the beginning of the war.

John Burke

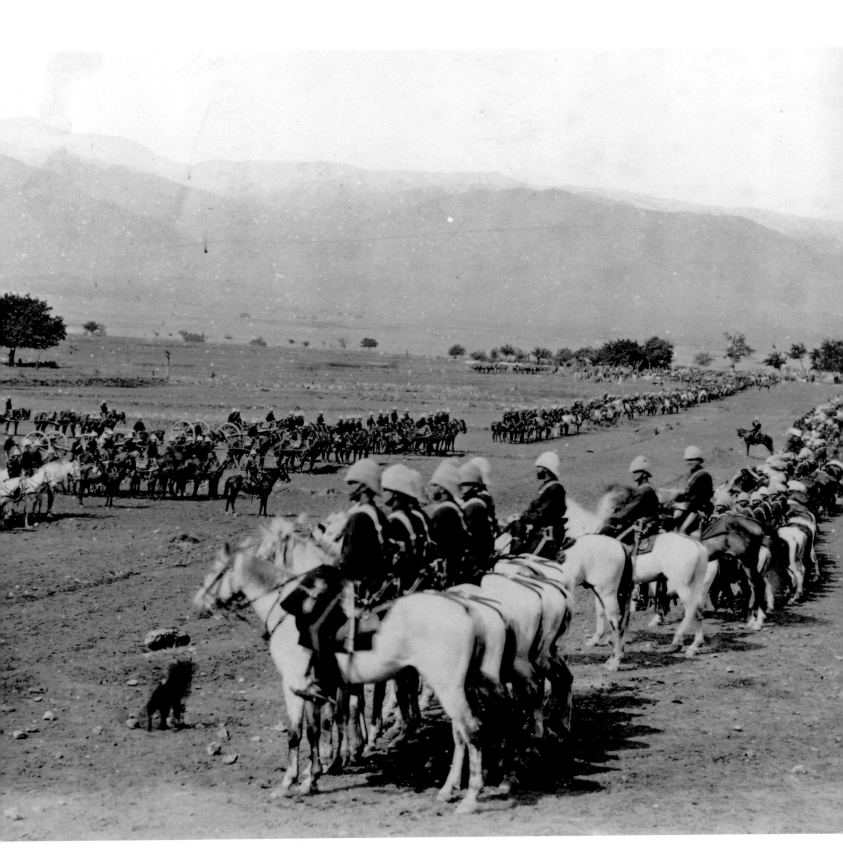

Sudan

Wassa, Battalion Dog of the Cameron Highlanders, gets a pat during the Sudan campaign, 1898. He survived the battles of Atbara and Omdurman.

A British Maxim machine-gun-battery aboard a native craft, behind the steamer that is towing it on the Nile, 1898.

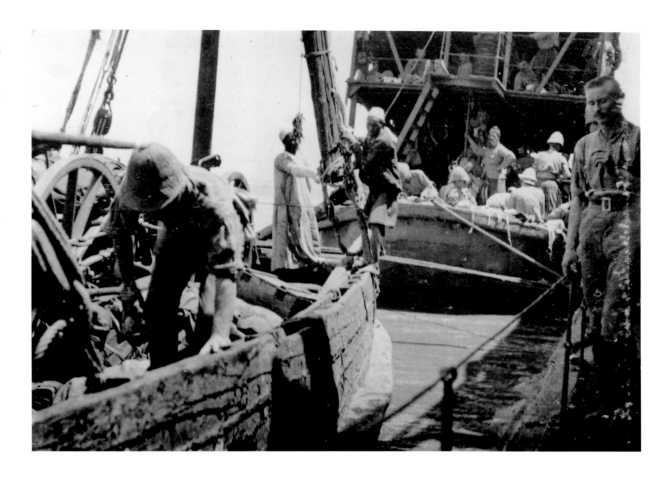

The young Winston Churchill, serving with the Anglo-Egyptian-Sudanese force intent on avenging the death of General Gordon some thirteen years before, describes its advance up the Nile and across the desert under Sir Herbert Kitchener in 1898.

It was a remarkable sight to watch these steamers carrying up British infantry, full of fierceness and armed to the teeth, as if they were so many tons of stores, dumping them down at the point of concentration and returning swiftly with the current of the river, as if light-hearted as well as lightly laden, for more. Nor was it a spectacle which the Dervishes would have admired had they been there to see. Perhaps to these savages, with their vile customs and brutal ideas, we appeared as barbarous aggressors. The British subaltern, with his jokes, his cigarettes, his meat lozenges, and his Sparklet soda-water, was to them a more ferocious creature than any Emir or fanatic in Omdurman. The Highlanders in their kilts, the white loopholed gunboats, the brown-clad soldiery, and the Lyddite shells were elements of destruction which must all have looked ugly when viewed from the opposite side.

Future President Theodore Roosevelt goes into action against the Spanish in Cuba with his Rough Riders, the irregular unit that he had raised, 1898.

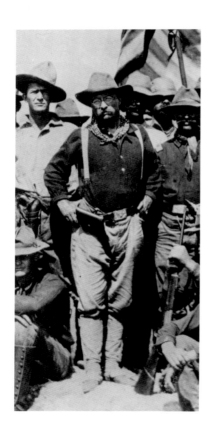

Theodore Roosevelt with his Rough Riders in Cuba after their capture of San Juan Hill, 1898. Roosevelt was renowned for his jingoistic view of life: 'We must play a great part in the world, and especially perform those deeds of blood and valour which above everything else bring national renown.'

Where I struck the regulars there was no one of superior rank to mine, and after asking why they did not charge, and being answered that they had no orders, I said I would give the order. There was naturally a little reluctance shown by the elderly officer in command to accept my order, so I said, 'Then let my men through, sir,' and I marched through, followed by my grinning men. The younger officers and the enlisted men of the regulars jumped up and joined us. I waved my hat, and we went up the hill with a rush. Having taken it, I, very much elated, ordered a charge on my own hook to a line of hills still farther on. Hardly anybody heard this order, however; only four men started with me, three of whom were shot. I gave one of them, who was only wounded, my canteen of water, and ran back, much irritated that I had not been followed — which was quite unjustifiable, because I found that nobody had heard my orders. General Sumner had come up by this time, and I asked his permission to lead the charge. He ordered me to do so, and this time away we went, and stormed the Spanish intrenchments. There was some close fighting, and we took a few prisoners. We also captured the Spanish provisions, and ate them that night with great relish. One of the items was salted flying-fish, by the way.

Spanish-American War

US soldiers near Manila, the capital of the Philippines, during the Spanish-American War, 1898. They were accused of massacring Filipino civilians on several occasions during the guerrilla war against Filipino nationalists that followed the defeat of the Spanish. In 1898 Rudyard Kipling, married to an American and excited by the outbreak of this war, wrote his famous exhortation to America to 'Take up the White Man's Burden' and join Britain in her Imperial mission. The poem achieved instant fame, so much so that when a black US regiment was landing in the Philippines and a white soldier shouted out, 'What are you coons doing here?', a black soldier instantly replied, 'We've come to take up the White Man's Burden.'

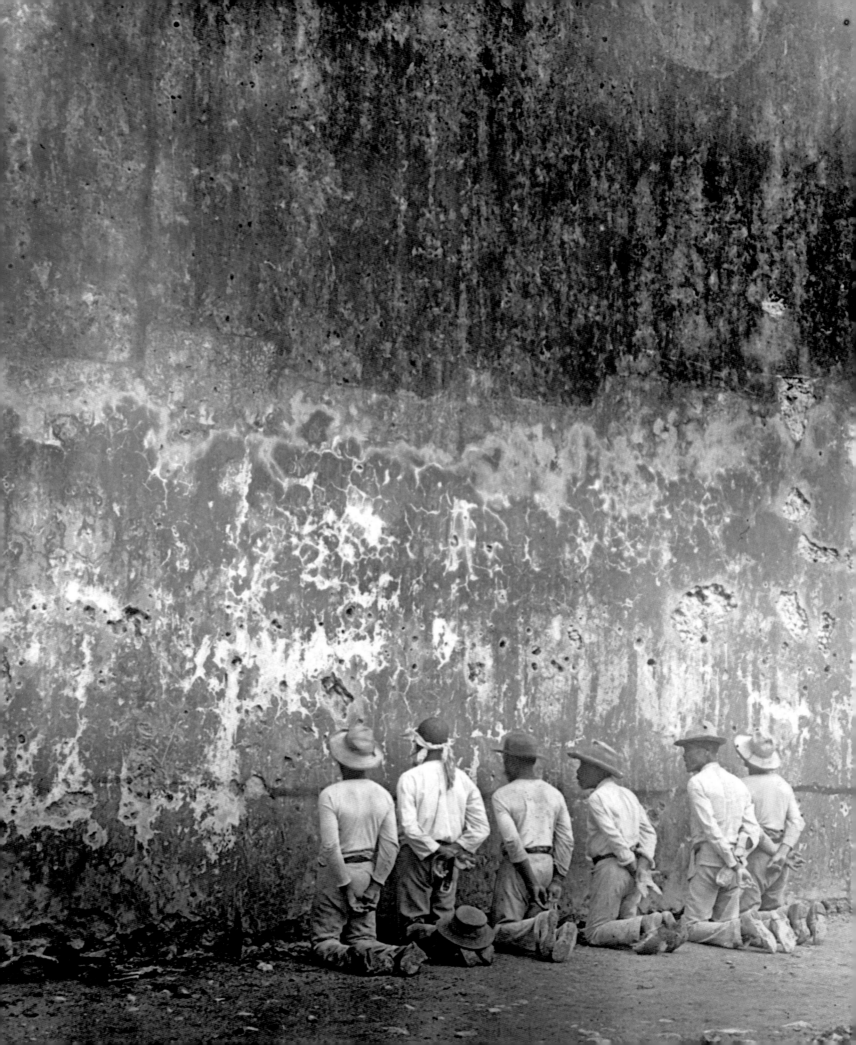

Cuban rebels, taken prisoner by the Spanish and about to be executed by firing squad. The journalist Richard Harding Davis had inflamed public opinion in the US to support the rebels with his article 'The Death of Rodríguez'. Rodríguez, a rebel captured in a skirmish, had been publicly executed by firing squad, 'the blood from his breast sinking into the soil he had tried to free'.

An American soldier is given a shave by one of his comrades during a lull in the fighting in Cuba, 1898. As a result of the Spanish-American War, Spain lost control of the remains of its overseas empire.

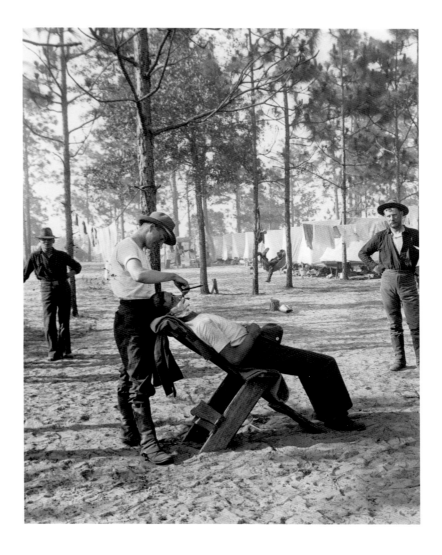

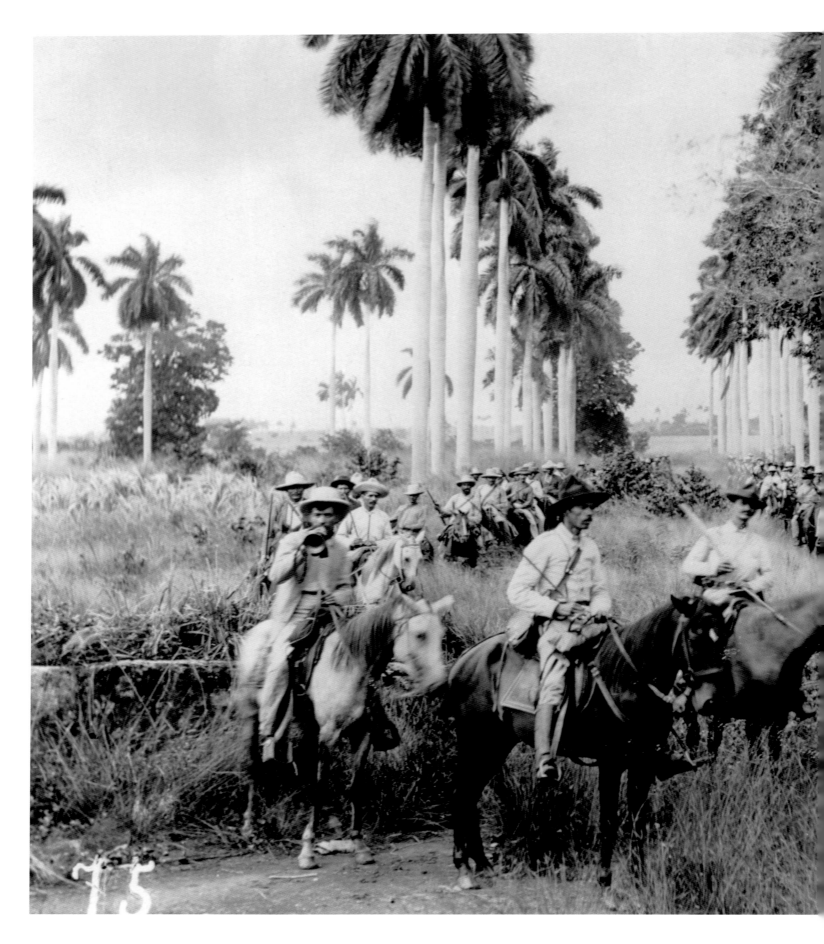

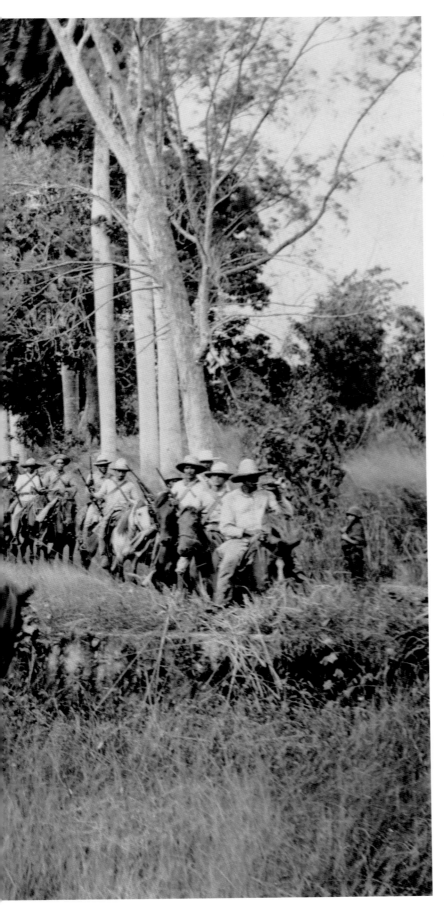

American and Cuban irregular cavalry on patrol near Pinar del Río during the Spanish-American War. The war was so well covered by American journalists and photographers that small skirmishes were blown into great battles in the quest for headlines and newspaper sales.

3. Rehearsals for Armageddon 1900–14

IT IS DIFFICULT TO EXAGGERATE the enthusiasm with which Britain embarked on the Boer War. It was the high noon of British imperialism and few questioned force as an arm of policy. In Victorian Britain, war was a marvellous game: the greatest game of all, 'the clash of sword and hollow reverberating clang of brazen buckler, the storm and wild joy of battle'. So when a British expeditionary force set out to quell the rebellious Dutch settlers in South Africa, the Boers, there was widespread enthusiasm for the campaign.

Only one small shadow spoiled an otherwise perfect picture. This was the first time since the Crimean War, almost half a century earlier, that the British Army was fighting other white men, so certain standards had to be maintained, and no native troops were to be used.

In the field, the journalists, artists and cameramen saw their duty as denigrating the Boers, downplaying British casualties, and praising the valour of the British troops. 'Not Rome in her palmiest days ever possessed more devoted sons,' wrote Bennett Burleigh of the *Daily Telegraph*. 'As gladiators marched proud and beaming to meet death, so the British soldiers doomed to die saluted and then, with alacrity, stepped forward to do their duty – glory or the grave.'

The grave it frequently was. The Boer, neither completely civilian nor completely a soldier, alternating between tending his farm and fighting the British, an experienced sporting marksman armed with an accurate repeating rifle, mobile, able to live for long periods on strips of dried meat and a little water, drawing on the surrounding support of his countrymen and women, not afraid to flee when the battle was not in his favour, was more than a match for any regular army, no matter what its strength. The British policy of retaliation, with its farm-burning, concentration camps and collective punishment, was similar to that ineffectively employed in Vietnam sixty-five years later.

The British trenches at Spion Kop were piled with British dead three deep and more. But photographs showing the slaughter were not published in Britain because editors considered them 'revolting Boer propaganda' and the few correspondents who did try to write about the disaster found that their reports were censored by staff officers. The war was the first to have authorized movie film coverage of the battlefield and an early Biograph newsreel showed Red Cross wagons and stretcher-bearers bringing back the wounded from Spion Kop. But it was shot at such distance as to conceal any distressing scenes. Instead British audiences saw a newsreel purporting to show a Red Cross tent and medical team treating a wounded British soldier while under fire from the heartless Boers. It was all a fake and the heroic scenes were actually filmed with actors on Hampstead Heath, a suburb of London.

No correspondent wrote of the high death rates in the camps where the British interned Boer women and children. It was left instead to Emily Hobhouse, a Quaker, to describe in a report to members of Parliament the appalling conditions in a camp she had visited, thus forcing the government to appoint a commission of enquiry and eventually carry out reforms. What the British public really wanted to read were not stories about starving natives or shifty Boers but the sterling, stiff-upper-lip dispatches from Colonel Robert Baden-Powell, hero of the siege of Mafeking. The telegraph line remained open during the 217-day siege, and Baden-Powell was soon sending out a series of messages that caused shivers of admiration all over

the Empire. 'One or two Boer field guns shelling the town. Nobody cares.' 'All well. Four hours of bombardment. One dog killed.' The British public took these literal truths as typical army officer understatement and the more casual, off-hand Baden-Powell's telegrams became, the more the world believed that Mafeking must be suffering dreadfully. When Mafeking was relieved on 18 May 1900, the celebrations in Britain lasted for five nights and surpassed the victory celebrations of the First and Second World Wars in size, intensity and enthusiasm. Baden-Powell became the most popular English hero since Nelson and a household name not only in Britain but also throughout the United States.

In the overall reporting of the war, one correspondent stood out. The American Richard Harding Davis saw that imperialism's days were numbered, that the Boers were fighting against odds for their independence and that they deserved to have their case and their struggle reported. His views caused much offence in Britain and Davis was expelled from his London club.

On the other side of the world, an earth-shattering war was developing – one between Russia and Japan over conflicting ambitions in Korea and Manchuria. The Russians had leased Port Arthur from China in 1898; in 1904 the Japanese launched a surprise attack and laid siege to it, forcing its surrender. Then to widespread amazement, the Japanese Navy defeated the Russian Baltic Fleet, which had sailed halfway round the world to do battle. The Japanese had won. The war was poorly reported, since most correspondents were kept cooling their heels in Tokyo hotels. Few witnessed the terrible battles of attrition – 160,000 casualties in one month-long encounter alone. Luigi Barzini, an Italian correspondent who was to become one of the best-known journalists in Europe, worked under terrible conditions – the cold often froze the ink in his pen. He managed nevertheless to fill 700 pages with notes and take hundreds of photographs. He saw no glory, no heroics in war, only slaughter. He had the ability to perceive repercussions beyond the battle he was witnessing and the courage to write what he believed.

He saw the tremendous political impact the war would have as Asia stirred through its length and breadth. An unknown and non-European race had scattered a European power, and the old-time glory and greatness of Asia seemed destined to return. He also saw the military significance. Increased fire power, the growth of artillery and even the use, by the Japanese, of a crude form of poison gas, meant that the way wars were fought would have to be rethought.

Spasmodic clashes, like those during the Mexican Revolution, photographed by Agustín Victor Casasola, a reporter for *El Imparcial*, where the soldiers behaved more like bandits, were over. The combined lessons of the Russo-Japanese War and of the Boer War were that trenches too long to be out-flanked would lead to stalemate, and that modern weaponry would increase casualty rates to levels previously considered impossible. But these lessons were not learned and after a few years of fragile peace, the world embarked on a war of colossal, sustained, industrialized butchery.

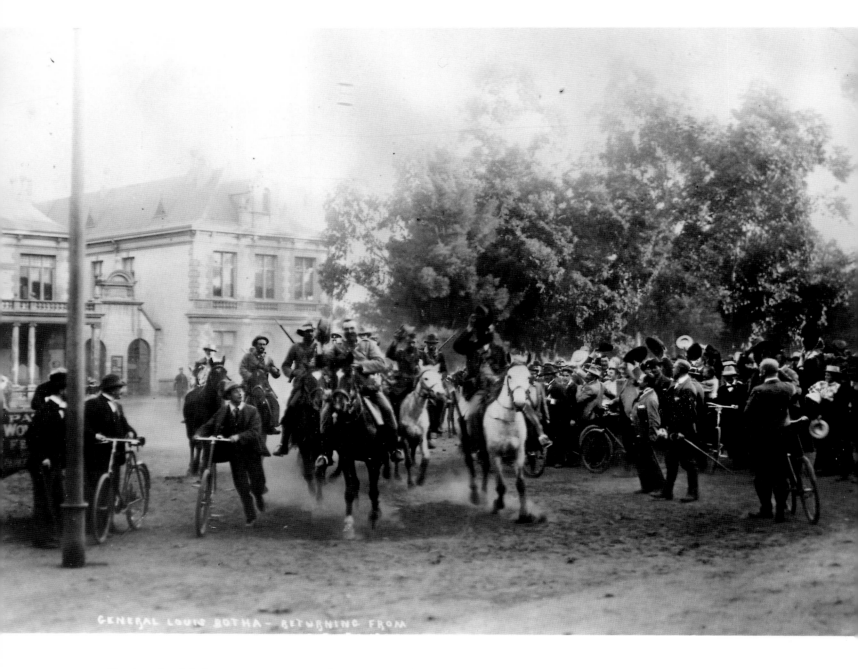

GENERAL LOUIS BOTHA — RETURNING FROM

It is foolish not to recognise that we are
fighting a formidable and terrible adversary ...
The individual Boer mounted in suitable country
is worth from three to five regular soldiers.

Winston Churchill

Boer War

Boer General Louis Botha 'returns from the fight at Kliprivier, 25 May 1900'. The jubilation of the welcoming crowd is misleading because the Boers were hard pressed at this time and about to lose their capital, Pretoria, to the British.

David Barnett

British dead collected in a shallow trench for burial after their defeat at Spion Kop on 23 January 1900. General Botha had a major part in this Boer victory. Photographs like this one showing the slaughter were not published in Britain, because the newspapers considered them 'revolting Boer propaganda', and correspondents played down the extent of British casualties.

J. B. Atkins

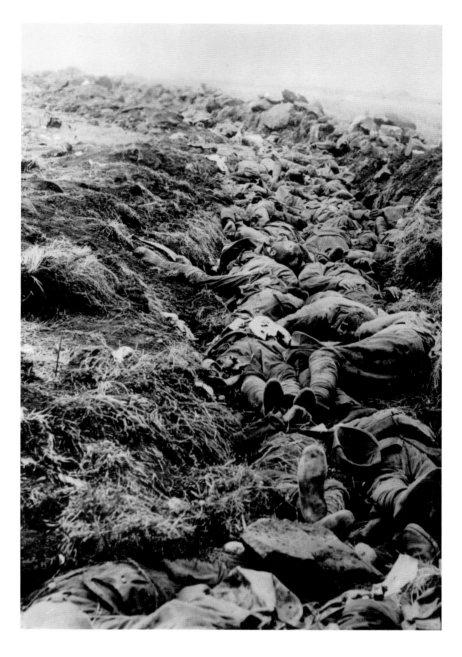

Three miles of trench and a mile of men
In a rough-hewn, slop-shop grave;
Spades and a volley for one in ten —
Here's a hip! Hurrah! for the brave.

Crimson flecks on a sand-coloured mound,
Like rays of the rosy morn,
And splashes of red on a khaki ground,
Like poppies in fields of corn.

Herbert Cadett 'The Song of Modern Mars', 1900

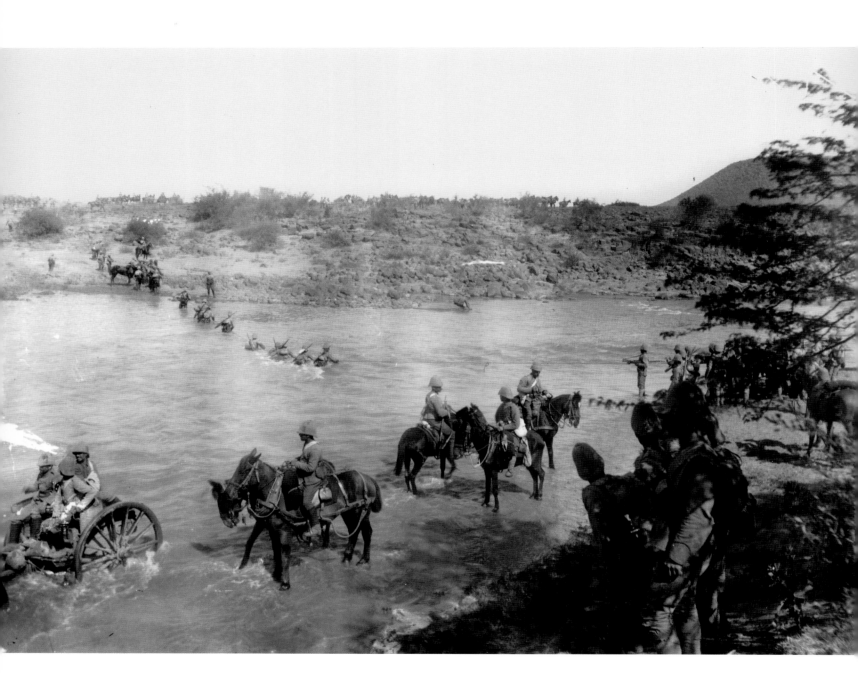

British soldiers and field artillery cross the
Paardeburg Drift in 1900. A line has been
stretched across the river for the infantry
to hold on to.
Reinhold Thiele

A Boer family on the way to a British concentration camp in its wagon, pulled by a team of mules, in late 1901 or early 1902. More than 120,000 Boer civilians, mostly women and children, were interned, and many died there from malnutrition and disease. The British sought to stop Boer guerrilla groups getting shelter and supplies from their families by this policy, which drew international criticism.

A diary entry by Emily Hobhouse, 31 January 1901, describing one of the concentration camps set up by the British into which Boer women and children were herded so that they could not give succour to their menfolk.

I was at the camp today, and just in one little corner this is the sort of thing I found. A girl of twenty-one lay dying on a stretcher — the father, a big, gentle Boer, kneeling beside her; while, next tent, his wife was watching a child of six, also dying, and one of about five drooping. Already this couple had lost three children in the hospital, and so would not let these go, though I begged hard to take them out of the hot tent ... I sent ... to fetch brandy, and got some down the girl's throat, but for the most part you must stand and look on, helpless to do anything because there is nothing to do anything with. Then a man came up and said, 'Sister, come and see my child, sick for three months.' It was a dear little chap of four, and nothing left of him but his great brown eyes and white teeth from which the lips were drawn back, too thin to close. His body was emaciated. The little fellow had craved for fresh milk, but of course there had been none until these last two days, and now the fifty cows only give four buckets. I can't describe what it is to see these children lying about in a state of collapse. It's just exactly like faded flowers thrown away. And one has to stand and look on at such misery and be able to do almost nothing.

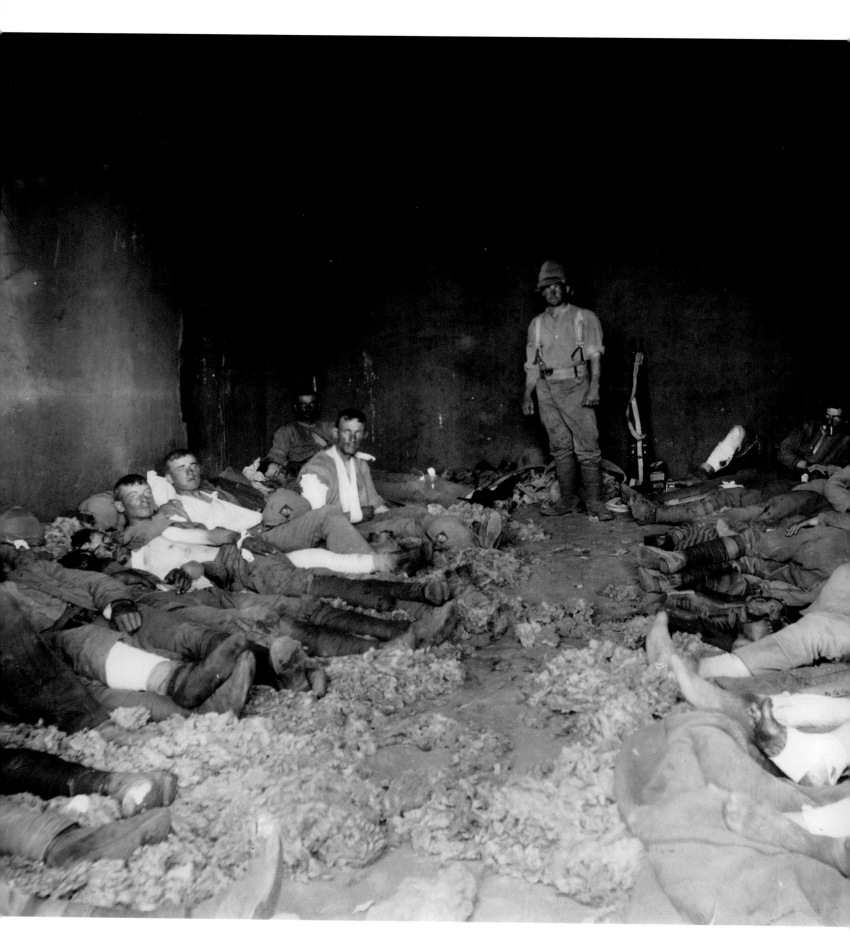

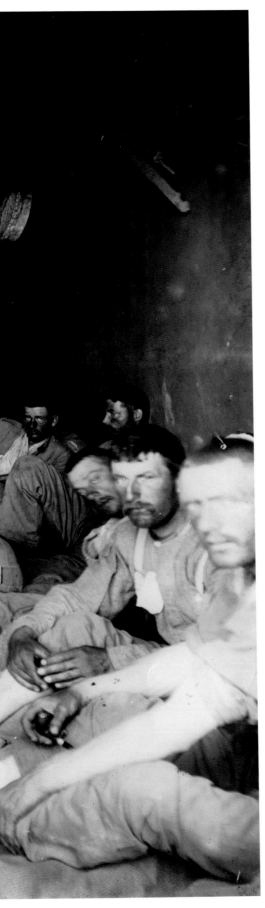

British wounded in a dirty wagon house serving as a dressing station, near the Modder River in 1900. As a result of poor sanitation and primitive hospital facilities, of the 22,000 men Britain lost in the war, 14,000 died of sickness rather than enemy action. Rudyard Kipling, who was covering the war for *The Friend*, an army newspaper, declared: 'We have had no end of a lesson, it will do us no end of good.'

Reinhold Thiele

Lieutenant Charles Veal of the Welsh Regiment was wounded in the head not far from the Modder River, 1 February 1900.

I was nearly suffocated with blood when I lay down and the sun (and I must confess fright) did not improve matters ... Eventually they put me on a stray orderly's horse, the two bearers holding me on while the other chap led the pony ... A short time afterwards we reached the hospital, which consisted of an operating marquee and a few wagons and bell-tents. A Wesleyan parson took me off the horse and produced some brandy and beef tea which I gulped down with the greatest relief. Shortly afterwards I was taken into the operating tent and put on the table. Two doctors then shook their heads and thought my case was too bad to trouble about with all the cases still waiting but a remark, unfit for publication, from me changed their minds and in a few minutes I was patched up and had great notches cut out of my beautiful scarlet beard. I then returned to the bell-tent and was given an outside stretcher which I much appreciated.

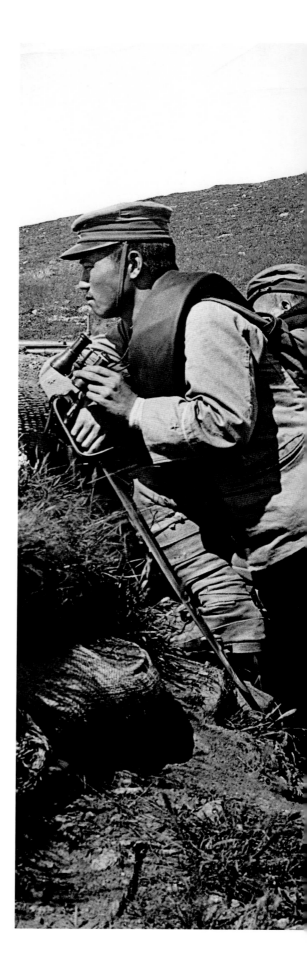

General Sir Ian Hamilton, attached to the Japanese staff during the Russo-Japanese war, 1904–5, criticizes the Japanese for over-dense formations and over-preparation.

The Japanese expose four of their soldiers to fire at the long range, where one would suffice. If, of course, the men need the touch of a comrade's elbow to carry them on, that is argument I can understand; but I do not believe this of the brave Japanese, and to get the ranks half emptied by rifle bullets and shrapnel at long ranges is not the best way to conserve weight for the bayonet work at the end. The advance, as I have seen it practised today, is a formidable modification of its original German model and the element of speed which has been introduced might prove exceedingly demoralising to second-rate troops, especially if they had not great confidence in their own marksmanship at the short ranges. I believe, nevertheless, that such a system of attack must fail against such marksmen as the British infantry have now become. If the Russians shoot as badly as they are said to do, then, of course, all is possible.

Nothing would induce them to make the plunge until they had completed their most minute preparations. Let the Germans admire this if they will; it is not the principle by which Marlborough, Napoleon, or Lee won their reputations. On the day they meet a first-class General this passion for making all things absolutely safe may be the ruin of our careful little friends.

Russo-Japanese War

Japanese soldiers packed tightly, shoulder to shoulder, in a trench awaiting a Russian attack. The officers are equipped with European-style swords, but during the Second World War many took samurai swords with them into action.

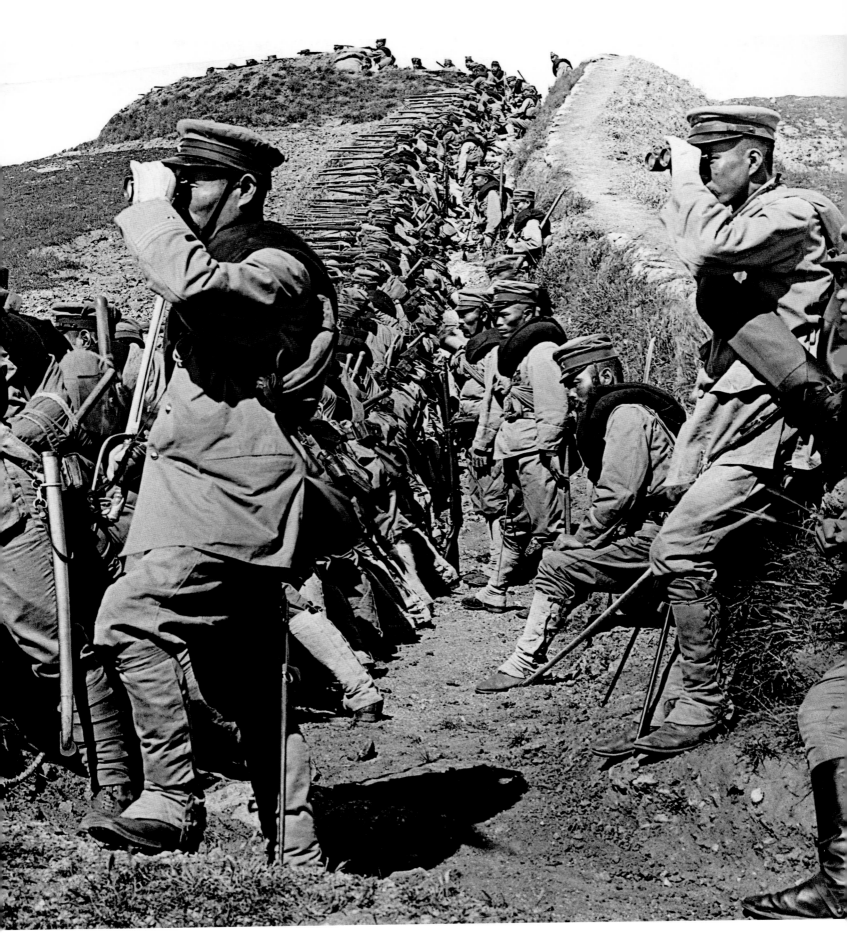

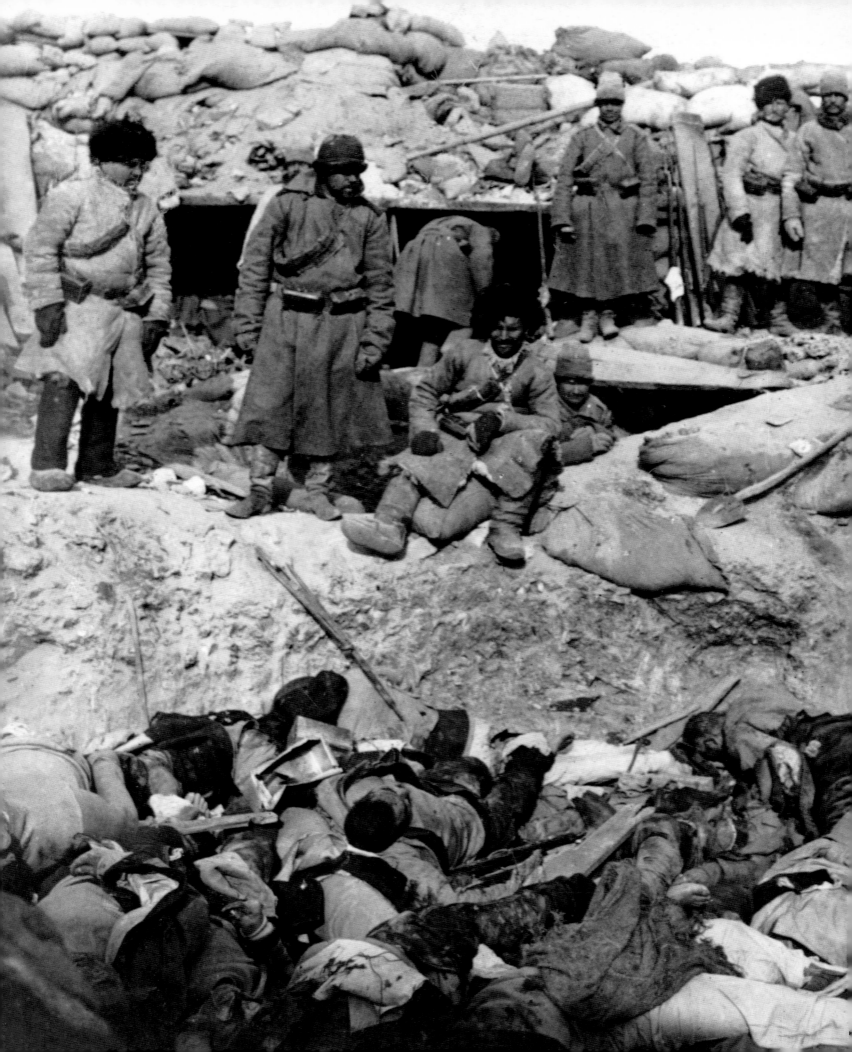

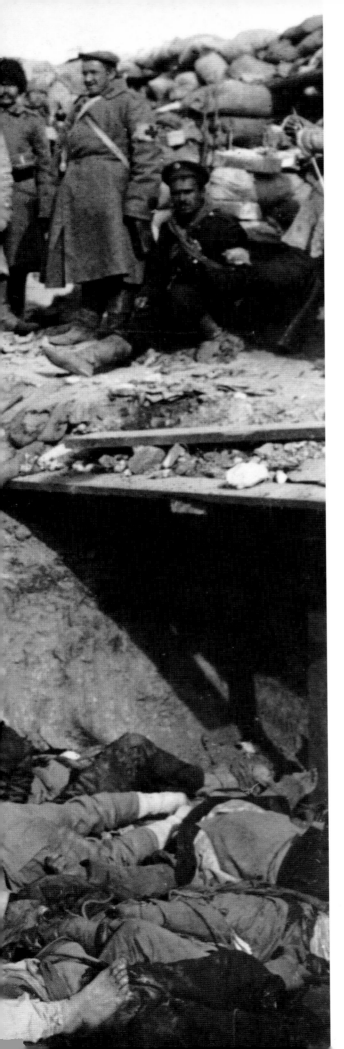

Maurice Baring reported for the *Morning Post* from the Russian side. His comment, on the battle of Llaoyong, chimes in with Hamilton's criticism of the density of Japanese formations.

All through the night the Japanese attacked the forts; a Cossack officer, who was in one of these forts, told me that the sight was beyond words terrible; that line after line of Japanese came smiling up to the trenches to be mown down with bullets, until the trenches were full of bodies, and then more came on over the bodies of the dead. An officer who was in the fort he described went mad from the sheer horror of the thing. Some of the gunners went mad also.

Japanese dead piled up in a ditch at a Russian strongpoint are inspected by its defenders. Japan's victory forced Russia to abandon its expansionist policy in the Far East and Japan became the first Asian nation in modern times to beat a European power.

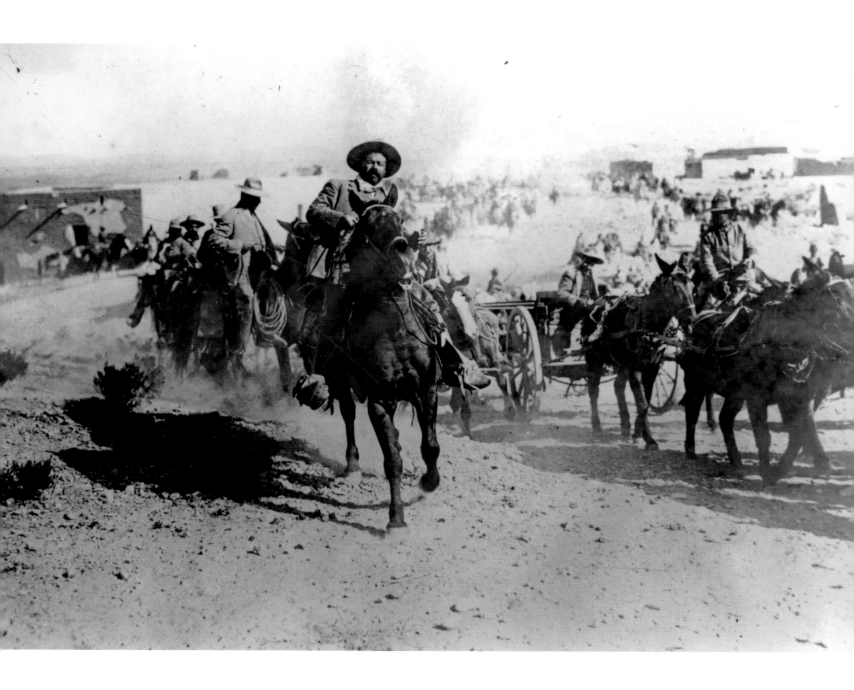

Mexican Revolution

Pancho Villa, one of the leading guerrilla leaders in 1913 during the Mexican Revolution, was a mixture of swagger, brutality, bravery and charisma. Both he and the peasant Emiliano Zapata emerged as folk heroes of the Mexican Revolution, successfully attacking the Mexican army and gaining control of their respective regions. In order to finance the revolution, Villa sold the film rights to his own battles to a film corporation. To help them he tried to fight in daytime rather than at night.

Agustín Victor Casasola

In January 1916 the American staff of the Cusi Mining Company thought it was safe to return to Mexico. But their train was stopped by seventy of Pancho Villa's followers under Colonel Pablo López. A Mexican employee of the company also on the train told an El Paso newspaper what happened.

No sooner had the train been brought to a standstill by the wreck the bandits had caused ahead than they began to board the coaches. They swarmed into our car, poked Mausers into our sides and told us to throw up our hands or they would kill us. They rifled our pockets, took our blankets and baggage and even our lunches.

Then Colonel Pablo López ... said 'If you want to see some fun, watch us kill these gringos. Come on boys,' he shouted to his followers. They ran from our coach crying 'Viva Villa' and 'Death to the gringos'. I heard a volley of rifle-shots and looked out of the window. Manager Watson was running toward the Santa Ysabel river, a short distance away. Four other Americans were running in other directions, the Villistas shooting at them. Some of the soldiers dropt [sic] to their knees for better aim. Watson fell after running about a hundred yards. He got up, limping, but went on a short distance further, when he threw up his arms and fell forward, his body rolling down the bank into the river ...

The other Americans were herded to the side of the coach and lined up. Colonel López selected two of his soldiers as executioners, and this nearly precipitated a fight among the bandits over who should have the privilege of shooting the Americans. The two executioners used Mauser rifles. One would shoot his victim and then the other soldier would take the next in line.

Within a few moments the executioners had gone completely down the line. The Americans lay on the ground, some gasping and writhing in the cinders ... Colonel López ordered the 'mercy shot' given to those who were still alive, and the soldiers placed the ends of their rifles at their victims' heads and fired, putting the wounded out of their misery. All the bodies were completely stripped of clothing and shoes.

Men of the South, it is better to die on your feet than live on your knees.

Emiliano Zapata

The Mexican approach to combat during their civil war is epitomized in this group *(left)*. Some, however, were also capable of feats of the greatest bravery, like Guadalupe Condelería, the fifteen-year-old pictured *(right)* in 1913 in his cart that he used to collect the wounded where the fighting was thickest.

British journalist Hamilton Fyfe on the fighting in Monterey.

Mexicans ... are not in the habit of rushing. Their only method is to get behind something and fire their rifles, seldom with any particular aim. Many I saw did not raise them to their shoulder. Of those who did this, few looked along the barrel.

Timothy Turner, an American journalist, describes the Mexican way of fighting during the attack on Ciudad Juárez in 1911.

They moved in no formation whatsoever, just an irregular stream of them, silhouettes of men and rifles. Thus they were to move in and move out ... throughout the battle. They would fight awhile and then come back to rest, sleep and eat, returning refreshed to the front.

4. First World War 1914 – 18

THE FIRST WORLD WAR began with the promise of splendour, honour and glory. It continued as a genoc-idal conflict on an unparalleled scale, battle after battle producing an enormous number of casualties, until a state of exhaustion set in because no one knew how to end it. The effects of the war still linger today – one writer says he traces English melancholy to the battlefields of the Somme.

Generals commanded larger armies than the world had seen before. (Looking at the photographs of the period one is struck by the sheer numbers of men involved, row upon row of soldiers stretching from the foreground to the horizon.) But the high commands on both sides could find no way of using them except as fodder for the machine guns. Nearly ten million people were killed in the fighting or as a direct result of it, twenty-one million were wounded and a rotting corpse on barbed wire became a symbol of a world gone mad.

What was it all about? What was the point? The idea that all those people might have died for nothing apears incredible. Yet the very first sentence in John Keegan's book, *The First World War*, reads: 'The First World War was a tragic and unnecessary conflict.' Other historians agree with him, asking why the British did not let the Germans slug it out with the Russians and French and so spare not just British lives but the future horrors of Nazism and Bolshevism and the incursion of America into Europe's affairs.

As late as July 1914, the British Chancellor of the Exchequer, Lloyd George, assured the House of Commons that relations with Germany were better than they had been for years and that the Germans posed no real threat to the British Empire. Yet within months the Allies and Germany were locked into a war of attrition that was to last four long years.

To arouse the fighting spirit of the British, the war was made to appear one of defence against a menac-ing aggressor. The Kaiser was painted as a beast in human form. In a single report the London *Daily Mail* referred to him as a 'lunatic', a 'barbarian', a 'madman', a 'monster', a 'modern Judas' and a 'criminal monarch'. The Germans were portrayed as only slightly better than the hordes of Genghis Khan – rapers of nuns, mutilators of children and destroyers of civilization. The media was pulled on side by censorship and appeals to patriotic sentiment.

Defeats, retreats and set-backs were ignored or glossed over. The retreat from Mons, centre of a min-ing area in Belgium, a British set-back in its first encounter with the Germans, was described in the official bulletin as 'The British forces have reached their new position'. The French fared even worse. At the Battle of the Frontiers between 14 and 25 August 1914, the Germans wiped out about 300,000 French soldiers, or nearly 25 per cent of the combatants, a rate of wastage never equalled in the rest of the fighting on any front. There was a correspondent from *The Times* there but not a single word about this defeat appeared in his dispatches to his newspaper, or in his private letters to his editor. The disaster remained completely un-reported in Britain until the war was over.

It might have gone on like this had not former American President Theodore Roosevelt told the British government that its refusal to allow war correspondents to pursue their task was harming Britain's cause in the United States: ' … the only real war news, written by Americans who are known to and trusted by the

American public, comes from the German side.' So GHQ agreed to have 'a few writing chappies' with the armies in the field. But how much would they be allowed to report? A rough rule of thumb was established by General J. V. Charteris, Chief of Intelligence, when asked by a correspondent what he would be allowed to write: 'Say what you like, old man. But don't mention any places or people.'

Under the control of their conducting officers and the censors, the six official war correspondents provided colourful stories of heroism and glory calculated to sustain public enthusiasm for the war, to cover any mistakes the high command might make, preserve it from criticism in its conduct of the war and safeguard the reputations of its generals. The six were virtually incorporated into the military machine – they were given officer rank, uniforms, batmen, drivers and conducting officers and lived in chateaux requisitioned by the General Staff. The horrors of trench warfare were kept concealed by a ban on all photography. One of the correspondents, Philip Gibbs, explained five years after the war was over why the correspondents had gone along with this charade: 'We identified ourselves absolutely with the Armies in the field … We wiped out of minds all thoughts of personal scoops and all temptation to write one word which would make the task of officers and men more difficult or dangerous. There was no need of censorship of our despatches. We were our own censors.'

Again, photographs or artists' sketches might have rectified the failure of the correspondents. But only two photographers, both army officers, were eventually allowed to cover the Western Front and since their main task was compiling a historical record, not providing the press with material, none of their 'realistic' photographs was released. The penalty for anyone else caught taking photographs at the front was the firing squad. One soldier is known to have risked it. F. A. Fyfe, a press photographer who had enlisted as a private, concealed a small camera in his bandolier and took photographs of a dawn attack on German trenches, in 1915 (see p. 79).

Artists were not allowed to go to the front until 1916 but by 1918 there were more than ninety of them. They were not much more successful than the correspondents in presenting a true picture of the war. One, Paul Nash, protested: 'I am not allowed to put dead men into my pictures because apparently they do not exist … I am no longer an artist. I am a messenger who will bring back word from the men who are fighting to those who want the war to go on for ever. Feeble, inarticulate will be my message, but it will have a bitter truth and may it burn their lousy souls.'

Since the United States did not enter the war until 1917, the American correspondents were able to cover its first years as neutrals, although they were later forced to choose sides. Their role in the war was one long battle to report it as they saw it, not as the British, German or the American censor wanted it. With a courage that must be admired, some, such as Richard Harding Davis, disgusted at not being allowed by the British or the French to visit the front lines, refused to compromise their professional integrity. They packed up and went home, forefeiting their accreditation, rather than remain silent. As for all the others, when the war was over, the British historian Arthur Ponsonby gave his verdict: 'There was no more discreditable period in the history of journalism than the four years of the Great War.'

Richard Harding Davis of the *New York Tribune* sees the German army marching through Brussels on 20 August 1914.

At the sight of the first few regiments of the enemy we were thrilled with interest. After three hours they had passed in one unbroken steel grey column [and] we were bored. But when hour after hour passed and there was no halt, no breathing time, no open spaces in the ranks, the thing became uncanny, inhuman. You returned to watch it, fascinated. It held the mystery and menace of fog rolling towards the sea.

The gray of the uniforms worn by both officers and men helped this air of mystery. Only the sharpest eye could detect among the thousands that passed the slightest difference ...

This army has been on active service three weeks, and so far there is not apparently a chinstrap or a horseshoe missing. It came in with the smoke pouring from cookstoves on wheels, and in an hour had set up postoffice wagons, from which mounted messengers galloped along the line of column distributing letters and at which soldiers posted picture postcards ...

The men of the infantry sang 'Fatherland, My Fatherland.' Between each line of song they took three steps. At times two thousand men were singing together in absolute rhythm and beat ...

For seven hours the army passed in such solid column that not once might a taxicab or trolley car pass through the city. Like a river of steel it flowed, grey and ghostlike. Then, as dusk came and as thousands of horses' hoofs and thousands of iron boots continued to tramp forward, they struck tiny sparks from the stones, but the horses and the men who beat out the sparks were invisible.

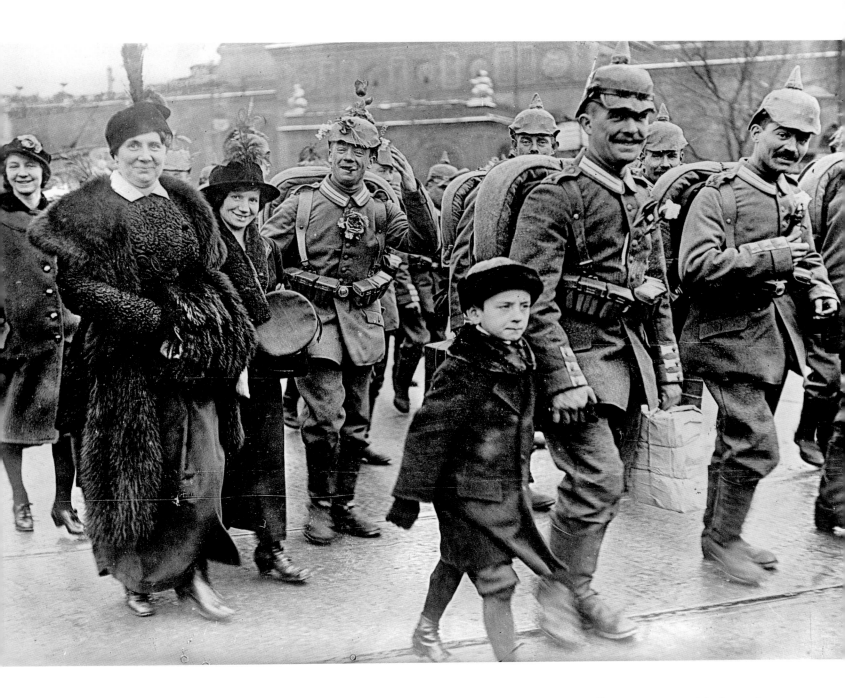

German troops set out for the war in
August 1914. Their rifles must either be
stacked out of sight or be on a vehicle
or train.

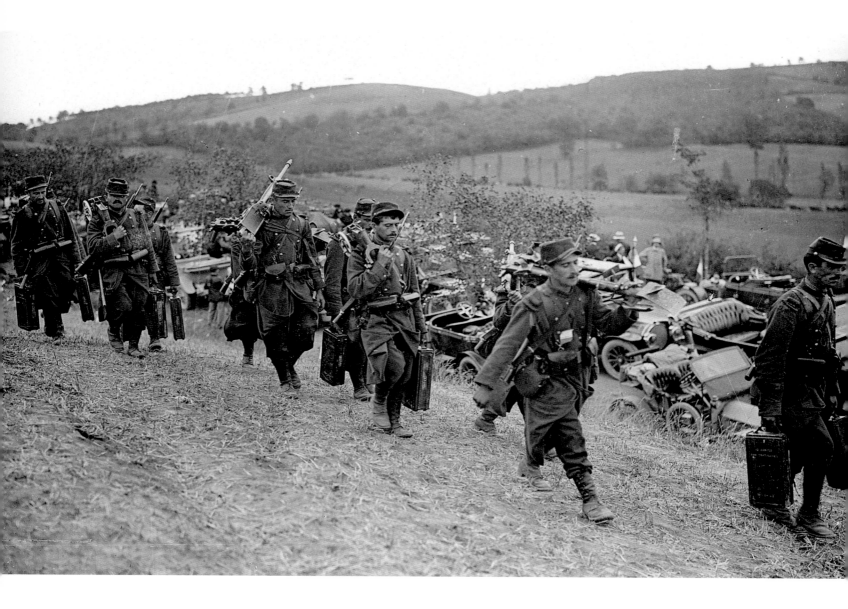

These French machine gunners have just arrived on the Marne in September 1914, transported from Paris in the taxis to be seen behind them. General Galliéni, whose brilliant idea this was, shrugged it off with the remark, 'Eh bien, voilà au moins qui n'est pas banal,' ('Oh well, at least it's not boring.'). It was in fact enough to halt the German advance into the French heartland.

The Liverpool Scottish take cover under the parapet of the German front-line trench that they have just captured at 'Y' Wood near Hooge on 16 June 1915. The flag signals their success and that they are moving on. A rare action shot taken by Private F. A. Fyfe. A press photographer by profession, Fyfe enlisted in the army as an ordinary soldier and, in spite of the threat of a court martial and a possible death penalty, he took an illegal, concealed camera with him.

Private F. A. Fyfe

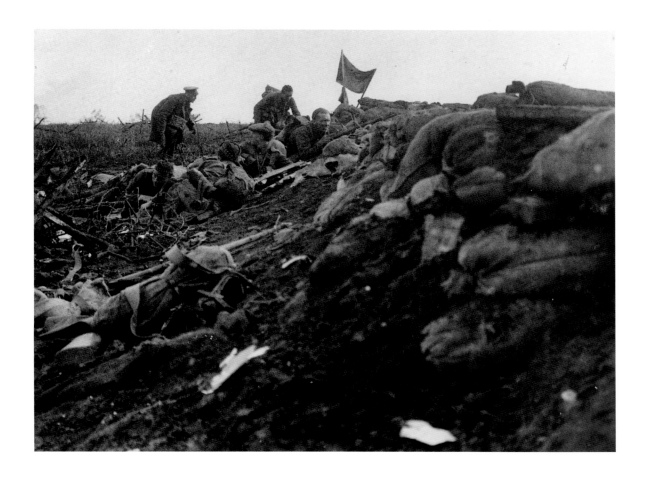

We went over. We'd got nothing to fight with. We'd got three machine guns in our Battalion, that's all. I've got a bag of Mills bombs, that's all, twelve, we were rationed out, don't waste anything if you can help it, kind of thing. So when we went over at Loos I'd got twelve bombs, my rifle, 150 rounds of ammunition (plenty of ammunition) and we hadn't got half-way when Jerry started machine-gunning. He'd got a machine gun every yard and there we were, three machine guns, we'd got a few bombs. If a bullet had hit us, that was it, I'd have been blown to smithereens. I heard Tommy Winkler go 'Ah!' He was my mate — and he was gone — just like that.

Private W. H. Nixon, at Loos, September 1915.

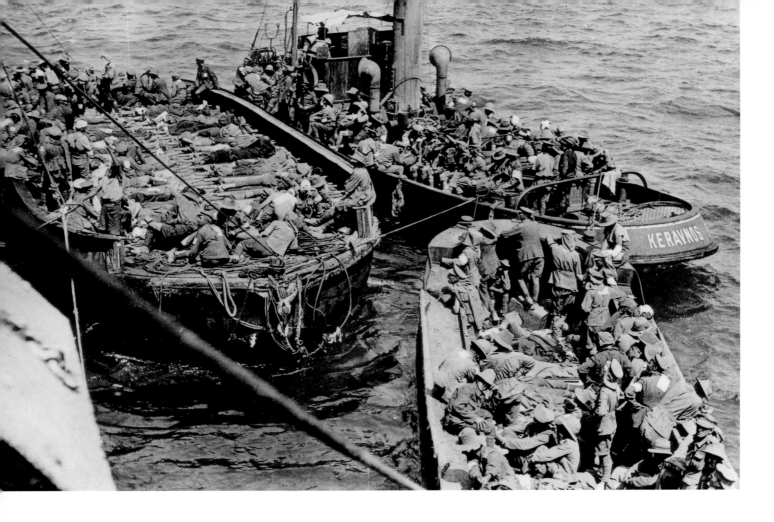

Private Harold Boughton of the London Regiment describes conditions in the trenches at Gallipoli.

One of the biggest curses was flies. Millions and millions of flies. The whole side of the trench used to be one black swarming mass. Anything you opened, like a tin of bully, would be swarming with flies. If you were lucky enough to have a tin of jam and opened that, swarms of flies went straight into it. They were all around your mouth and on any cuts or sores that you'd got, which then turned septic. Immediately you bared any part of your body you were smothered. It was a curse, it really was.

British wounded being ferried out by lighters to ships waiting off Gallipoli early in the campaign. One ship took 600 wounded on the four-day journey back to Egypt in the care of a single vet – such was the shortage of doctors.

Australian troops in captured Turkish trenches at Lone Pine in Gallipoli, August 1915, during the last great offensive. Seven Victoria Cross medals were won, 1700 Australians fell and over 5000 Turks were killed in this particular encounter. It was the high point of Australian efforts at Gallipoli.

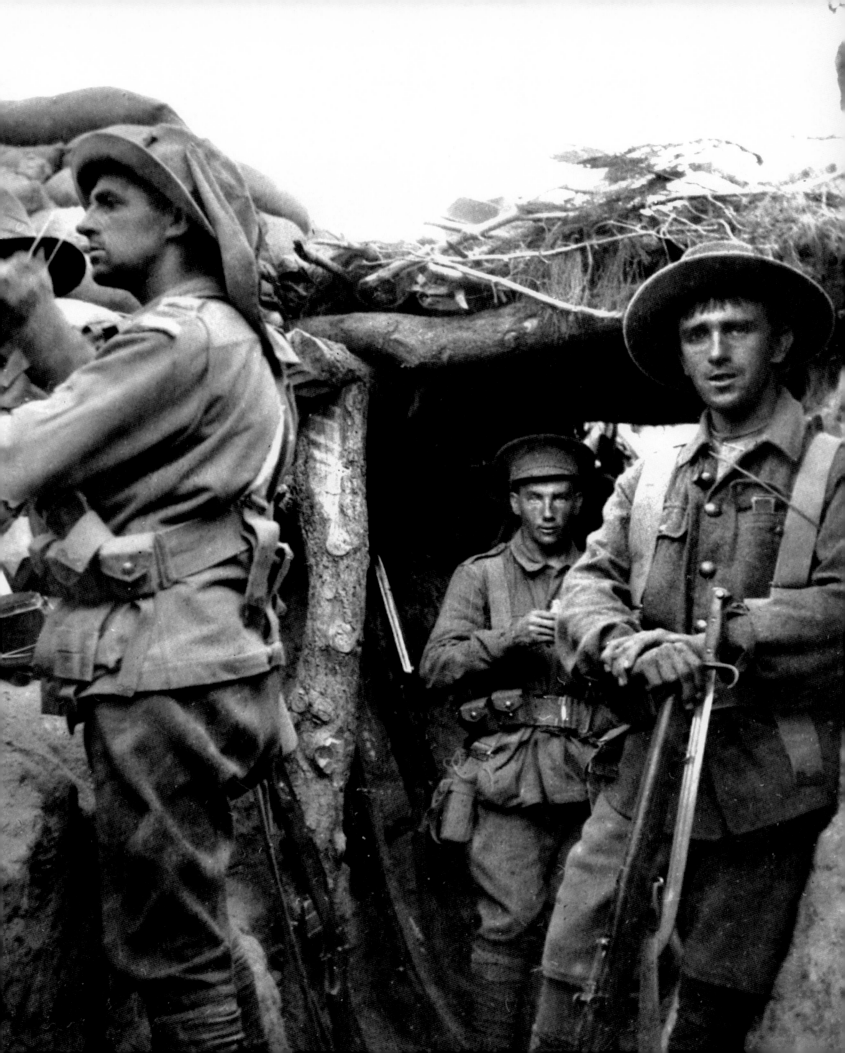

Mrs M. Hall, a munitions worker, on the effect of the chemicals used in the explosives.

After each day, when we got home we had a lovely good wash. And believe me the water was blood-red and our skin was perfectly yellow, right down through the body, legs and toenails even, perfectly yellow. In some people it caused a rash and a very nasty rash all round the chin. It was a shame because we were a bevy of beauties, you know, and these girls objected very much to that ... The hair, if it was fair or brown, it went a beautiful gold, but if it was any grey, it went grass-green. It was quite a twelve-month after we left the factory that the whole of the yellow came from our bodies. Washing wouldn't do anything — it only made it worse.

● *Overleaf:* The Russian imperial army was called the 'Russian Steamroller' by its allies. Here hundreds of Russian soldiers in their boots and blouse-like tunics, many of their caps at defiantly rakish angles, pose for the camera at some forgotten place and moment out of the front line in the First World War.

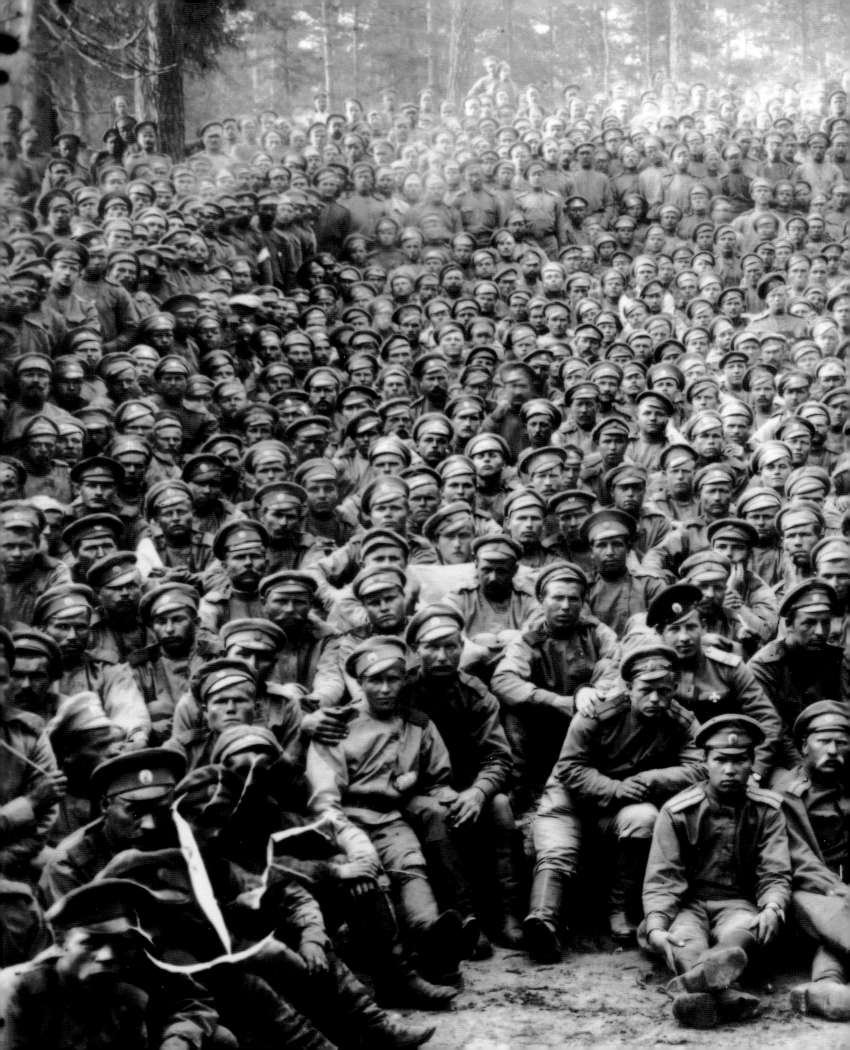

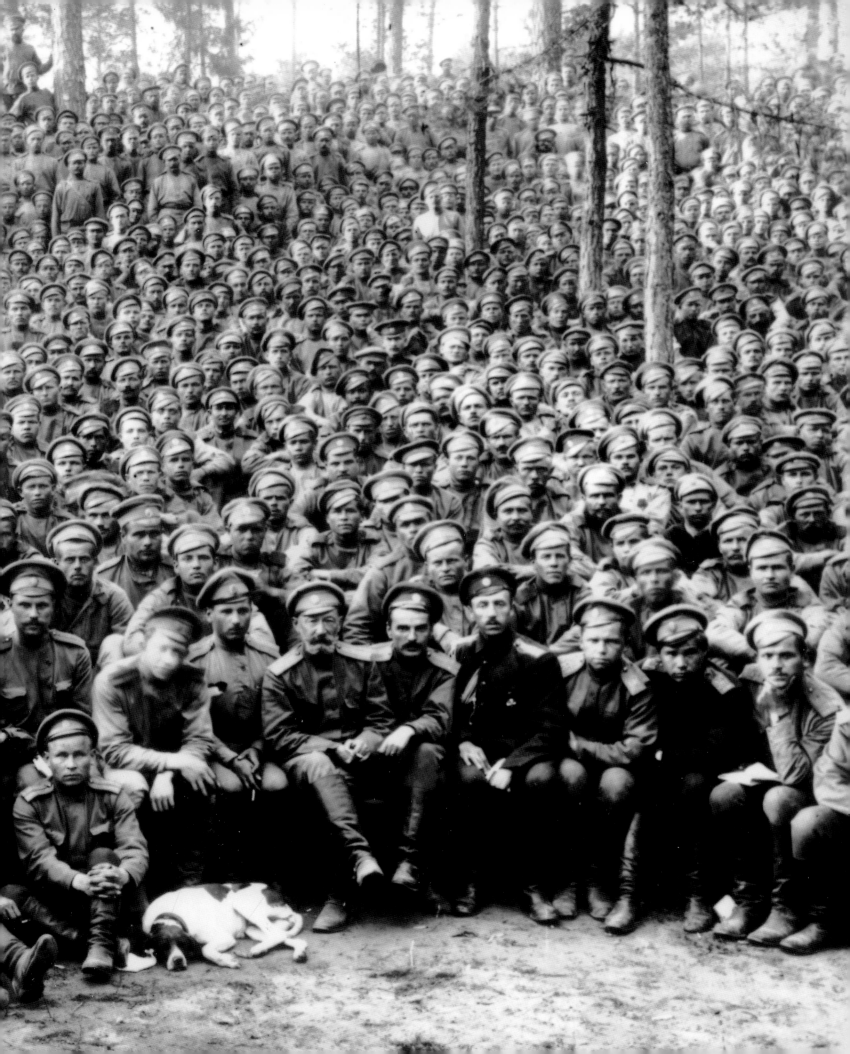

A sergeant in the 26th Infantry Regiment helps hold Hill 304, at Verdun.

The trench no longer existed, it had been
filled with earth. We were crouching in
shell-holes, where the mud thrown up by each
new explosion covered us more and more. The
air was unbreathable. Our blinded, wounded,
crawling and shouting soldiers kept falling
on top of us and died while splashing us with
their blood ... Suddenly, the enemy artillery
lengthened its fire, and almost at once
someone shouted: 'The Boches are coming!' ...
The redan's [strongpoint] machine gun had been
buried by shell-fire, and all of its crew
killed. The second machine gun was lying
nearby, its legs in the air, but nothing was
broken. We cleaned it hurriedly, and were able
to start firing at the very moment the Germans
appeared.

The Germans' new weapon introduced at Verdun was the flame thrower.
A German doctor on duty at Fort Douaumont after its capture from the French
remembered how:

One day I wandered through the casements and
found one that had been bricked up. Somebody
had written on it, 'Here lie 1,052 German
soldiers.' I asked what that meant and they
told me a whole battalion was in that
casement. It had been used to store barrels
of fuel for the flame-throwers and somebody
must have been very careless as the whole
thing blew up. Nobody was left — they couldn't
even get at them, so they just bricked it up.

La Voie Sacrée, the Sacred Way, a narrow
secondary road up which all French
supplies and reinforcements for Verdun
had to come. One driver remembered,
'It was impossible to pass anyone. All you
could do was to follow the line moving
down … in a very slow progression
interrupted by a thousand jerks and jolts.'

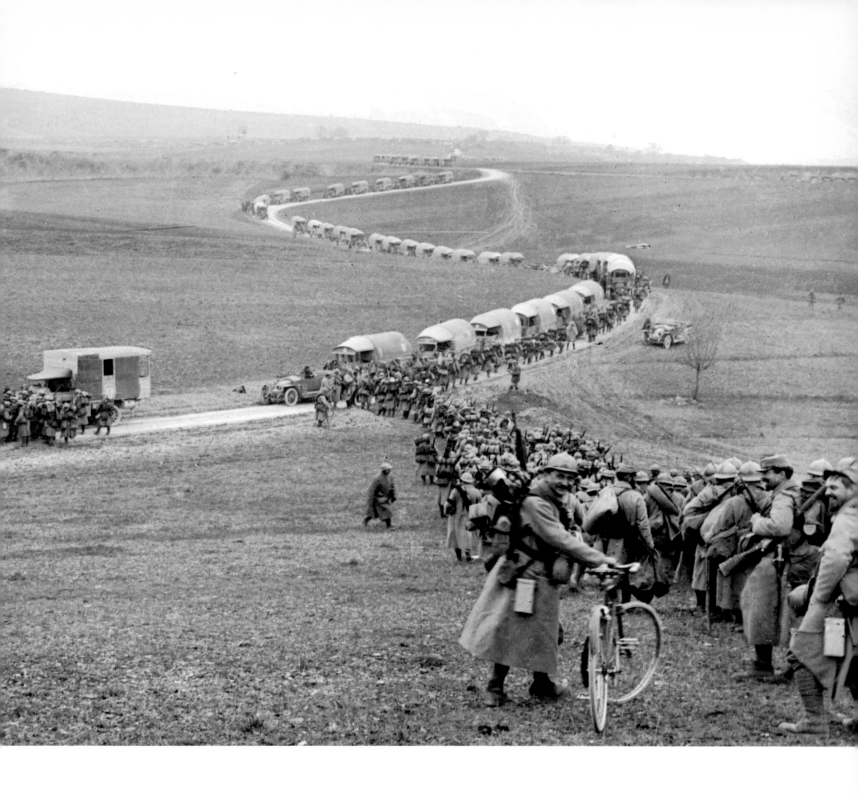

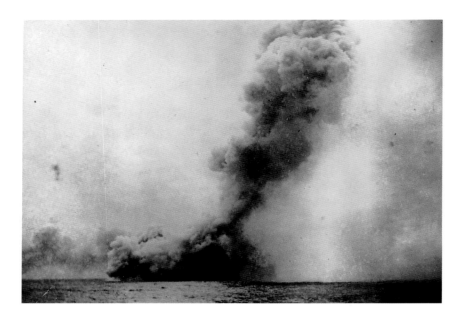

HMS *Queen Mary* blows up at the Battle of Jutland.

Crew members of a surfaced German U-boat, their faces betraying the strain inseparable from their particularly hazardous kind of underwater warfare.

At the Battle of Jutland, 31 May 1916, the biggest naval encounter of the war, German gunnery outclassed British. Commander Georg von Hase was first gunnery officer on the battleship *Derfflinger*.

We were firing as at gunnery practice. The head-telephones were working splendidly, and each of my orders was correctly understood. Lieutenant-Commander von Stosch reported the exact fall of each shot with deadly accuracy: 'Straddling! Two hits!' 'Straddling! The whole salvo in the ship!' I was trying to get in two salvoes to the enemy's one ...

 About 6.26 pm was the historic moment when the Queen Mary, the proudest ship of the British fleet, met her doom ... First of all a vivid red flame shot up from her forepart. Then came an explosion forward which was followed by a much heavier explosion amidships, black debris of the ship flew into the air, and immediately afterwards the whole ship blew up with a terrific explosion.

Petty Officer Ernest Francis, who was in X Turret on HMS *Queen Mary* at the Battle of Jutland.

I put my head through the hole in the roof of the turret and nearly fell through again. The after 4-inch battery was smashed out of recognition, and then I noticed that the ship had got an awful list to port. I dropped back again into the turret and told Lieutenant Ewert the state of affairs. He said, 'Francis, we can do no more than give them a chance, clear the turret' ...

 When I got to the ship's side, there seemed to be quite a fair crowd, and they didn't appear to be very anxious to take to the water. I called out to them, 'Come on you chaps, who's coming for a swim?' ... I struck away from the ship as hard as I could and must have covered nearly fifty yards when there was a big smash, and stopping and looking round, the air seemed to be full of fragments and flying pieces.

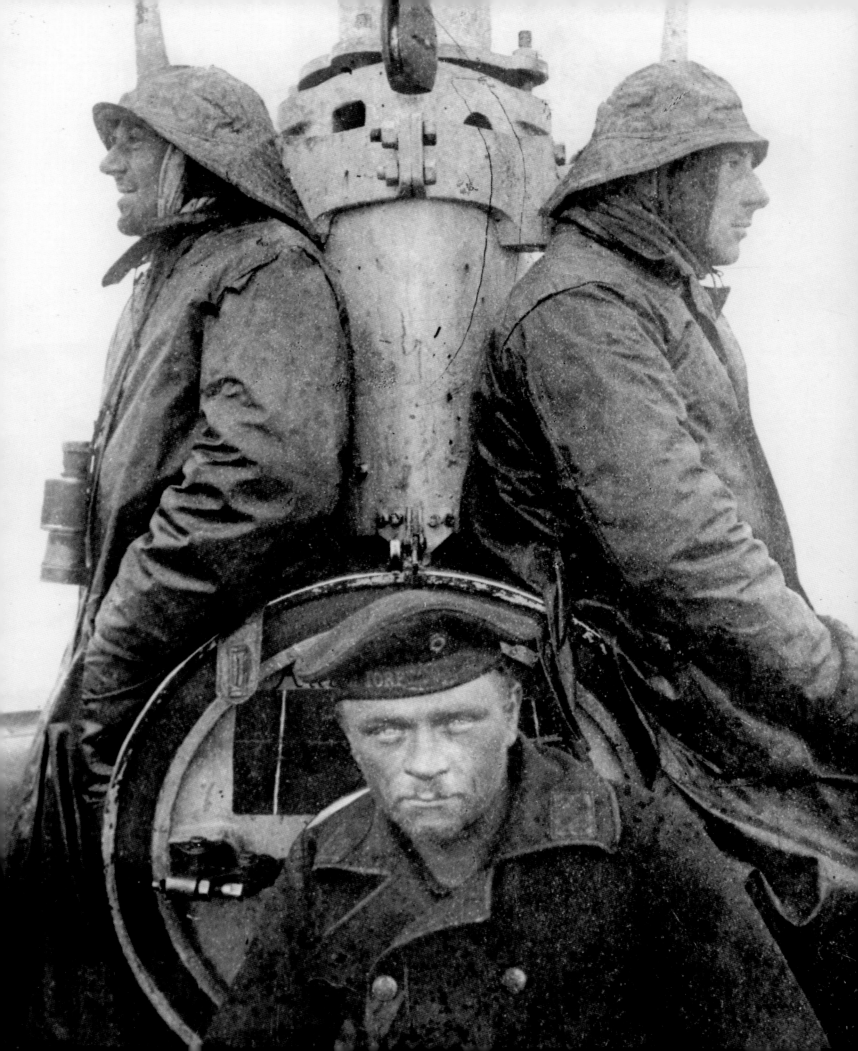

A British Tommy carries a wounded comrade along a trench in July 1916, in the early days of the Battle of the Somme. This is a still from a documentary film, which had been seen by half the British population by the end of October 1916. The wounded man died a few minutes after reaching the dressing station. The wounded had to be carried in this way when trenches were too narrow or twisting for stretchers to be used.

The experiences of Private Ernest Deighton of the King's Own Yorkshire Light Infantry on the first day of the Somme, 1 July 1916.

I were in the first row and the first one I saw were my chum, Clem Cunnington. I don't think we'd gone twenty yards when he got hit straight through the breast. Machine-gun bullets. He went down. I went down. We got it in the same burst. I got it through the shoulder. I hardly noticed it, at the time, I were so wild when I saw that Clem were finished. We'd got orders: 'Every man for himself and no prisoners!' It suited me that, after I saw Clem lying there.

I got up and picked up my rifle and got through the wire into their trench and straight in front there was this dugout — full of Jerries, and one big fellow was on the steps facing me. I had this Mills bomb. Couldn't use my arm. I pulled the pin with my teeth and flung it down and I were shouting at them, I were that wild.

'There you are! Bugger yourselves! Share that between you!' Then I were off! It was hand to hand! I went round one traverse and there was one — face to face. I couldn't fire one-handed, but I could use the bayonet. It was him or me — and I went first! Jab! Just like that. It were my job. And from there I went on. Oh, I were wild! Seeing Clem like that!

We were climbing out of the trench, making for the second line, and that's where they got me again just as I were climbing out, through the fingers this time, on the same arm. I still managed to get on. I kept up with the lads nearly to the second line. Then I got another one. It went through my tin hat and down and straight through my foot. Well, that finished it!

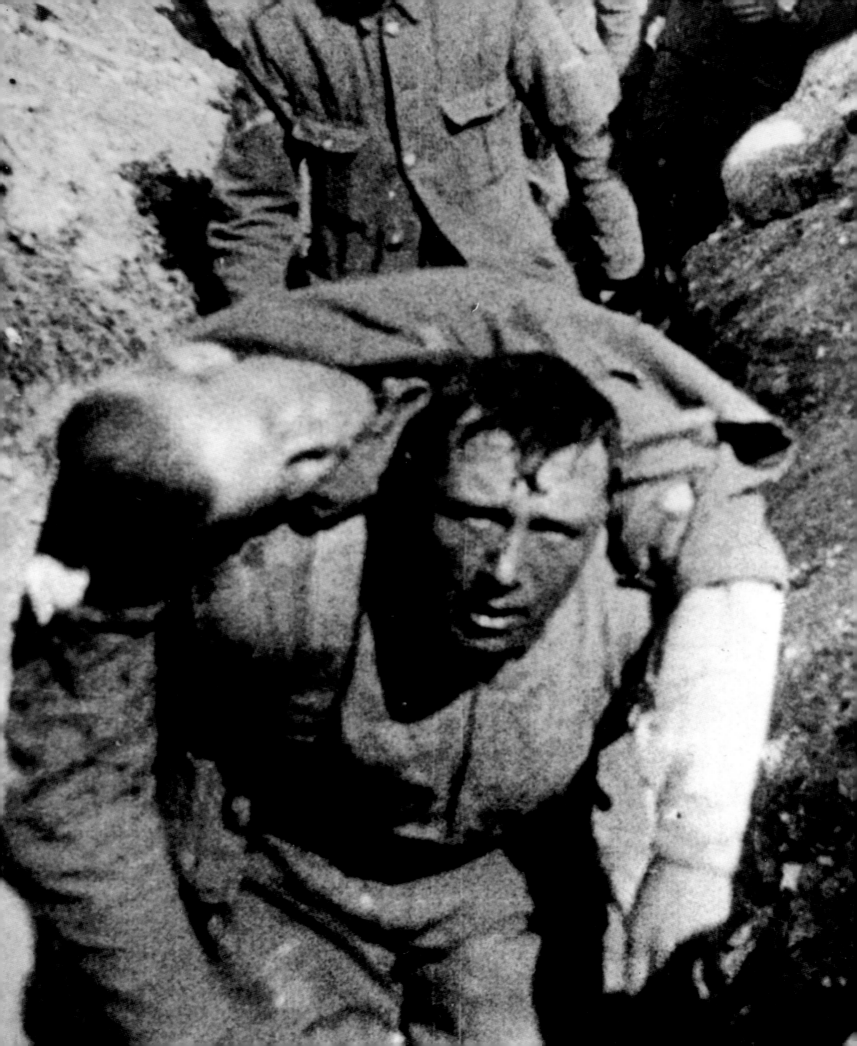

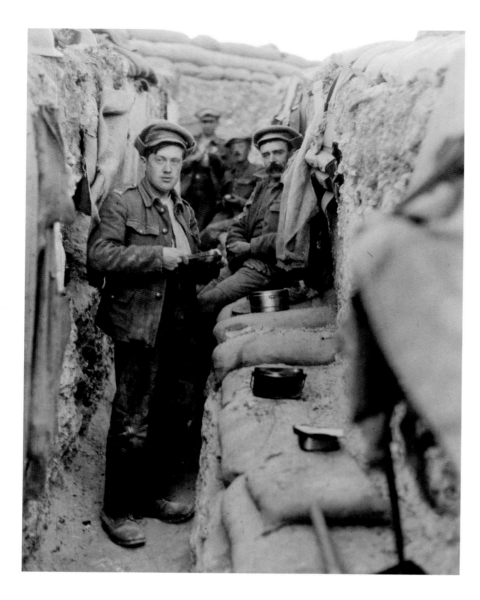

British troops eating in a trench on the Western Front early in the war, their mess tins resting on convenient sandbags.

Bread was very, very scarce. You might not see bread for two months, so mostly it was just big square biscuits, like dog biscuits. They were nutritious no doubt, but we'd have to break them up with a trenching tool handle to make them small enough to eat.

There were potatoes though, and Maconochie vegetable rations. I don't know if it was a form of greens, it was concentrated. You'd get a round tin each of sliced potatoes and a little lump of fat pork in the middle, and you'd just jack-knife it open and eat them as they were. Then there was bully beef, which was more or less plentiful. I think everybody had a fair share of bully beef. I did see bacon once or twice, but it was very rare. You might get a bit of cheese occasionally, but not often, and you got margarine but never butter. I only ever had hot food once or twice in the trenches, and that was when we were on a very quiet front and our kitchens were able to get right up to the reserve line.

Sergeant Perry Webb, of the Dorsetshire Regiment

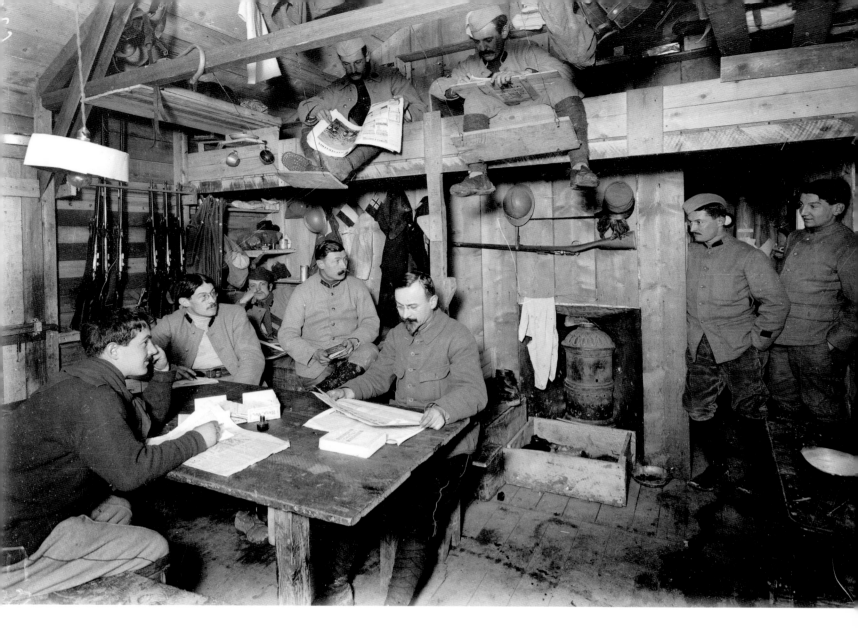

French engineering troops responsible for the Verdun region's military telephone exchange in their underground quarters in January 1916. This cosy scene was about to be violently disturbed by the German offensive on Verdun, which started the following month.

M. Emmanuel Gorce

The remains of the internal framework of the zeppelin shot down by Lieutenant Tempest *(see story below)*.

The God of War looks at his handiwork – bomb damage to a Paris mansion.

Shooting down a Zeppelin, Potters Bar, London, October 1915. Lieutenant W. J. Tempest, RFC.

I decided to dive at her ... firing a burst straight into her as I came. I let her have another burst as I passed under her and then banked my machine over, sat under her tail and flying along underneath her pumped lead into her for all I was worth ... As I was firing, I noticed her begin to go red inside like an enormous Chinese lantern. She shot up about 200 feet, paused, and came roaring down straight on to me before I had time to get out of the way. I nose-dived for all I was worth, with the Zeppelin tearing after me ... I put my machine into a spin and just managed to corkscrew out of the way as she shot past me, roaring like a furnace ... then proceeded to fire off dozens of green Very lights in the exuberance of my feelings.

Suddenly, one of the impudent fellows fell on me, attempting to force me down. I calmly let him come on, and then we began a merry dance. At one point my opponent flew on his back, then he did this, then that. It was a two-seater. I was superior to him, and he soon realized that he could not escape me. During a pause in the fighting I looked around and saw that we were alone. Therefore, whoever shot better, whoever had the greatest calm and the best position in the moment of danger, would win.

It did not take long. I squeezed under him and fired, but without causing serious damage. We were at least two kilometres from the Front and I thought he would land, but I miscalculated my opponent. When only a few metres above the ground, he suddenly levelled off and flew straight ahead, seeking to escape me. That was too bad for him. I attacked him again and went so low that I feared I would touch the houses in the village beneath me. The Englishman kept fighting back. Almost at the end I felt a hit on my machine. I must not let up now, he must fall. He crashed at full speed into a block of houses, and there was not much left. It was again a case of splendid daring. He defended himself right up to the end.

A Handley Page 0/400 bomber photographed from a sister machine. It had a crew of four and a top speed of 97 mph.

The Red Baron, Manfred von Richthofen, the greatest of the German fighter aces, with his dog. He was killed in April 1918 when his plane was shot down by Australian machine gunners.

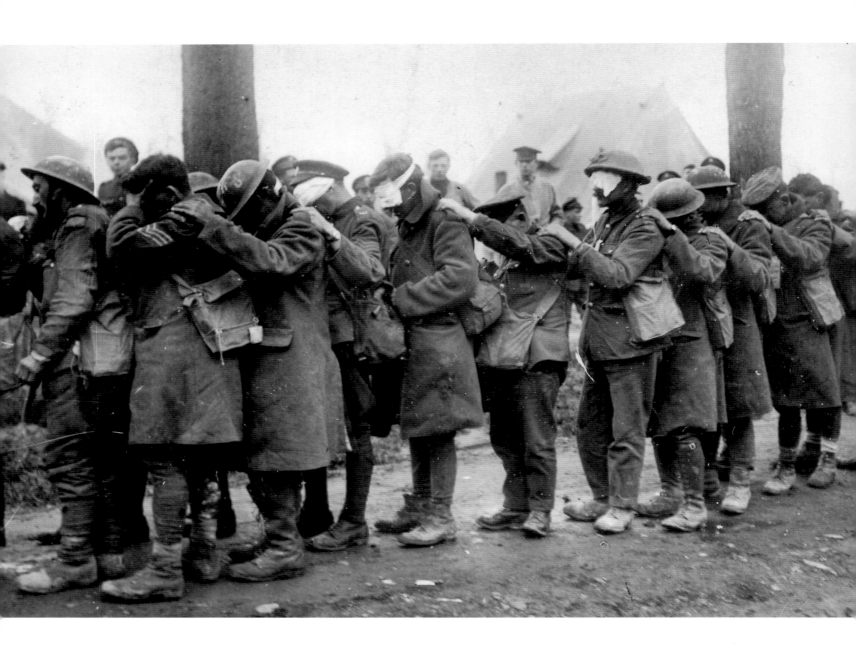

Sergeant Jack Dorgan, Northumberland Fusiliers, on the first gas attack, April 1915.

We'd only gone a hundred yards in front of the Canadians when we encountered gas. We'd had no training for gas prevention, never heard of the gas business. Our eyes were streaming with water and pain, and all we had was a roll of bandages in the first aid kit we carried in our tunic. So we bandaged each other's eyes, and anyone who could see would lead a line of half a dozen or so men, each with his hand on the shoulder of the one in front. In this way lines and lines of British soldiers moved along, with rolls of bandages around their eyes, back towards Ypres.

British victims of a gas attack on the Western Front doing what the Northumberland Fusiliers had to do in Jack Dorgan's account *(below)*. It was a scene such as this that inspired John Singer Sargent's famous painting, *Gassed*, in the Imperial War Museum in London.

A British nurse tends stretcher cases near the front line in 1918. Nurses also drove motor ambulances, taking the wounded from casualty clearing stations to field hospitals.

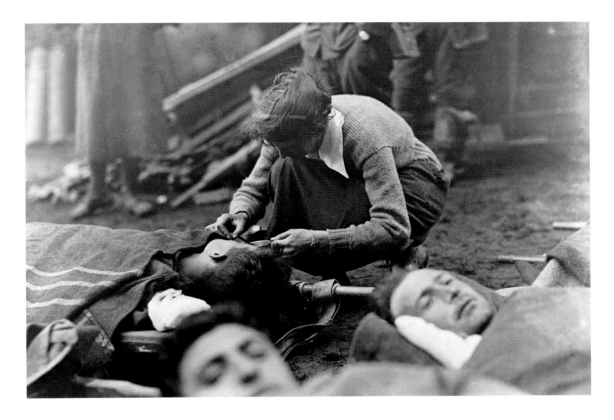

The effects of the successful gas attack were horrible. I am not pleased with the idea of poisoning men. Of course, the entire world will rage about it first and then imitate us. All the dead lie on their backs, with clenched fists; the whole field is yellow.

Rudolf Binding, a German, 24 April 1915.

Bernard Martin, a young lieutenant in the North Staffordshire Regiment who had already survived over a year on the Western Front, leads his men over the top on the first day of Passchendaele, 31 July 1917.

I spaced my men along the tape evenly, one metre or so
apart. Shells from our barrage screeched just over our
heads. The enemy artillery, taken by surprise, had not yet
opened fire. I set a steady walking pace, everything going
according to plan. But after a few steps I found myself in
a huddle on the ground, gasping for breath,bewildered. The
blast of a shell had thrown me down violently. As I
struggled to get up, to regain balance, still confused, I
realised that what seemed to be an unrecognisable heap on
the ground alongside me was, in fact, a man; one arm
extended, a long bare arm disclaiming any connection with
the body, the hand open with fingers wide apart as though
glad to be done with grasping. Undoubtedly a Goner ... My
reflections were cut short. From the battered parapet of
Jehovah, a little to my left, I saw the flash of a rifle:
so we could expect some resistance. Another rifle flash,
this one straight in front ... a knock-out blow ... legs
sagging ... collapse: and as I crossed the hazy limits of
consciousness into the non-world, I knew I had been shot
through the head.

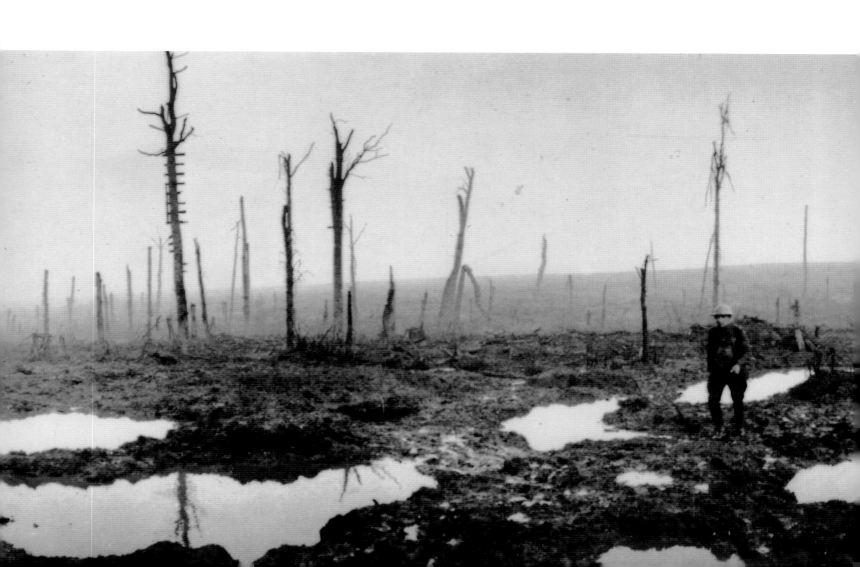

Corporal Jack Dillon of the Tank Corps recounts his initial impressions of the battlefield at Passchendaele.

At Passchendaele the smells were very marked and very sweet. Very sweet indeed. The first smell one got going up the track was a very sweet smell which you only later found out was the smell of decaying bodies — men and mules. After that you got the smell of chlorine gas, which was like the sort of pear drops you'd known as a child. In fact the stronger and more attractive the pear-drop smell became, the more gas there was and the more dangerous it was. When you were walking up the track a shell dropping into the mud and stirring it all up would release a great burst of these smells.

The Passchendaele battlefield in November 1917, reduced to a quagmire by months of rain and incessant shelling. The tree trunk on the left has been turned into a ladder for an observer. Access to the front was severely restricted for photographers, and battlefield landscape is a rarity. The poet Siegfried Sassoon wrote, 'I died in Hell. (They called it Passchendaele.)'
William Rider-Rider

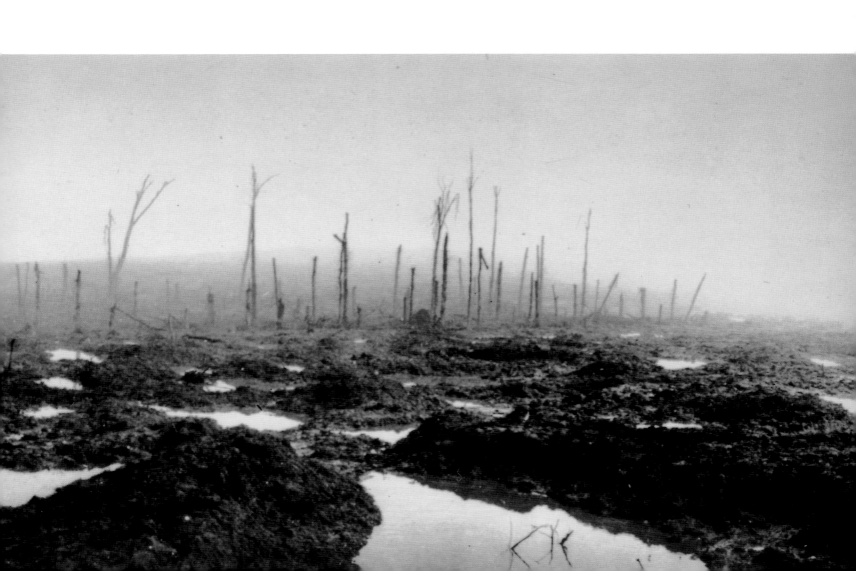

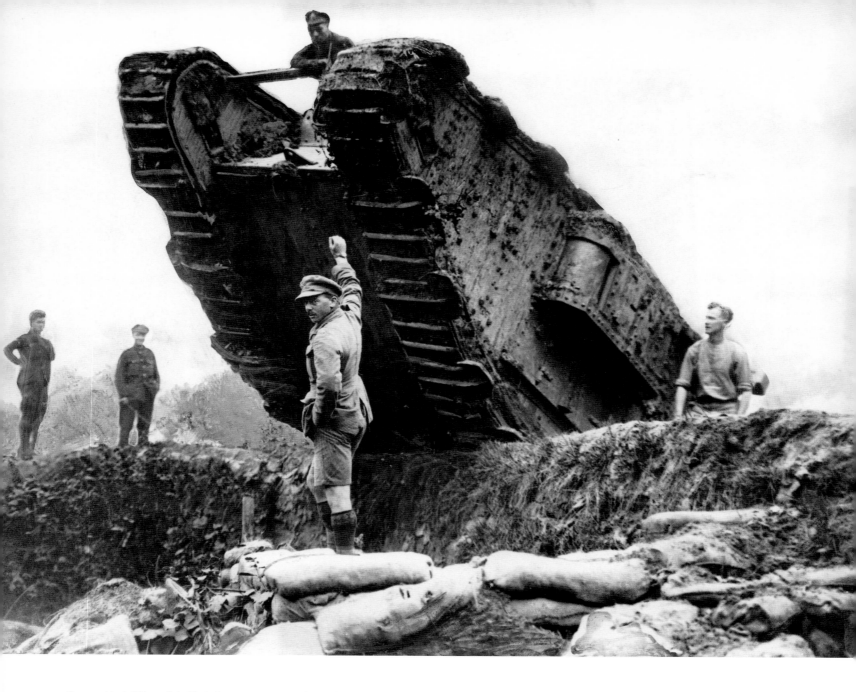

Corporal Jack Dillon of the Tank Corps on one way that tanks were put to use at Cambrai at the end of 1917.

The tanks cleared the wire for the crossing of large numbers of people by driving into it two abreast, dropping in steel anchors, then turning away from each other and going down the length of the wire pulling the anchors after them. The result was ... balls of wire about 20 feet high.

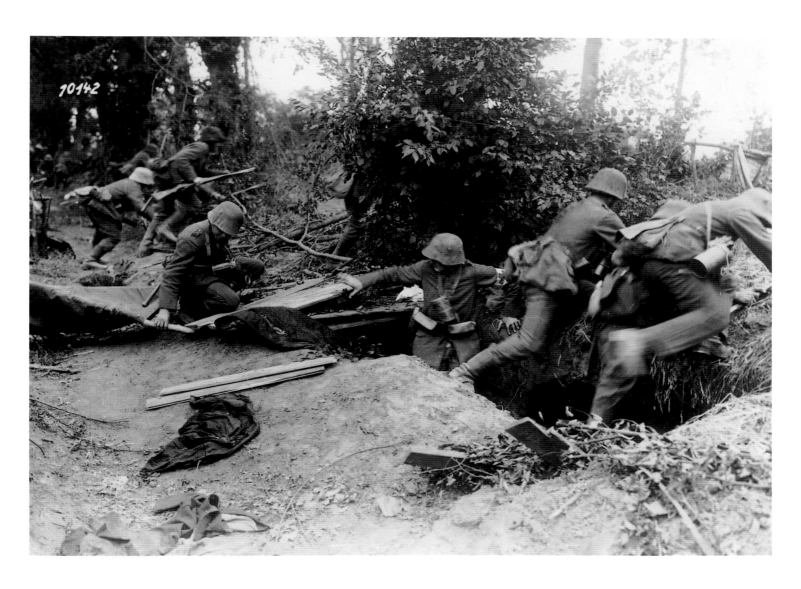

A British tank, nicknamed Winston's Folly, at Cambrai in 1917, the first time this new weapon was used effectively. The British infantry and 400 tanks crashed through the Hindenberg line with great initial success, but there weren't enough reserves to exploit the breakthrough.

German storm troopers advance in May 1918, with stretcher bearers in close attendance, part of Ludendorf's Spring Offensive, which knocked the British and French back on their heels.

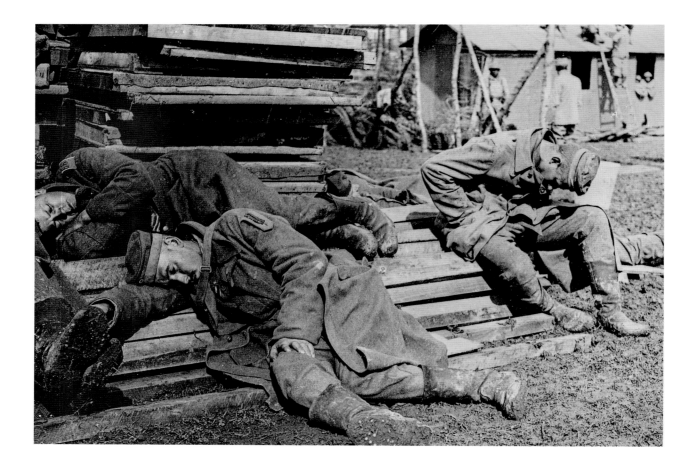

Major Keith Officer, of the Australian Corps, on the Armistice.

Nearby there was a German machine-gun unit giving our troops a lot of trouble. They kept on firing until practically 11 o'clock [on 11 November]. At precisely 11 o'clock an officer stepped out of their position, stood up, lifted his helmet and bowed to the British troops. He then fell in all his men in the front of the trench and marched them off. I always thought that this was a wonderful display of confidence in British chivalry, because the temptation to fire on them must have been very great.

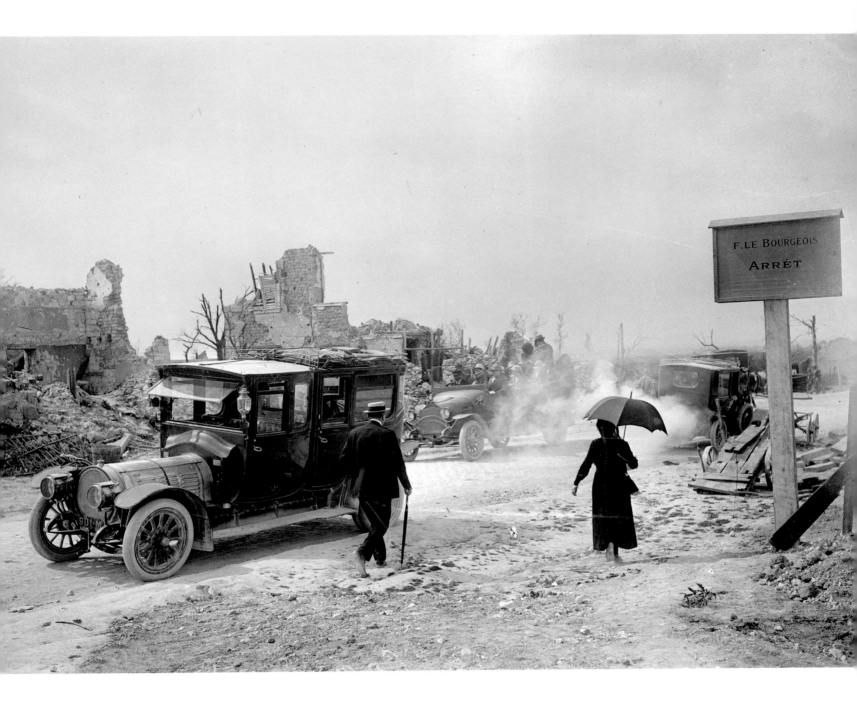

German prisoners waiting to be moved to the rear in 1918, towards the end of the war.

The village of Craonne between Laon and Reims, north of the Aisne, visited by very early motorized war tourists in late 1918 or early 1919. Close to 850,000 buildings had been destroyed or badly damaged in France, so that rebuilding was not finished until 1938.

5. Short Intermission 1918 – 39

While Germany and the Allies fought each other to exhaustion on the Western Front, on the Russian Front momentous events were taking place. Russia had suffered terrible casualties. Hindenburg, the German commander, estimated the total Russian dead and wounded at five to eight million and complained of a new military problem: how to use machine guns when the field of fire was blocked by mounds of Russian corpses.

In March 1917, the Russians had had enough. A series of strikes spread rapidly, a provisional government was formed and the Czar abdicated. Any hope the Allies had that Russia would continue the war should have been dashed by August, when the great garrison towns in Galicia filled with a million Russian deserters heading home. But at first the Allies refused to believe this. A photograph showing Russian troops packed on to the roofs of railway carriages on their way back to their villages was published in the London *Daily Mirror*, but the caption said: 'Russian Troops Hasten to the Front.' And in the United States one headline read: 'Russians Repulse Attacks Everywhere.'

No wonder the Russian Revolution came as such a shock to the world. Not only did everyone believe that the Russians were beating the Germans but no one had heard of the forces of the extreme Left except in terms that indicated them to be madmen. This is why there are so few photographs of the earth-shaking events that took place in St Petersburg as the Bolsheviks seized power: hardly any Westerners witnessed them and even those who did failed to understand enough of what was happening to appreciate their significance. No photographers and only three Western journalists – the American John Reed and the Englishmen Morgan Philips Price and Arthur Ransome – heard Lenin tell the cheering delegates to the Second Congress of Soviets, 'We shall now proceed to construct the Socialist order.'

The ensuing Civil War between the Reds and the White Russians, and then the Allied intervention to put down Bolshevism, were better recorded as war correspondents arrived to cover the armies of more than fifteen nations who combined to crush 'the Red Peril'. But it was to be left to novelists like Boris Pasternak and his graphic *Dr Zhivago* to capture the drama, idealism and misery of the period.

As if determined to make up for their failures during the Russian Revolution, the Western media turned up in force to cover the war between Italy and Abyssinia, which began in 1935. There were 120 journalists, including many soon to be famous, such as Evelyn Waugh, H. R. Knickerbocker, Herbert Matthews and Ladislaus Farago. World sympathy was with the Abyssinians. Mussolini, the Italian leader, was regarded as a bombastic braggard trying to prove his country's new-found virility by colonizing an African country. Emperor Haile Selassie, the Lion of Judah, was seen as a romantic primitive resisting European imperialism.

The big news of the war was that the Italians were using gas against Abyssinian civilians. George Steer, reporting for *The Times* of London, wrote: 'This writer and correspondents of British newspapers have seen and photographed gas cases.' More photographic evidence would have helped prove the charge but the photographers covering the war worked under great difficulty. Without freedom of movement, they were forced to pose photographs behind the lines. Matthews later estimated that of all the photographs published of the war ninety-nine out of a hundred had been faked. For instance, Joe Caneva of the Associated Press persuaded the Italians to manoeuvre about fifty tanks and several companies of soldiers

for his benefit and his photograph of this later appeared in many publications throughout the world as an actual charge against the Abyssinians. The outcome of the war was never really in doubt. Haile Selassie's strategy was to arouse international public opinion, represented mainly by the League of Nations. When it became apparent that the League was powerless – its sanctions against Italy were being ignored by the major American oil companies – Abyssinia gave up. It was the end of the war and the end of the League of Nations.

On the other side of the world, a militaristic Japan moved in 1937 to take over northern China. The Chinese fought back and there was a brief return to the Golden Age of war reporting, with ruthless, bloody and dramatic battles that were easy to cover. While nearly a million Japanese and Chinese fought in Greater Shanghai, the correspondents and photographers had a ringside seat in the International Settlement area there. It was as though Gettysburg were fought in Harlem while the rest of Manhattan remained a neutral observer. We can notice with hindsight that war was entering a new phase where bombing would become a terrible strategic weapon and civilians a target. As the London *Evening News* put it: 'Canton Bombed, People Go Mad With Terror.'

And so it was that, in April 1937, in the middle of the Spanish Civil War, the German Condor Legion, fighting for General Franco's Fascist forces against the Republican government, bombed Guernica, a small town near the Basque capital of Bilbao, with a devastating mix of incendiaries and high explosives. Its ruthless destruction passed into the traditions of the Left as a symbol of everything hateful about Fascism, an indiscriminate bombing of a civilian target, enshrined in Picasso's masterpiece, *Guernica*. A vital line had been crossed: 'The Nazis led the way; but the British and the Americans in the Second World War would inexorably follow with their strategic bombing, which would kill over half a million German civilians ...'

Small wonder that the Spanish Civil War aroused such intense and partisan emotions among those who photographed and wrote about it. The intervention of Hitler and Mussolini on the side of the old order of bankers, landlords, clergy and army, and the Soviet Union backing the Republic, made the war an apocalyptic moment in history, a point in time at which to choose and make a stand. A war that really did not directly concern them exercised a fascination on some of the most talented writers and photographers of the period, men and women like André Malraux, George Orwell, John Dos Passos, Stephen Spender, Ernest Hemingway, Arthur Koestler, Robert Capa, Martha Gellhorn, Antoine de Saint-Exupéry and Henri Cartier-Bresson. Most saw it as something far wider than a civil conflict. 'In essence it was a class war,' wrote Orwell. 'If it had been won, the cause of common people everywhere would have been strengthened. It was lost, and the dividend-drawers all over the world rubbed their hands.'

Those writers and photographers who had reported from the Republican side found that the experience had changed their lives. 'Today, wherever in this world I meet a man or woman who fought for Spanish liberty, I meet a kindred soul,' said Herbert Matthews of the *New York Times*. 'In those years we lived our best and what has come after and what there is to come can never carry us to those heights again.'

Russian Revolution
Women's Death Battalion, their heads already shorn, take the oath on a holy icon and the flag in June 1917. The first revolution and the fall of the Tsar has taken place in February, but Russia is still at war with Germany and the women's real purpose is to shame male soldiers into not deserting.

A new Soviet hero, machine gunner Anton Bliznyak, photographed in 1918 during the Russian Civil War. He has lost an eye and been wounded many times, as the stripes on his sleeves testify. But most of the wounds must antedate the Red Revolution of October 1917. The cigar is his reward; Trotsky would hand out tobacco and cigars to troops who distinguished themselves.

Dear friend, Again I say a terrible stormcloud hangs over Russia. Disaster, grief, murky darkness and no light. A whole ocean of tears, there is no counting them, and so much blood. We all drown in blood. The disaster is great, the misery infinite.

Gregory Rasputin to Tsar Nicholas II, July 1914, on the eve of war

Civil wars are always cruel. We were always being shown photographs of atrocities committed by the Reds. But later we were to see identical photographs shown as examples of atrocities committed by the Whites. There were sinister stories of Red soldiers hammering nails into the shoulders of White officers, one for each star on the epaulettes.

Lieutenant-General Sir Brian Horrocks, who trained White counter-revolutionaries

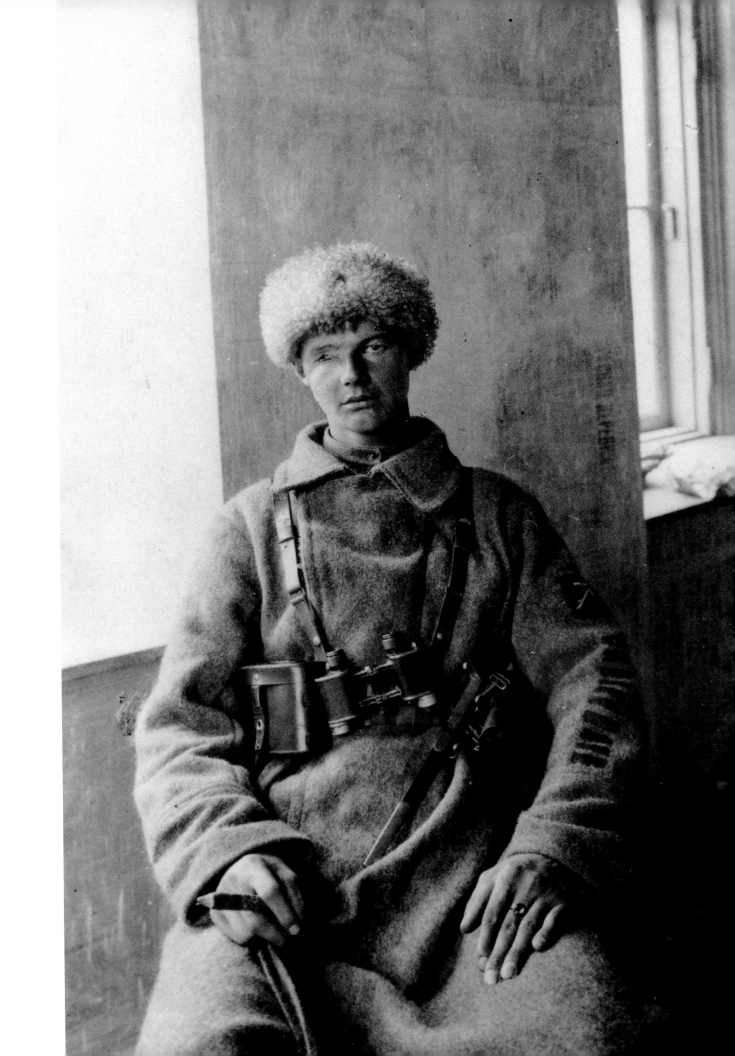

Mussolini's designs on Abyssinia were unsuited to the ethics of the twentieth century. They belonged to those dark ages when white men felt themselves entitled to conquer yellow, brown, black or red men, and subjugate them by superior strength and weapons.

Winston Churchill

I still have in mind the spectacle of a little group [of Abyssinian cavalry] blooming like a rose when some of my fragmentation bombs fell in their midst.

Vittorio Mussolini, son of Benito Mussolini

Italy's Invasion of Abyssinia

Italian troops en route for Abyssinia in 1935. Backed by tanks, machine guns, artillery and aircraft dropping high-explosive and gas bombs, their victory was predictable against the fiercely brave but undisciplined and underarmed Abyssinians.

Abyssinian troops on the march. Most of the population are Christian but these are Muslims, moving down to defend the border with Italian Somaliland in September 1935 in anticipation of the outbreak of war, which came in October.

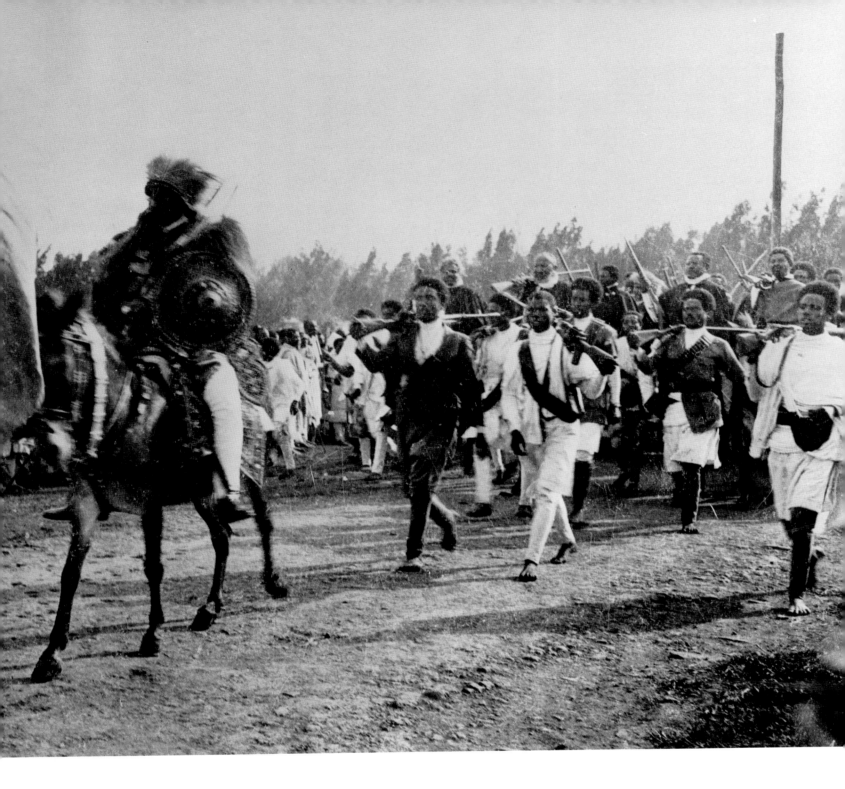

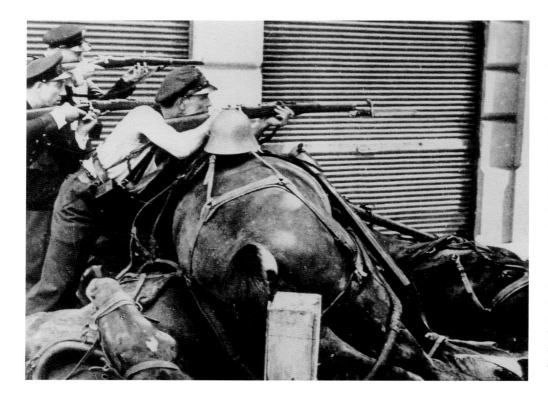

A Reuters correspondent gives an account of the fierce fighting in Barcelona in July 1936.

The worst day was Sunday ... By dusk that evening at least 300 lay dead. At one time bodies were lying piled on the steps of an underground railway station. The firing was continuous from early morning. Machine guns and artillery were used. The Colon Hotel in Catalonia Square was shelled in an attempt to dislodge the rebels, who were in force there. The noise was tremendous. Besides the firing, aeroplanes roared continuously overhead. Taxis and private cars were commandeered to transport the wounded to hospital. There was a continuous stream of such improvised ambulances. The hospitals were full to overflowing, and an appeal was sent to all private doctors to come and attend patients ...

Bands of anarchists and Communists raged through the town sacking, looting and setting fire to every church and convent and other religious buildings. No fewer than twenty convents and churches were razed to the ground or seriously damaged, and only the famous cathedral remains intact. In one religious seminary, it is stated, many priests were put to death. It is believed that the clergy were able to get away most of the church treasures before the looters arrived. The mob, drunk with victory, afterwards paraded the streets of the town attired in the robes of ecclesiastical authorities and other officials. After the fighting on Sunday and Monday the streets were littered with the dead bodies of men and horses.

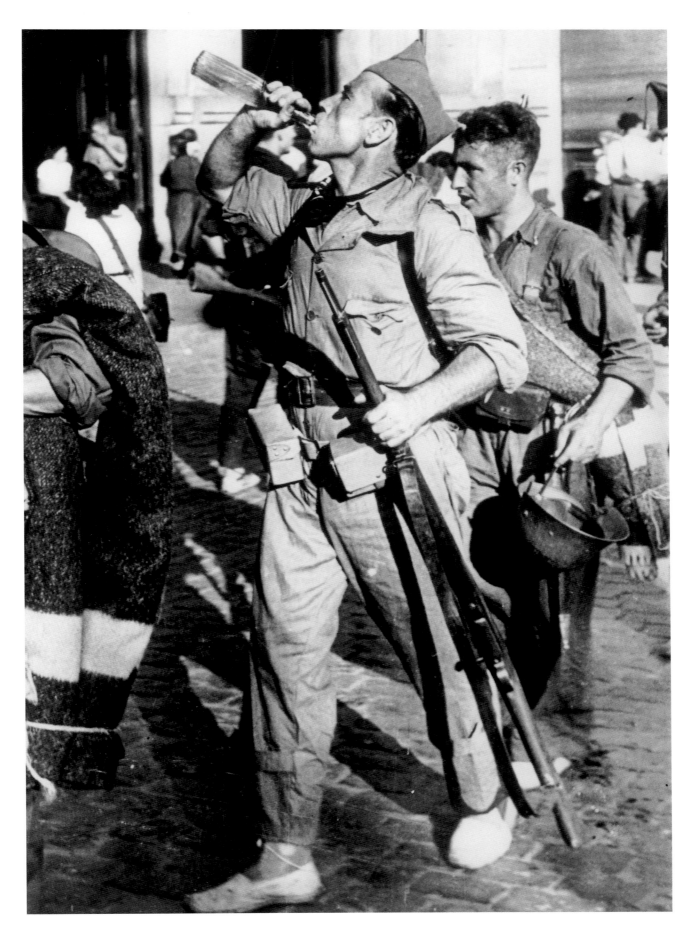

I arrived in Guernica on April 26 at 4.40 pm. I had hardly left the car when the bombardment began. The people were terrified. They fled, abandoning their livestock in the market-place. The bombardment lasted until 7.45 pm. During that time five minutes did not elapse without the sky being black with German aeroplanes.

The method of attack was always the same. First there was machine-gun fire, then ordinary bombs, and finally incendiary. The planes descended very low, the machine-gun fire tearing up the woods and roads, in whose gutters, huddled together, lay old men, women, and children. Before long it was impossible to see as far as 500 metres owing to the heavy smoke occasioned by the bombardment.

Fire enveloped the whole city. Screams of lamentation were heard everywhere and the people, filled with terror, knelt, lifting their hands to heaven as if to implore divine protection.

The planes descended to 200 metres, letting loose a terrible machine-gun fire. I reached my car and just had time to take refuge in a small group of oaks. I have not heard of any inhabitants who survived among the ill and wounded in the hospitals.

The first hours of the night presented a terrible spectacle of men and women in the woods outside the city searching for their families and friends. Most of the corpses were riddled with bullets.

As a Catholic priest, I state that no worse outrage could be inflicted on religion than the Te Deums to be sung to the glory of Franco and Mola in the Santa María Church at Guernica, which was miraculously saved by the heroism of firemen from Bilbao.

A member of the German Condor Legion, components of Hitler's Luftwaffe sent to fight in Spain for Franco's Nationalists, loads a bomb into one of their planes (left). There were 150 of these initially, and 5600 men, reinforced and replaced as the war went on.

The saturation bombing of Guernica, which lasted three hours, almost razed the town to the ground, wreaking terrible destruction and killing more than a thousand. Here, a mother weeps for her dead son, surrounded by other victims of Nationalist bombing in Lérida, Catalonia in November 1937.

Agustí Centelles

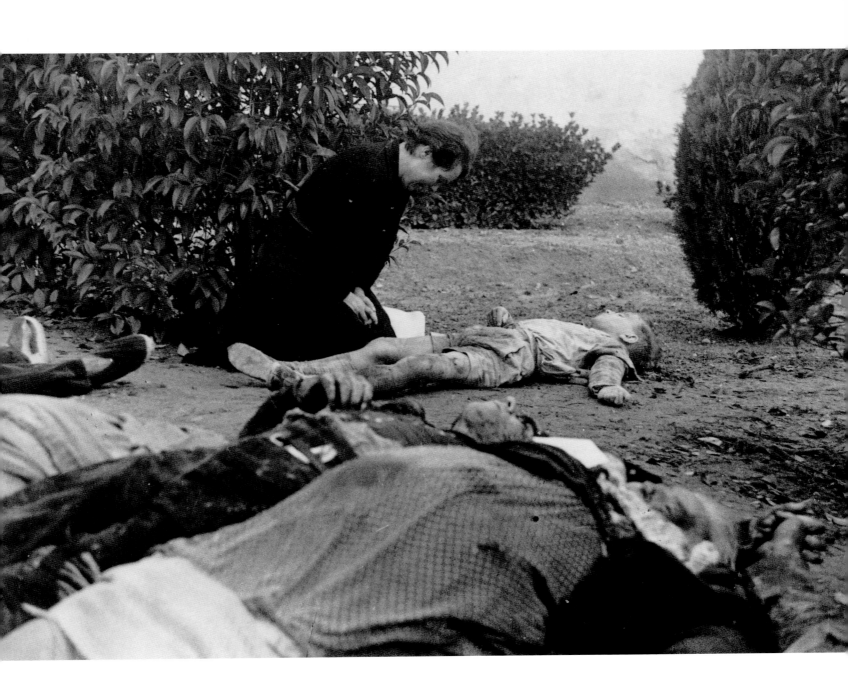

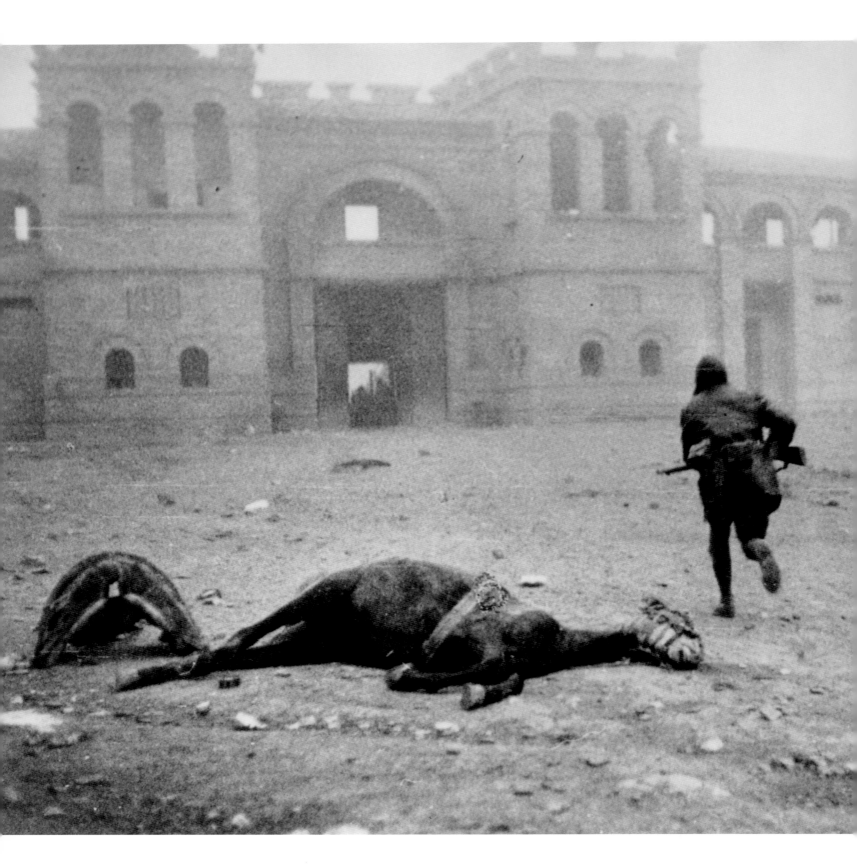

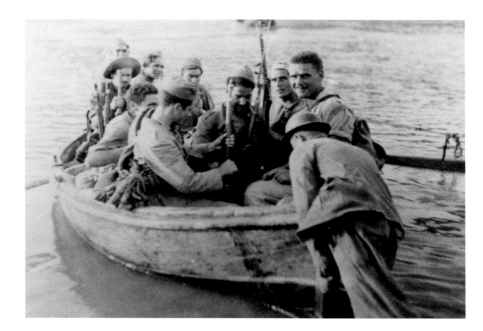

By a tragic coincidence this war, essentially Spanish, has 'caught on' abroad. Lured by somewhat shallow parallelisms, men, institutions and even Governments outside Spain have been adding fuel to the fire which is consuming our unhappy country. Spain is thus suffering vicariously the latent civil war which Europe is — so far — keeping in check.

Salvador de Madariaga in 1937

You can go with pride. You are history. You are legend. You are the heroic example of the solidarity and universality of democracy ... We shall not forget you, and, when the live tree of peace puts forth its leaves, entwined with the laurels of the Spanish Republic's victory — come back!

Dolores Ibarurri (La Pasionaria) says farewell to the International Brigades, Barcelona, 29 October 1938

The Republicans storming Teruel bullring during their attempt to take the town in December 1937, a bitter battle fought in bitter winter weather during its later stages. The town fell in January 1938 but was recaptured by the Nationalists the following month.
Alfonso, Madrid

Americans, members of the Abraham Lincoln Battalion of the International Brigade fighting for the Republicans, crossing the River Ebro in northern Spain in 1938 for the last great Republican offensive. 'We had no fear of death, no fear of nothing ...' said one member of the Lincoln Battalion.

Dispatch sent by Ernest Hemingway from Barcelona on 3 April 1938, describing the Nationalist advance to the Mediterranean.

It was a lovely false spring day when we started for the front this morning. Last night, coming in to Barcelona, it had been gray, foggy, dirty and sad, but today it was bright and warm, and pink almond blossoms colored the gray hills and brightened the dusty green rows of olive trees.

Then, outside of Reus, on a straight smooth highway with olive orchards on each side, the chauffeur from the rumble seat shouted, 'Planes, planes!' and, rubber screeching, we stopped the car under a tree.

'They're right over us,' the chauffeur said, and, as this correspondent drove head-forward into a ditch, he looked up sideways, watching a monoplane come down and wing over and then evidently decide a single car was not worth turning his eight machine guns loose on.

But as we watched, came a sudden egg-dropping explosion of bombs, and ahead, Reus, silhouetted against hills a half mile away, disappeared in a brick-dust-colored cloud of smoke. We made our way through the town, the main street blocked by broken houses and a smashed water main, and, stopping, tried to get a policeman to shoot a wounded horse, but the owner thought it was still possibly worth saving, and we went on up toward the mountain pass that leads to the little Catalan city of Falset ...

A carnival of treachery and rotten-ness on both sides.

Ernest Hemingway to Maxwell Perkins, October 1938

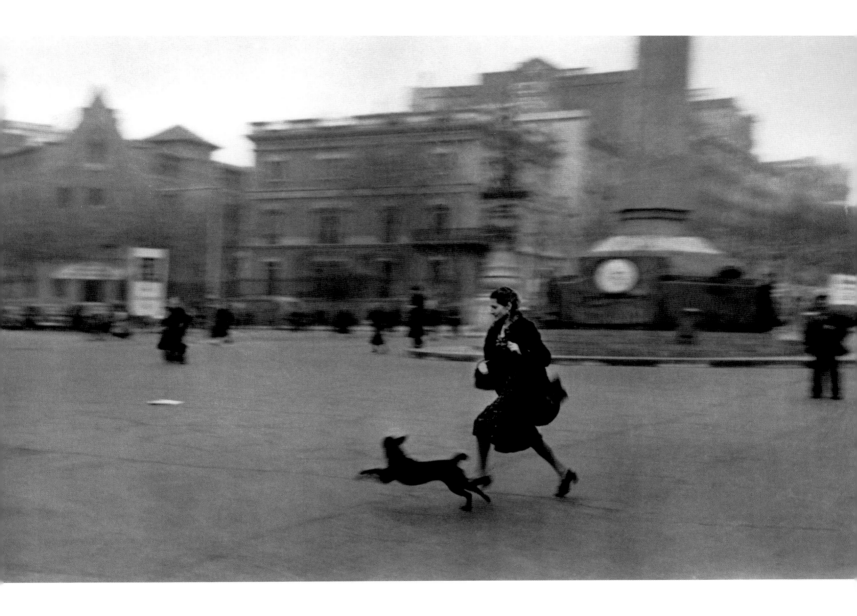

An elegant Catalan lady is forced to run for cover during a Nationalist air raid on Barcelona in January 1939, just before the town fell to the Nationalists. Refugees had flocked to Barcelona, where they suffered in the heaviest air raids of the war.

Robert Capa

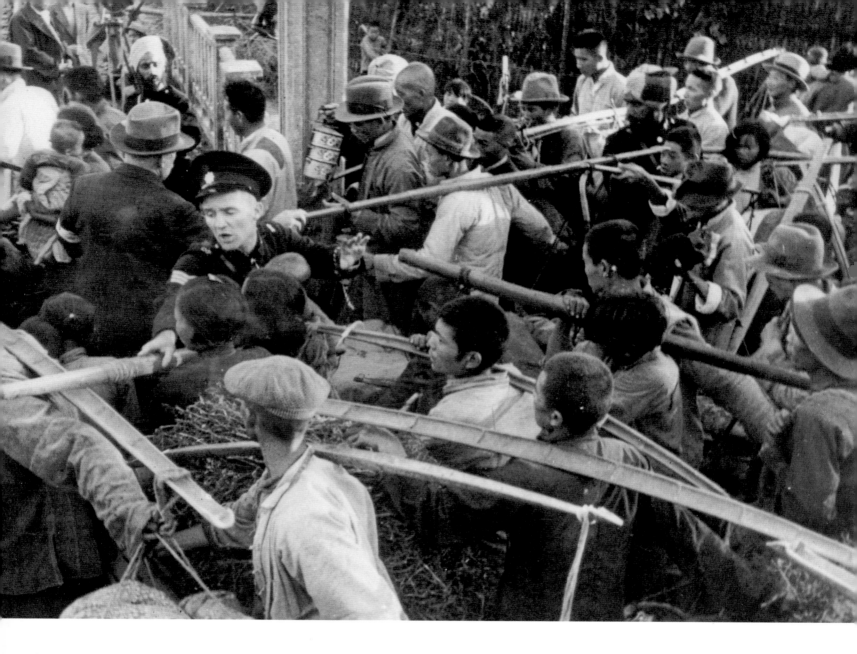

An American, Rhodes Farmer, describes the scene on the Garden Bridge in Shanghai in August 1937, the only entrance to the International Settlement not blocked off, as Chinese refugees fled for their lives.

My feet were slipping ... on blood and flesh. Half a dozen times I knew I was walking on the bodies of children or old people sucked under by the torrent, trampled flat by countless feet. A crowd of marines and ronin stood beside the two Japanese sentries on the far side of the bridge. One of them bayoneted an old man and pitched his body into the creek. I saw several good-looking girls seized by the soldiers and dragged into neighbouring buildings.

Japan's Invasion of China
Chinese refugees stream into the International Settlement area of Shanghai in November 1937. Chiang Kai-shek's Nationalist forces there have finally been defeated by the Japanese and are retreating inland towards Nanking. The policeman can do little to impose order.

A mother from Shanghai, carrying her son, in a safety zone at Nantao near Canton organized by various international bodies.

George Krainukov

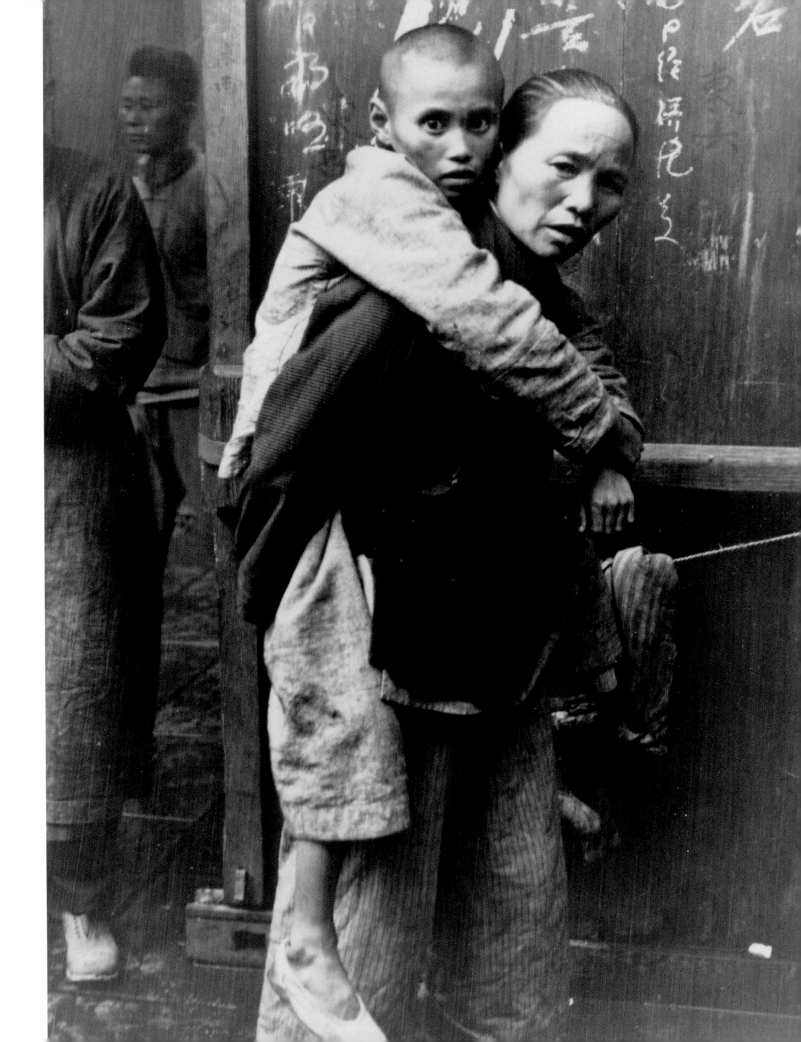

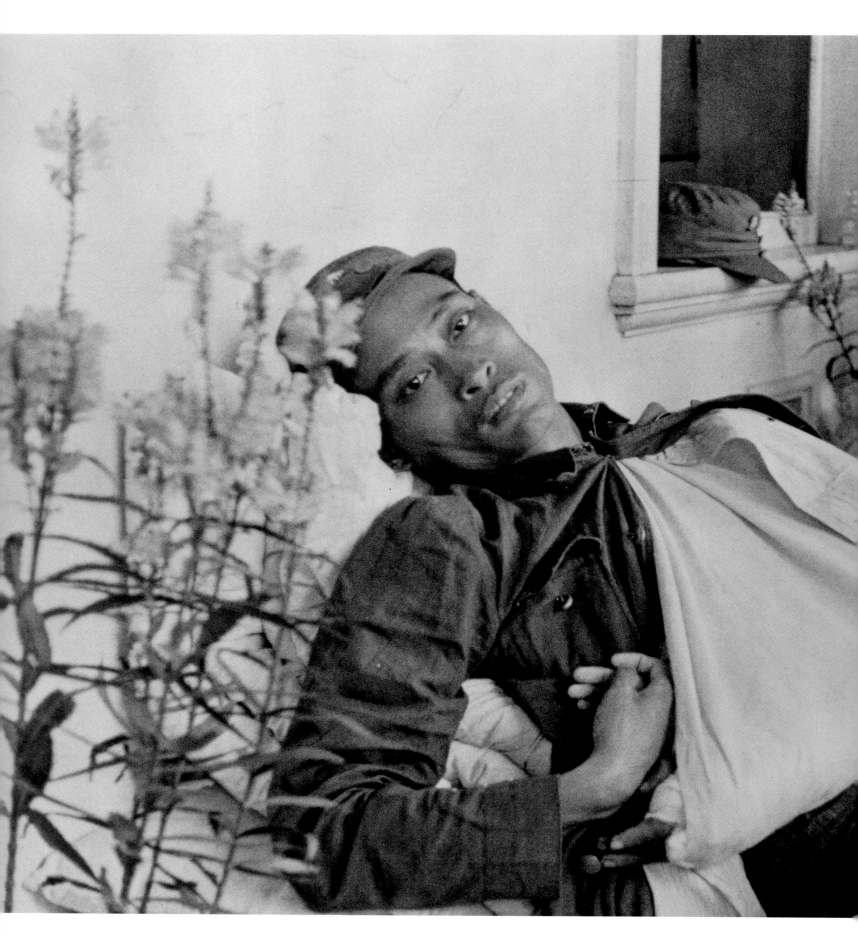

In December 1937 the Japanese Army perpetrated one of history's worst massacres, known as the Rape of Nanking, when somewhere between 250,000 and 300,000 non-combatants were killed in that city. Yukio Omata, a Japanese military journalist, witnessed the scene at one of the many killing grounds in the city.

Those in the first row were beheaded, those in the second row were forced to dump the severed bodies into the river before they themselves were beheaded. The killing went on non-stop, from morning until night, but they were only able to kill 2,000 persons in this way. The next day, tired of killing in this fashion, they set up machine guns. Two of them raked a cross-fire at the lined-up prisoners. Rat-tat-tat-tat. Triggers were pulled. The prisoners fled into the water, but no one was able to make it to the other shore.

A Chinese soldier, wounded in the Hankou campaign in August 1938 as his side retreated westwards towards Chungking in Szechwan, which was to become the Nationalist capital under Chiang Kai-shek.
George Krainukov

6. | Second World War 1939 – 45

IT BECAME CLEAR quite early in the Second World War that forebodings aroused in Abyssinia, China and Spain were justified and a new type of clash between nations was upon us – total war. As the bombing of Guernica in 1937 had suggested, the German Air Force considered civilians legitimate targets to be dive-bombed and strafed as they fled before the advance of the German army. The Allies ran for the Channel, France fell and a whole world collapsed. 'This is the end of the British Empire,' the Chief of the Imperial General Staff, General William Ironside, told Anthony Eden. Britain, too, prepared for total war. The first peace-time conscription in British history had been introduced in April 1939 and was later extended to include women – for the first time in the history of any civilized nation – and the Emergency Powers (Defence) Act authorized the government to do virtually what it liked without reference to Parliament. If Britain was at war so was the Empire. Although many of these countries had active movements fighting for independence from Britain – India, for example – once war broke out, many of their citizens wanted to fight for the Mother Country. They went to war for Britain out of gratitude, a sense of familial obligation, a call of duty. There was no overriding purpose, no common stance against the rise of Fascism in Europe or Japan's military adventurism in China. Yet it was the greatest mobilization in the history of the world – eleven million people fighting under the same flag. It was often impossible for ordinary citizens to know more of the war than what they experienced in their own small corner of the world. The Battle of the Atlantic, for instance, the day-by-day struggle to supply Britain with food and munitions from North America by beating the German submarine blockade, took place in a virtual news blackout. American journalist Ed Murrow complained, 'Nothing may be said to the Americans or the British public about this battle which, we are told, will determine the destinies of free men for centuries.'

Yet what stories of the bravery of British merchant seamen – volunteers at £9 a month – could have been told. A Royal Navy rating described fifty years later what it was like on a British destroyer during convoy duty in the North Atlantic. 'When a freighter that had been torpedoed went down there would often be survivors, merchant seamen, swimming around in the water. We'd be going all out after the submarine and we'd have to race past them, leaving them to drown. They knew we couldn't stop to pick them up. They understood that. I'll never forget one of them waving his hand as we went by and shouting at the top of his voice, "TAXI, TAXI".'

After Britain's victory in the Battle of Britain put an end to Germany's invasion plans, the bombing campaign began. The Luftwaffe bombed British cities, the RAF German ones, to little real strategic end. The *New York Times* said the futility of it all was depressing and quoted a Londoner as saying, 'It's a crazy war, guv'nor. I don't see why Jerry doesn't bomb Berlin and let the RAF take care of London. We'd both save petrol and we'd be none the worse.'

There was, however, one theatre of war, North Africa, where the action took place in an empty arena, devoid of those houses, schools, churches and civilians that elsewhere get in the way of battle. It became the most romanticized part of the war, a media paradise, 'the last gentlemen's campaign'. The armies rose to this challenge. Erwin Rommel, the German general, became 'the Desert Fox', operations had code names like 'Crusader', orders to tank and truck commanders were given in cavalry terms and soldiers on both sides sang the German hit tune 'Lili Marlene'. This was a striking contrast with the war on the Eastern Front, where

Germany had invaded the Soviet Union on 22 June 1941. This became the decisive front of the Second World War, a bloody struggle for survival between two of the greatest armies the world had ever seen. The battles were enormous. Kursk, in July 1943, was the biggest armoured battle in the history of warfare. It ended in a Russian victory and German losses of 70,000 men, 2000 tanks, 1392 planes and 5000 motor vehicles.

The intense cold, shortage of food and proper clothing, ruthless and racially ingrained behaviour of troops on both sides, the policy of public hanging as retribution for partisan attacks, the mass killing of Jews in German-occupied areas, the shooting of deserters and slackers, the gratuitous murder of civilians, the sieges and the starvation, made the Russian Front like the horrors of Hell. Photography was banned at first, but Margaret Bourke-White of *Life* magazine complained to Harry Hopkins, President Roosevelt's personal envoy to Stalin, 'The biggest country enters the biggest war in the world and I'm the only photgrapher on the spot.' She managed to get out photographs of Moscow under night bombing attack and even a portrait of Stalin himself.

When the war turned in Russia's favour and the Red Army drove the Germans back over the border and advanced on Berlin, the official attitude changed and photographers were there to record the stark outline of gutted cities, the house-to-house fighting, the blood and the bodies. War photography had changed and the terrible face of battle was no longer taboo. Nor was the sickening sight of the Nazi death camps, where the camera came into its own because words were inadequate to describe the horror of piles of the dead. George Rodger's graphic photograph of two people walking across a square in Belsen that is littered with bodies is particularly disturbing *(see p.166)*.

On the other side of the world, the war in the Pacific theatre went on after Germany had surrendered, as the Americans fought their way tenaciously and at great cost from island to island on their way to Japan. Starved of oil by the US Navy's submarine assault, Japan resisted every inch of the way. The Battle of Okinawa was history's largest involving land, sea and air forces. There were terrible casualties, particularly among civilians – more than 150,000 died. The US Navy suffered greater casualties than in all its previous engagements in both the Atlantic and the Pacific. Kamikaze attacks sank or damaged a hundred US ships and throughout the spring and summer of 1945 West Coast shipyards were so glutted with wrecked ships that some of the worst ones had to be sent to East Coast yards.

The cameras were there when two Japanese planes, each carrying 1100 pounds of bombs, plunged into the flight deck of the USS *Bunker Hill*, Admiral Mitscher's flagship, killing nearly 400 officers and men, 'and transforming one of our biggest flat-tops into a floating torch, with flames soaring nearly 1000 feet into the sky' *(see p.153)*.

Then on 6 August 1945, the United States dropped an atom bomb on Hiroshima. Radio Tokyo reported, 'The impact of the bomb was so terrific that practically all living things, human and animal, were literally seared to death by the tremendous heat and pressure engendered by the blast.' Again words were inadequate to describe what had happened and it was left to the camera to show a lunar-type wasteland as the Second World War ended and the atomic age began.

British soldiers in the sand dunes behind the beaches at Dunkirk waiting their turn for a place on one of the 'little ships' to take them back to England, May 1940.

Lucky survivors from the packet steamer *Mona's Queen* are brought alongside a rescuing ship off Dunkirk. Sent to the northern French ports in 1940, she rescued 2000 troops from Boulogne on 22 May and 1200 from Dunkirk on the 27th. Returning to Dunkirk on 29 May, she hit a mine and broke in two, taking twenty-four of her crew with her.

We shall not flag or fail. We shall go on to the end. We shall fight
in France, we shall fight on sea and oceans, we shall fight with
growing confidence and growing strength in the air, we shall defend
our island, whatever the cost may be. We shall fight on the beaches,
we shall fight on the landing grounds, we shall fight in the fields
and in the streets, we shall fight in the hills; we shall never
surrender.

Winston Churchill, in a speech made as the evacuation of the British Army from Dunkirk drew to a close, 4 June 1940

They defended themselves ... with the proven tenacity of the Anglo-
Saxon race which Germany has never underestimated.

Hamburger Fremdenblatt, a German newspaper, commenting on Dunkirk

BLOODY MARVELLOUS!

Daily Mirror headline

As France staggered before the German Blitzkrieg in May 1940, Winston Churchill went to Paris for a meeting with her leaders, including the Commander-in-Chief, General Gamelin. Churchill recorded the scene.

The General talked for perhaps five minutes without anyone saying a word. When he stopped there was a considerable silence. I then asked: 'Where is the Strategic Reserve?' and breaking into French, which I used indifferently (in every sense): 'Où est la masse de manoeuvre?' General Gamelin turned to me, and with a shake of the head and a shrug, said: 'Aucune.'

There was another long pause. Outside in the garden of the Quai d'Orsay clouds of smoke arose from large bonfires, and I saw from the window venerable officials pushing wheelbarrows of archives into them. Already, therefore, the evacuation was being prepared.

'Aucune.' I was dumbfounded. What were we to think of the great French Army and its highest chiefs? It had never occurred to me that any commanders having to defend five hundred miles of engaged front would have left themselves unprovided with a mass of manoeuvre. No-one can defend with certainty so wide a front; but when the enemy has committed himself to a major thrust which breaks the line one can always have, one must always have, a mass of divisions which marches up in vehement counter-attack at the moment when the first fury of the offensive has spent its force.

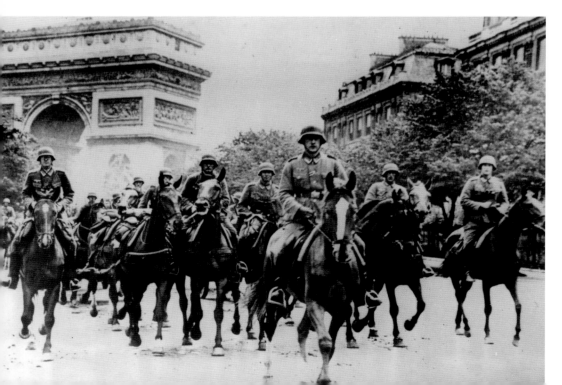

The Germany army marches into Paris past the Arc de Triomphe in June 1940 (left) while a Frenchman in the crowd watching weeps in sorrow (right). However, the victorious German occupiers were described in L'Illustration as 'handsome boys, decent, helpful and above all correct'. Every effort was made to avoid alienating the Parisians. A huge victory parade was cancelled, and within a few days public services were almost back to normal. The horse-drawn artillery underlines that the mechanization of the Wehrmacht is far from complete.

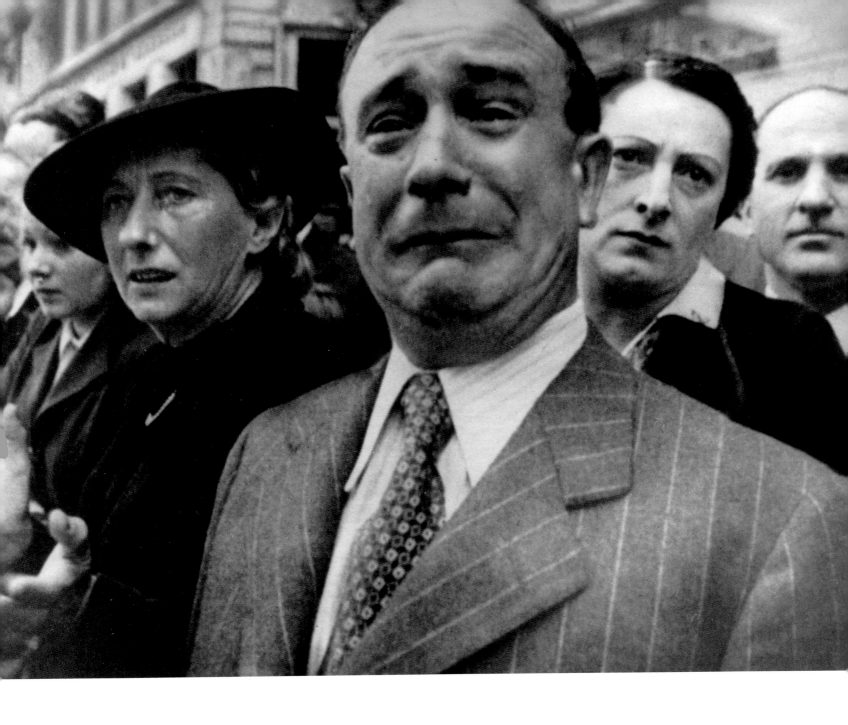

Never in the field of human conflict was so much owed by so many to so few.

Winston Churchill pays tribute to RAF Fighter Command, 20 August 1940

Sergeant John Burgess joined the Battle of Britain at its height, 31 August 1940. His squadron was based at Hornchurch close to London.

The CO said, 'Going Down! Going down! Going down!' and down he went, turning on his back. The others followed after him, on the attack, one by one. I was last in line — number fourteen, and I still couldn't even see the Germans we were attacking. Eventually, the chappy ahead of me — number thirteen — rolled on his back and went screaming towards where the enemy was supposed to be. I went after him. As I rolled over on my back and straightened out, I looked down and there they finally were — massed patterns of greeny-brown aircraft with little white crosses on their wings. It was a very large formation of Messerschmitt 110s — maybe thirty or forty of them. I dived down. I had no fear. They wouldn't hit me, just like Errol Flynn never got hit in his films. As I dived down, one group of the 110s formed a big defensive circle, going round and round. I straightened up and went for that circle. The 110s were passing in front of me, one by one. I kept firing. I kept my finger on the button. Finally, I had to pull away. I don't know if I hit anybody. But there was a bullet hole in my wing tip. I thought, 'jolly good. I've got a souvenir.' That was my first taste of combat.

That evening, we were sent up again, to patrol Dover. We were over Dover when suddenly there was a bang and a bullet whistled between my legs. I looked out over the nose of my aircraft and saw little white dots appearing there. Bullets were puncturing the skin of my aircraft. I looked up and not more than twenty or thirty feet above me was a duck-egg blue wing with an Iron Cross on it, a Messerschmitt 109. We were being bounced by 109s. The man I was formating on was in flames. I pulled sharply away and found my engine overheating badly. I went down and just managed to get back to base when my engine seized. It was then that I realized finally that the Germans were intent on killing me and that it wasn't a great big game or a newsreel and that if I didn't keep my wits about me, I was going to die pretty quickly.

Jig and Ann Lowe served in the WAAFs at Tangmere, a famous fighter station. Listening in on the radio was 'a horrifying experience at times'.

They'd leave their transmitters on and you'd hear their sweet voices calling out with glee when they saw a German aeroplane, and you'd hear the crackle of the machine gun and then sometimes you'd hear them go down, and you'd hear the last cries as bullets hit the aeroplane and the transmitter went off.

We'd be with them in the Nag's Head in Chichester one day and on the next day they would be gone. Wiped out, their names removed from the board in the ops room. You always knew when they were dead when they took their names off the board. But never from our hearts and memories. There were so many. They mourned each other so simply and with no fuss and went off rushing into the air again. Now at last, we began to know and understand a little and now we knew war. Always there was the sound of weeping. Every day some girl was weeping.

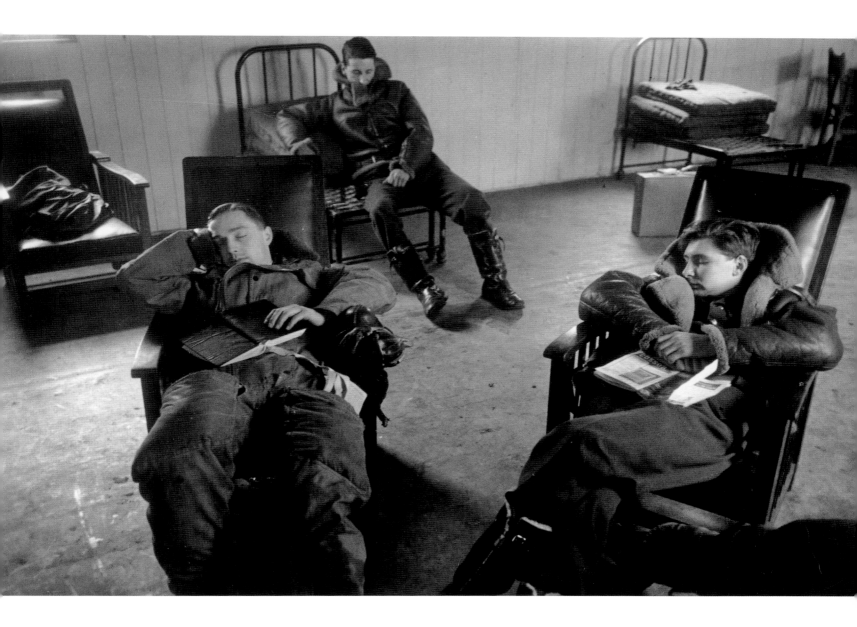

'The Battle of Britain is about to begin. Members of the Royal Air Force, the fate of generations lies in your hands' was the RAF Order of the Day in August 1940. British fighter pilots *(above)* sleep between sorties during the Battle of Britain. They must be ready to run instantly to their waiting Spitfires or Hurricanes, once the message 'scramble' comes through, and get above the Luftwaffe formations flying across the Channel. One of them recalled, 'Hanging around was the worst part, waiting for the bloody phone to ring. But as soon as you started running out to the aircraft, and once you started your engine, it was all right.'

Humphrey Spender

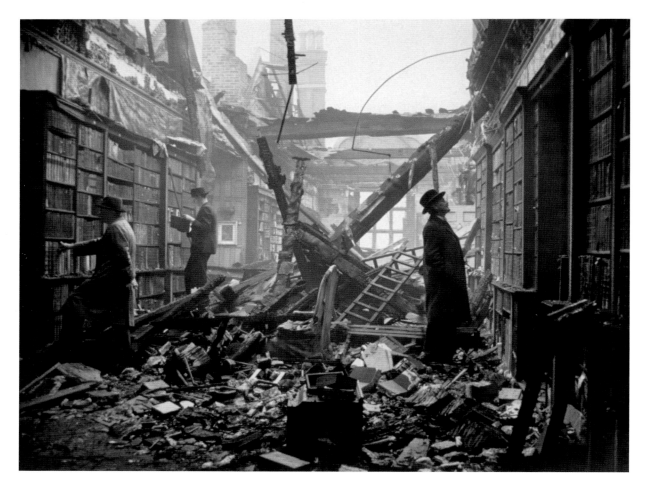

The remains of the library at Holland House, a seventeenth-century mansion in West London fire-bombed in October 1940. The figures examining the books are insurance assessors.

St Paul's Cathedral in the City of London survived the war, despite being hit by incendiaries on 29 September 1940. Some thought it a miracle but London was, Winston Churchill said, 'like some huge prehistoric animal, capable of enduring terrible injuries, mangled and bleeding from many wounds, and yet preserving its life and movement'. Most of the surrounding buildings were destroyed.
Wolf Suschitzky

Chips Channon's entry in his diary, 14 October 1940:

Dinner proceeded, and suddenly, Lambert, the butler, ushered in ... Harold Balfour [Parliamentary Under-Secretary for Air], black from head to foot. He had been standing in the smoking-room, of the Carlton Club ... drinking sherry before going in to dinner: suddenly, with a blinding flash, the ceiling had fallen, and the club collapsed on them. A direct hit. Harold swam, as he put it, through the rubble, surprised to be alive, but soon realised that his limbs were all intact: he called out to his companions to see if they were still alive, and fortunately, all answered ... Holland House, too, has gone, and I am really sorry. It seems that it is beyond repair. I have been thinking of that last great ball there in July 1939, with the crush, the Queen, and 'the world' still aglitter.

The crew on board a Royal Navy mine-sweeper off the British coast share a letter from home in 1940.
Humphrey Spender

Survivors form the German battleship *Bismarck* are rescued by the British Cruiser HMS *Dorsetshire*, whose torpedoes had administered the *coup de grâce*. Only 115 out of a ship's company of 2200 were saved.

If we lose the war at sea we lose the war.

Admiral of the Fleet Sir Dudley Pound, First Sea Lord, 5 March 1942

Alan Swanton, a swordfish – 'stringbag' – bi-plane torpedo bomber pilot on the aircraft carrier *Ark Royal*, describes its plane attacking and disabling the German battleship *Bismarck* on 26 May 1941.

Then we saw Bismarck. We descended to 100 feet behind Stewart-Moore in a four-ship formation. There she was half a mile away, big, black and menacing. She had guns all over her, and they all seemed to be stabbing red flame in our direction. I levelled, heading for her amidships. Gerry just behind me was shouting his head off with the usual sort of Observer rubbish. I pushed the 'tit', the torpedo fell away, and the aircraft jumped into the air. Then it all went sour. There were a series of flashes, and flak ripped through the underside of the fuselage. 'Christ,' I yelled, 'look at this lot.' Bismarck was firing her main armament on a flat trajectory ahead of us. The shells were hitting the sea in front, pushing up 100 foot mountains of water. We continued low and fast until we were out of range. Gerry gave me heading for home, and said that 'Flash' Seager our TAG [air gunner] had been hit but was all right. It was then Gerry spotted the dark stain on my flying overalls.

 'No problem,' I lied, 'I'm perfectly OK,' but added that it would be nice to get back to the ship. I formated on 'Scruffy' who had a radar. I was glad to have Gerry with me that day. He told Ark what was going on, and requested an emergency landing. Twenty minutes later we arrived back on deck. It was a bit of a controlled crash, but I was able to walk away from it.

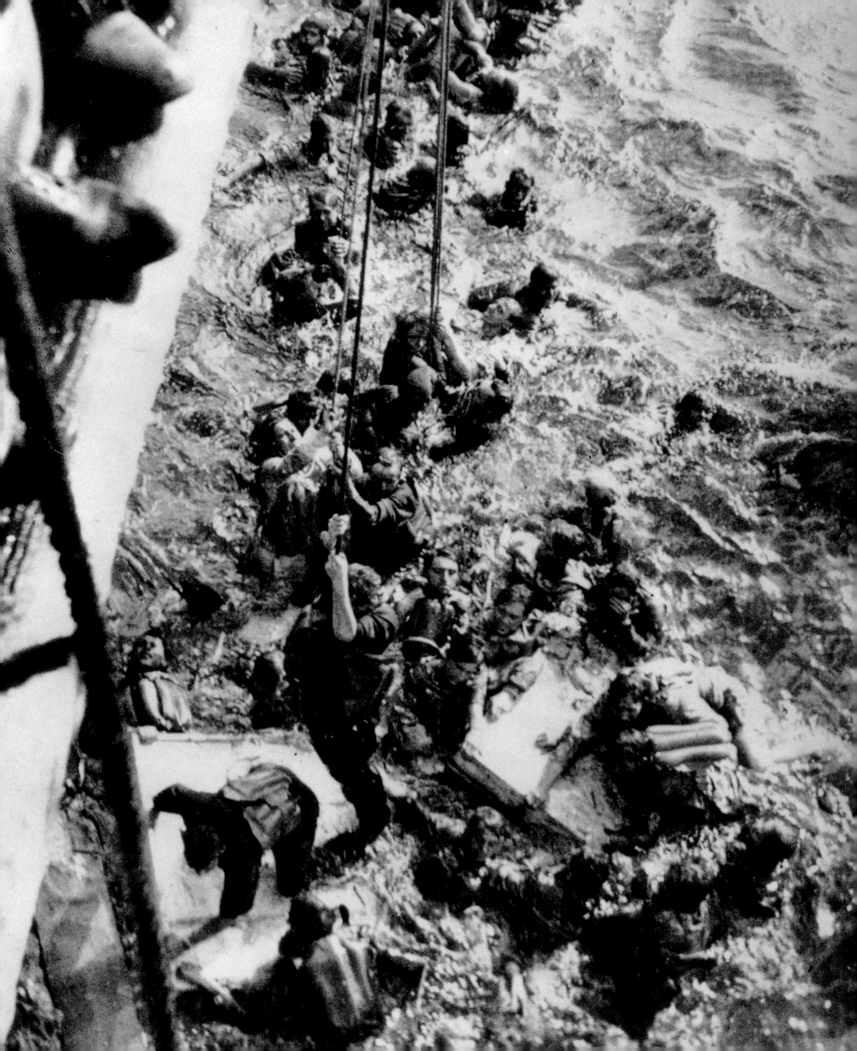

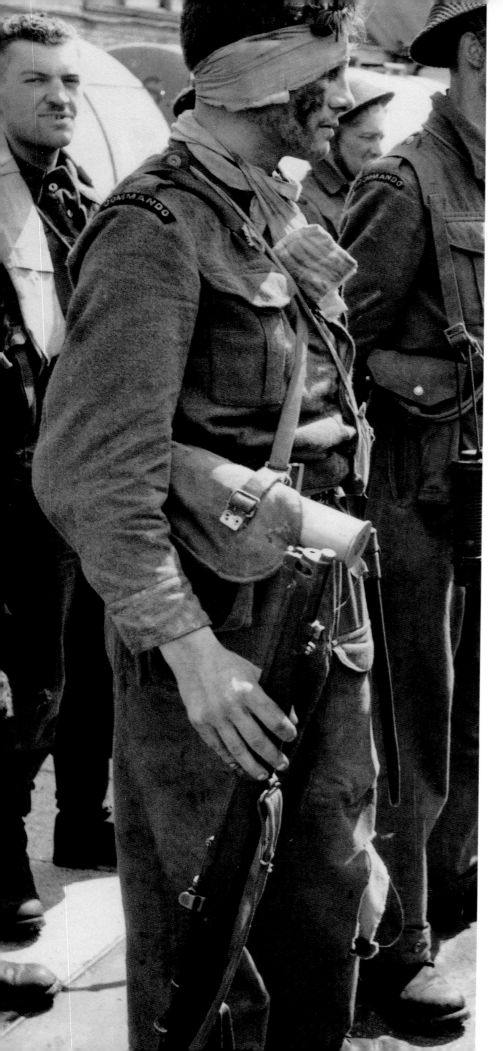

A wounded British
Commando at the
roll-call back in Newhaven
at the end of the Dieppe
Raid. The Commandos,
whose task was to
incapacitate the heavy
batteries on high ground
either side of Dieppe,
did not suffer the same
huge losses as the
Canadians, who had to
attack the town itself.
Humphrey Spender

A German photograph
of Canadian prisoners
captured during the
Dieppe Raid walking
through the town.

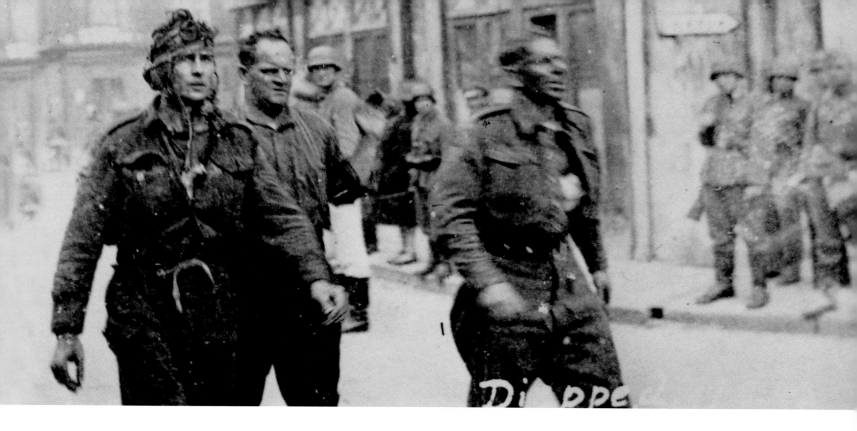

In August 1942 an over-ambitious raid on the French Channel port of Dieppe ended in disaster, with over two-thirds of the nearly 5000 Canadian troops involved killed, wounded or captured. Support from the air and from the guns of the Royal Navy was totally inadequate. Members of the Royal Hamilton Light Infantry remember:

Being so green, we had loaded ourselves down with so much ammunition we could hardly walk: besides tommy gun ammo, I had a couple of hand grenades and two mortar bombs. When the craft hit the beach, I stepped off and fell flat on my face in the bloody water ... Tracer started coming at us even before we got to shore. We said, what the hell goes on? This wasn't supposed to happen. Then I was hit. Soon there was only one man left in our platoon who was not killed or wounded.

Corporal John Williamson

My platoon's first task was to blow a gap through the wire obstacle with a Bangalore torpedo. It was a huge, thickly-coiled roll of concertina wire, almost as tall as I was and about seven feet deep. Corporal Jack Brabbs and Private Bill Grant bravely crawled up to the wire and pushed the torpedo in place. Suddenly George Naylor yelled, 'Bill's been hit!' He was dead, shot in the head. (Bill had been in the regiment since 1926 and had married an English girl just a few weeks before.) Jack Brabbs took over and the wire was blown, but his elbow was shattered by rifle fire. By this time several of my men had been wounded.

Captain Denis Whitaker

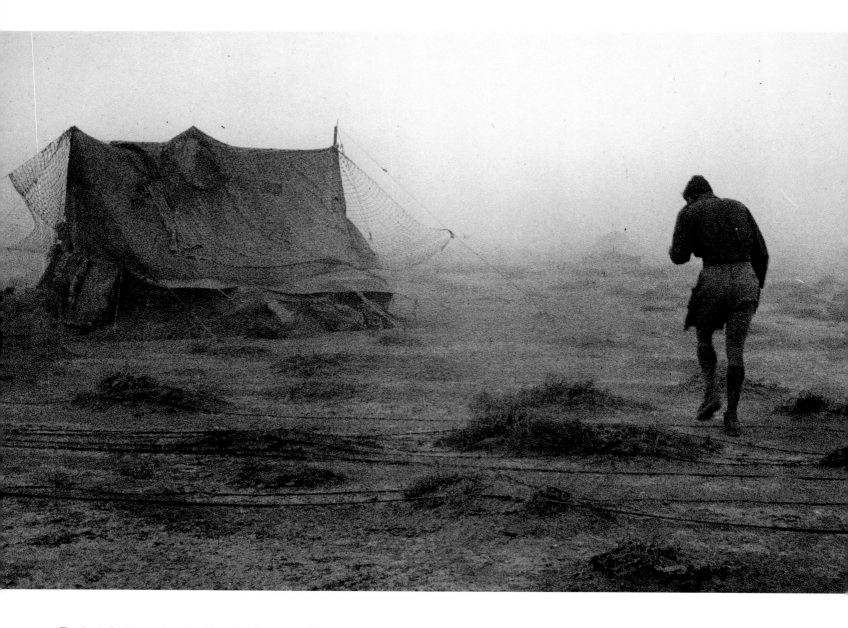

The Australian-born writer, Alan Moorehead, was one of the outstanding journalists who made their names in the war, beginning in North Africa.

More and more I began to see that desert warfare resembled war at sea. Men moved by compass. No position was static ... When you made contact with the enemy you manoeuvred about him for a place to strike, much as two fleets will steam into position for action. There were no trenches. There was no front line ... Always the desert set the pace, made the direction and planned the design. The desert offered colours in browns, yellows and greys. The army accordingly took these colours for its camouflage. There were practically no roads. The army shod its vehicles with huge balloon tyres and did without roads. Nothing except an occasional bird moved quickly in the desert. The army for ordinary purposes accepted a pace of five or six miles an hour. The desert gave water reluctantly, and often then it was brackish. The army cut its men — generals and privates — down to a gallon of water a day when they were in forward positions. There was no food in the desert. The soldier learned to exist almost entirely on tinned foods, and contrary to popular belief remained healthy on it.

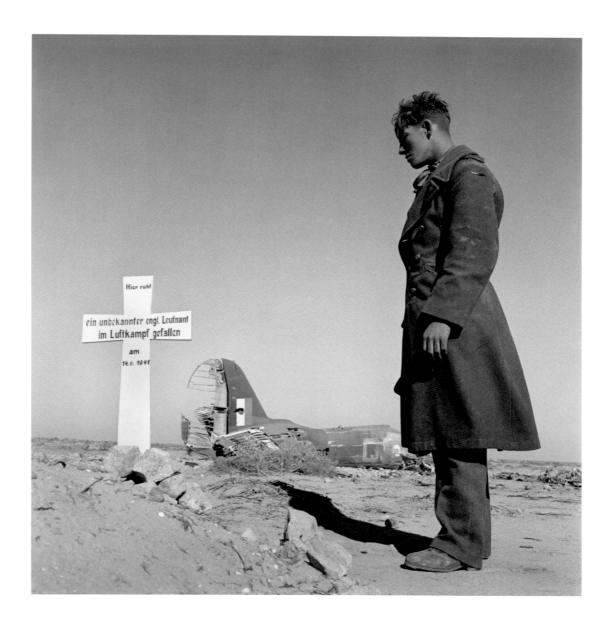

A sandstorm in the Western Desert,
North Africa, 1942 (*left*). In a
characteristic speech to his officers, on
arriving to take command of the 8th
Army in North Africa, General
Montgomery declared: 'We ourselves will
start to plan a great offensive ... which will
hit Rommel for six right out of Africa ...
He's definitely a nuisance. Therefore we
will hit him a crack and finish with him.'
Cecil Beaton

The grave of an 'unknown English
lieutenant'(*above*), from the crew of the
downed British bomber seen in the back-
ground, buried by the Germans in the
Western Desert, 1941.
George Rodger

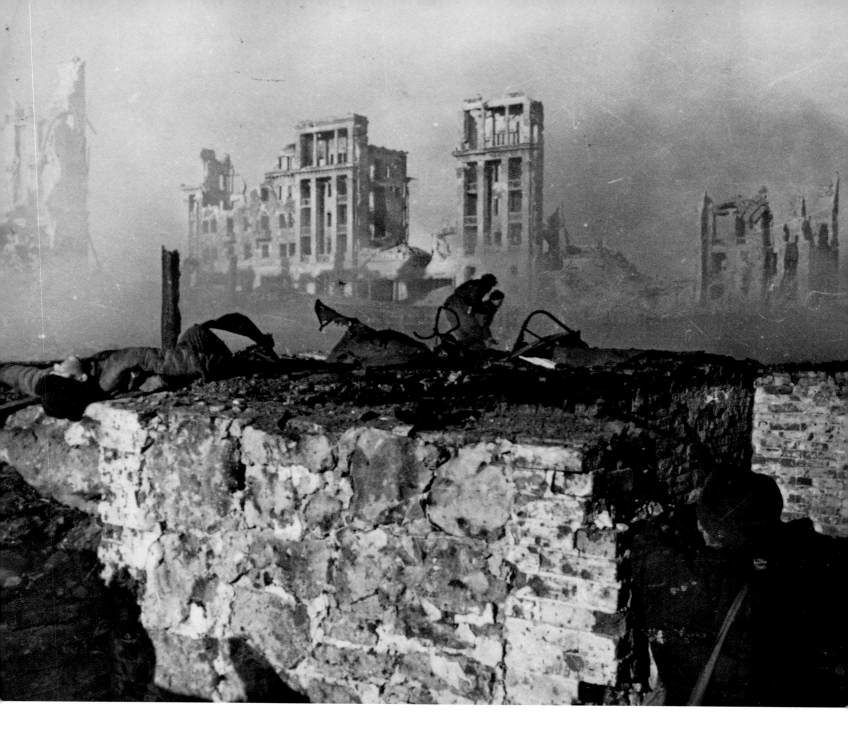

A Panzer officer describes the intense hand-to-hand fighting in Stalingrad.

We have fought during fifteen days for a single house ... The front
is a corridor between burnt-out rooms ... faces black with sweat, we
bombard each other with grenades in the middle of explosions, clouds
of dust and smoke, heaps of mortar, floods of blood, fragments of
furniture and human beings ... The street is no longer measured by
meters but by corpses ... Stalingrad is no longer a town ... when
night arrives, one of those scorching howling bleeding nights, the
dogs plunge into the Volga and swim desperately to gain the other
bank. The nights of Stalingrad are a terror for them. Animals flee
this hell; the hardest stones cannot bear it for long; only men endure.

This, one of the archetypal images to emerge from Stalingrad, the pivotal battle of the Second World War, is in fact a re-enactment performed for the cameras the day after the event it portrays. Russian assault squads such as this seldom fought in the open. The killing was done in the ruined buildings, the rubble and dug-outs. Two million casualties resulted.

Georgy Zelma

Russian women bomber pilots smoke, write a letter and clean up before setting out on another night-time mission. Their planes were too slow and vulnerable for daytime sorties. Russian women also supplied valuable labour in munitions plants and farms.

Yevgeny Khaldei

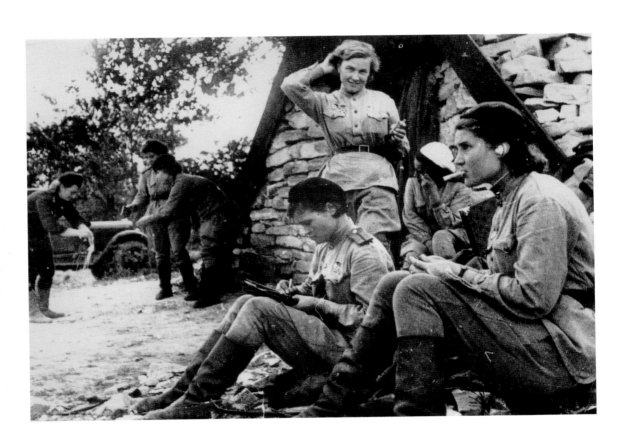

The Russian journalist Alexander Werth remembers Stalingrad immediately after the German surrender there, 31 January 1943.

At the bottom of the trenches there lay frozen green Germans and frozen grey Russians and frozen fragments of human shapes, and there were helmets, Russian and German, lying among the thick debris ... How anyone could have survived was hard to imagine. But now everything was silent in this fossilized shell, as though a raving lunatic had suddenly died of heart failure.

A soldier with Gross Deutschland remembers Kursk:

```
... tightly riveted machines ripped
like the belly of a cow that has
just been sliced open, flaming and
groaning; trees broken into tiny
fragments ... the cries of officers
and noncoms, trying to shout across
the cataclysm to regroup their
sections and companies.
```

Kursk, the greatest tank battle in history, began on 5 July 1943. There were 7000 tanks and self-propelled guns about evenly divided between the two sides. The Germans lost nearly 100,000 men in not much more than a week. It was the last time they mounted a major offensive in the east.

Michael Savin

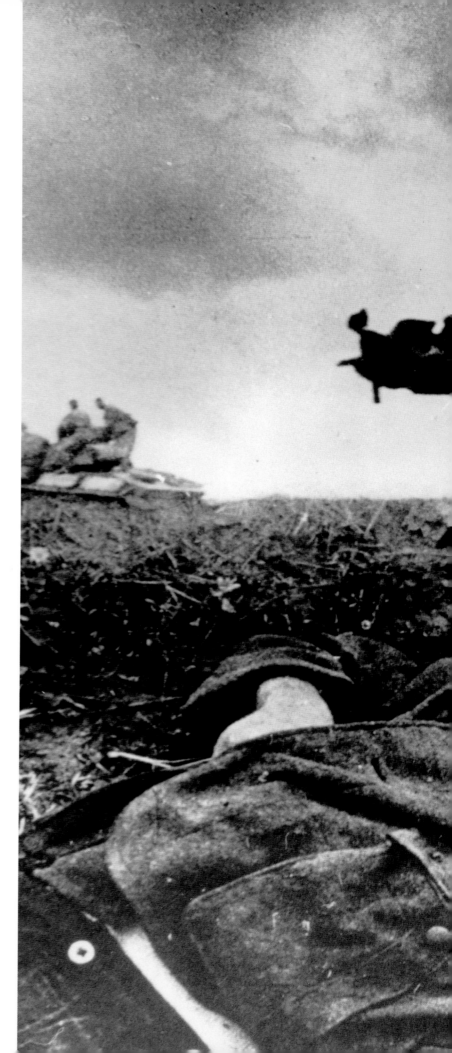

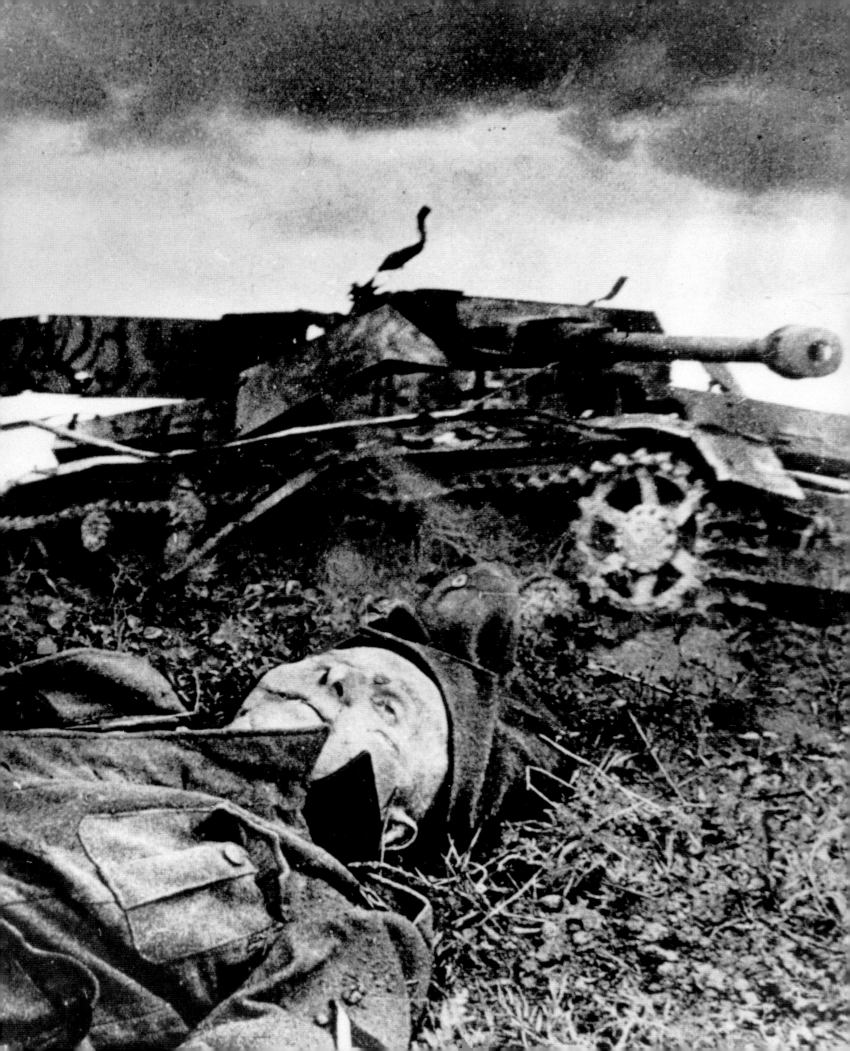

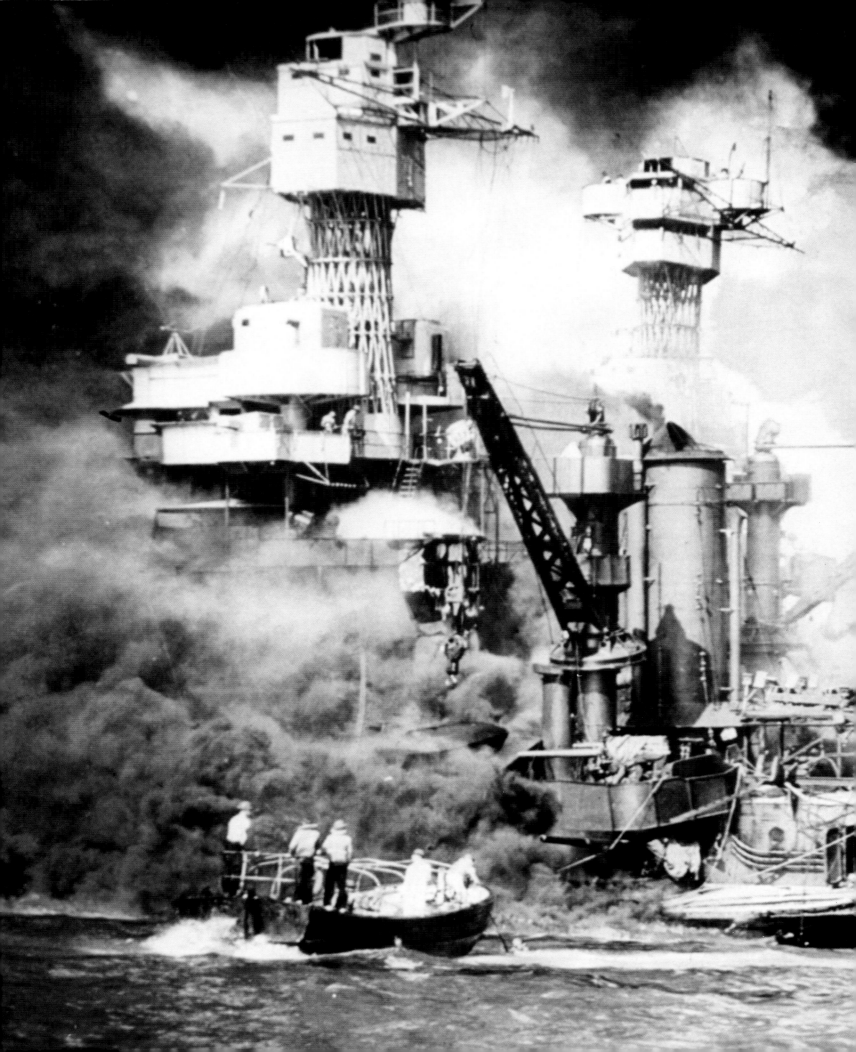

A day which will live in infamy.

President Roosevelt

I fear we have only awakened a
sleeping giant, and his reactions
will be terrible.

Admiral Yamamoto

The battleship *West Virginia* sank in
Pearl Harbor, 7 December 1941. Of the
other battleships there, *Arizona* had blown
up – as a Marine recalled, 'She just rained
sailors' – *Oklahoma* had capsized, while
California, *Tennessee*, *Nevada*, *Maryland*
and *Pennsylvania* had been damaged.
But vitally the four aircraft carriers
were absent.

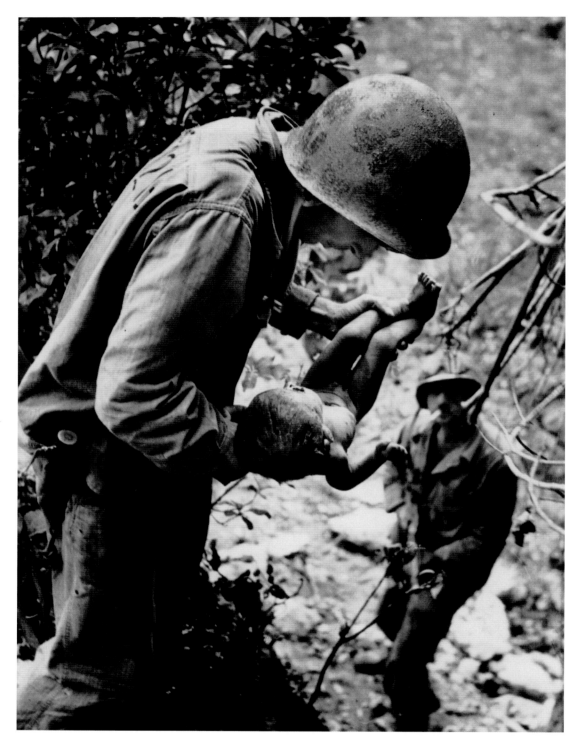

The photographer W. Eugene Smith, who accompanied US Marines searching for Japanese civilian refugees on the island of Saipan in July 1944, later recalled the moment when, after many hours, they found their first living person *(above)*.

Hands trained for killing, gently worked the sod away from the small lopsided head and extricated the infant. The eyes were sockets of pus, covered with the clinging flies. The head was obviously mashed to one side in its softness, and the little body was covered with scratches — but it was alive ...

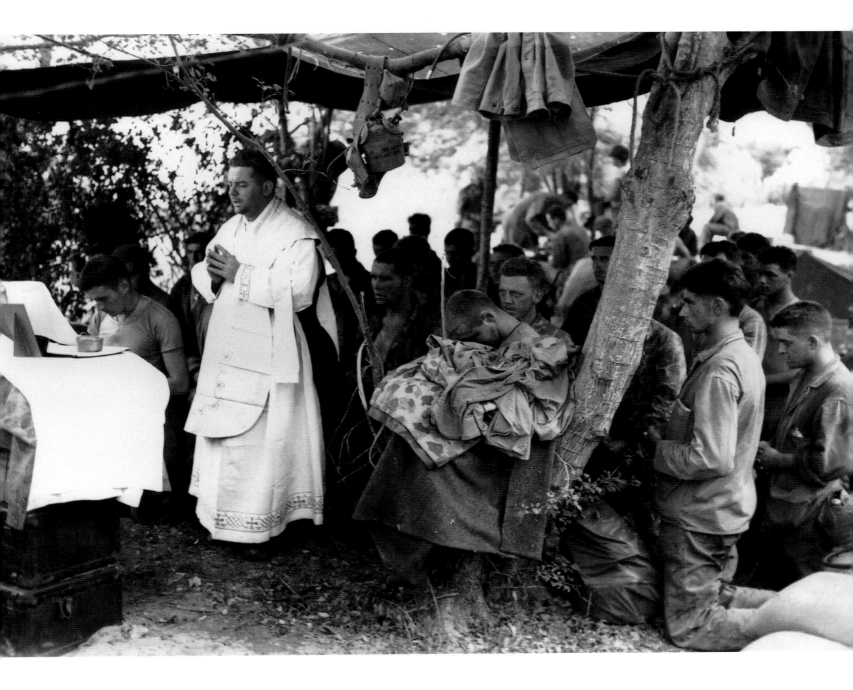

Robert Sherrod was at Tarawa Atoll in the Gilberts in November 1943, the day after Beto Island was secured.

Going westward up the beach, beyond the farthest point I had yet reached, we see on the beach the bodies of Marines who have not yet been reached by the burial parties. The first is a husky boy who must have been three inches over six feet tall. He was killed ten feet in front of the seawall pillbox which was his objective. He is still hunched forward, his rifle in his right hand. That is the picture of the Marine Corps I shall always carry: charging forward.

Two views of the US
aircraft carrier *Bunker
Hill* in the Pacific.
A soldier's body *(left)*
is committed to the
deep in the traditional
fashion off the Marshall
Islands, January 1944. A
casualty *(right)* is trans-
ferred to another ship
from the carrier after
the Kamikaze attack in
1945, which killed 353
on board, as the two
vessels steam in parallel
at the same speed.
W. Eugene Smith *(left)*
Kenneth E. Roberts *(right)*

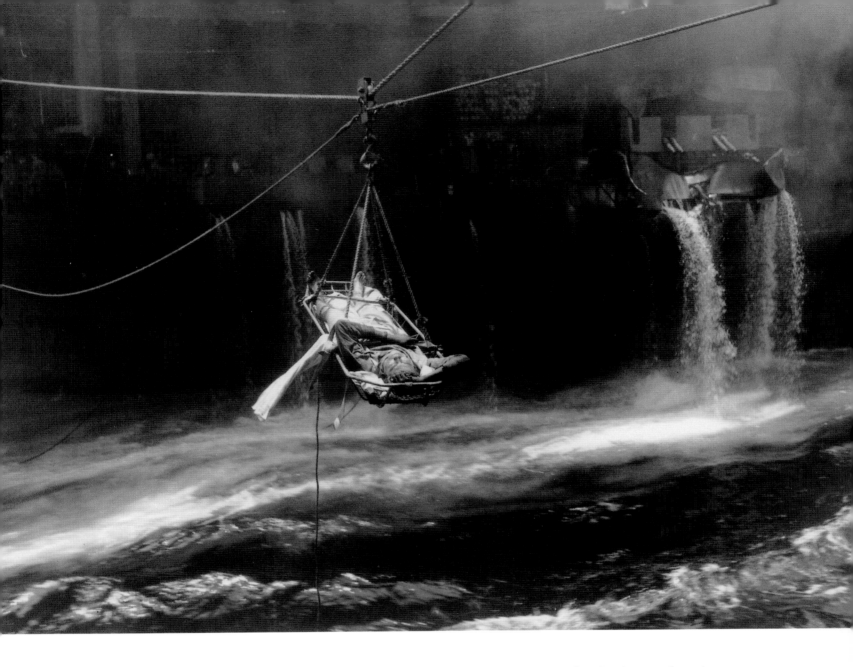

In May 1945 the American aircraft carrier *Bunker Hill* was hit by two Kamikaze suicide bombers. It became a mass of burning planes, gasoline and exploding ammunition, but it survived. Phelps Adams was on a nearby carrier.

The entire hangar deck was a raging blast furnace, white hot throughout its length. Even from where I stood the glow of molten metal was unmistakable. By this time the explosions had ceased and a cruiser and three destroyers were able to venture alongside with hoses fixed in their rigging. Like fireboats in New York Harbor, they pumped great streams of water into the ship and the smoke at last began to take on that greyish tinge which showed that somewhere a flame was dying.

Up on the bridge, Capt. George A. Seitz, the skipper, was growing increasingly concerned about the dangerous list his ship had developed, and resolved to take a gambling chance. Throwing the Bunker Hill into a 70-degree turn, he heeled her cautiously over onto the opposite beam so that tons of water which had accumulated on one side were suddenly swept across the decks and overboard on the other. By great good fortune this wall of water carried the heart of the hangar deck fire with it.

Robert Sherrod's account of the attack on Iwo Jima appeared in *Life* in March 1945.

During the entire second day I saw only 12 dead Japs, though many others had undoubtedly been burned in their pillboxes by flamethrowers. The Jap plan of defense was plain. Only a few men would defend the beaches. The mortars and machine guns from the hillside caves, long ago registered on the beaches, would stop the landing. The Jap plan of defense failed because we had so much power we could stun them if we could not kill them, because the Navy's guns and planes could keep them down during our atttacks. And it failed because the marines kept advancing despite their losses.

About the dead, whether Jap or American, there was one thing in common. They died with the greatest possible violence. Nowhere in the Pacific war have I seen such badly mangled bodies. Many were cut squarely in half. Legs and arms lay 50 feet away from any body. In one spot on the sand, far from the nearest cluster of dead men, I saw a string of guts 15 feet long. There are 250 wounded aboard the transporter where this story is being written. One of the doctors tells me that 90 per cent of them require major surgery. Off Normandy last summer, he says, only 5 per cent who were brought aboard this transport needed such surgery. On the beach this morning I saw at least 50 men still fighting despite their wounds. Only the incapacitated request evacuation.

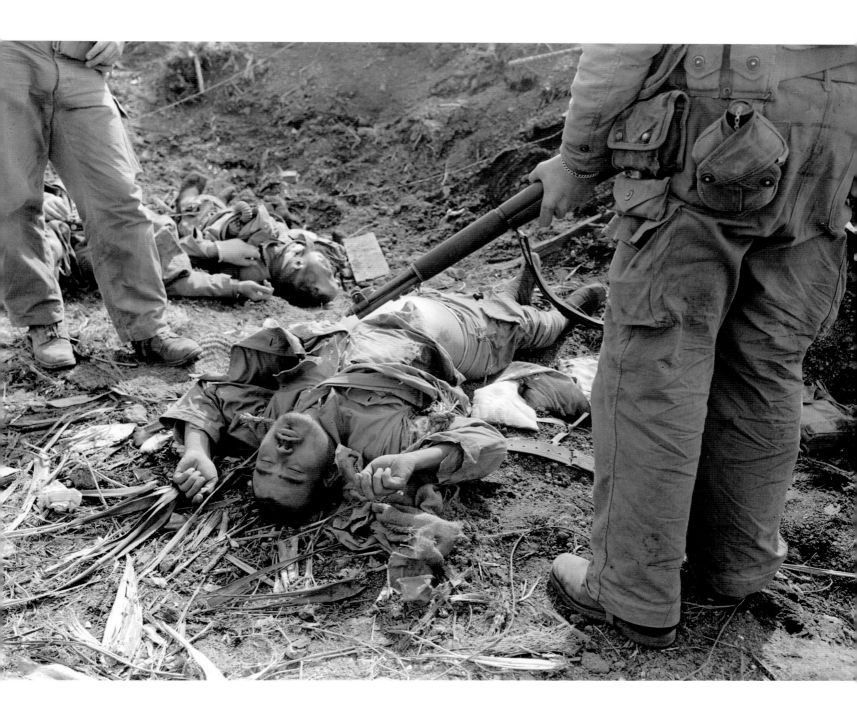

Japanese dead who defended the stronghold lie at the feet of US Marines following the American invasion of the small volcanic island of Iwo Jima on 2 March 1945. Three divisions of Marines took five weeks to overcome the dug-in Japanese, and 6000 Americans died in the process. The plan was to build an aerodrome on it, from which fighters could take off to escort B29s when they bombed Japan.

Joe Rosenthal

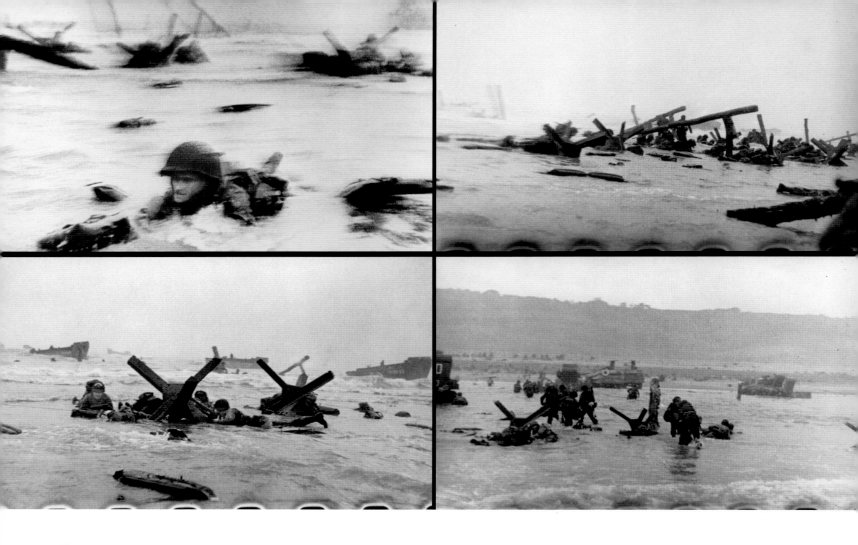

The photographer Robert Capa describes his landing with American troops in the first wave on Omaha Beach in Normandy on D-Day, 6 June 1944.

I was going in very elegant with my Burberry raincoat on my left hand. In a moment I had a feeling I would not need that raincoat ... Reluctantly I tried to move away from my steel pole, but the bullets chased me back every time. Fifty yards ahead of me, one of our half-burnt amphibious tanks stuck out of the water and offered me my next cover ... Between floating bodies I reached it, paused for a few more pictures, and gathered my guts for the last jump to the beach ... The slant of the beach gave us some protection, so long as we lay flat, from the machine-gun and rifle bullets, but the tide pushed us against the barbed wire, where the guns were enjoying open season ... I took out my second Contax camera and began to shoot without raising my head. From the air, 'Easy Red' [the beach] must have looked like an open tin of sardines. Shooting from the sardine's angle, the foreground of my pictures was filled with wet boots and green faces, my picture frames were filled with shrapnel smoke; burnt tanks and sinking barges formed my background.

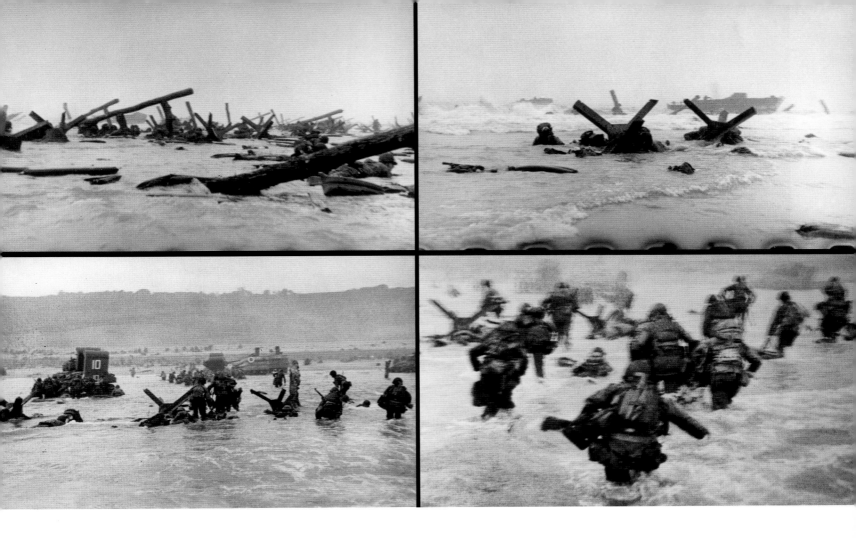

After Capa had used up all the film in his two 35mm Contax cameras he found his hands were shaking so much he couldn't reload them, so he got a lift off the beach on a medical landing craft, and was taken back to England. In the haste to meet the deadline for the next issue of *Life* magazine in the USA, all but nine of the seventy-two frames that Capa had shot were ruined in the magazine's London photo lab by being overheated in the drying cabinet. The person responsible was Larry Burrows, one of the greatest photographers in Vietnam. The pictures above appeared in *Life* on 19 June 1944. Capa called them 'a cut-out of the whole event which will show more of the real truth of the affair to someone who was not there than the whole scene'.

Robert Capa

Helen Kirkpatrick of the *Chicago Daily News* in Paris in August 1944, when de Gaulle and other Free French generals went to the cathedral of Notre Dame to offer thanksgiving for the liberation of Paris.

The generals' car arrived on the dot of 4.15. As they stepped from the car, we stood at salute and at that very moment a revolver shot rang out. It seemed to come from behind one of Notre Dame's gargoyles. Within a split second a machine gun opened from a nearby room ... It sprayed the pavement at my feet. The generals entered the church with 40-odd people pressing from behind to find shelter ...

Suddenly an automatic opened up from behind us — it came from behind the pipes of Notre Dame's organ. From the clerestory above other shots rang out and I saw a man ducking behind a pillar above. Beside me FFI men and the police were shooting.

For one flashing instant it seemed that a great massacre was bound to take place as the cathedral reverberated with the sound of guns ...

It seemed hours but it was only a few minutes, perhaps ten, when the procession came back down the aisle. I think the shooting was still going on but, like those around me, I could only stand amazed at the coolness, imperturbability and apparent unconcern of French generals and civilians alike who walked as though nothing had happened. Gen. Koenig, smiling, leaned across and shook my hand ...

Once outside, one could hear shooting all along the Seine ... I learned later that shooting at the Hôtel de Ville, the Tuileries, the Arc de Triomphe and along the Elysées had started at exactly the same moment ...

It was a clearly planned attempt probably designed to kill as many of the French authorities as possible, to create panic and to start riots after which probably the mad brains of the militia, instigated by the Germans, hoped to retake Paris.

A crowd of 5000 fling themselves to the ground in the Place de l'Hôtel de Ville in Paris as snipers open up on 26 August 1944, the day after the liberation of Paris. The snipers were soon rounded up and the festivities continued.
Robert Capa

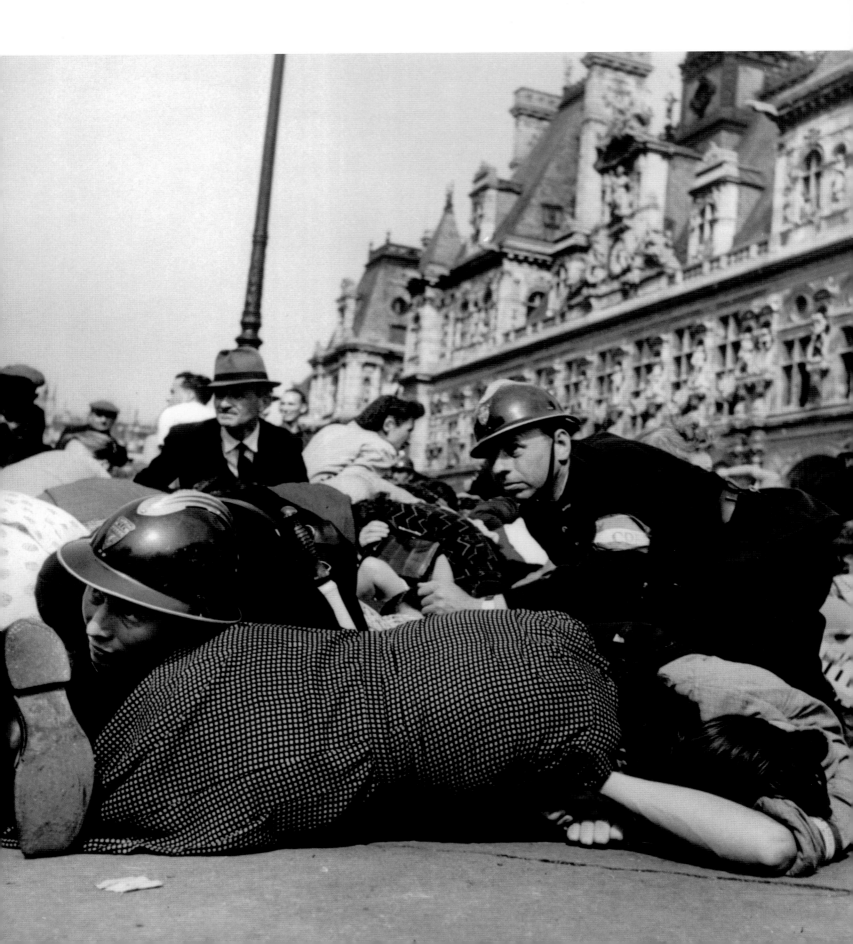

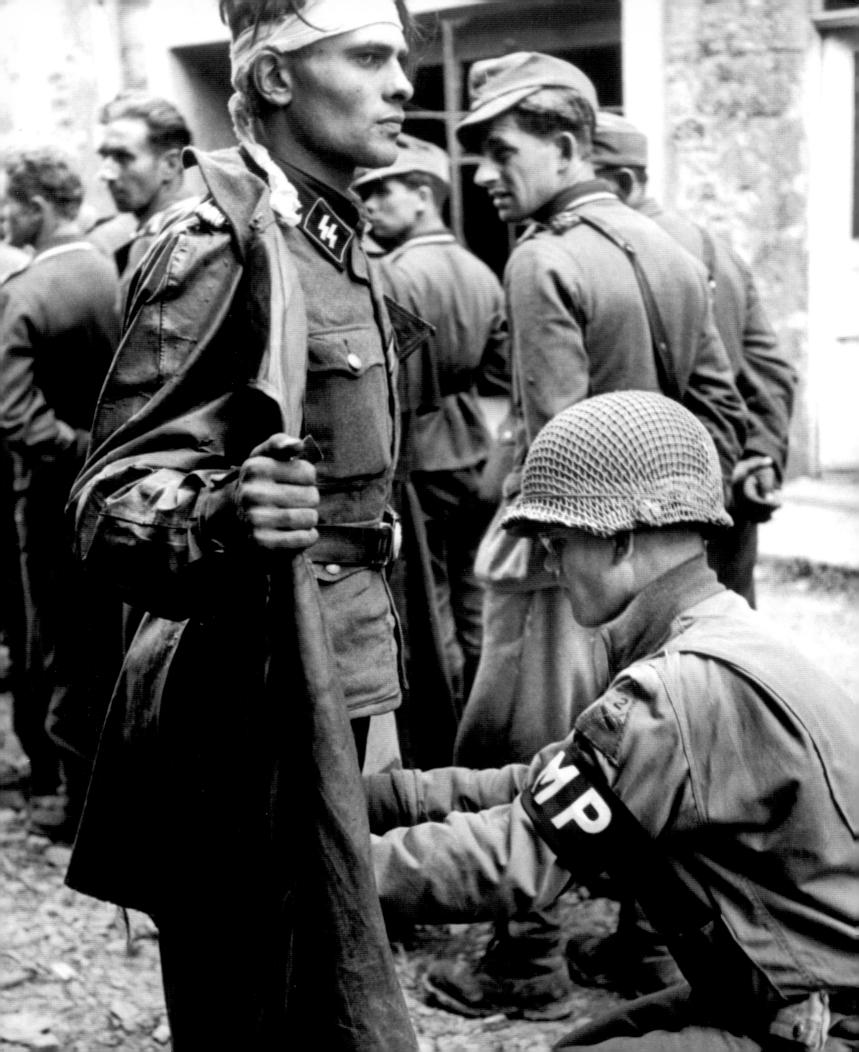

An American military policeman frisks a young SS soldier in Normandy in 1944, a column of recently captured German POWs in the background.

Robert Capa

On 18 April 1945 photographer Robert Capa had climbed to the top of an apartment building in the centre of Leipzig as the US First Army took the city, 'to see if the last picture of the crouching and advancing infantrymen could be the last picture of the war', he later wrote. Seconds after he entered, a young corporal machine-gunner on one of the balconies was hit by a sniper's bullet and killed instantly.

Robert Capa

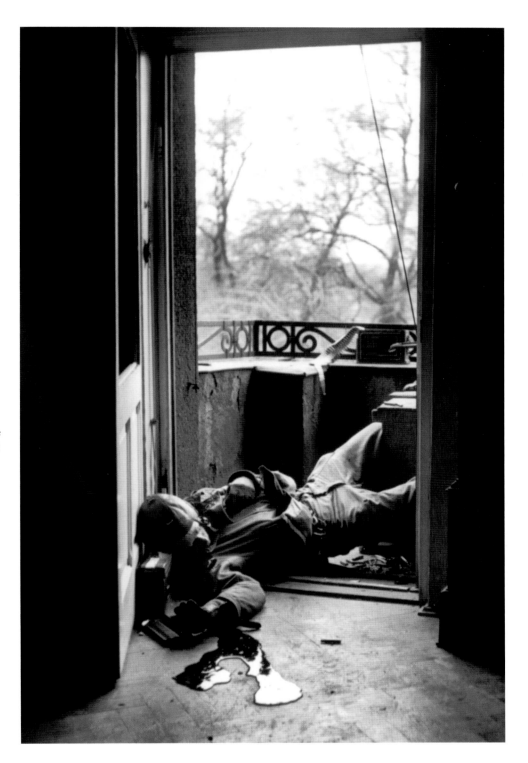

War is lonely and individual work; it is hard to realize how small it can get. Finally it can boil down to ten unshaven gaunt-looking young men, from anywhere in America, stationed on a vital road with German tanks coming in.

Martha Gellhorn, reporting the Battle of the Bulge, December 1944

Suddenly I saw people again, right in front of me. They scream and gesticulate with their hands, and then - to my utter horror and amazement - I see how one after another they simply let themselves drop to the ground ... Today I know that these unfortunate people were the victims of lack of oxygen. They fainted and then burnt to cinders. I fall then, stumbling over a fallen woman and as I lie right next to her I see how her clothes are burning away. Insane fear grips me and from then on I repeat one simple sentence to myself continuously: 'I don't want to burn to death - no, no burning - I don't want to burn!' ... Suddenly, I'm standing up, but there's something wrong, everything seems so far away and I can't hear or see properly any more. As I found out later, like all the others, I was suffering from lack of oxygen. I must have stumbled forwards roughly ten paces when I all at once inhaled fresh air ... Dead, dead, dead everywhere. Some completely black like charcoal. Others completely untouched, lying as if they were asleep. Women in aprons, women with children sitting in the trams as if they had just nodded off.

Margret Freyer, a survivor of the bombing of Dresden

In February 1945, Dresden, the capital of Saxony and one of the most beautiful cities in Germany, was bombed by the RAF by night and the US 8th Air Force by day, reducing it to this. It will never be known how many were killed because the town was full of refugees fleeing from the Russians, but the figure must be between 60,000 and 120,000.

Richard Peters Jnr

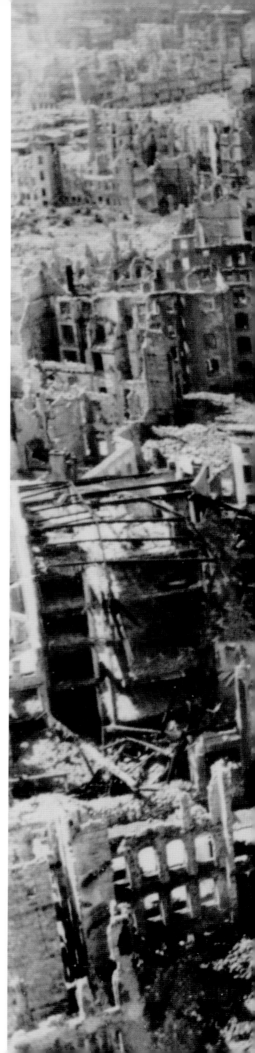

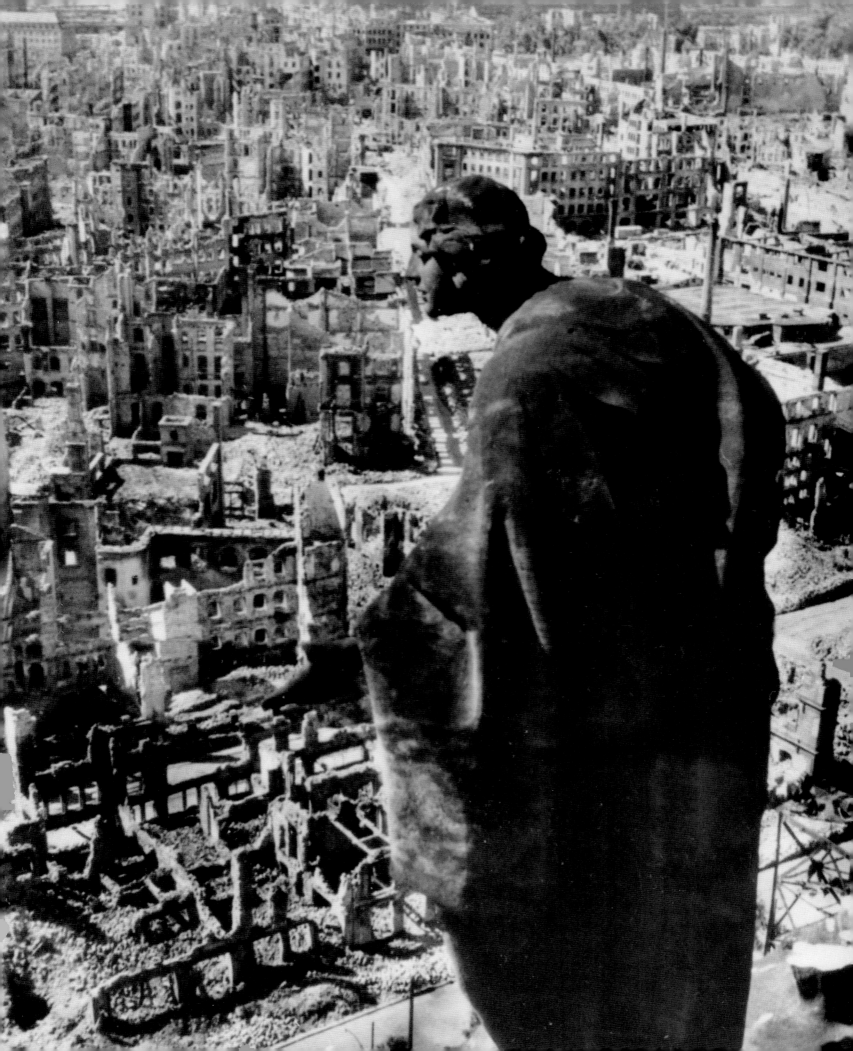

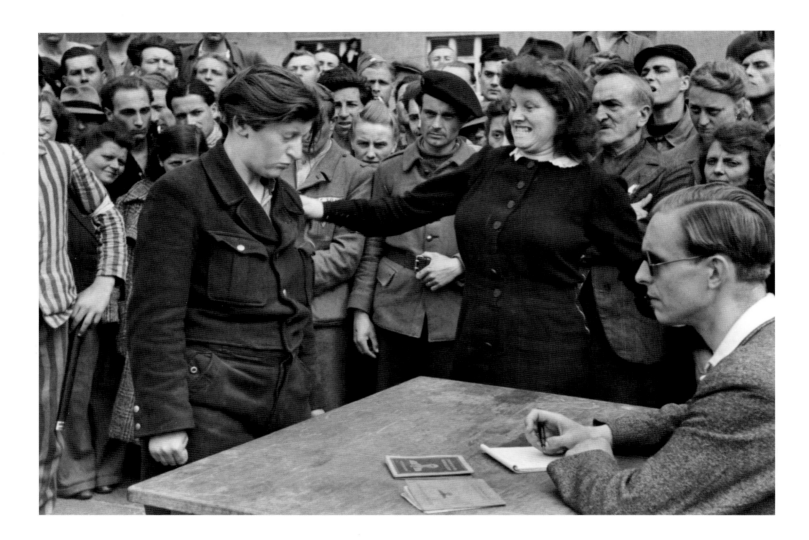

Displaced persons' camps were set up all over Europe to handle the countless thousands of human flotsam and jetsam left by the war. Here a Gestapo informer who sought to acquire a new identity in the DP camp at Dessau is exposed. This photograph was taken by Henri Cartier-Bresson, who was taken prisoner when France fell to the Germans in 1940. Escaping three years later, he joined the French Underground Photographic Unit.

Henri Cartier-Bresson

The daughter of the Burgomaster of Leipzig who, together with her parents, committed suicide in April 1945 as the Americans captured the city. The photographer, Lee Miller, wrote: 'She had exceptionally pretty teeth.'

Lee Miller

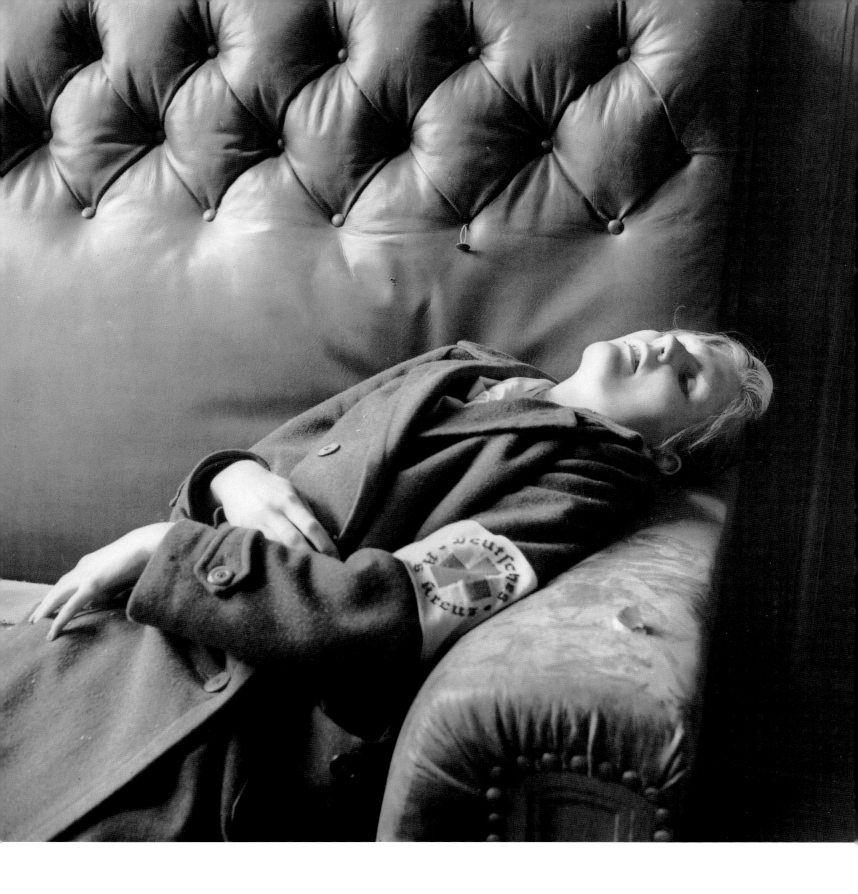

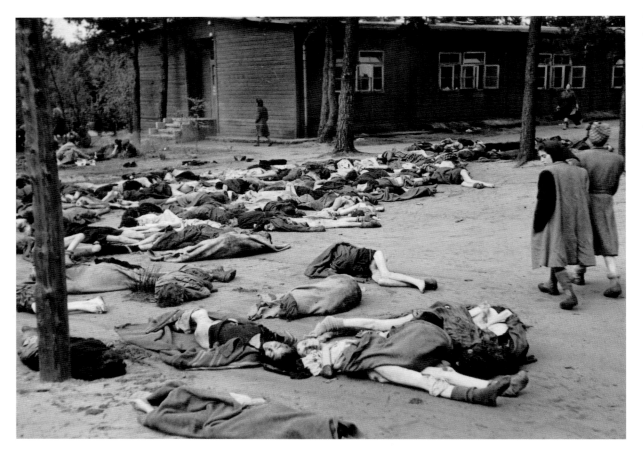

Reporting for BBC Radio, Richard Dimbleby describes the scenes he encountered at Belsen concentration camp a few days after its liberation by Allied soldiers, April 1945.

I picked my way over corpse after corpse in the gloom, until I heard one voice raised above the gentle undulating moaning. I found a girl, she was a living skeleton, impossible to gauge her age for she had practically no hair left, and her face was only a yellow parchment sheet with two holes in it for eyes. She was stretching out her stick of an arm and gasping something, it was 'English, English, medicine, medicine', and she was trying to cry but she hadn't enough strength. And beyond her down the passage and in the hut there were the convulsive movements of dying people too weak to raise themselves from the floor.

In the shade of some trees lay a great collection of bodies. I walked about them trying to count, there were perhaps 150 of them flung down on each other, all naked, all so thin that their yellow skin glistened like stretched rubber on their bones. Some of the poor starved creatures whose bodies were there looked so utterly unreal and inhuman that I could have imagined that they had never lived at all. They were like polished skeletons, the skeletons that medical students like to play practical jokes with ... I have never seen British soldiers so moved to cold fury as the man who opened the Belsen camp this week.

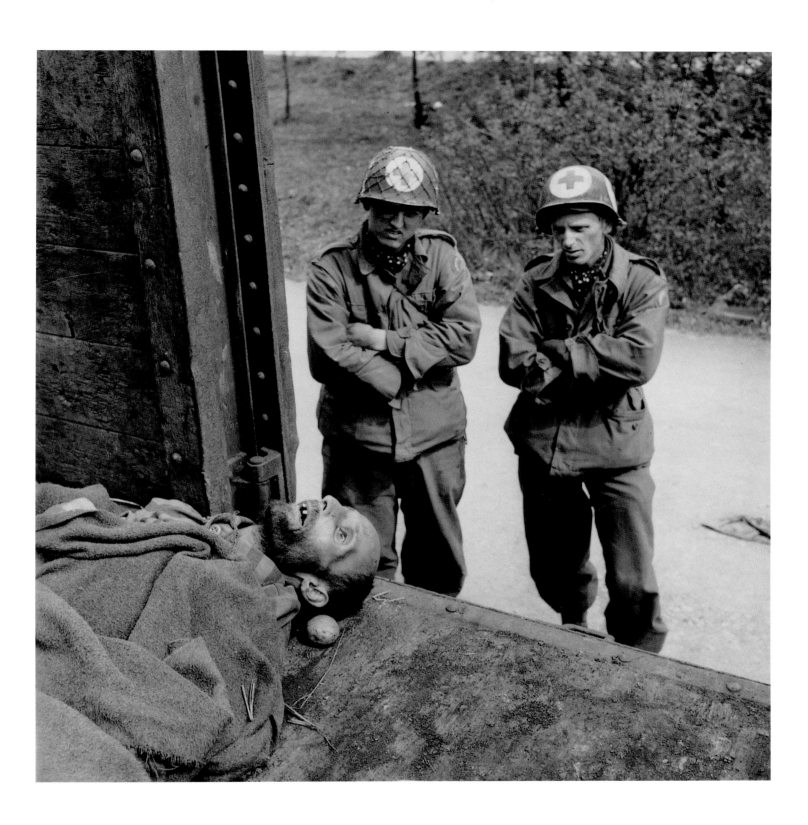

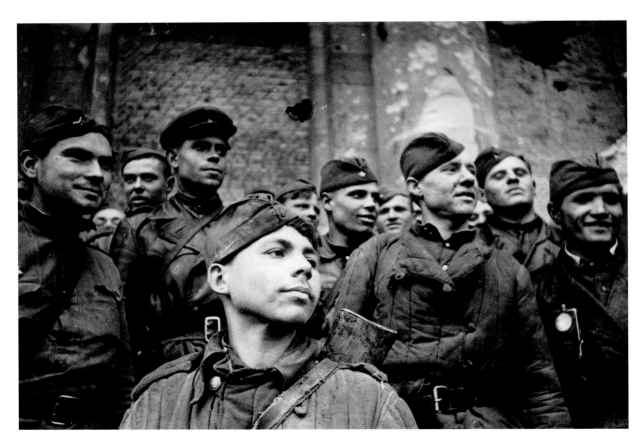

Russian troops relish their victory in Berlin after 12 days of fierce house-to-house fighting. The final Russian push through Germany had cost them 304,887 casualties.

Yevgeny Khaldei's historic photograph taken atop the Reichstag, the red tablecloth blowing in the wind over Berlin, early afternoon, 30 April 1945. Germans are still fighting in the basement of the building as the photograph is taken, while Hitler has committed suicide close by.

Yevgeny Khaldei

A few days before the fall of Berlin, the Red Army ran out of Red Flags. The great war photographer Yevgeny Khaldei flew back to Moscow. He found no flags. Instead, he commandeered three large red tablecloths from the Tass News Agency where he worked. The Tass commissary asked what they were for, and Khaldei said it was a military secret. He was told he would have to return them and was made to sign for them. Then he had his uncle, a tailor, sit up deep into the night stitching home-made hammers and sickles onto them. Khaldei returned to Berlin for the final assault and photographed one flag on top of the Air Ministry, another on the Brandenburg Gate. He took the last tablecloth with him as he followed an assault squad into the burning Reichstag and onto the roof. The image he then captured, of the flag being planted, has become part of history.

Brian Moynahan, historian and author, who interviewed the photographer Yevgeny Khaldei shortly before his death

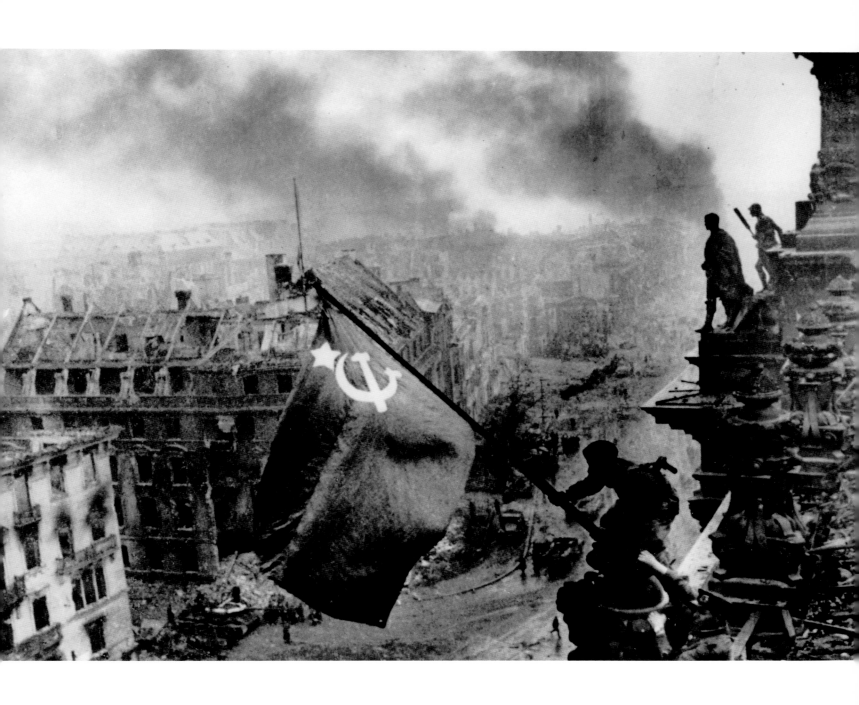

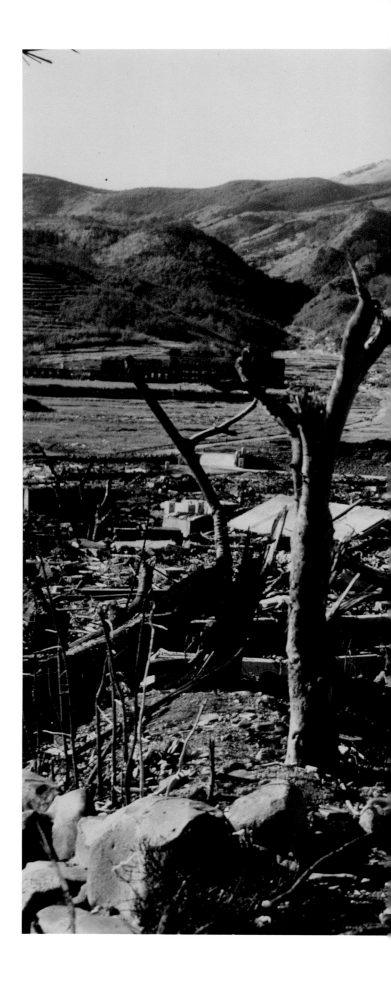

Dr Takashi Nagai, from Nagasaki Hospital, on the bombing of the city on 9 August 1945.

I saw the flash of light in the radium
laboratory. Not only my present but also my
past and future were blown away in the blast.
My beloved students burned together in a ball
of fire right before my eyes. Then I collected
my wife, whom I had asked to take care of
the children after my death but who now had
become a bucket-full of soft ashes, from the
burnt-out ruins of our house. She had died
in the kitchen.

Dr Takashi Nagai in the atomic wasteland
of Nagasaki a month after the bombing
on 9 August 1945, which left 35,000 dead
and devastated 1.8 square miles. Dr Nagai
died from the effects of radiation a few
days after the photograph was taken.

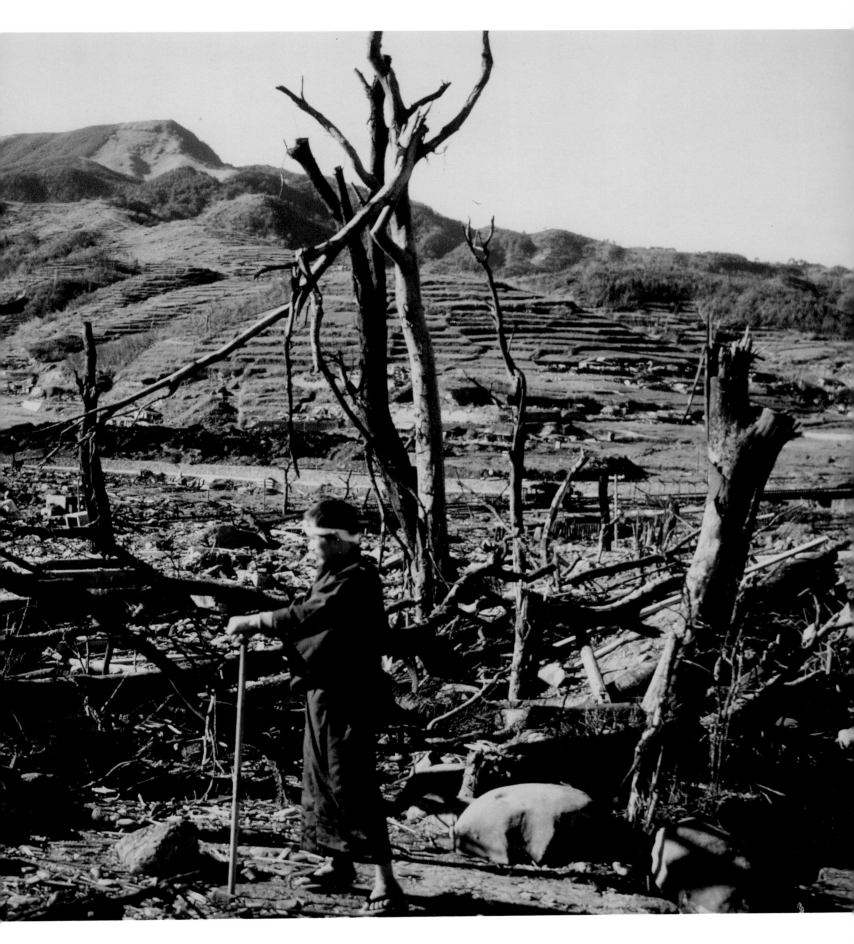

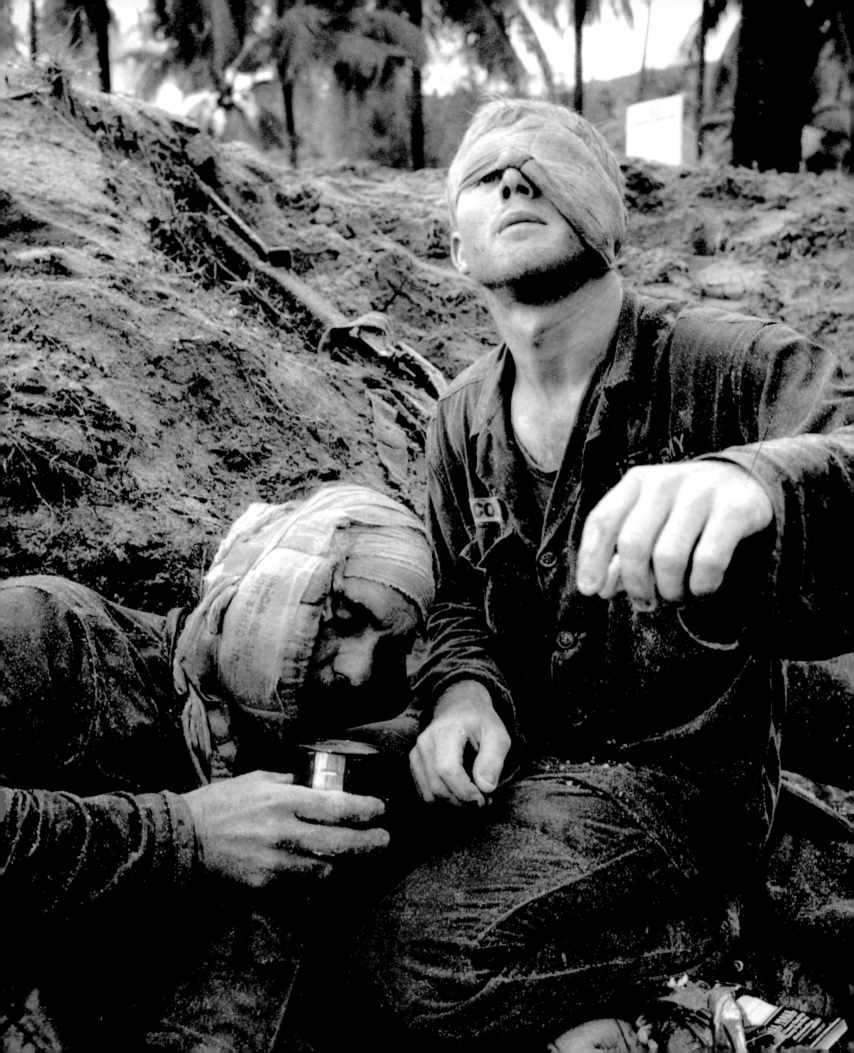

7. Independence Wars 1945 – 94

KOREA, INDOCHINA, VIETNAM, CAMBODIA, BANGLADESH, LATIN AMERICA, FALKLANDS, AFRICA

THE ATOMIC AGE began with the world in chaos. Millions of displaced people in Europe were living in camps awaiting a chance of a new life abroad. Germany was in ruins, Britain nearly bankrupt, France still traumatized by the Occupation, the Soviet Union exhausted.

Colonial empires in the East had collapsed and although imperial powers like Britain, the Netherlands and France hoped for a return to the pre-war state of affairs, their colonial subjects were demanding independence. Bowing to the inevitable, Britain moved to grant independence to India and partition the country into Muslim Pakistan and Hindu India. But France decided to fight to keep Indochina, and Vietnam's long and cruel war began.

Other wars threatened. Fearful of the power of the Soviet Union – especially after it ended the American nuclear monopoly by exploding its own atom bomb in 1949 – the West acted to contain the spread of Communism. The first test came in Korea. Divided after the war into a Communist North, supported by Moscow and later Peking, and an anti-Communist South supported by the United States, Korea had become a flash-point in the Cold War. Fighting broke out in June 1950 and after early Communist victories Washington persuaded the United Nations to create an army to confront Communism.

Soon there were 270 photographers and reporters covering the war. It was not an easy task. At first there was voluntary censorship, described by one photographer as the military saying, in effect, 'Take whatever photographs you like and if we don't like them we'll shoot you.' But it brought so much confusion that, as criticism of the war grew, the Commander-in-Chief of the UN Forces, General MacArthur, placed the media under the full jurisdiction of the army and imposed military censorship. There was a lot to censor. Casualties were enormous: 300,000 soldiers killed, wounded or missing on the UN side, two million civilians killed, more than 100,000 children left orphaned. The British correspondent for the BBC, René Cutforth, said that the whole Korean peninsula 'looked as if a gigantic wind had swept it clean of everything'.

It was more a photographers' war than a journalists' one. The latter were restricted in what they could say, unable to assess whether the UN intervention was justified, whether its aims were feasible, whether any long-term gains were worth the terrible cost, and so they became engrossed in describing the war in terms of military gains and losses. The photographers concentrated on human interest shots and tried to portray what the trauma of war was doing to both the soldiers and the Korean civilians.

David Douglas Duncan of *Life* magazine captured the grim experience of GIs, baked in the Korean summer, frozen in winter, with death from an enemy massed attack or a cleverly planted mine never very far away *(see pp. 177–9)*. Bert Hardy of *Picture Post* showed the appalling treatment meted out by the South Korean government to its political prisoners but his proprietor, Edward Hulton, refused to publish his photographs *(see p. 181)*.

In Vietnam, under the American military, there was no such censorship. After the French defeat at Dien Bien Phu in 1954 and the division of Vietnam into the Communist North and the anti-Communist South, the United States, as part of its policy of containing China, decided to support South Vietnam. A press corps that was eventually nearly 700 strong and that included more photographers than had ever covered

any earlier war, turned up in Saigon to see whether the Americans could achieve what the French had failed to do – defeat a nationalist army.

The Associated Press would lend virtually anyone a camera and a film and promise to pay $15 for any acceptable picture. Several amateur photographers who started this way went on to become famous. Others, like Sean Flynn, son of the film star Errol, were killed when they ventured too far into enemy territory. Since this was an insurgency war fought largely in monsoon jungles, the high-technology weapons of the United States eventually proved no match for the guerrilla tactics of the Vietcong. The Americans set out to win 'the hearts and minds' of the people of Vietnam, but, as countless photographs show, instead they alienated them. Unable to distinguish ordinary Vietnamese civilians from Vietcong, they treated every male between fifteen and fifty as an enemy. This was the first television war, with nightly bulletins in the United States showing colour footage of wounded GIs, napalmed civilians, ill-treated prisoners and bloodied children.

The war went on too long, American casualties were too high, there was no light at the end of the tunnel, the United States withdrew and, in April 1975, South Vietnam fell to the Communists. Vietnam was lost because television brought the brutality of war into the comfort of American living rooms and took away America's will to fight on, a lesson the military would not forget.

The war to contain Communism continued elsewhere. In Cuba, Chile, El Salvador and Nicaragua, it was fought clandestinely and at one remove. The CIA backed an attempt by Cuban exiles to invade Cuba at the Bay of Pigs in 1961 and spark an uprising against Fidel Castro. It failed, but CIA-organized covert operations against the Leftist governments of Chile and Nicaragua were more successful. The government of President Allende of Chile was deposed in 1972 after an attack on the president's headquarters, captured on film, Allende then committing suicide.

Civil wars in Africa to settle grievances that went back to the departure of the colonial rulers years earlier or which had their origin in tribal rivalries were marked by massacres and atrocities. In Rwanda at least 800,000 people were killed in just one hundred days, the most efficient mass killing since the atomic bomb. Western attempts to intervene on humanitarian grounds were disasters.

The only old-fashioned war of this period was the British expedition to the South Atlantic in 1982 to recapture the Falkland Islands, invaded and occupied by Argentina, which claimed them as its own territory. It was old fashioned in the sense that a small army, with RAF support, sailed off in Royal Navy ships to land, then engage the enemy and re-occupy a British possession.

The task force was accompanied by seventeen British correspondents and photographers; their censorship was mild by later standards, the photography honest and often outstanding. Some terrible TV film showing the effects of fire on British soldiers in the attack on the landing craft *Sir Galahad* even made it to the screen, but only after the war was over. 'Rejoice,' said the then Prime Minister, Mrs Thatcher, when victory came.

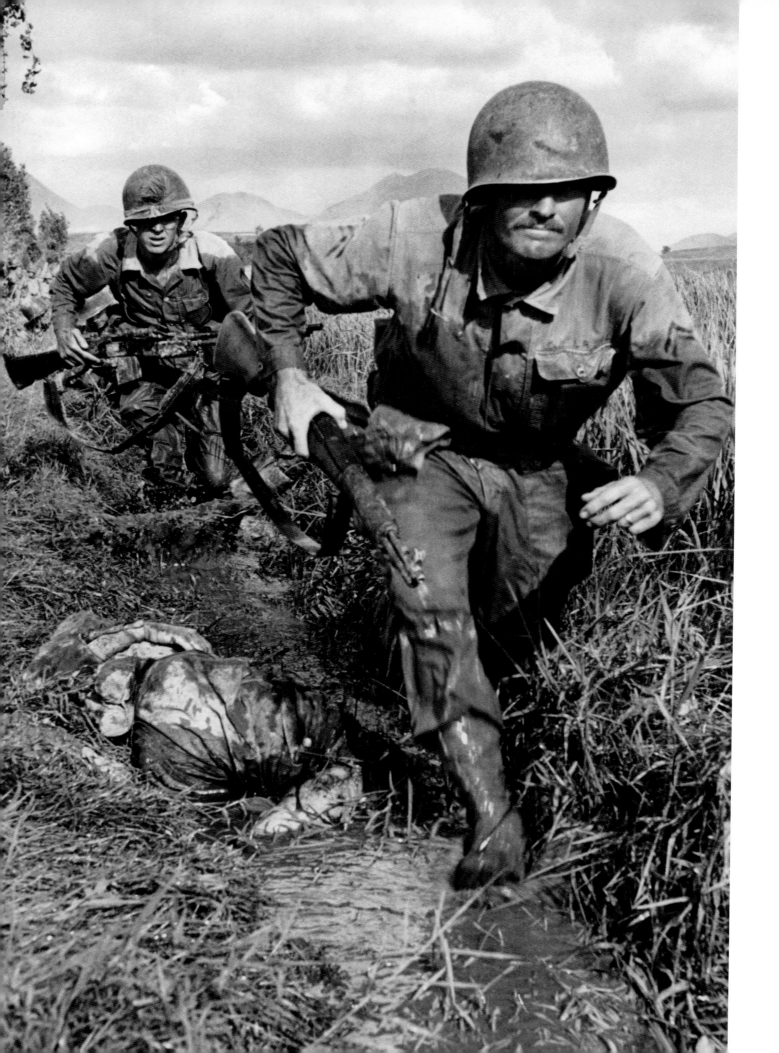

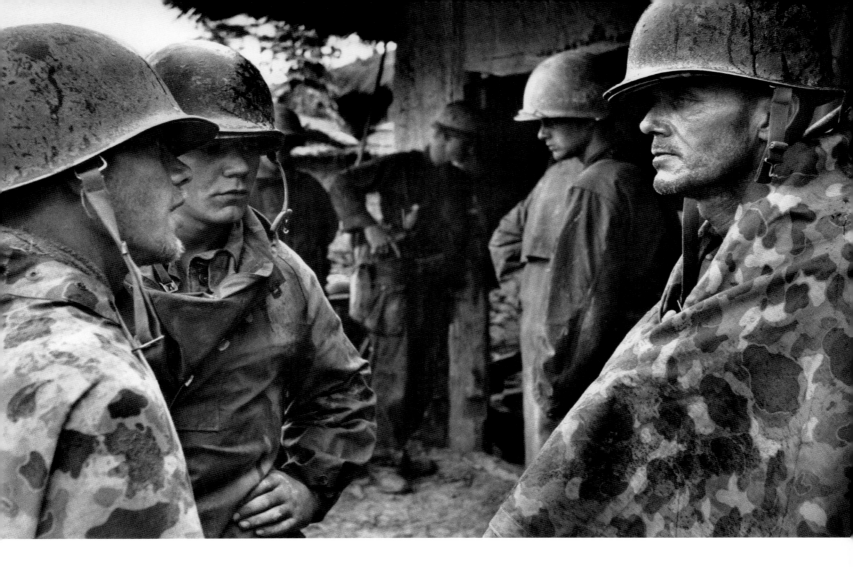

Korea

In September 1950 US Marines were engaged in a desperate defence of the perimeter area around the port of Pusan, the last foothold preventing total Communist victory in South Korea. Marines leap over the body of a dead North Korean (*left*) as they advance under machine-gun fire along a roadside ditch. The end of the action (*above*). The Marines have fought off repeated attacks, despite running out of ammunition and being denied reinforcements, and now their one concern is for their wounded (*see account right*).

David Douglas Duncan

Outside the emergency aid station a tiny group of Marines always stood. They were men who had come down the hill, from the firing line above, as soon as other men had been found who could take their weapons and places facing the enemy. They were men who had almost nothing to say. They just stood outside the crude little hut which was the aid station. They were waiting. When their time was up, and they had to go back up on the hill, other men, other men just like them came down to take their places. They, too, were waiting to learn whether their buddies were still alive ... or dead.

David Douglas Duncan, *This is War!*, 1951.

Many vehicles wound down that road and they all were loaded with vital equipment, the equipment with which to run a full combat division ... so the men walked. They walked with necks bent, shoulders hunched up, eyes almost closed to a kind of cold against which there was no protection ... in which no clothes had warmth. So they just walked ... carried their rifles ... and froze ...

Down the road, Marines at other fires tried to heat their food, but it was more from habit than hunger — for in that cold even hunger itself had died. Finally, on the canyon floor, the column halted once again before making the finishing effort needed to push out through it and into the plain, with its sea beyond. The men of the Division stood, and smoked, and waited, then climbed slowly back upon the road. And that time, as they moved down the road, the wounded and frozen got to ride. The dead also rode — tied upon trucks and trailers. Behind them — the shuffle of their feet following the rising and falling beat of a tragic rhythm — walked the living.

David Douglas Duncan, *This is War!*, 1951

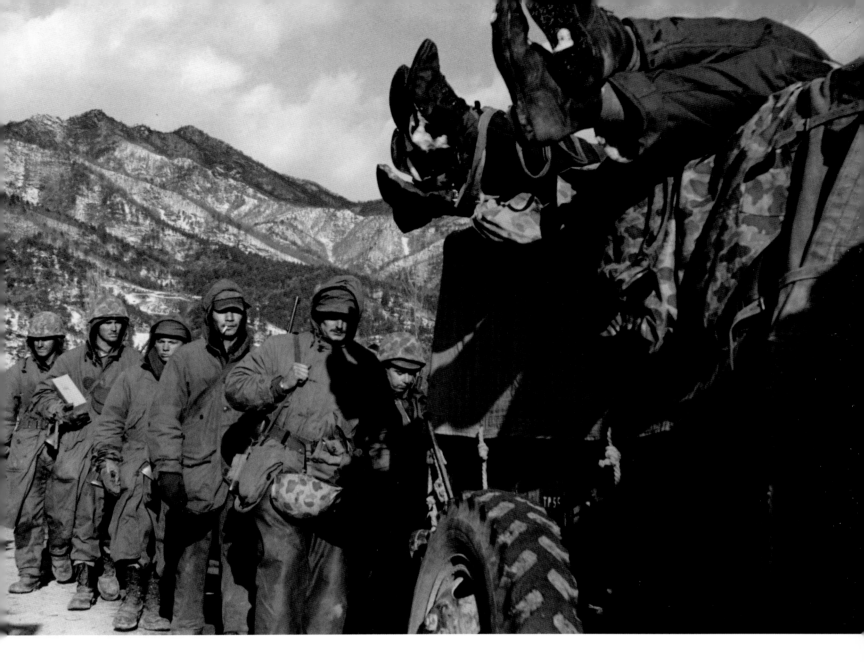

In October 1950 General MacArthur gambled by landing a large force on the east coast of North Korea, intent on reaching the Yalu river, the border with China. He was defeated by the entry of China into the war. The Marines conducted a fighting retreat in bitter winter weather back to the beaches, or in the words of their commander, 'Retreat, hell! We're just fighting in another direction.'

David Douglas Duncan

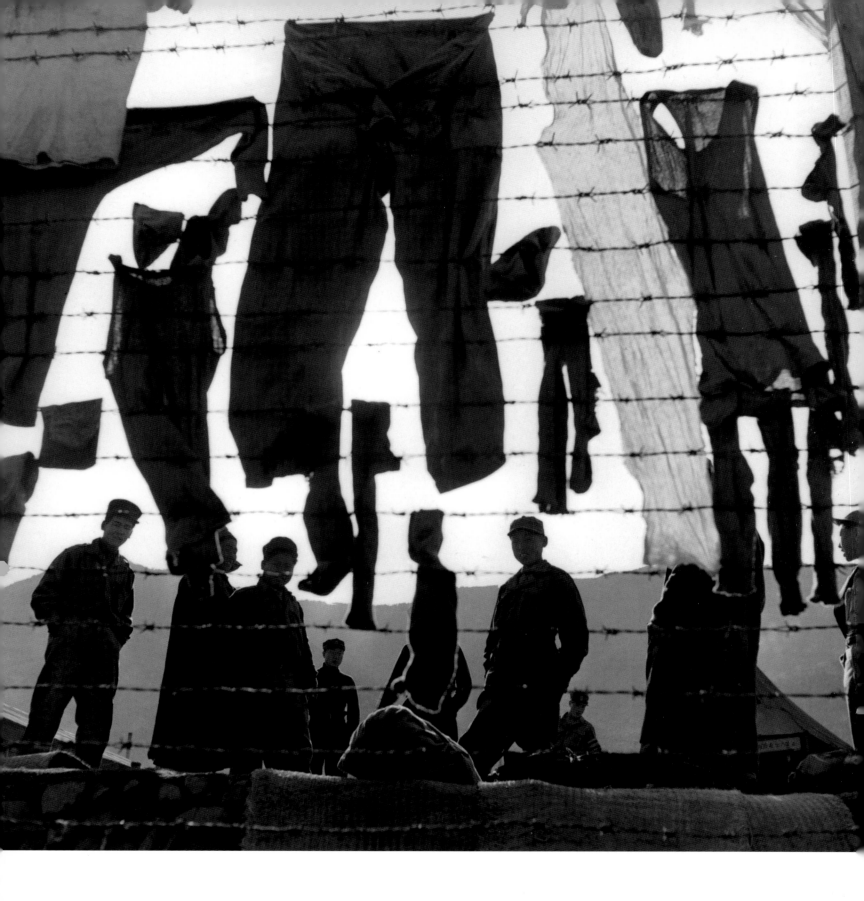

North Korean prisoners of war hang their washing on the barbed-wire fence of their camp to dry, Koje do Island, 1952. There were frequent mutinies in this mismanaged camp because hard-liner inmates were allowed to exercise far too much control.

Werner Bishof

One of Bert Hardy's pictures of South Korean political prisoners, some only twelve years old, whose treatment is described in the accompanying extract by James Cameron.

Bert Hardy

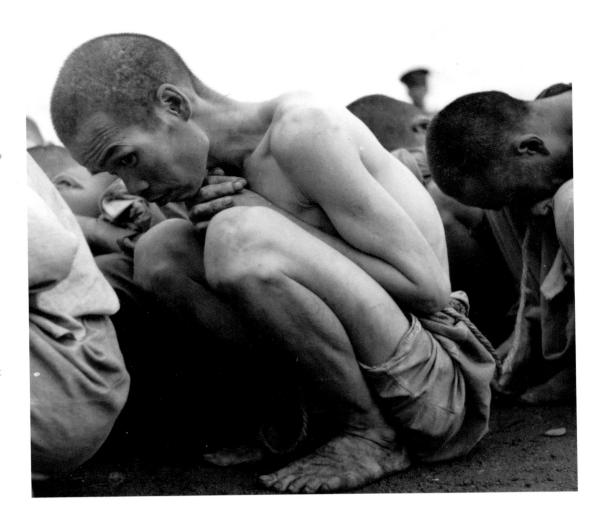

James Cameron describes the treatment of South Korean political prisoners by the South Korean Government in Pusan in 1951, in full view of the US headquarters and the United Nations Commission there. His story and Bert Hardy's pictures were never published by their employer, *Picture Post* magazine, but they got out all the same.

They were skeletons — they were puppets of skin with sinews for strings — their faces were a terrible, translucent grey, and they cringed like dogs. They were manacled with chains or bound to each other with ropes. They were compelled to crouch in the classic oriental attitude of subjection, the squatting, foetal position, in heaps of garbage ... Any deviation from their attitude brought a gun butt on their skulls. Finally they were herded ... into trucks with the numb air of men going to their deaths. I was assured, by a willing attendant anxious to make a good impression, that most of them were. Sometimes, to save inconvenience, they were shot where they were.

The enemy will be caught in a dilemma: he has to drag out the war in order to win it and does not possess, on the other hand, the psychological and political means to fight a long drawn-out war.

General Giap, Commander of the Vietminh forces

What we are facing here is a social war, a class war. As long as we don't destroy the mandarin class, abolish excessive tenancy rates and so fail to give every farmer his own plot of land, this country'll go Communist as soon as we turn our backs.

A French Officer in Indochina

If your pictures aren't good enough, you're not close enough.

Robert Capa

Indochina

A haunting picture taken in Indochina (Vietnam) in the Red River Delta on 25 May 1954 by Robert Capa when covering the story of the French forces evacuating two small forts. Hours later he was killed by an anti-personnel mine, as he tried to get just that little bit closer.
Robert Capa

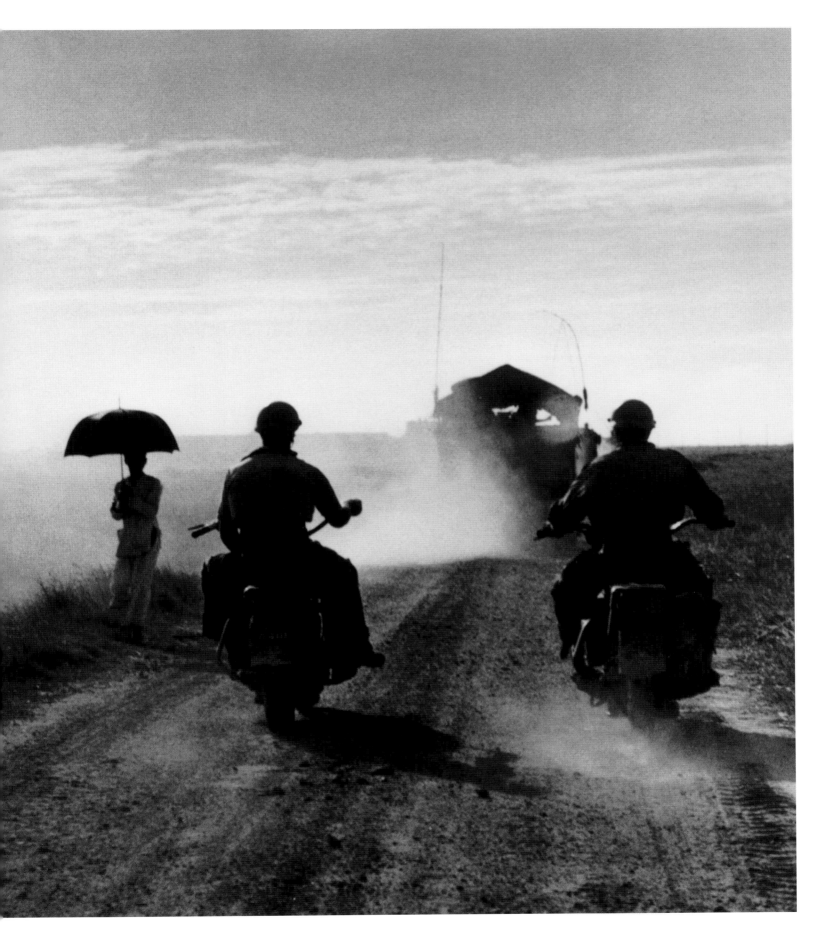

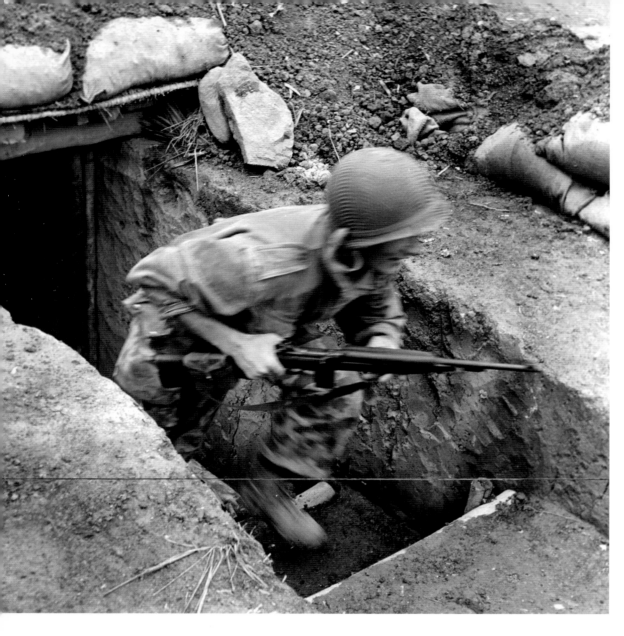

General Navarre, French Commander-in-Chief in Indochina, on the battle of Dien Bien Phu.

Under the influence of [Communist] Chinese advisers, the Viet-Minh command had used processes quite different from the classical methods. The artillery had been dug in by single pieces. The guns had been brought forward dismantled, carried by men, to emplacements where they had direct observation of their targets. They were installed in shell-proof dugouts, and fired point blank from portholes or were pulled back as soon as our counterbattery fire began. Each piece or group of pieces was covered by massed antiaircraft artillery put into position and camouflaged in the same manner as the guns. This way of using the artillery and AA guns was possible only with the 'human ant hill' at the disposal of the Viet-Minh and was to make shambles of all the estimates of our own artillerymen. It was the major surprise of the battle.

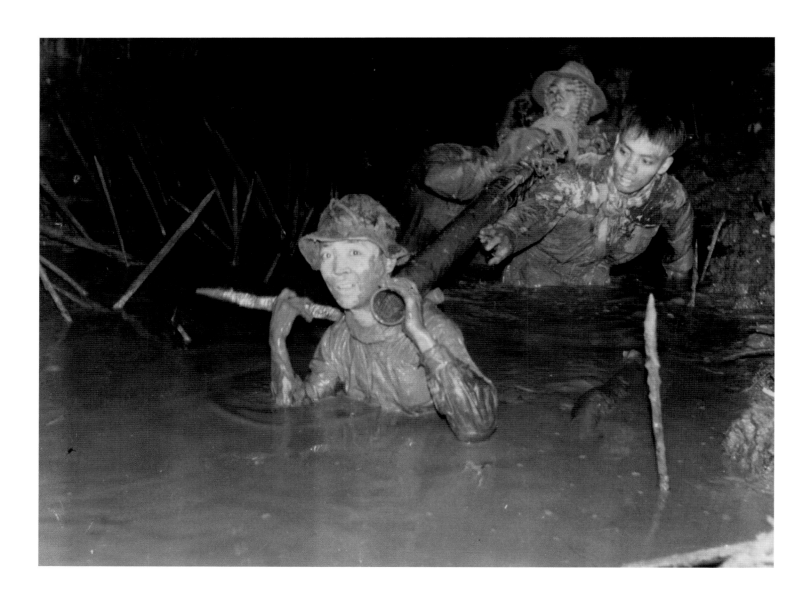

If the tiger ever stands still the elephant will crush him
with his mighty tusks. But the tiger does not stand still.
He lurks in the jungle by day and emerges by night. He will
leap upon the back of the elephant, tearing huge chunks
from his hide, and then he will leap back into the dark
jungle. And slowly the elephant will bleed to death.

Ho Chi Minh

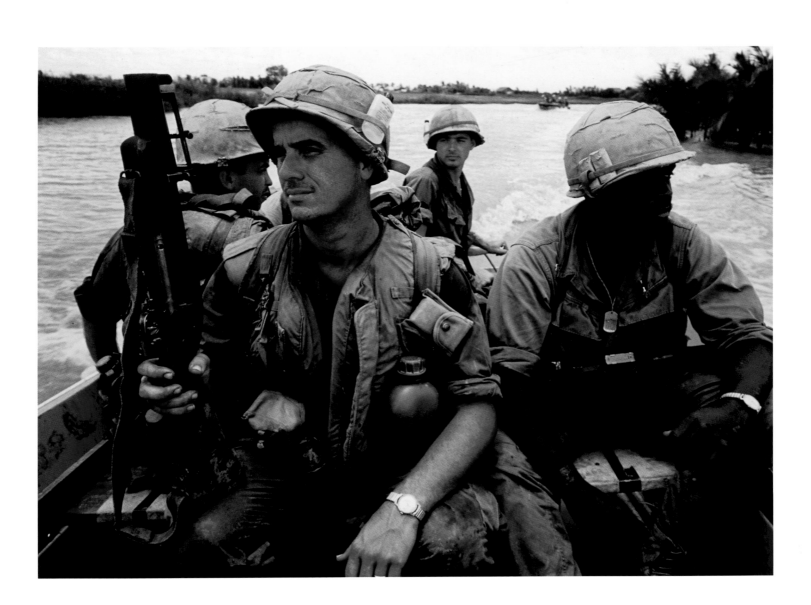

Vietnam

Vietcong with a rocket launcher in the mangrove swamps of the Mekong Delta in 1963, where they renewed the Indochina war, attacking isolated South Vietnamese outposts and hamlets. Unlike the Vietcong, neither the regular South Vietnamese army nor US forces were ever at home in the swamps and jungles.

Tran Bihn Khuol

US Marines on a river patrol in South Vietnam in c. 1965 in the Mekong Delta area. The Marine on the left holds a grenade launcher.

Philip Jones Griffiths

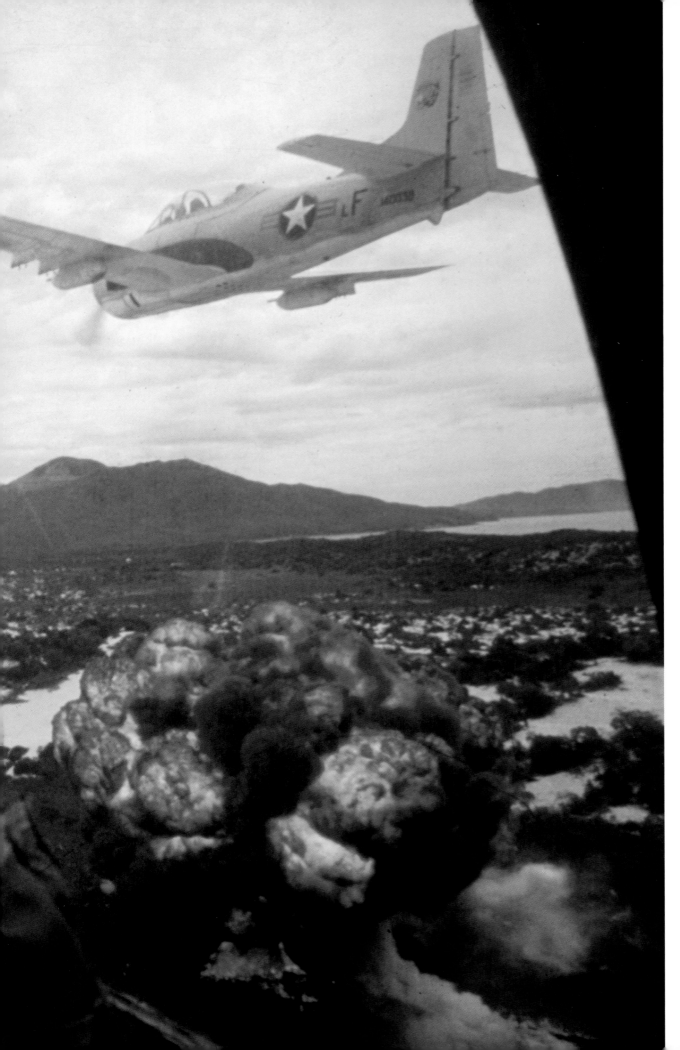

Vietnamese Air Force planes, with one Vietnamese and one American pilot, drop napalm in 1962.
Larry Burrows

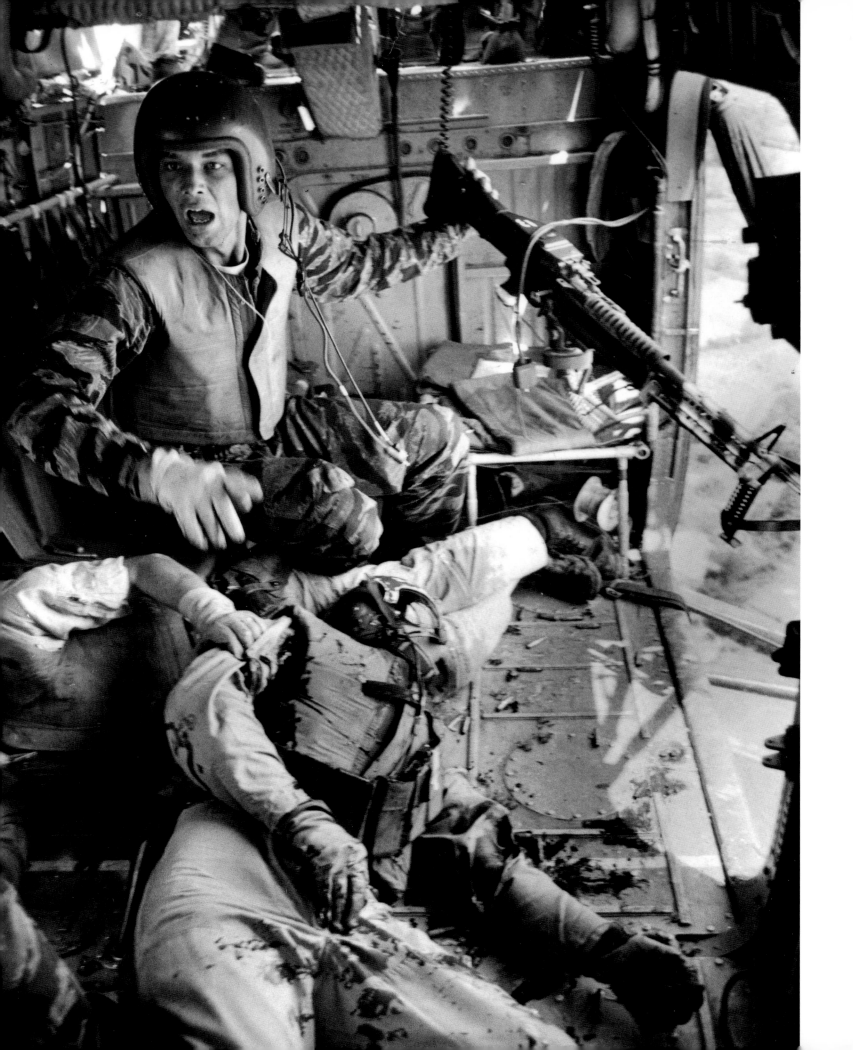

'One ride with Yankee Papa 13', published in *Life* in April 1965, was perhaps the most haunting photo-story from Vietnam. Photographer Larry Burrows flew in this, one of seventeen helicopters ferrying a South Vietnamese battalion. When sister helicopter YP3 went down, its wounded co-pilot and another crewman made it to YP13, which had landed alongside. Lance-Corporal James Farley, 21, a gunner on YP13, then ran across to try to rescue YP3's pilot, with Burrows close behind, braving Vietcong machine-gun fire. Farley (*left*), kneels beside his two YP3 crew members, one of them dying if not already dead. Back at base (*right*), Farley breaks down.

Larry Burrows

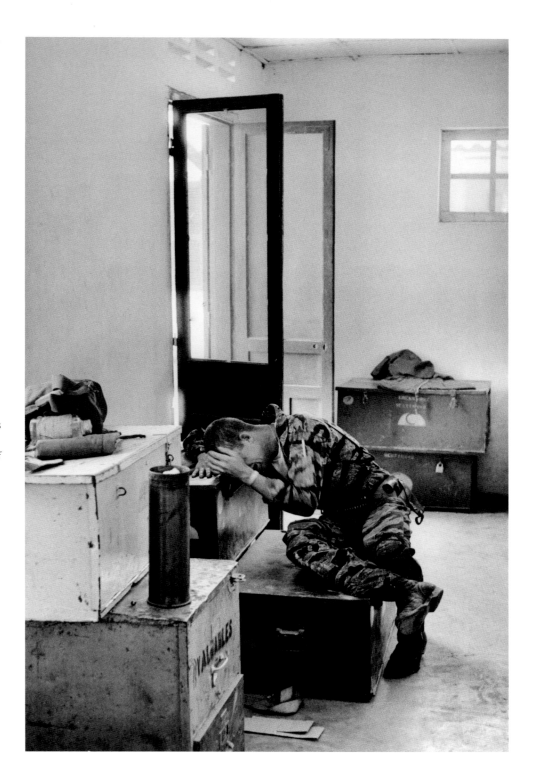

I was torn between being a photographer and the normal human feelings. It is not easy to photograph a pilot dying in a friend's arms and later to photograph the breakdown of the friend ... Was I simply capitalising on someone else's grief?

Larry Burrows

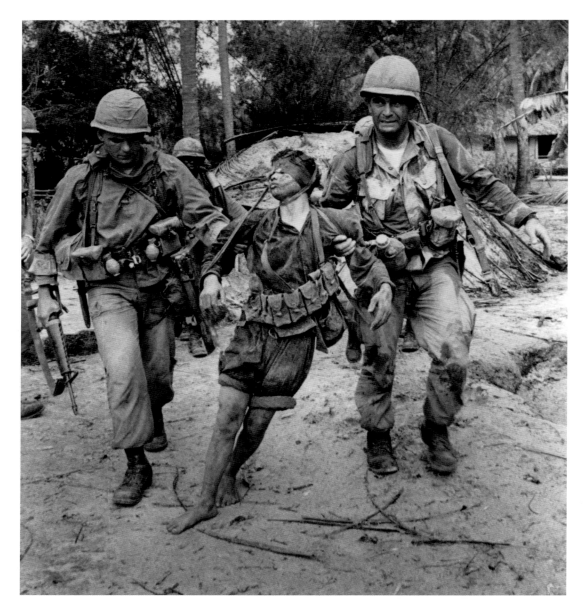

A Vietcong soldier who had held up their advance for an hour with his machine gun is dragged wounded from his bunker by soldiers of the US 1st Cavalry Division, 1966. On 28 October 1970 the photographer Kyoichi Sawada was ambushed with a colleague twenty-four miles south of Phnom Penh in Cambodia. Both men had been shot in the chest, neither was armed, and both were in civilian clothing.
Kyoichi Sawada

Suspect Vietcong led away for interrogation by the Americans.
Philip Jones Griffiths

When they [Lurps — long-range reconnaissance patrollers] came back in the morning he had a prisoner with him, blindfolded and with his elbows bound sharply behind him. The Lurp area would definitely be off-limits during the interrogation.

Michael Herr, *Dispatches*, 1977

Anyone who was male and between 15 and 50 was automatically assumed to be Vietcong and treated as such. After the traumatic experience of being arrested and then 'interrogated', any person released would quickly want to join the Vietcong.

Philip Jones Griffiths, *Vietnam Inc.*, 1982

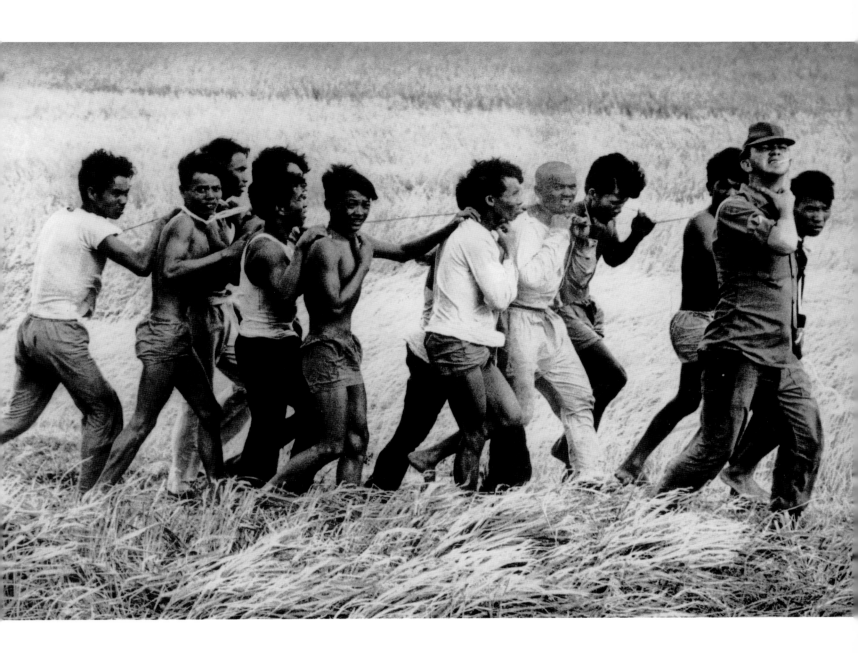

● *Overleaf:* Vietnam, 1966. A first-aid centre where wounded US Marines are treated before being helped to air evacuation points. It has just come under 'friendly fire' from US tanks, which kills three men. This powerful and emotive picture was taken by British photographer Larry Burrows, known by the Marines as 'the compassionate photographer', who had burnt most of Robert Capa's D-Day shots by mistake in June 1944. He was killed when the helicopter he was in was shot down over Laos in 1971.

Larry Burrows

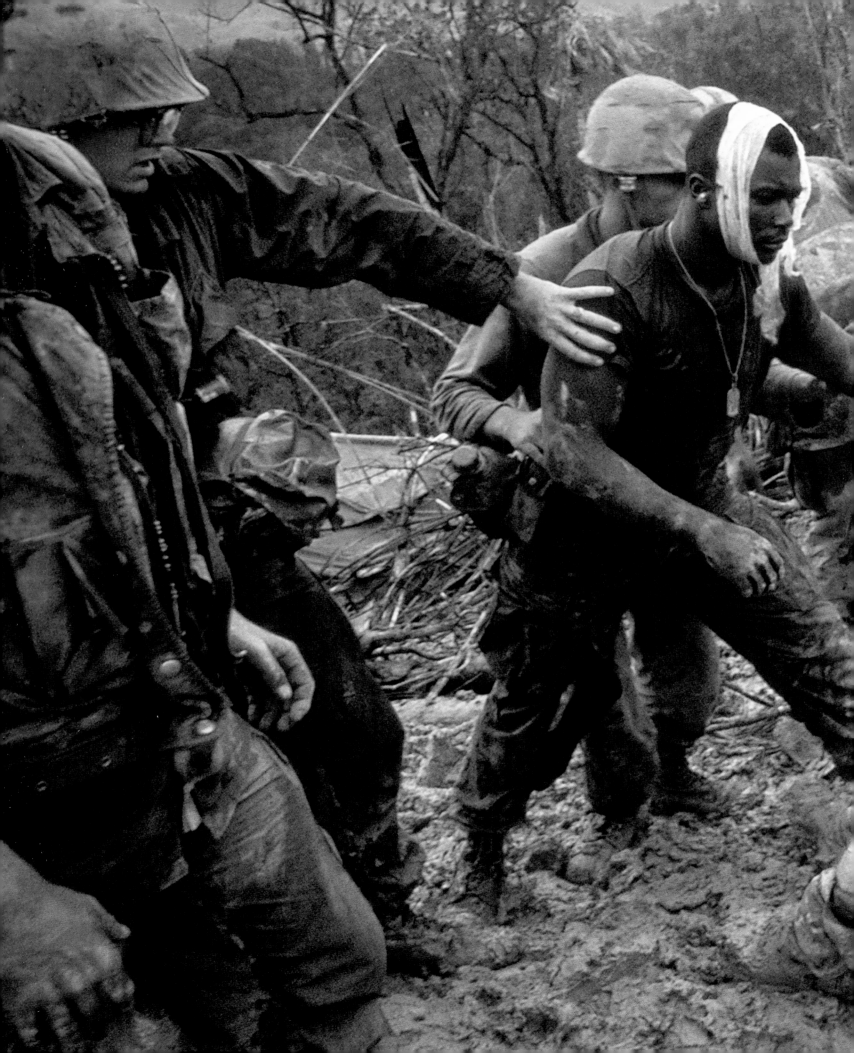

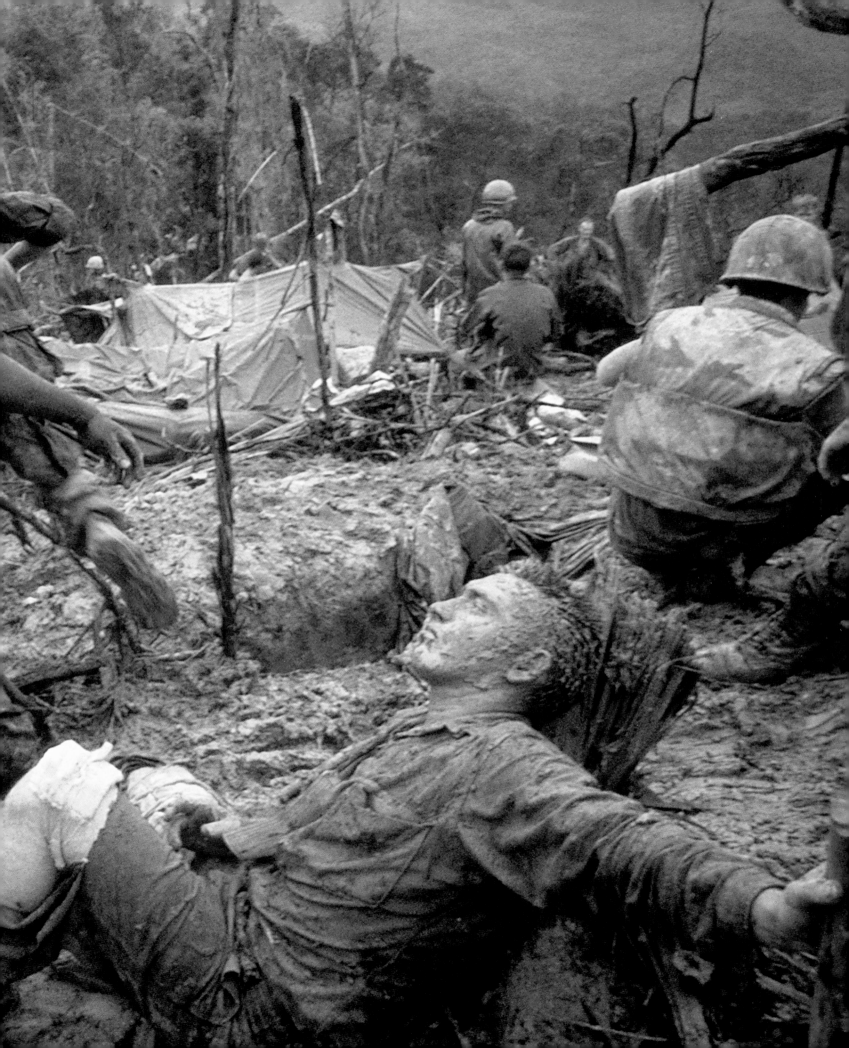

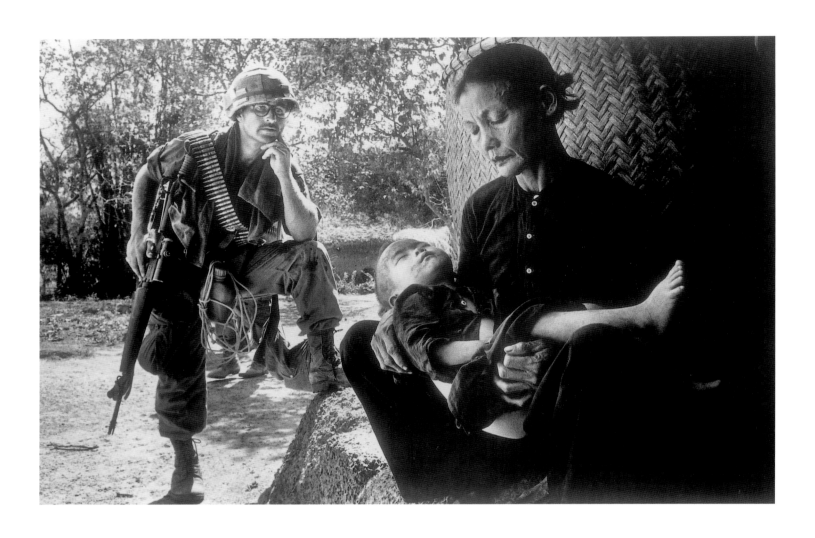

This Vietnamese woman's husband has been killed by US soldiers a few minutes earlier, together with other male villagers, because they were found hiding in a tunnel, seen by the Americans as standard Vietcong practice. After blowing up all tunnels and bunkers that might offer shelter, the soldiers will withdraw and then call down an artillery barrage on the village, which will kill the woman, the child and everyone else there, 1967.
Philip Jones Griffiths

A napalm victim, 1967. A pilot detailed the finer selling points of napalm – described euphemistically by US apologists as 'unfamiliar cooking fluid' – to the photographer Philip Jones Griffiths: 'The original product wasn't so hot – if the gooks were quick they could scrape it off – now it sticks like shit to a blanket. But if the gooks jumped under water it stopped burning, so they added Willie Peter [white phosphorous] to make it burn better ... one drop is enough, it'll keep on burning right down to the bone so they die anyway from phosphorous poisoning.'
Philip Jones Griffiths

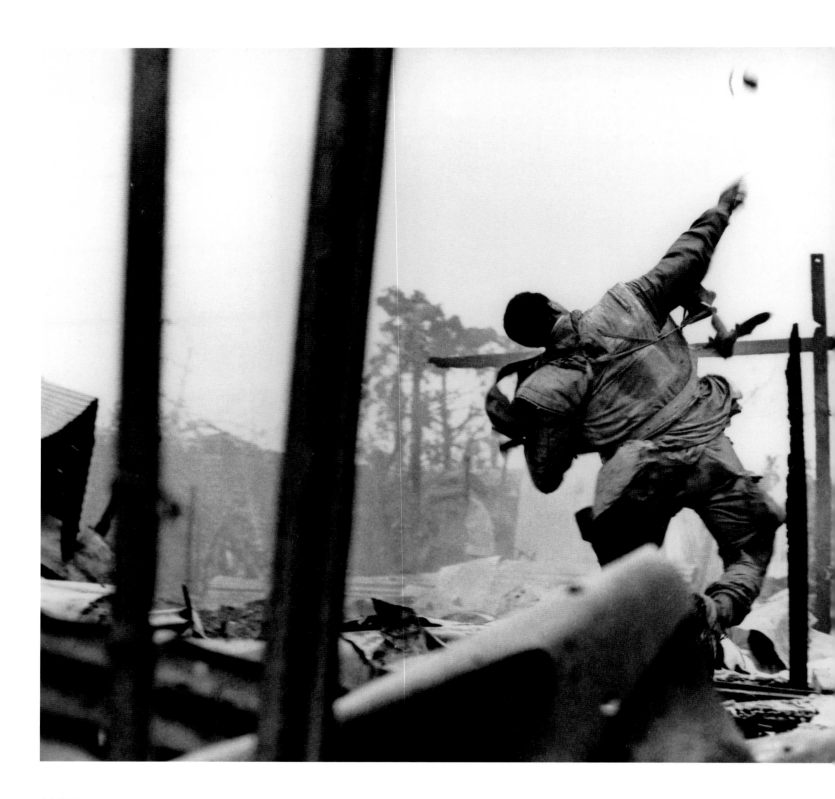

A US Marine throws a grenade in Huê
moments before he himself is wounded.
In January 1968 North Vietnamese
General Giap launched the Tet offensive
against all the major cities of the South,
during which Huê citadel was captured
and held until 24 February.
Don McCullin

Attaching myself to an American marine battalion ... I took to the amphibian assault craft which crossed the Perfumed River and, unarmed, entered the street-by-street engagement. The commander assured me that it was a 24-hour operation to recapture the citadel. Twelve days later seventy of my companions were dead and the city was utterly destroyed.

Don McCullin, *Sleeping With Ghosts*, 1994

There was a black Marine called Philly Dog who'd been a gang lord in Philadelphia and who was looking forward to some street fighting after six months in the jungle, he could show the kickers what he could do with some city ground. (In Hue he turned out to be incredibly valuable. I saw him pouring out about a hundred rounds of .30-calibre fire into a breach in the wall, laughing, 'You got to bring some to get some'; he seemed to be about the only man in Delta Company who hadn't been hurt yet.) And there was a Marine correspondent, Sergeant Dale Dye, who sat with a tall yellow flower sticking out of his helmet cover, a really outstanding target. He was rolling his eyes around and saying, 'Oh, yes, oh, yes, Charlie's got his shit together here, this will be bad,' and smiling happily. It was the same smile I saw a week later when a sniper's bullet tore up a wall two inches above his head, odd cause for amusement in anyone but a grunt.

Michael Herr, *Dispatches*, 1977

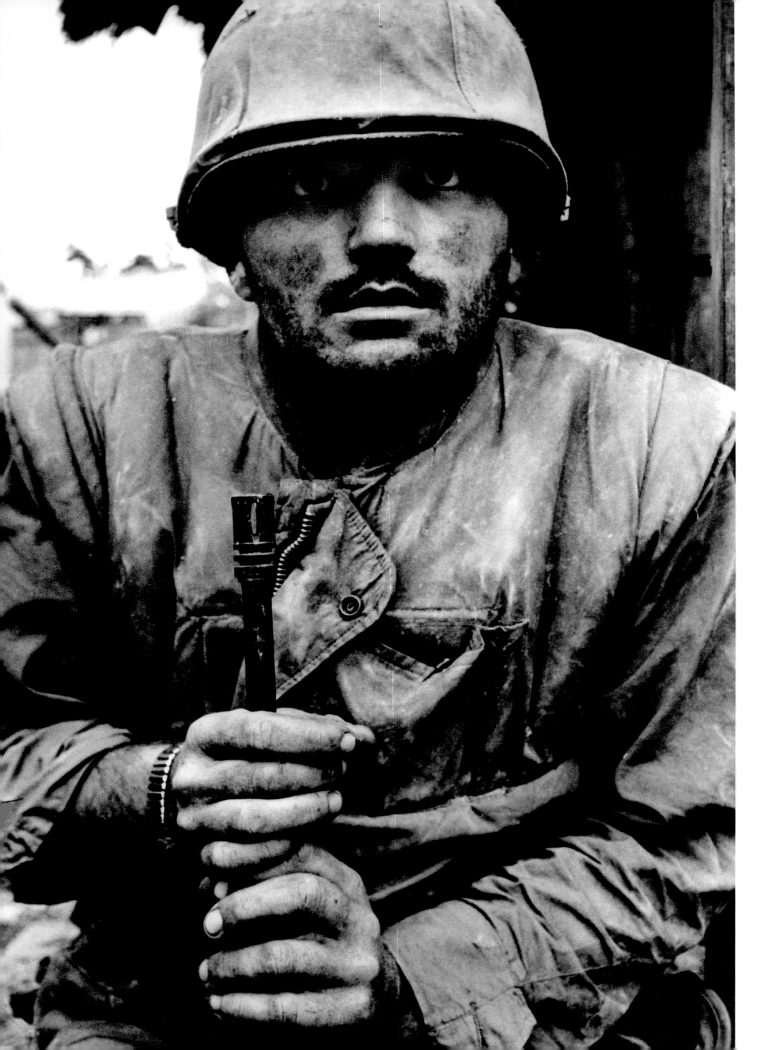

A US Marine in shock
from the street
fighting in Huê, 1968.
American firepower
reduced 80 per cent of
the city to rubble.
Don McCullin

Vietnamese man and
his child wounded
by hand grenades in
Huê, 1968. The
photographer Don
McCullin recalled the
harrowing moments
from the twelve-day
assault on Huê: 'I had
become an expert on
what a bullet can do to
a frail human body as it
zips through flesh and
fragments on bone.'
Don McCullin

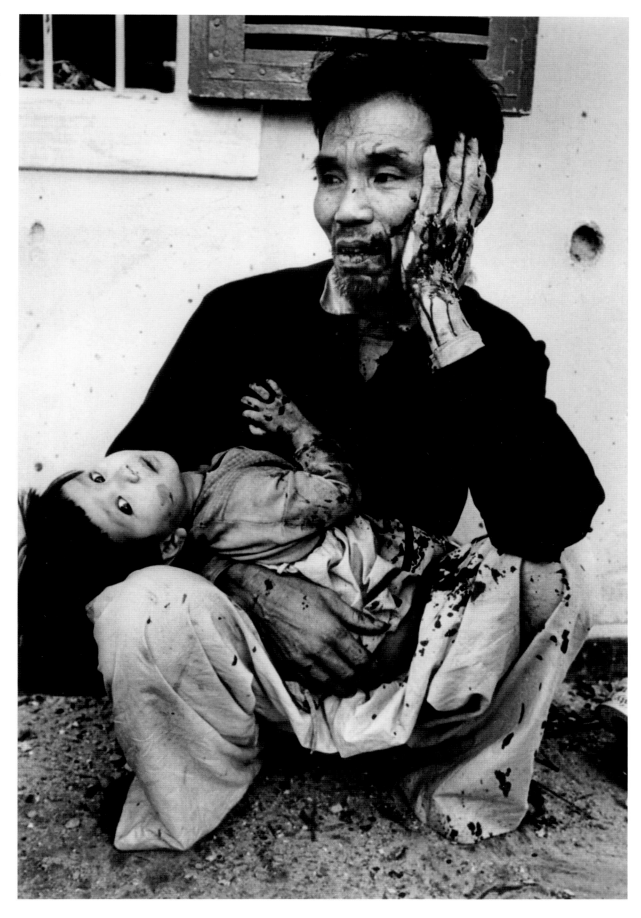

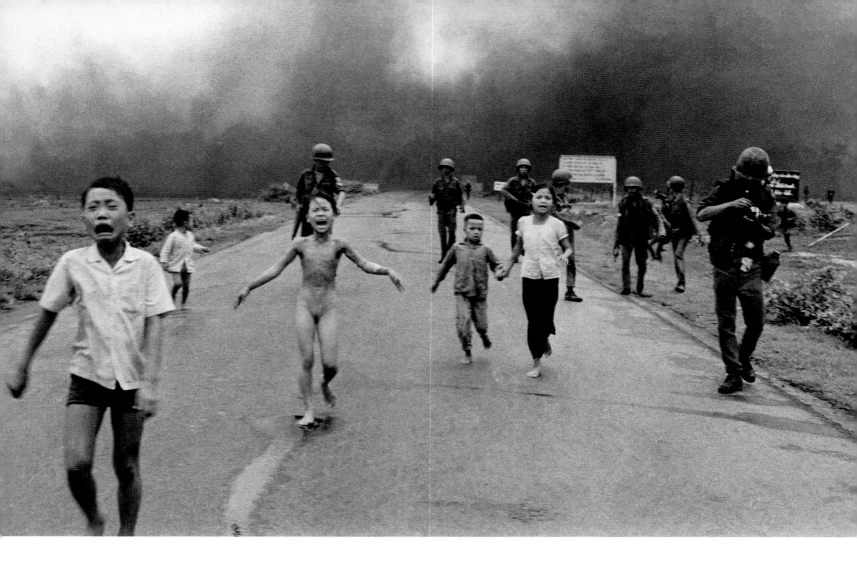

Television brought the brutalities of war into the comfort of the living room. Vietnam was lost in the living rooms of America — not on the battlefields of Vietnam.

Marshal McLuhan, soon after the fall of South Vietnam in April 1975

Terrified South Vietnamese children fleeing after napalm has been dropped accidentally on their homes, 1972. Nine-year-old Kim Phuc has stripped off her burning clothes and screams 'Too hot, please help me' to the Vietnamese photographer 'Nick' Ut. The soldiers in the background are South Vietnamese. Having taken his photograph, Ut made sure Kim received medical care. She had seventeen transplants and other operations. The photograph won a Pulitzer prize and is one of the most iconic war images of all time.

Hung Cong 'Nick' Ut

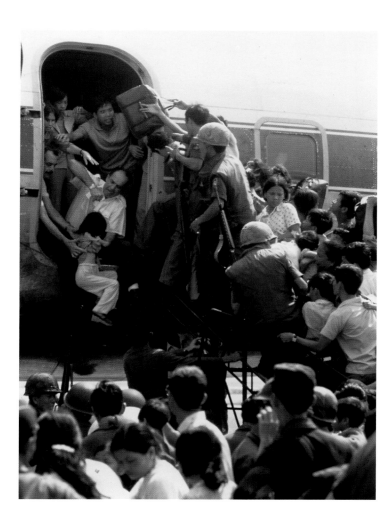

James Fenton witnessed the scenes of panic and chaos in Saigon as hundreds of civilians sought to escape on one of the last evacuation missions out of the city before the country fell to the North Vietnamese.

Before too long the large helicopters, the Jolly Green Giants, began to appear, and as they did so the mood of the city suffered a terrible change. There was no way of disguising this evacuation by sleight-of-hand, or, it appeared, of getting it over quickly. The noise of the vast helicopters, as they corkscrewed out of the sky, was a fearful incentive to panic ... All over Saigon there were people who had been promised an escape. There were others, like the officers of the morning, who thought that they would definitely die. And there were others still who for no definite reason went into a flat spin. Always the beating of the helicopter blades reminded them of what was happening. The accumulated weight of the years of propaganda came crashing down upon a terrified city ...

Although the last helicopter was just now leaving, people still thought there were other chances of getting out. One man came up to me and asked confidentially if I knew of the alternative evacuation site. He had several plausible reasons why he was entitled to leave. Another man, I remember, could only shout, 'I'm a professor, I'm a professor, I'm a professor,' as if the fact of his academic status would cause the Jolly Green Giants to swoop down out of the sky and whisk him away.

Two views of Cambodia as it succumbed to corruption and civil war before finally being subjected in 1975 to the Khmer Rouge terror in which two million Cambodians died in the Killing Fields and elsewhere.

Everyone knew in their bones that Lon Nol had lost the war: the unscrupulous generals in their Mercedes; the cyclo-drivers carrying the wounded to hospital; the blind soldier-minstrels wandering the street; the legless cripples; the fortune-tellers; the women grappling with unaffordable food prices; the shop-keepers; the soldiers; the bargirls. When lightning split the spire of the shrine on the tip of the little Phnom hill, the fortune-tellers said it was a bad omen. Phnom Penh had changed, too: the old French bars were replaced by brash haunts covered in rabbit wire, as in Saigon.

Jon Swain, *River of Time*, 1995

In 1973, I started to see that war was changing Cambodia into a strange and sinister country, quite different from anywhere else in Indo-China. The old charm and insouciance were still apparent but there were intimations of horror and savagery ... The army was troubled by astral events, particularly an eclipse of the sun, which the troops regarded as a giant toad, and attacked with millions of shots. Another aspect of the Cambodian character made itself known in the much publicised photograph of a smiling government soldier clutching in each hand the severed head of an enemy. Slowly the journalists came to suspect that the Khmer Rouge might turn out to be very much nastier than the Vietnamese Communists.

Richard West, *War and Peace in Vietnam*, 1995

To preserve you is no benefit, to destroy you is no loss.

Khmer Rouge slogan

Cambodia
One of Lon Nol's Cambodian soldiers rescuing a wooden carving of the Buddha from a village temple destroyed in fighting with the Khmer Rouge, 1974. The photographer, Sou Vitchith, along with his wife and family, took refuge in the French Embassy when Phnom Penh fell in April 1975 but were forced out by the Khmer Rouge. They began walking along Routes 5 and 6 towards the Killing Fields, where Vitchith died.
Sou Vitchith

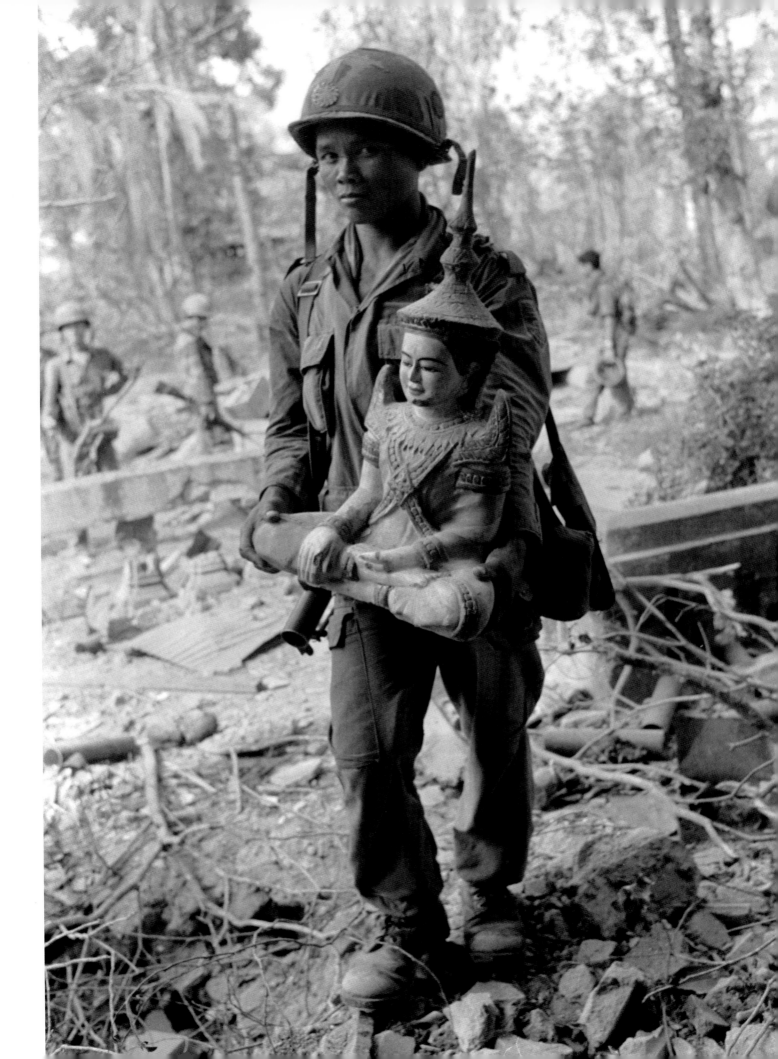

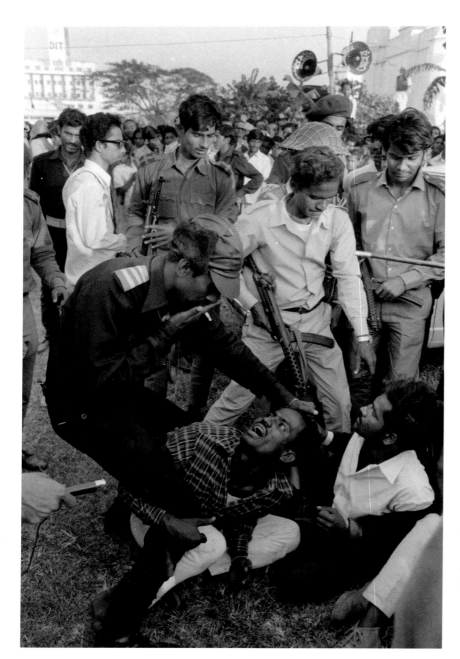

Bangladesh

In December 1971 Bangladesh (East Pakistan) won its independence, with India's help, from the rest of Pakistan, but only after a million of its people died. The day following victory, at a rally to celebrate the new nation, four bound prisoners, local militia who had been under Pakistan's command and were accused of rape and murder, were tortured with lighted cigarettes before being repeatedly bayoneted by Bangladeshi guerillas, in such a way as to delay death as long as possible. It took almost an hour before the crowd ended it by trampling all over them. These controversial photographs shocked the world and caused Mrs Gandhi, the Indian Prime Minister, to bring pressure to bear on the new state of Bangladesh to stop such incidents.

Horst Faas/ Michel Laurent

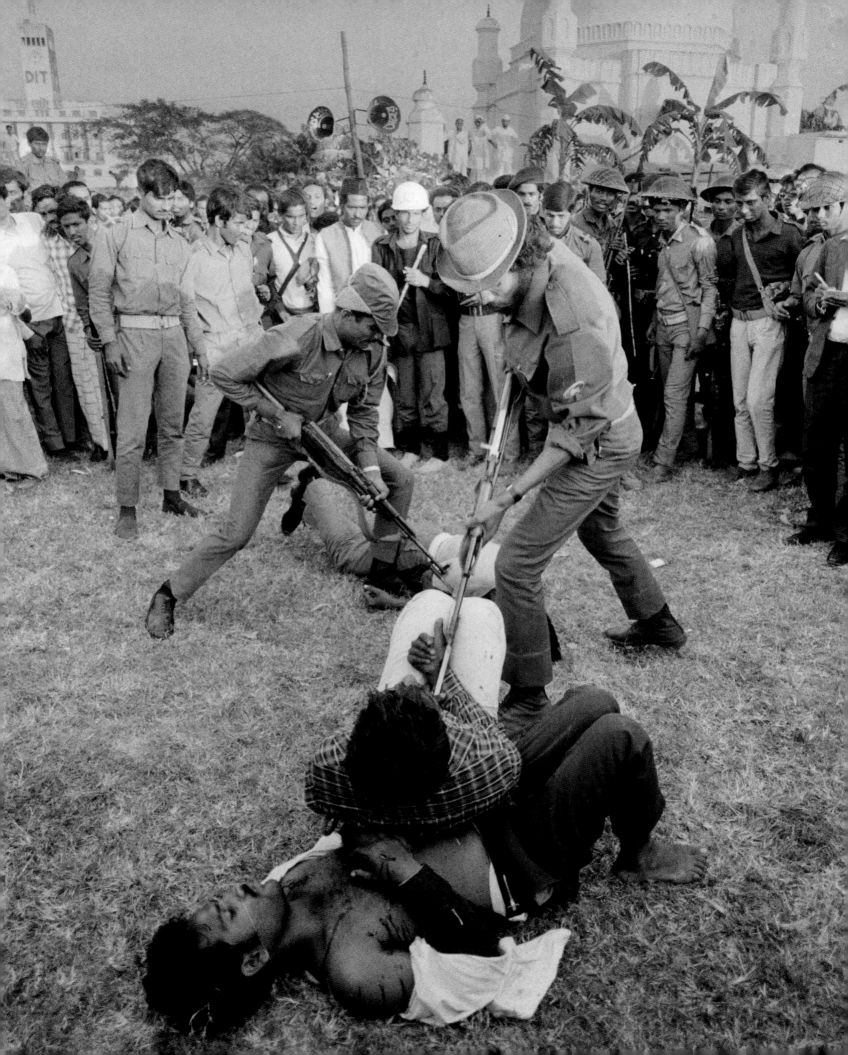

Cuba

A young guerrilla follower of Fidel Castro speaks to an elegant citizen of Havana in 1959, as the revolutionaries take over control of the city, and of Cuba, from the dictatorship of Fulgencio Batista. The US government was actively encouraging Castro at this stage. She appears to be wearing a handkerchief embroidered with the Communist hammer and sickle.

Burt Glinn

Chile

President Allende of Chile emerges from his palace, surrounded by bodyguards and armed with the gun given to him by Castro, on 11 September 1973, during General Pinochet's putsch. Allende was dead by the end of that day.

In March 1972 speculation about the arrival of 13 heavy crates from Havana, addressed personally to the President, provoked Allende into disclosing that they contained mango-flavoured icecream ... The crates had in fact been crammed with Czech weapons which went to the private arsenal Allende stored at his residence up in the Andes.

Alistair Horne, *Small Earthquake in Chile*, 1972

[Pinochet's] tanks opened fire, the black berets of Allende's Grupo de Amigos Personales (GAP) returned the fire, in which El Compañero Presidente is said to have participated — with the sub-machinegun his friend Fidel Castro had given him [and which he later used to commit suicide].

Alistair Horne, *Small Earthquake in Chile*, 1972

El Salvador

● *Overleaf:* The Salvadorean army has carried wounded soldiers to a village football pitch to be evacuated by helicopter in 1984. Girls, dressed for church, come down to watch.

James Nachtwey/VII

Nicaragua

A small tank left as a monument in a park in Managua, the capital of Nicaragua, is put to good use by a child in 1983. It had belonged to the dictator Anastasio Somoza's National Guard, defeated by the Sandinista revolutionaries.

James Nachtwey/ VII

A bodyguard of Commander Zero, a former Sandinista hero now fighting against them, is carried to the tree line after being shot in the stomach, 1984.

James Nachtwey/ VII

The Falklands

A British paratrooper 'yomping' – footslogging – on Sussex Mountain prior to the Goose Green attack, May 1982. Britain and Argentina had gone to war over the Falklands, a group of tiny islands in the South Atlantic. The seventeen British correspondents who received accreditation were issued with a Ministry of Defence booklet advising them that they would be expected to 'help in leading and steadying public opinion in times of national stress or crisis'. Max Hastings said: 'Most of us decided before landing that our role was simply to report as sympathetically as possible what the British forces are doing here today', before going on to quote his father, a noted war correspondent in the Second World War, 'When one's nation is at war, reporting becomes an extension of the war effort'.

Robert Fox describes the liberation of Goose Green for the BBC, 30 May 1982.

The surrender came after a fourteen-hour battle the previous day. It began before dawn — a full battalion assault on an enemy twice as numerous as expected, almost 1500 in all and very well dug in. The attack began under naval gunfire, and shells lit the sky as the Paras moved forward. But in the daylight they were on their own, covered only by guns and mortars. The enemy were falling back slowly to prepared positions. At each post their own mortars had been ranged perfectly. Time and again we were pinned down by fire from mortars and anti-aircraft guns. I was with the battalion headquarters, and if we were within ten feet of death from shrapnel and shells once, we were there forty times.

Around mid-morning we were pinned down in a fold in the land by mortar fire when the first prisoners and casualties came in. The prisoners made a pathetic sight, looking for their own dead and preparing them for burial. This was interrupted by an air attack from Pucara aircraft. As they swung across the sky every firearm available opened up to no effect, and the two planes shot down a Scout helicopter just beyond our ridge. In mid-afternoon we were again pinned down by mortar fire among some gorse bushes.

We were told that the commanding officer, Lt-Col. H. Jones, always known as 'H', had been shot by machine-gunners as he led an attack against machine-gun nests which had held up the battalion for over half an hour ... 'He was the best, the very best,' said Staff Sergeant Collins. In the evening they brought his body down from the hillside, a soldier walking in front, his weapon pointed to the ground. The silhouette of this silent ceremony the most indelible image of the day.

I counted them all out and I counted them all back.

Brian Hanrahan, BBC broadcast, 1982, in reference to the carrier-borne Harrier fighter planes of the British task force

Into the middle of this crowd [of Belgian civilian refugees in the Congo in 1960] strode an unmistakably British TV reporter, leading his cameraman and sundry technicians like a platoon commander through hostile territory. At intervals he paused and shouted, in a stentorian but genteel BBC voice, 'Anyone here been raped and speaks English?'

Ed Behr, *Anyone Here Been Raped and Speaks English?*, 1981

The Congo represented true anarchy. [You drove down an empty road] not knowing whether the soldiers at the next roadblock round the corner were going to wave you on, beat you up, shoot, or even eat you.

John de St Jorre, *The Nigerian Civil War*, 1975

The Congo
Congolese troops, commanded by Colonel Mobutu, the future dictator of Congo/Zaïre, taunt captive followers of the radical Patrice Lumumba, before killing them.
Don McCullin

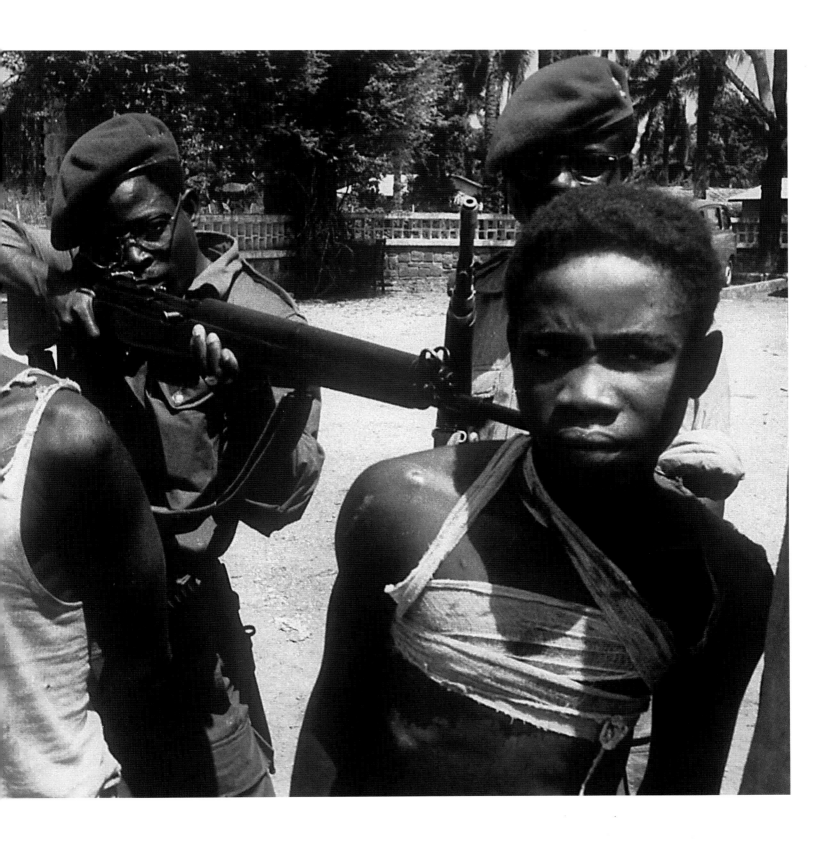

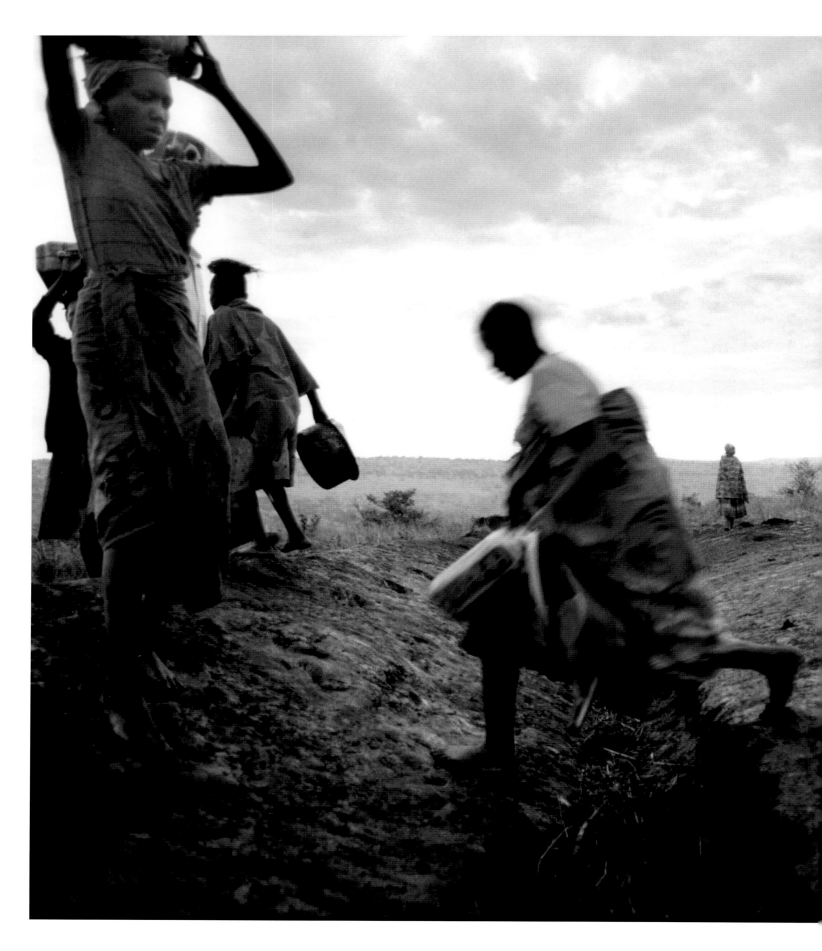

Rwanda

A Rwandan refugee camp near the border of the country, 1994.

Gilles Peress

Journalist Philip Gourevitch on the Rwandan genocide of 1994.

Although the killing was low-tech — performed largely by machete — it was carried out at dazzling speed: of an original population of about 7.5 million, at least 800,000 people were killed in just 100 days ... The dead of Rwanda accumulated at nearly three times the rate of Jewish dead during the Holocaust. It was the most efficient mass killing since the atomic bombings.

A Tutsi who survived the massacre describes the Hutus' method of killing in an interview with Gourevitch.

They saved bullets and killed us with bamboo spears. They cut Achilles tendons and necks, but not completely, and then they left the victims to spend a long time crying until they died. Cats and dogs were there, just eating people.

To kill Rangers you had to make them stand and fight. The answer was to bring down a helicopter. Part of the Americans' false superiority, their unwillingness to die, meant they would do anything to protect each other, things that were courageous but also foolhardy. Aidid and his lieutenants knew that if they could bring down a chopper, the Rangers would move to protect its crew. They would establish a perimeter and wait for help. They would probably not be overrun, but could be made to bleed and die.

Mark Bowden, *Black Hawk Down*, 2000

Somalia

An image that shocked America: the naked corpse of a US serviceman exposed in the streets of Mogadishu in Somalia in October 1993 while the crowd chant 'Victory, victory. Look at the white, look at the American.'

Keith Burnstein

US Marines search for a suspected sniper in Mogadishu, December 1992. US forces, sent into Somalia to stop looting of UN supplies by local gangs, found the streets of the capital impossible to police.

Christopher Morris/ VII

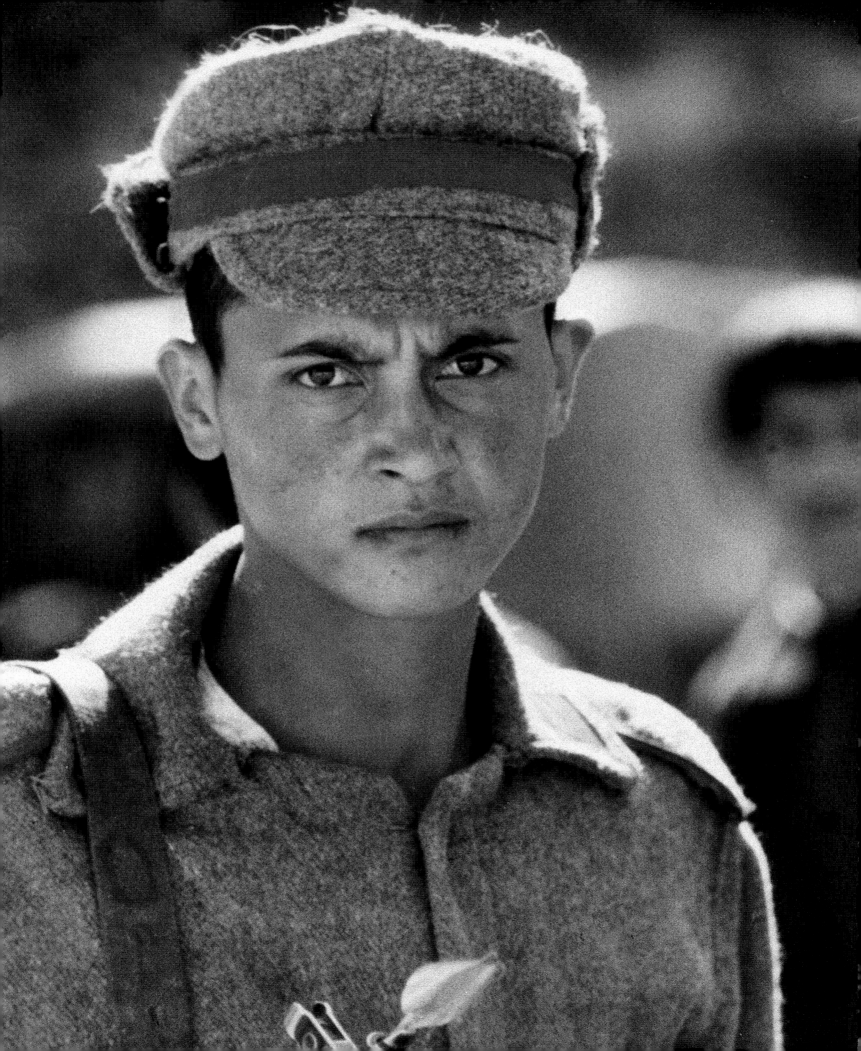

8. | Conflicts of Faith 1948 – 2003

NO MODERN NATION has fought so many wars in such a short time as Israel. This new, tiny state, established in 1948 with the ending of the British Palestinian mandate under the League of Nations, its population swollen as Jews from all over Europe sought a homeland, was immediately attacked by its Arab neighbours. But the Arab nations were far from united and Israel was fighting for its very existence. The result was an enlargement of the original Israeli boundaries and the beginning of a bitter struggle between Arab and Jew that has lasted into the 21st century.

Eight years later, Britain and France attacked Egypt over the seizure by President Nasser of the Suez Canal. Israel joined the war and captured Sinai and the Gaza Strip but withdrew after the entry of a United Nations force. Eleven years later, fighting between the Arabs and Israel broke out again, the so-called Six-Day War. Again Israel was victorious, capturing the Golan Heights from Syria, Old Jerusalem and the West Bank from Jordan, and occupying the Gaza Strip and Sinai Peninsula as far as the Suez Canal. This time only six years passed before the Arabs and Israelis were again at war. In October 1973, the Arabs attacked on the Day of Atonement, Yom Kippur, and, taking Israel by surprise, crossed the Suez Canal, while the Syrians in the north advanced into the Golan Heights. The Israelis counter-attacked and regained the territory in the course of the next two or three weeks.

Palestinian guerrillas based in Lebanon carried out raids on Israel from the early 1970s, so in June 1982 Israeli forces launched a full-scale invasion and occupied West Beirut. They stayed three years and then withdrew without any real gain for losses suffered.

These are only the formal wars between the Israelis and the Arabs. As well, an almost non-stop, low-intensity war has been fought between Israelis and Palestinians. Shootings and suicide bombings by the Palestinians, retaliation and collective punishment by the Israelis, riots, demolitions and political assassinations have marked this apparently never-ending war. Its very length means that all the best journalists from all over the world, people like writer Robert Fisk and photographers Don McCullin and James Nachtwey, have at one time or another covered the story.

But it was not always Arab versus Israeli in the Middle East. In 1980 war broke out between Iran and Iraq when the Iraqi leader, Saddam Hussein, accused Shia Iran of encouraging the Shia majority in Iraq to rebel. The fighting, which lasted eight years, resembled the First World War: it was marked by offensive and counter-offensive, with human waves charging fixed positions, interspersed by long periods of stalemate; poison gas was used; and about one million people died. The outcome was inconclusive. During the war, the United States made secret arms shipments to Iran but later gave military intelligence support to Iraq, factors that became relevant in the First Gulf War two years later, when Iraq invaded and occupied Kuwait. Saddam Hussein accused the Kuwaitis of flooding the international market with low-cost oil just at a time when Iraq needed increased oil revenues to recover from the Iran–Iraq war. He believed that because the United States had tilted towards Iraq in this war, it would tolerate his action. When Iraq ignored a United Nations resolution to pull out of Kuwait, a coalition of nations led by America attacked.

It was a strange war. Three television correspondents – John Simpson of the BBC, Peter Arnett of CNN

and Brent Sadler of ITN – reported the bombing of Iraq from the enemy capital, Baghdad. Their vivid film of night skies alight with explosions and the exhaust flames of missiles, interspersed with breathless commentary, gripped Western viewers. The ground war was a walk-over for the Allies that left an estimated 250,000 Iraqis dead, most killed from the air. Photographs and TV film showing incinerated bodies were not widely published; not a single newspaper in the United States would print the photograph on page 254 and only TV stations in Japan would use the film.

In 2003 another coalition led by the United States and Britain was back in the Gulf, attacking Iraq for a second time. It accused Saddam Hussein of developing weapons of mass destruction, sponsoring terrorism and refusing to disarm. The Coalition announced that it would disarm Saddam Hussein by force and liberate the Iraqi people from his despotic rule. The precedent for attacking a country to improve the lot of its people had been set in 1999, when NATO announced that it could not stand by and see Serbia 'ethnically cleanse' Kosovo of its Muslim population, and so bombed Serbia into submission and a change of government. This was the fourth and final episode in the protracted death-agony of former Yugoslavia, after the breakaway of Slovenia and the wars in Croatia and Bosnia.

In the Second Gulf War the ground campaign was again an easy victory for the Coalition, the Iraqi forces melting away in the face of fast-moving, high-technology attacks. The war had grown out of the Al Qaeda terrorist bombing of New York's Twin Towers on 11 September 2001 and the subsequent attack led by America on Afghanistan, which it accused of harbouring these terrorists. Both the fighting in Afghanistan and the Second Gulf War were notable for the intensity of the media coverage: thousands of journalists, TV and radio reporters and photographers turning up to provide round-the-clock news to a fascinated world. Another development marked both wars – the arrival on the scene of Arab TV, which broke the monopoly of TV war news long held by the Western networks.

Viewers noticed that this changed the nature of what images were seen. Arab TV had no inhibitions about showing war dead and this forced the Western media to be franker in exhibiting the real face of battle. But the most striking visual image of the war was the destruction of the large bronze statue of Saddam Hussein in Fardus Square *(see page 282)*, central Baghdad, opposite the hotel where the international press corps was staying. In an information war heavy with symbolism, the toppling of the statue marked the end of the Iraqi leader and the Coalition's victory. It was also a lesson in the power of the media. Without the presence of the camera, the event would have meant nothing.

Donald McCullin, probably the greatest war photographer of the age, once spent months in the darkroom of his country cottage, going through thousands of negatives from dozens of wars, choosing the best and printing them, seeing out of the wash and fumes of chemicals, his own life slowly emerge in the faces of the soldiers he had photographed. 'It was like *All Quiet on the Western Front*,' he recalled. 'Men marching through the mist. Men I'd seen killed came up out of the mist of war to join me.'

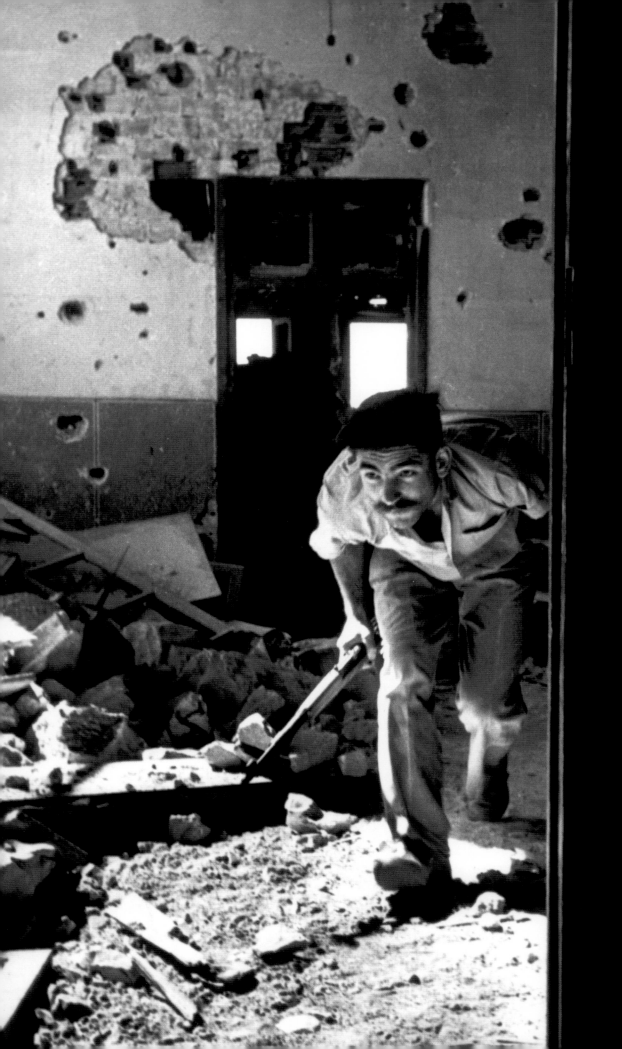

A Jewish sniper runs crouching to a new position in the fighting against Palestinians and forces from the surrounding countries as the new state of Israel is established.

Robert Capa

Crowds celebrate in the streets of Tel Aviv as Israeli independence is declared on 14 May 1948. The next day, as the British withdrew, the Arab armies invaded, the old City in East Jerusalem being surrendered by the Israelis to King Abdullah of Jordan's Arab Legion on 28 May.

Robert Capa

James Cameron describes David Ben Gurion declaring Israel's independence, 14 May 1948.

His white woolly halo danced, his face glistened in the heat, his eloquence mounted to a Hebraic fervour; he was speaking for Joshua and David, Nehemiah and Ezra the Writer, for the fugitives from the Crusaders and Saladin and Spain, for the survivors of Dachau and Ravensbruck, for the sabra Yishuv who had drained the Hulah swamps, the founders of Rehovot, the builders of Tel-Aviv itself, for the immigrant bus-drivers and the waiters in the cafés of Dizengoff Square, and those who were yet to come.

'Therefore by virtue of the natural and historic right of the Jewish people to be a nation as other nations, and of the Resolution of the General Assembly of the United Nations, we hereby proclaim the establishment of the Jewish nation in Palestine, to be called the Medinat Yisrael: the State of Israel.' ... It had taken exactly thirty-two minutes. Plus, of course, 2000 years.

Algeria

Suspected members of the ALN, the Algerian rebel army, are led away by French soldiers in May 1957.

Mark Flament

The body of an ALN soldier electrocuted on the Morice Line, the fence erected by the French on the border between Algeria and Tunisia to prevent the infiltration of rebel forces. It was two hundred miles long and was charged with 5000 volts, as well as having mines on either side. The ALN lost 6000 men directly and indirectly because of it in the seven months after its completion in September 1957.

M. Vandy

The only possible negotiation is war ... Algeria is France. And who among you ... would hesitate to employ every means to preserve France?

François Mitterand, November 1954

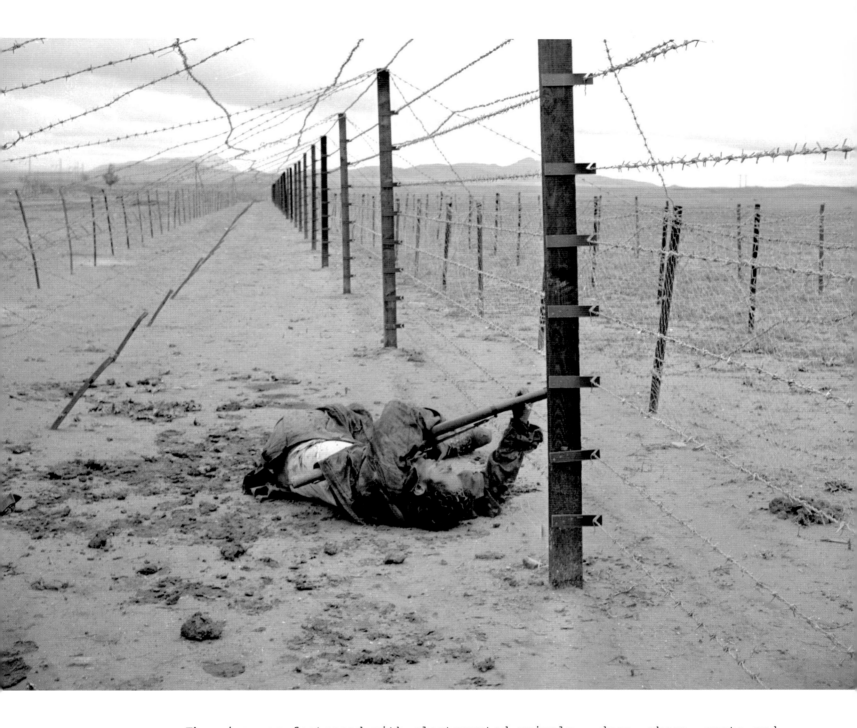

The wire was festooned with electrocuted animals — dogs, sheep, goats and even occasionally a pathetic little donkey. The German Foreign Legionnaires were particularly distressed at the sight of the handsome Alsatian tracker dogs electrocuted by the wire.

Alistair Horne on the Morice Line

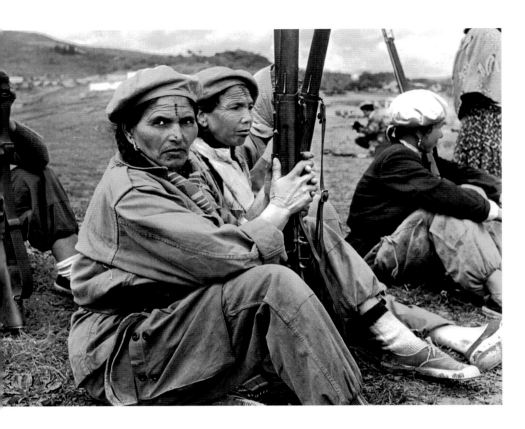

Alistair Horne describes the fate of the Harkis after Algerian independence, 1962.

```
Hundreds died when put to work clearing the
minefields along the Morice Line, or were shot
out of hand. Others were tortured atrociously;
army veterans were made to dig their own tombs,
then swallow their decorations before being
killed; they were burned alive, or castrated,
or dragged behind trucks or cut to pieces and
their flesh fed to dogs ... Estimates of the
numbers thus killed vary wildly between 30,000
and 150,000.
```

A group of women *Harkis*, Algerians recruited by the French to fight against their fellow countrymen. Their gruesome fate after the French withdrew in 1962 is described above.

M. Kierzkowski

French troops trudge across the dunes of the Sahara in pursuit of an Algerian company from the French Camel Corps who have just deserted.

Mark Flament

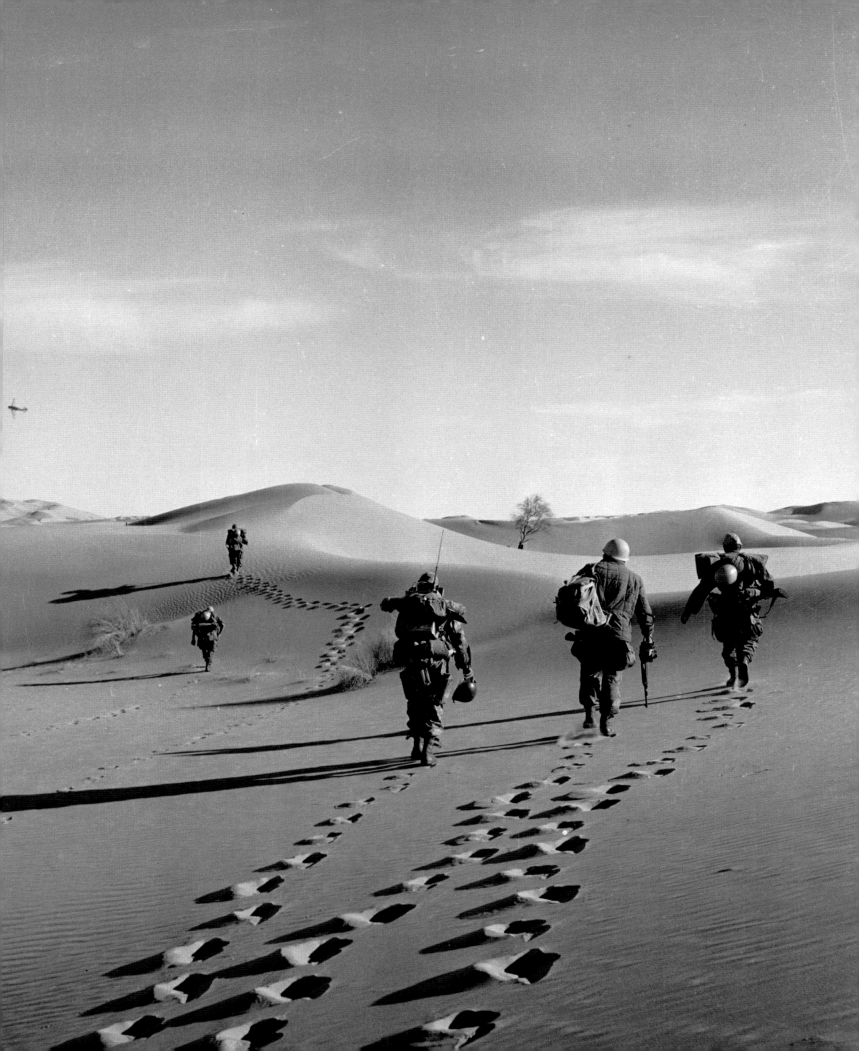

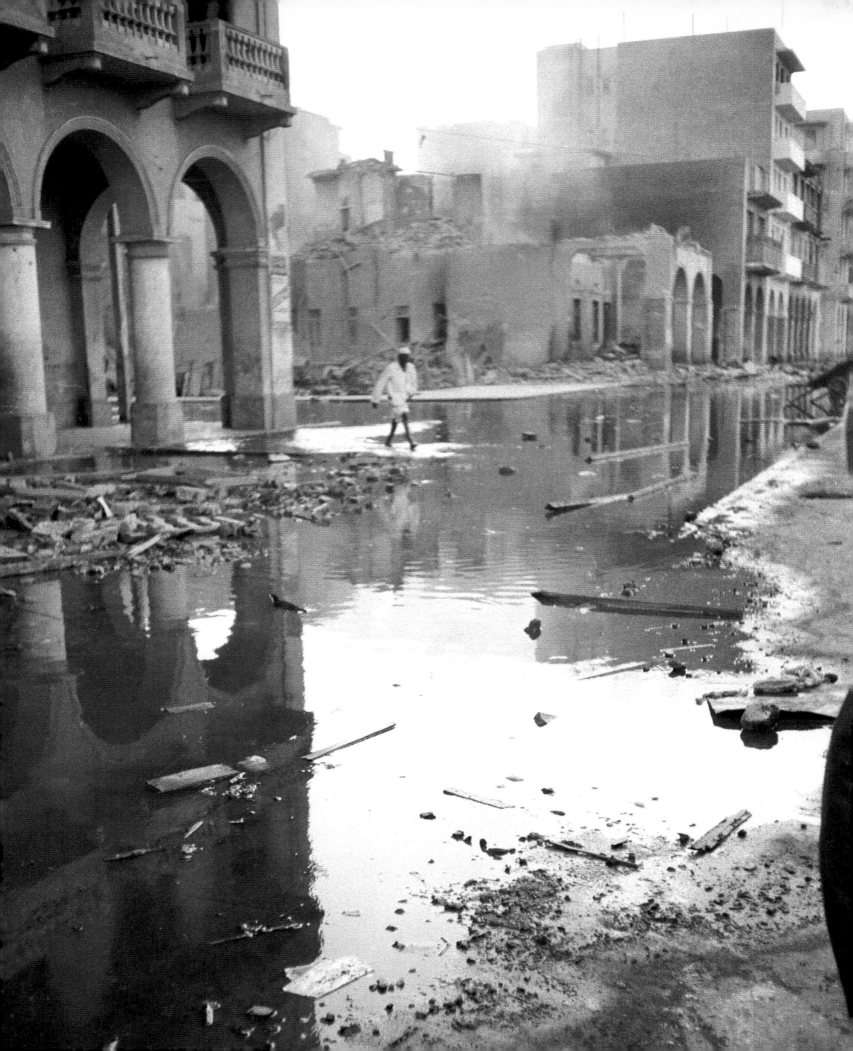

Suez

Port Said in Egypt, after attack from the air and seizure by the Franco-British invasion force in November 1956. The excuse for the invasion was to stop the fighting between the Israelis and Egyptians. But in reality the French and British were in collusion with Israel and wanted to get back control of the Suez Canal, recently nationalized by President Nasser of Egypt.
David Seymour

Frightened Arab children watch Israeli troops move through El Arish on the Mediterranean coast road going westwards towards the Suez Canal on 31 October 1956.
Burt Glinn

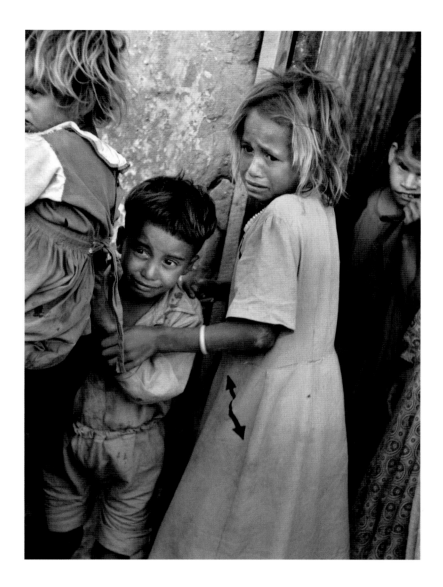

The captain had a radio set on the bridge tuned to the BBC and we heard a bland voice announcing that all resistance had ceased in Port Said. It was just then when with a great scream that froze me in terror, a section of naval fighter-bombers dived down over us dropping their rockets and firing their cannon just ahead of us. Almost quicker than sight they wheeled away into the sky while clouds of grey smoke rose into the air. We were all silent on the bridge for a minute or two. This was the attack by Sea Furies on Navy House where 40 Commando had encountered tough resistance from a hundred-odd Egyptians who had barricaded themselves in. Even the tanks, firing at point-blank range, had been unable to dislodge them so the Navy was called in to help with an air-strike. The Navy complied, but with some regret for the building had become over the years part of the Royal Navy's heritage. Even after this devastating attack, however, the Egyptians fought on and a Marine officer told me they had to clear them out room by room. 'They didn't know how to fight professionally,' he said to me. 'But by God they fought to the end.'

Donald Edgar, *Express '56*, 1957

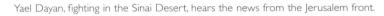
Yael Dayan, fighting in the Sinai Desert, hears the news from the Jerusalem front.

[Wednesday 7th June] A few minutes later we heard the sentence which shook us all — The Old City of Jerusalem is ours.

Did I say fatigue? Minefield, late night, Sinai desert — all disappeared. Suddenly there was the Temple Mount and the Wailing Wall and a heart too small to contain the thought. Was it joy that brought tears from the toughest soldiers? Pride? Sense of history? Religion? All I know is that this brilliance was cried out, and it sparkled like electricity from convoy to convoy.

Six-Day War
Israeli troops pray at the Wailing Wall in East Jerusalem, newly liberated from the Jordanians in the Six-Day War, June 1967. The Israelis were also fighting the Egyptians in the Sinai Desert.
Micha Bar Am

The fact that the surprise attack had taken place on Yom Kippur facilitated the mobilization of Israel's reserves, as most of them were either in the synagogues at prayer or at home. Thus a nation at prayer rushed to units and assembly areas, changing prayer shawls for battle kit on the way. Israel was again fighting for its existence.

Chaim Herzog, *The Arab-Israeli Wars*, 1980

Yom Kippur War

On the second day of the Yom Kippur War, 8 October 1973, Israeli women soldiers say goodbye to their comrades before being evacuated from a frontline camp. It was not yet the policy for them to fight alongside the men. In this war, Israel was attacked by Egypt and Syria.

Leonard Freed

Both sides had fought to a standstill ... but suddenly
a report came in ... that the Syrian supply trains were
turning round and withdrawing. The Syrian attack had
been broken ... The remnants of the 7th Brigade, including
Yossi's reinforcements, totalled some twenty tanks.
Exhausted, depleted to a minimum, many wounded, with their
tanks bearing the scars of war, they now began to pursue the
Syrians, knocking out tanks and armoured personnel carriers
as they fled. On the edge of the anti-tank ditch, they
stopped: the brigade had reached the limits of human
exhaustion.

Chaim Herzog, *The War of Atonement*, 1975

An Israeli tank unit, driving forward into
Syria after the close-fought battle on
the Golan Heights, described in the
accompanying extract, pauses and a
soldier takes the opportunity to say his
devotions draped in his prayer shawl,
16 October 1973.
Leonard Freed

Lebanon

A Christian Phalangist gunman in the streets of Beirut during the Lebanese Civil War in 1978. The delicate balance between the country's Maronite Christian and Muslim inhabitants had been upset by the arrival of great numbers of Palestinian refugees expelled from Jordan by King Hussein in September 1970, and fighting began in 1975. Christopher Morris, a BBC television reporter in Beirut, explained, 'Not only is everyone armed ... but they are armed with sophisticated weapons which they use unpredictably ... It's easy to get killed – no difficulty whatsoever.'

Raymond Depardon

What we found inside the Palestinian Chatila camp at ten o'clock on the morning of 18 September 1982 did not quite beggar description, although it would have been easier to retell in the cold prose of a medical examination. There had been massacres before in Lebanon, but rarely on this scale and never overlooked by a regular, supposedly disciplined army. In the panic and hatred of battle, tens of thousands had been killed in this country. But these people, hundreds of them, had been shot down unarmed ... We might have accepted evidence of a few murders; even dozens of bodies, killed in the heat of combat. But there were women lying in houses with their skirts torn up to their waists and their legs wide apart, children with their throats cut, rows of young men shot in the back after being lined up at an execution wall. There were babies — blackened babies because they had been slaughtered more than twenty-four hours earlier and their small bodies were already in a state of decomposition — tossed into rubbish heaps alongside discarded US army ration tins, Israeli army medical equipment and empty bottles of whisky ... There were cartridge cases across the main road. I saw several Israeli flare canisters, still attached to their tiny parachutes. Clouds of flies moved across the rubble, raiding parties with a nose for victory.

Down a laneway to our right, no more than fifty yards from the entrance, there lay a pile of corpses. There were more than a dozen of them, young men whose arms and legs had been wrapped around each other in the agony of death. All had been shot at point-blank range through the cheek, the bullet tearing away a line of flesh up to the ear and entering the brain. Some had vivid crimson or black scars down the left side of their throats. One had been castrated, his trousers torn open and a settlement of flies throbbing over his torn intestines.

The eyes of these young men were all open. The youngest was only twelve or thirteen years old. They were dressed in jeans and coloured shirts, the material absurdly tight over their flesh now that their bodies had begun to bloat in the heat.

Robert Fisk, *Pity the Nation*, 1990

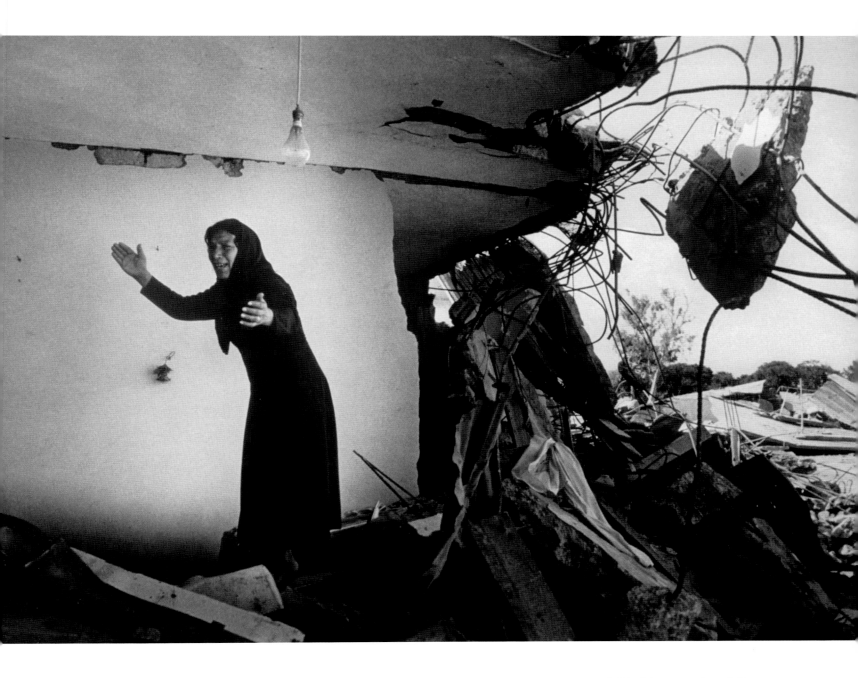

A Palestinian woman bewails the
destruction of her home in Sabra
refugee camp, Beirut, September 1982.
Following the full-scale Israeli invasion of
Lebanon in June 1982, it, like Chatila
camp, was attacked by Phalangist
Lebanese-Christian allies of the Israelis
and many of the inhabitants massacred.
Don McCullin

A Lebanese-Christian gunman stands guard on a Beirut street corner in 1978, an image of the Virgin Mary taped to the butt of his rifle.

Raymond Depardon

In 1983 Israel withdrew from all but a five-mile deep border security zone in Lebanon. Here Shia gunmen, probably members of the Iranian-backed Hezbollah, celebrate the release of prisoners by Israel at that time.

Chris Steele-Perkins

Chechnya

A young Chechen boy-soldier in the streets of Grozny, capital of Chechnya, in January 1995.

Christopher Morris/ VII

A Chechen soldier flees from the presidential palace in Grozny, in January 1995, under fire from the Russians. Russian troops had entered the break-away republic in the North Caucasian Mountains that month and were not withdrawn until two years – and 80,000 lives – later.

Christopher Morris/ VII

Grozny was not some small half-baked provincial town of the Third
World; it was a large industrial city, the second-biggest oil-
refining centre of the world's biggest oil-producing country, and
formerly the world's second biggest industrial power.

Down the torn-up, muddy roads roared Russian armoured personnel
carriers, like giant grey female woodlice covered with babies —
their infantry crews. The Chechens looked down as they passed. As
one of them told me, 'during the battle in the city, if the men on
the APCs saw someone on the street, they'd shoot at them like
game. They don't do that now, unless they're very drunk, but if
they don't like the look of you, they will stop and arrest you,
or maybe just beat and rob you.'

Anatol Lieven, *Chechnya: Tombstone of Russian Power*, 1998

Afghanistan

● *Overleaf:* A Russian tank and armoured personnel carrier drive through Kandahar in Western Afghanistan, sometime during the Red Army's last war, 1979–89. Like the British in the nineteenth century, the Russians discovered to their cost that Afghanistan was no place to fight a conventional war.

Grachtchenkov

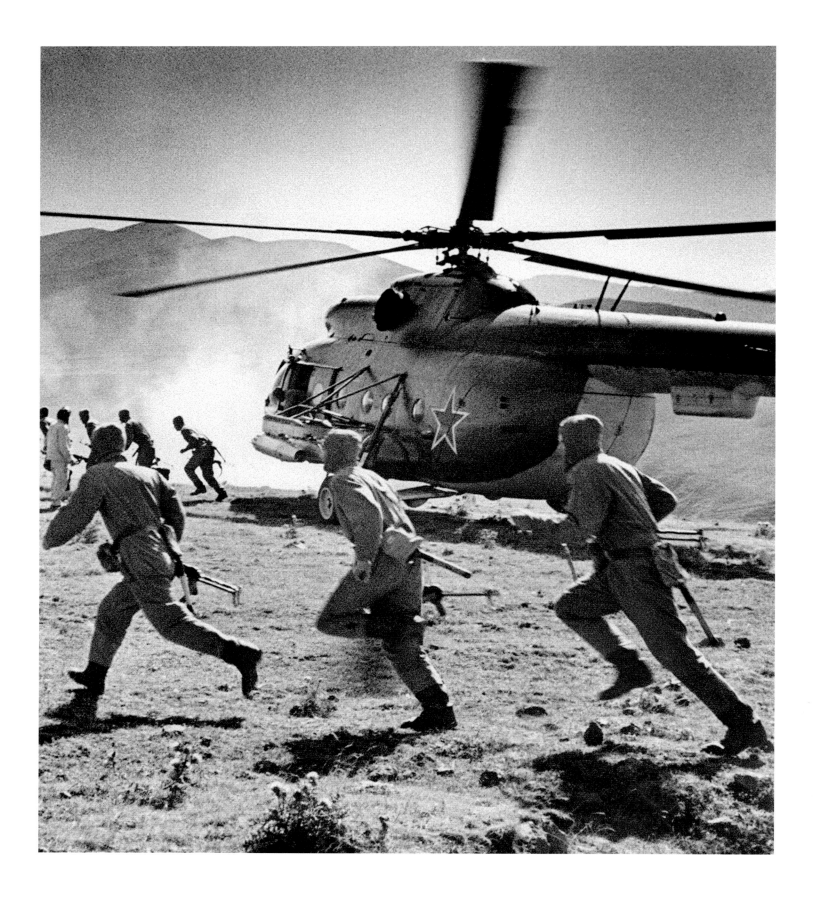

Helicopter-borne Russian troops at the double after being dropped somewhere in the Afghanistan mountains during 1989, the last year of the war.

Alexi Yefimov

Among the ruins of Afghanistan's capital Kabul, battered first in the Russian war and then in faction fighting, a small boy carries a length of wood that he has found to feed the fire that heats his home and cooks his food, 1994.

Laurent Van Der Stockt

The war had its own ghastly rules: if you were photographed or if you shaved before a battle, you were dead. It was always the blue-eyed heroes who were the first to be killed: you'd meet one of those types and before you knew it, he was dead. People mostly got killed either in their first months when they were too curious, or towards the end when they'd lost their sense of caution and become stupid. At night you'd forget where you were, who you were, what you were doing there. No one could sleep during the last six or eight weeks before they went home.

Svetlana Alexiyevich, 'Boys in Zinc', *Granta*, 1990

An Iraqi soldier describes the attacks by Iranian Revolutionary Guards, ill-trained fanatical volunteers convinced they were on their way to paradise.

They came at us like a crowd coming out of a mosque on Friday. Soon we were firing into dead men, some draped over the barbed wire fences, and others in piles on the ground, having stepped on the mines.

Iran–Iraq War

Death and devastation on the southern front *(left)* during the Iran-Iraq War, 1984.
A human wave of 25,000 Iranians, many mere children or old men, attacked Iraqi tanks here at Beida. The Iraqis claimed there were only 250 survivors after the assault. An Iraqi *(right)* celebrates the reconquest of the Al Fow (Fao) peninsula at the mouth of the Shatt al Arab in 1988. The picture of Iranian leader Ayatollah Khomeini has been used as a target.

François Lochon (left)
Eric Bouvet (right)

Ayatollah Khomeini, when asked who his enemies were in Paris in 1978, replies:

First the Shah; then the American Satan; then Saddam
Hussein and his infidel Baath Party.

We are not the kind of people to bow to Khomeini. He has
wagered to bend us and we have wagered to bend him. We
shall see who will bend the other.

Saddam Hussein, 1980

Gulf War

This photo of an Iraqi soldier in a vehicle hit by a rocket on Highway 8, the road out of Kuwait back to Basra, was not deemed suitable for publication in the United States. *The Observer* newspaper published it in England and was inundated with complaints. CBS cameraman Jim Helling, who was with Jarecke, describes it as 'the face of war'.

Kenneth Jarecke

I'd seen a couple of casualties here and there in Kuwait, but the first serious bodies were on Highway 8 ... This picture has become well known, but I didn't think it was anything special when I took it. I was just one of many photographers there. I think the reason it stands out is that you can imagine the driver alive ... He is fighting to get out of his burning vehicle, and anyone looking at the photograph can understand how powerful the desire to live is.

Kenneth Jarecke

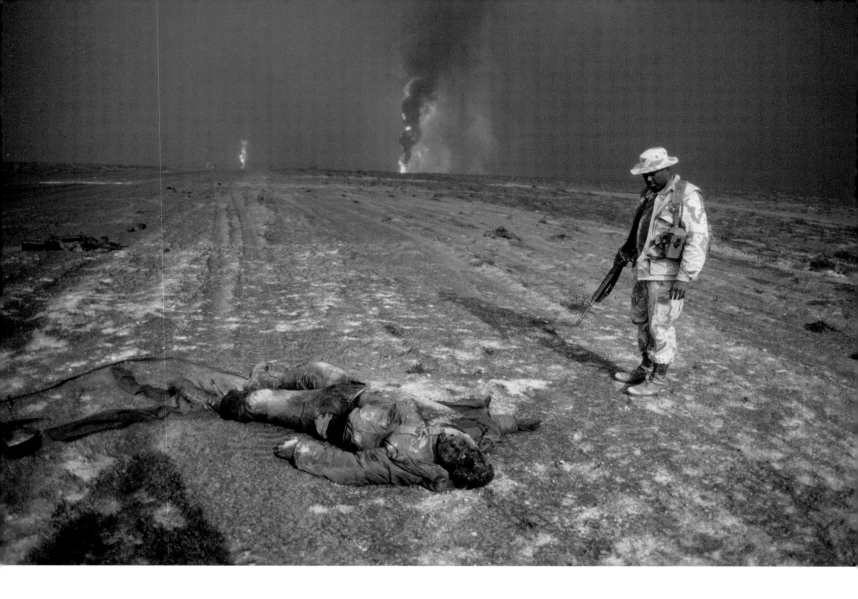

You guys are doing a great job ... Now I want to make sure you understand your mission from here on out. It is to inflict maximum destruction, maximum destruction, on the Iraqi military machine. You are to destroy all war-fighting equipment. Do not just pass it on the battlefield. We don't want the Iraqis coming at us again five years from now.

Norman Schwarzkopf

Iraqis will never forget that on 8 August 1990 Kuwait became part of Iraq legally, constitutionally and actually. It continued to do so until last night, when withdrawal began.

Saddam Hussein, 26 February 1991

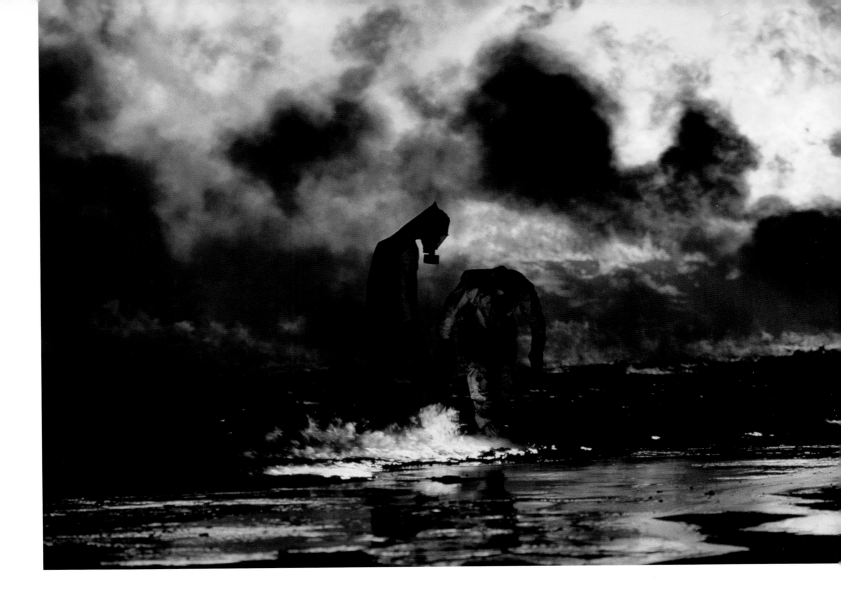

Blood on the tracks: an American Marine
inspects a charred Iraqi corpse *(left)* as
the wells of the Burgan oil field burn in
Kuwait after Iraq's defeat in the Gulf War
in 1991. Saddam Hussein had set fire to
the wells in a final act of petulant, wilful
destruction when he knew that he had
lost the war. Images such as this had
swung public opinion in the United States
against the idea of continuing the war
until Saddam was deposed. Their gas
masks making them look like praying
mantises, oilfield specialists *(above)* work
to extinguish the fires.

Bruno Barbey (left)
Steve McCurry (above)

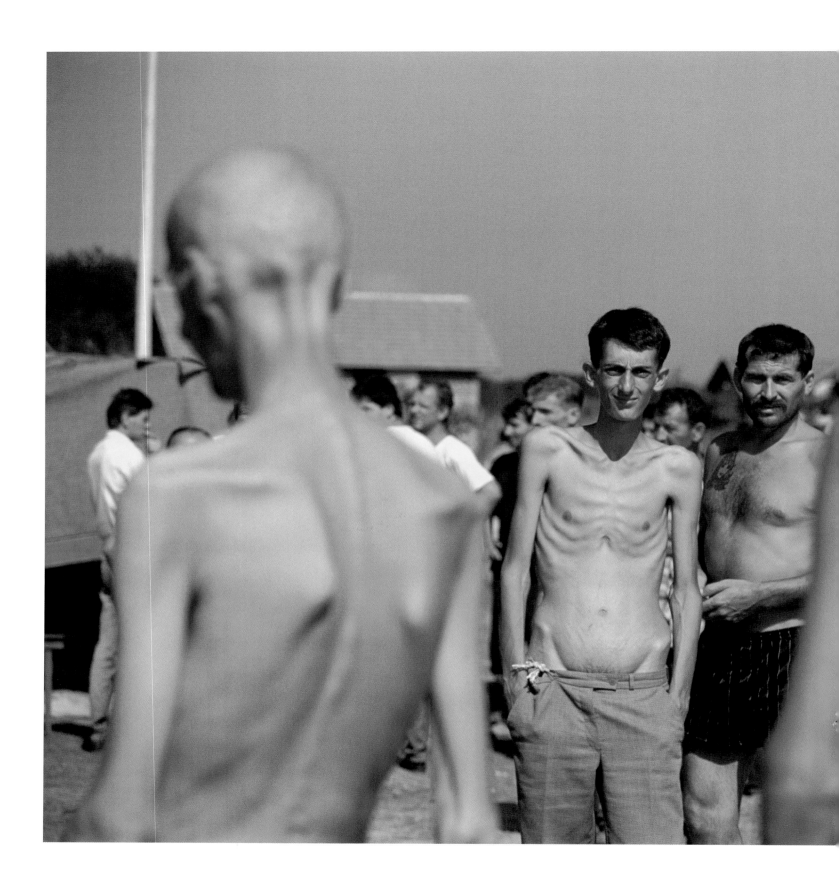

Bosnia
Bosnian Muslims, separated from their wives and children and kept prisoner by the Serbs in a camp at Trnopolje in Bosnia, summer 1992. Such pictures were early evidence of ethnic cleansing by the Serbs, unsurprisingly lending credence to the belief that they were sole aggressors in the Bosnian conflict, part of the ongoing disintegration of former Yugoslavia throughout the 1990s.
Ron Haviv/ VII

I remember looking at the pictures of the Jews lining up to board the trains for Auschwitz, and somehow never entirely believing in them. Maybe it was because the photos were in black and white. And yet now we're the Jews, we Muslims. I see my friends lining up in front of the bus station here when there is a rumour that it is possible to leave, and I think sometimes, 'That's the way it was in the forties. But it's in colour now, and it's not the Jews, it's us.'

A Bosnian Muslim from Banja Luka

A Sarajevan woman who had once been a judge declares at a reception given by the French Ambassador in Sarajevo:

When you see me now, it is not as I really am. I am not this dirty, poor woman, in smelly clothes, that all my perfume cannot cover. I am not the person I was, you see ... I never envied anyone before the war. And now I am consumed, eaten by envy. That's what I have been reduced to, what all of us have been reduced to in Bosnia ... We have become a nation of beggar

First I was a Yugoslav. Then I was a Bosnian. Now I'm becoming a Muslim. It's not my choice. I don't even believe in God. But after two hundred thousand dead, what do you want me to do?
A Sarajevo resident.

A shop selling or hiring out wedding dresses in Sarajevo, the Bosnian capital, stays open for business during the Serbian siege, 1993.
Abbas

The Sarajevo String Quartet plays in the ruins of the National Library in 1994. They often played there before the outbreak of war and continued to perform regularly during the siege of the city.
Paul Lowe

I managed to get access through a group of Croatian militiamen in the
very first days of the fighting as they were trying to ethnically cleanse
the city of Mostar. They were fighting from house to house, from street to
street, sometimes from apartment to apartment, pushing their own neighbours
out of the city.

James Nachtwey

I shook the hand of my neighbour when I left. We had grown up together.
I think he took my house.

A Bosnian refugee

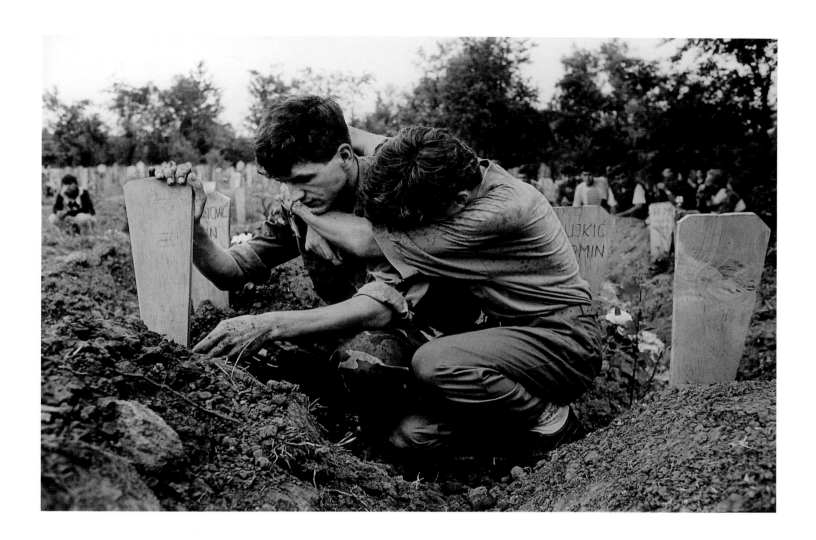

A Bosnian-Croat militiaman fires at his Muslim neighbours in Mostar, Bosnia Herzegovina, 1993–4.
James Nachtwey/ VII

Bosnian Muslim soldiers weep on the grave of a comrade killed fighting the Serbs. The soccer pitch of this village in Bosnia-Herzegovina has been turned into a cemetery, 1993–4.
James Nachtwey/ VII

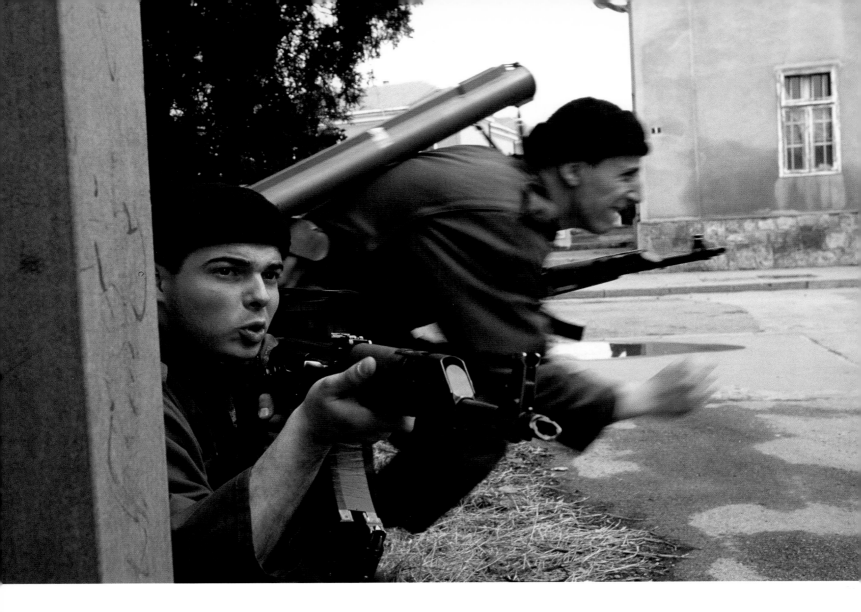

Arkan's 'Tigers' – Serbian paramilitaries –
at work ethnically cleansing Bijeljina, the
first Bosnian town to fall to the Serbs,
spring 1992. This was the beginning of the
sequence that was to climax with the
massacre at Srebrenica three years later.
The Tigers were in part recruited from
the official fan club of Belgrade's Red Star
football team.
Ron Haviv/ VII

Children, survivors of the massacre
of Bosnian Muslims by the Serbs at
Srebrenica, at a refugee camp, during
summer 1995.
Ron Haviv/ VII

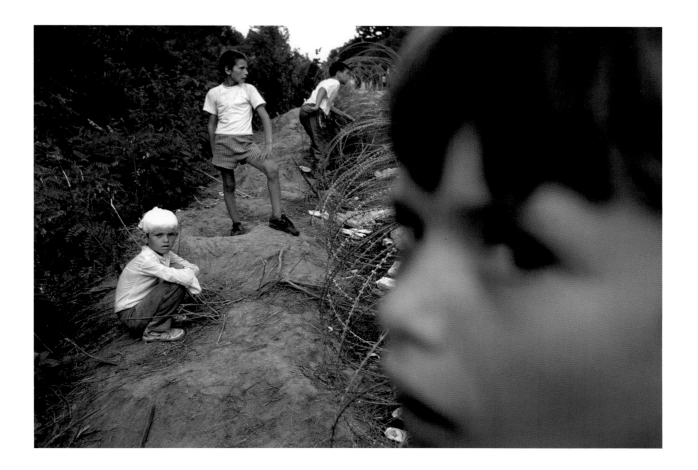

The massacres, both inside the camps and outside, were obviously a disaster for the victims but in a more abstract sense they were a catastrophe for the Serbs too. From the moment of their discovery, all lingering doubts in the international community about whether all sides in the war were guilty or not were driven into the background. The Serbs were branded as the aggressors and as the Balkan successors to the Nazis.

Tim Judah, *The Serbs*, 2000

The Serbs came, they slaughtered, they conquered, while the world looked on. What is going on is genocide. In the West, many people choose to call it war. But it's not war, it's slaughter.

Haris Silajdzic, Bosnian Prime Minister

Kosovo
Graffiti written in Cyrillic and English on a building near the road between Prizren and Pristina in Kosovo.
Gary Knight/ VII

A Kosovo Albanian arrives at a refugee camp administered by Medecines-sans-Frontieres near Kukes, Northern Albania.
Gary Knight/ VII

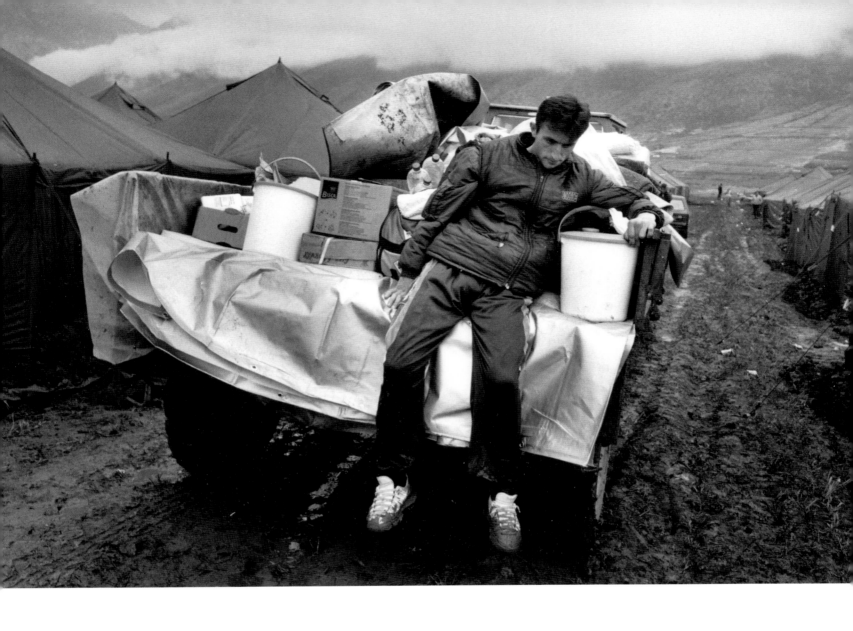

An army can beat an army, but an army cannot beat a people.

Shlomo Avineri, professor at the Hebrew University of Jerusalem and former director-general of the Israeli foreign ministry

In the Intifada the Palestinians have discovered the power of their weakness and the Israelis the weakness of their strength.

General Ephraim Sneh, former head of the civil administration on the West Bank

Intifada

A Palestinian youth throwing a Molotov cocktail at Israeli troops in Ramallah, a West Bank town, in 2000, early in the second Intifada uprising. The hand in the foreground holds another ready.

James Nachtwey/ VII

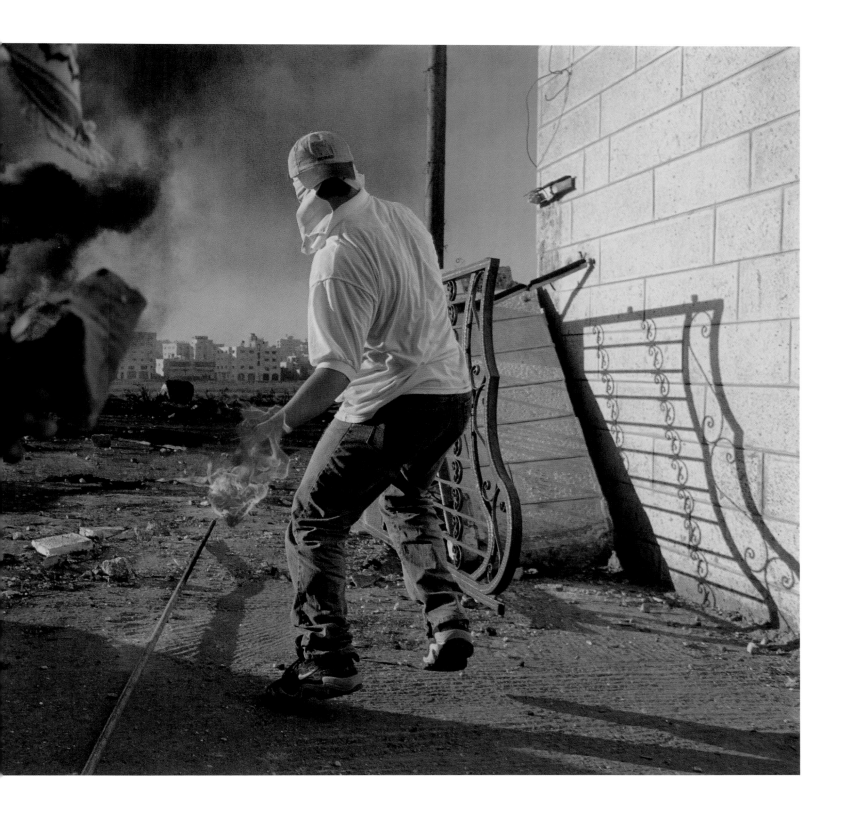

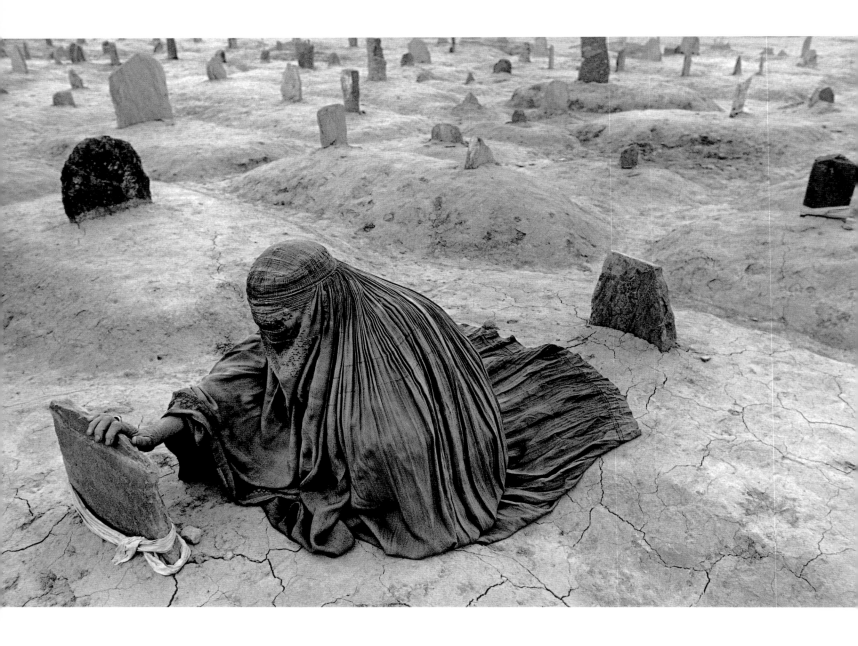

Afghanistan

An Afghani woman mourns at the grave of her brother in Kabul. He was killed during a Taliban rocket attack on the capital in 1996. These fundamentalist Muslims controlled much of Afghanistan in the 1990s, until the US and British intervention in 2002.

James Nachtwey/ VII

The photographer James Nachtwey describes his experiences at the World Trade Center, 11 September 2001.

As I was making coffee, I heard what sounded like a piece of steel hitting my roof. I looked out of my window, where I had a clear view of the World Trade Center, and saw black smoke billowing out of the south tower. As I was organizing my cameras and film, I heard another loud sound. I looked out my window again, and saw that now the north tower was burning as well.

I made my way through the crowd of fleeing people and began to photograph. As I was framing the south tower with the cross of a nearby church in the foreground, the skyscraper collapsed. The massive cloud of smoke and ash was filled with glass and steel as it raced through the canyons of lower Manhattan. To my eyes everything seemed to be in slow motion. I thought I had all the time in the world to photograph. Only at the last moment did I realize I was about to be hit. I raced to find shelter behind the buildings on the opposite side of the street as the debris crashed down and the street was engulfed in smoke.

I knew I had to photograph the wreckage of the tower lying on the ground. Firetrucks and police cars were crushed and burning, their emergency flashers still blinking on-and-off. As I was photographing, I heard what sounded like a huge waterfall in the sky above me. I looked up and saw the north tower falling straight down on me, a billowing avalanche of smoke and steel, and I understood that if I took even a moment to raise my camera to photograph it, I would not survive.

The moment I entered the lobby I saw the big, plate glass windows and knew that the room would be oblitereated. Like a trapped animal I sought out the deepest recess I could find. I dashed into the hallway with the hotel elevators and then into an open lift just as the debris came crashing in. Everything went totally black ... I might have been dead. The only way I knew I was still alive was that I was suffocating. The ashes were so dense it was like trying to breathe through a mouthful of mud. I was convinced I was buried beneath the wreckage and would probably die there. A construction worker had dived into the elevator just as I did, and we held onto each other's hands as we began to crawl through the blackness. We called out to ask if there was anyone else who might need help, but no one replied. Everyone who had been in the lobby was most likely dead. I began to see small points of light in the darkness, but did not know what they might be. Then I realized they were the emergency lights of cars and that we were on the street.

After I delivered my film to the picture editors at TIME I had a long journey home. Electrical power was out, and my area of the city was pitch-dark. The air was filled with smoke. Sirens were wailing, and jet planes were roaring overhead in the night sky. Once I reached my loft, there was no telephone, no hot water. I burned candles for light. Because I had been away, there was no food in the house and no place to get any. Actually, these conditions were very familiar to me. I had experienced them many times, in Grozny, Beirut, Rwanda, and Yugoslavia. I was once again living in a war zone, only this time it was my own city.

Al Qaeda

- *Overleaf:* The south tower of the World Trade Center collapses after the Al Qaeda terrorist attack, 11 September 2001.
James Nachtwey/VII

Afghanistan

A Pashtun tribesman with a plume of smoke from a B52 airstrike behind him at Tora Bora, the Taliban/ Al Qaeda mountain hideout, November–December 2001. These punishing airstrikes were part of the response to 9/11, supporting the tribal forces of the Northern Alliance in their ousting of the Taliban, the protectors of Osama Bin Laden.

Gary Knight/ VII

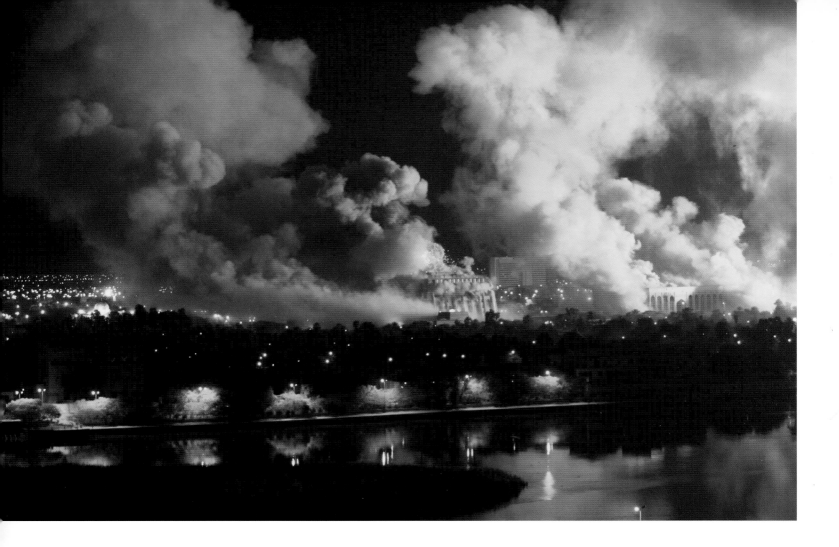

Second Gulf War

Smoke rises from central Baghdad during
one of the 'Shock and Awe' air-raids on
the Iraqi capital on 21 March, early in
the war, aimed at knocking out Saddam
Hussein's command-and-control
structure.

Ramzi Haidar

A British soldier watches civilians fleeing
Basra in southern Iraq to escape its
intermittent bombardment and shooting
by the Ba'thist party members.

Eddie Mulholland

Vice-Admiral Timothy Keating addresses the crew of the aircraft carrier USS *Constellation* shortly before cruise missiles are fired.

When the President says 'Go', look out, it's hammer time.

Lieutenant-Colonel Tim Collins addresses 800 men of the 1st Batallion of the Royal Irish Regiment, March 2003.

We go to liberate, not to conquer. We will not fly our flags in their country.
We are entering Iraq to free a people and the only flag that will be flown in
that ancient land is their own. Show respect for them. There are some who
are alive at this moment who will not be alive shortly. Those who do not
wish to go on that journey, we will not send. As for the others, I expect
you to rock their world. Wipe them out if that is what they choose. But if
you are ferocious in battle, remember to be magnanimous in victory. It is a
big step to take another human life. It is not to be done lightly ... Don't
treat them as refugees, for they are in their own country. Their children
will be poor; in years to come they will know that the light of liberation
in their lives was brought by you ... If there are casualties of war, then
remember that when they woke up and got dressed in the morning they did not
plan to die that day. Allow them dignity in death. Bury them properly and
mark their graves.

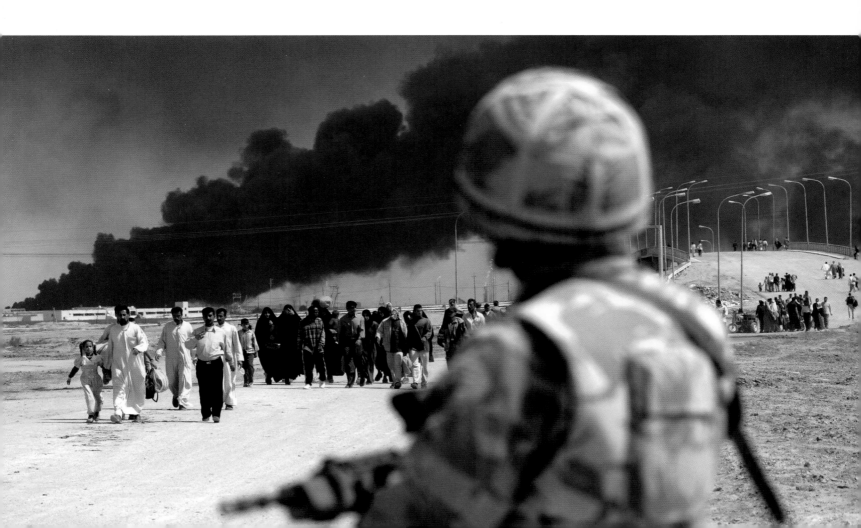

The day before, a sandstorm, the worst for more years than the locals could remember, raged across the desert in central Iraq, halting the Marines just north of the Euphrates. As the advance pushed forward that morning on Highway 1 to Baghdad an ambush lay in wait for the lead elements of the 5th Regiment.

Up to 200 men attacked the Marines, who immediately returned fire with grenades, 50mm machine-guns and M16 rifles. Several of the Marines were wounded but at least 15 Iraqis were killed.

In particular were two soldiers lying in a ditch by the side of the road, one face down in the mud, the other staring at the sky, a bag of clothes and personal items by his side.

Many of the Iraqi prisoners who were taken that day said they had been press-ganged, pistols put behind their heads and forced to fight. This soldier, staring into the red fog which hung in the air, seemed so poorly prepared for battle it was impossible not to wonder why he, amongst the thousands of Iraqi soldiers who simply tore off their uniforms and fled, had been one of those to die for Saddam Hussein.

James Hill, who took the picture opposite on 26 March 2003

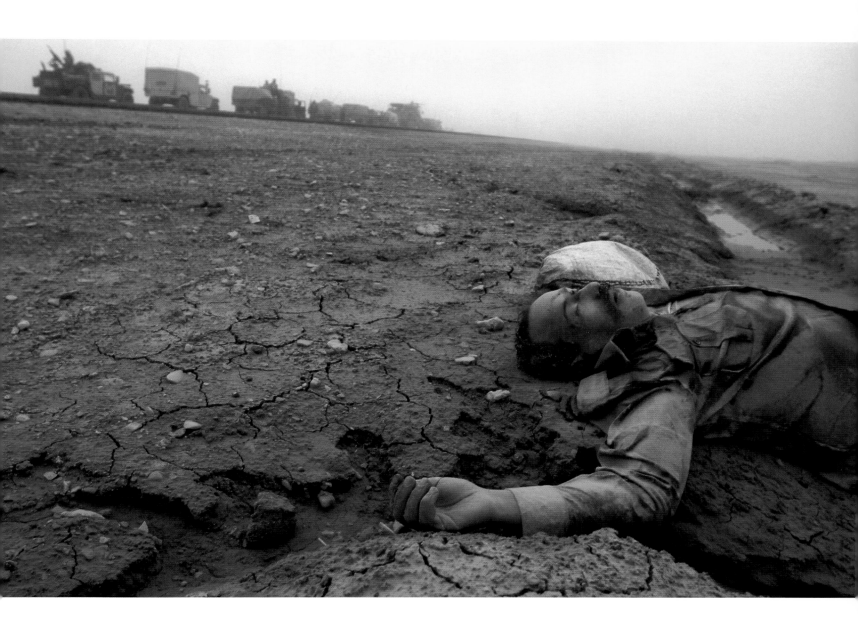

A dead Iraqi, and the US Marine convoy that he had attempted to ambush in the background *(see account opposite)*. The Allied troops encountered these pockets of resistance on the road to Baghdad, militia loyal to Saddam who took it upon themselves to fight.

James Hill

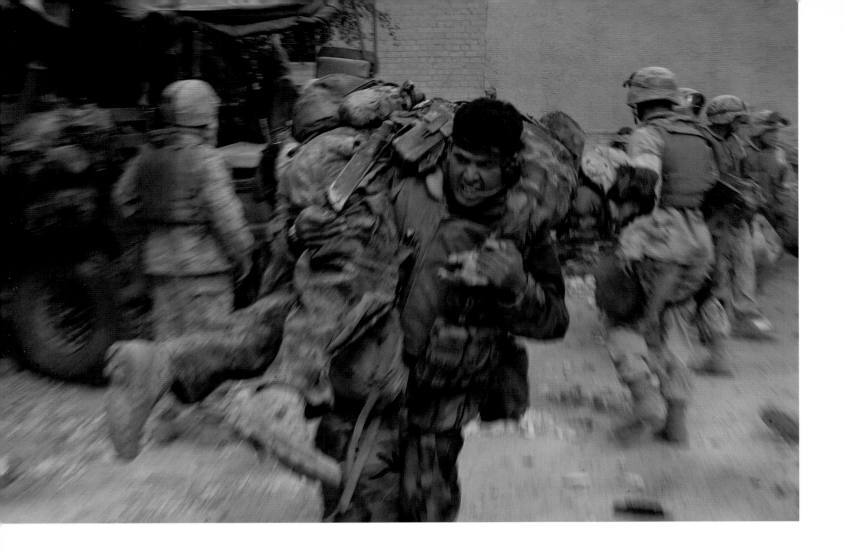

The photographer Gary Knight accompanies US Marines as they fight to take control of a bridge east of Baghdad.

Incoming, outgoing, it all feels like incoming it's so close. Next time I promise I will wear body armour. A Marine APC explodes 10 yards away, turret flies in the air, I run across the road through a cloud of dust and black diesel smoke. Two dead Marines on the ground, the wounded crying for help. Lucky it landed on the APC and not next to it, the casualties would have been higher. Marines not wounded swarm the area. The tension and anger rises.

Kilo and India companies start to move, run for the bridge, pass the boy covered in flies and span the holes in the floor with boards and infantry charge the northern banks. Everyone is shouting and bullets cut through the clouds of smoke and dust. What movie am I watching? Who killed the teenager on the bridge and why?

Dead Iraqis litter the street. Shrapnel and concrete crunch underfoot as the Marines move house to house. An old grey-haired civilian lies slumped with his head rested against the steering wheel of his truck, he looks like my grandfather, except the back of his head is missing, he is covered in flies and bullet holes cover the windshield of his truck. I imagine his wife is waiting for him to return from work.

A wounded US Marine
carried away after the
armoured personnel
carrier he was in was
hit by Iraqi artillery. The
Marines were fighting
to gain control of the
bridge east of Baghdad
(see *account opposite*).
Gary Knight/ VII

US Marines relax in the
rubble-strewn yet still
elegant surroundings of
one of Saddam's many
palaces in Baghdad as
the capital falls into
their hands like an
overripe fruit.
John Moore

The infidels are committing suicide by the hundreds on the gates of
Baghdad. Be assured, Baghdad is safe, protected. There are no
American infidels in Baghdad. Never!

Mohammed Saeed al-Sahhaf, Iraqi Minister of Information

The 40-foot bronze statue of Saddam in
Paradise Square, Baghdad, is toppled with
the help of a US tank on 9 April 2003.
Goran Tomasevic

A young looter carries away an ornate
mirror from one of Saddam's palaces in
Tikrit, his home town and powerbase to
the north of Baghdad, on 14 April 2003.
The Iraqi army and police had in fact left
the town two weeks earlier, but fear of
Saddam held back looters until they could
set to work, protected by US soldiery.
Sean Smith

Iraq is the 'cradle of civilization', the home of Sumerian, Assyrian and Babylonian cultures and the birthplace of Abraham. The main Baghdad museum alone held more than 170,000 artefacts, including a vast treasury of cuneiform clay tablets that have yet to be translated ... No one yet knows what was pillaged from important museums in Mosul and Basra, which were also ransacked by looters. 'This is the crime of the century,' Dr Donny George, a curator at the Baghdad museum, told a summit of experts from the world's greatest museums, convened to draft an emergency plan to recover the missing objects. 'The looted material belonged to all mankind.'

Fiachra Gibbons, *The Guardian*

Text sources

CHAPTER 1
14, William Howard Russell, *The British Expedition to the Crimea* (1858)
16, William Howard Russell, *The British Expedition to the Crimea* (1858)
18, Florence Nightingale, letter from Miss Nightingale to Queen Victoria, n.d., Royal Archives
21, Corporal William Forbes-Mitchell, *Reminiscences of the Great Mutiny* (Macmillan & Co., 1893)
23, Corporal William Forbes-Mitchell, *Reminiscences of the Great Mutiny* (Macmillan & Co., 1893)
25, Colonel Garnet Wolseley, *Narrative of the War with China in 1860* (Longman, Green and Roberts, 1862)
27, William Howard Russell, *My Diary, North and South* (Harper, 1863)
28, Reverend James P. Smith in Robert Underwood Johnson (ed.), *Battles and Leaders of the Civil War* (1888)
31 (caption), A chaplain, from Geoffrey C. Ward, with Ric Burns and Ken Burns, *The Civil War: An Illustrated History* (Alfred A. Knopf, 1990)
32, Samuel Wilkeson, *New York Times* (6 July 1863)
35, General Robert E. Lee, 13 December 1862
35, Abraham Lincoln, November 1863

CHAPTER 2
40, Captain Tristram Speedy, quoted in Richard Pankhurst, 'Captain Speedy's Entertainment', *Africa*, no. 38 (1983)
42, 'Pousse Cailloux' (Lieutenant-Colonel Leonard Bethell), 'Retaliation', *Blackwood's Magazine* (n.d.); subsequently published in L. Bethell (ed.), *Blackwood Tales from the Outposts III, Tales of the Border* (W. Blackwood & Sons, 1932)
44, Howard Hensman, *The Afghan War* (W. H. Allen & Co., 1881)
47, Winston Churchill, *The River War*, vol. 2 (1899)
48, Theodore Roosevelt, *An Autobiography* (1913)

CHAPTER 3
58, Winston Churchill
59, Herbert Cadett, 'The Song of Modern Mars' (1900)
61, Emily Hobhouse, *Tant Alie of the Transvaal: Her Diary 1880–1902* (1902)
63, Lieutenant Charles Veal, from Field Marshal Lord Carver, *The National Army Museum Book of the Boer War* (Sidgwick & Jackson, 1999)
64, General Sir Ian Hamilton, *A Staff-Officer's Scrap Book* (E. Arnold, 1905)
67, Maurice Baring, *With the Russians in Manchuria* (E. Arnold, 1905)
69, Emiliano Zapata
69, An employee of Cusi mining company, *The Literary Digest* (22 January 1916)
71, Hamilton Fyfe, *The Real Mexico* (William Heinemann, 1914)
71, Timothy Turner, *Bullets, Bottles and Gardenias* (South-West Press, 1935)

CHAPTER 4
76, Richard Harding Davis, *New York Tribune* (23 August 1914)
79, Private W. H. Nixon, from Lyn Macdonald, *Voices and Images of the Great War* (Michael Joseph, 1988)
80, Private Harold Boughton, from Max Arthur, *Forgotten Voices of the Great War* (Ebury Press, 2002)
82, Mrs M. Hall, from Max Arthur, *Forgotten Voices of the Great War* (Ebury Press, 2002)
86, A sergeant in 26th Infantry Regiment, from Henri Jacques Louis Colin, *La Côte 304 et Le Mort-Homme* (1934)
86, A German doctor, from Max Arthur, *Forgotten Voices of the Great War* (Ebury Press, 2002)
88, Commander Georg von Hase, *Kiel and Jutland*, tr. Arthur Chambers and F. A. Holt (Skeffington & Son, 1921)
88, Petty Officer Ernest Francis, from M. Moynihan (ed.), *People at War* (David & Charles, 1973)
90, Private Ernest Deighton, from Lyn Macdonald, *Somme* (Michael Joseph, 1983)
92, Sergeant Perry Webb, from Max Arthur, *Forgotten Voices of the Great War* (Ebury Press, 2002)
94, Lieutenant W. J. Tempest, from Jon E. Lewis (ed.), *The Mammoth Book of How It Happened* (Constable Robinson, 1998)
97, Manfred Freiherr von Richthofen, *The Red Baron*, tr. Peter Kilduff, ed. Stanley M. Ulanoff, (Doubleday, 1969)
98, Sergeant Jack Dorgan, from Max Arthur, *Forgotten Voices of the Great War* (Ebury Press, 2002)
99, Rudolf Binding, from Guy Chapman (ed.) *Vain Glory* (Cassell & Co., 1968)
100, Lieutenant Bernard Martin, *Poor Bloody Infantry: A Subaltern on the Western Front, 1916–17* (John Murray, 1987)
101, 102, Corporal Jack Dillon, from Max Arthur, *Forgotten Voices of the Great War* (Ebury Press, 2002)
104, Major Keith Officer, from Max Arthur, *Forgotten Voices of the Great War* (Ebury Press, 2002)

CHAPTER 5
110, Gregory Rasputin, to Tsar Nicolas II, July 1914
110, Lieutenant-General Sir Brian Horrocks, *A Full Life* (Collins, 1960)
112, Vittorio Mussolini
112, Winston Churchill, *The Gathering Storm* (Cassell, 1948)
114, Reuters correspondent, from the *Manchester Guardian* (23 July 1936)
116, The Dean of Valladolid Cathedral, from Robert Haigh, Dave Morris and Anthony Peters (eds.), *The Guardian Book of the Spanish Civil War* (Wildwood House, 1987)
119, Salvador de Madariaga, *The Times* (19 July 1937)
119, Dolores Ibarruri (La Pasionaria), from P. Preston, *¡Comrades! Portraits from the Spanish Civil War* (HarperCollins, 1999)
120, Ernest Hemingway, from *The Spanish Civil War: Dreams and Nightmares* (Imperial War Museum, 2001)
120, Ernest Hemingway, letter to Maxwell Perkins, October 1938
122, Rhodes Farmer, *Shanghai Harvest* (Museum Press, 1945)
125, Yukio Omata, from Iris Chang, *The Rape of Nanking* (Basic Books, 1998)

CHAPTER 6
131, Winston Churchill, speech, 4 June 1940
131, *Hamburger Fremdenblatt* (n.d.)
131, *Daily Mirror*, June 1940
132, Winston Churchill, *The Second World War*, vol. 2 (Cassell & Co., 1949)
134, Winston Churchill, speech, 20 August 1940
134, Sergeant John Burgess, from Norman Gelb, *Scramble* (Michael Joseph, 1986)
134, Jig and Ann Lowe, from Matthew Parker, *The Battle of Britain* (Headline, 2000)
135 (caption), Robin Appleford, from Patrick Bishop, *Fighter Boys: Saving Britain, 1940* (HarperCollins, 2003)
136, Sir Henry 'Chips' Channon, *Chips: The Diaries of Sir Henry Channon*, ed. R. Rhodes James (Weidenfeld, 1967)
138, Sir Dudley Pound, from Correlli Barnett, *Engage the Enemy More Closely* (W. W. Norton & Co., 1991)
138, Alan Swanton, from Julian Thompson, *The Imperial War Museum Book of the War at Sea* (Sidgwick & Jackson, 1996)
141, Corporal John Williamson, from Denis and Shelagh Whitaker, *Dieppe: Tragedy to Triumph* (Leo Cooper Ltd., 1992)
141, Captain Denis Whitaker, from Denis and Shelagh Whitaker, *Dieppe: Tragedy to Triumph* (Leo Cooper Ltd., 1992)
142, Alan Moorehead, *African Trilogy* (Hamish Hamilton, 1944)
144, A Panzer officer, from Brian Moynahan, *The Russian Century* (Chatto, 1994)
145, Alexander Werth, *Russia at War, 1941–1945* (Barrie & Jenkins, 1964)
146, A soldier of Gross Deutschland, from Brian Moynahan, *The Russian Century* (Chatto, 1994)
149, Franklin D. Roosevelt
149, Isoroku Yamamoto
150, W. Eugene Smith, from Jim Hughes, *W. Eugene Smith: The Life and Work of an American Photographer* (McGraw Hill, 1989)
151, Robert Sherrod, *Tarawa: The Story of a Battle* (1944)
153, Phelps Adams, *The New York Sun* (28 June 1945), from *Reporting World War II* (Library of America, 1995)
154, Robert Sherrod, *Life* (5 March 1945)
156, Robert Capa, *Slightly Out of Focus* (Henry Holt, 1947)
158, Helen Kirkpatrick, *Chicago Daily News* (20 August 1944)
161, Martha Gellhorn, *The Face of War* (Simon & Schuster, 1959/ Rupert Hart-Davis, 1959)
162, Margret Freyer, from Alexander McKee, *Dresden 1945: The Devil's Tinder Box* (Souvenir Press, 1982)
166, Richard Dimbleby, *The Cess Pit Beneath*, BBC Radio broadcast, 19 April 1945, from *Richard Dimbleby: Broadcaster*, ed. Leonard Miall (BBC Books, 1966)
168, Brian Moynahan, historian and author
170, Dr Takashi Nagai, from the website of the Nagasaki Atomic Bomb Museum

CHAPTER 7
177, David Douglas Duncan, *This Is War!* (Little, Brown, 1990)
178, David Douglas Duncan, *This Is War!* (Little, Brown, 1990)
181, James Cameron, *Point of Departure* (Arthur Barker, 1967, reprinted by Oriel Press, 1978)
182, General Vo Nguyen Giap
182, A French officer, from Bernard Fall, *Street Without Joy* (Stackpole Books, 1994)
182, Robert Capa, from Alex Kershaw, *Blood and Champagne: The Life and Times of Robert Capa* (Macmillan, 2002)
184, General Henri Navarre, *Agonie de l'Indochine* (Pion, 1956)
186, Ho Chi Minh, from Jean Lacouture, *Ho Chi Minh* (Allen Lane, 1968)
191, Larry Burrows, from Phillip Knightley, *The First Casualty* (Prion Books, 2000)
192, Michael Herr, *Dispatches* (Picador, 1991)
193, Philip Jones Griffiths, *Vietnam Inc.* (Collier Books, 1971)
197 (caption), A US pilot quoted in Philip Jones Griffiths, *Vietnam Inc.* (Collier Books, 1971)
199, Don McCullin, *Sleeping with Ghosts: A Life's Work in Photography* (Jonathan Cape, 1994)
199, Michael Herr, *Dispatches* (Picador, 1991)
202, Marshal McLuhan, *Montreal Gazette* (16 May 1975)
203, James Fenton, 'The Fall of Saigon' from *The Granta Book of Reportage* (Granta, 1998)
204, Jon Swain, *River of Time* (Heinemann, 1995)
204, Richard West, *War and Peace in Vietnam* (Sinclair-Stevenson, 1995)
209, Alistair Horne, *Small Earthquake in Chile: A Visit to Allende's South America* (Macmillan, 1972)
215, Robert Fox, *The Liberation of Goose Green*, BBC News (30 May 1982)
215, Brian Hanrahan, BBC Broadcast, 1982
216, Edward Behr, *Anyone Here Been Raped and Speaks English?* (Hamish Hamilton, 1981)
216, John de St Jorre, *The Nigerian Civil War* (Hodder & Stoughton General, 1972)
219, Philip Gourevitch, *We wish to inform you that tomorrow we will be killed with our families* (Picador, 1999)
220, Mark Bowden, *Black Hawk Down* (Corgi, 2000)

CHAPTER 8
227, James Cameron, *Point of Departure* (Arthur Barker, 1967, reprinted by Oriel Press, 1978)
228, François Mitterand, from Alistair Horne, *A Savage War of Peace* (Macmillan, 1977)
229, Alistair Horne, *A Savage War of Peace* (Macmillan, 1977)
230, Alistair Horne, *A Savage War of Peace* (Macmillan, 1977)
233, Donald Edgar, *Express '56* (John Clare Books, 1957)
234, Yael Dayan, *A Soldier's Diary: Sinai 1967* (Weidenfeld & Nicolson, 1967)
236, Chaim Herzog, *The Arab-Israeli Wars* (Cassell, 1980)
237, Chaim Herzog, *The War of Atonement* (Weidenfeld & Nicolson, 1975)
240, Robert Fisk, *Pity The Nation: Lebanon at War* (Andre Deutsch, 1990)
246, Anatol Lieven, *Chechnya: Tombstone of Russian Power* (Yale University Press, 1998)
251, Svetlana Alexiyevich, 'Boys in Zinc' from *The Granta Book of Reportage* (Granta, 1998)
253, Ayatollah Khomeini
253, Saddam Hussein
255, Kenneth Jarecke, *The Guardian* (14 February 2003)
256, Norman Schwarzkopf, *It Doesn't Take A Hero* (Bantam Doubleday Dell, 1992)
256, Saddam Hussein
259, A Bosnian Muslim, from Ron Haviv, *Blood and Honey: A Balkan War Journal* (TV Books, 2001)
260, A Sarajevo resident, from Ron Haviv, *Blood and Honey: A Balkan War Journal* (TV Books, 2001)
260, A Sarajevan woman, from Ron Haviv, *Blood and Honey: A Balkan War Journal* (TV Books, 2001)
262, James Nachtwey, in an interview with Elizabeth Farnsworth, 16 May 2000
262, A Bosnian refugee, from Ron Haviv, *Blood and Honey: A Balkan War Journal* (TV Books, 2001)
265, Tim Judah, *The Serbs* (Yale University Press, 2000)
265, Haris Silajdzic, from Ron Haviv, *Blood and Honey: A Balkan War Journal* (TV Books, 2001)
268, Shlomo Avineri, from A. Elon, *A Blood-Dimmed Tide* (Allen Lane/Penguin Press 2000)
268, General Ephraim Sneh, from A. Elon, *A Blood-Dimmed Tide* (Allen Lane/Penguin Press 2000)
271, © James Nachtwey
277, Vice-Admiral Timothy Keating
277, Lieutenant-Colonel Tim Collins, March 2003
278, James Hill
280, Gary Knight
281, Mohammed Saeed al-Sahhaf
283, Fiachra Gibbons, *The Guardian*

Text permissions

Max Arthur: from Private Harold Boughton, Mrs M. Hall, a German doctor, Sergeant Perry Webb, Sergeant Jack Dorgan, Corporal Jack Dillon, and Major Keith Officer, in *Forgotten Voices of the Great War* (Ebury Press, 2002), reprinted by permission of The Random House Group Ltd; **Field Marshall Lord Carver**: from Lieutenant Charles Veal, in *The National Army Museum Book of the Boer War* (Sidgwick & Jackson, 1999), reprinted by permission of Macmillan, London; **Iris Chang**: from Yukio Omata, in *The Rape of Nanking: The Forgotten Holocaust of World War II* (Basic Books, 1997), (c) 1997 by Iris Chang, reprinted by permission of Perseus Books Group; **Winston Churchill**: from *The River War* (1899), *The Gathering Storm* (Cassell, 1948), *The Second World War* (6 vols., 1948–54), and speeches (4 June 1940 and 20 August 1940), reprinted by permission of Curtis Brown Ltd on behalf of the Estate of Winston S. Churchill; **James Fenton**: from 'The Fall of Saigon' in *The Granta Book of Reportage* (Granta, 1998), reprinted by permission of Peters Fraser & Dunlop on behalf of the author; **H. Hamilton Fyfe**: from *The Real Mexico* (William Heinemann, 1914), reprinted by permission of The Random House Group Ltd; **Martha Gellhorn**: from *The Face of War* (Simon & Schuster, 1959/Rupert Hart-Davis, 1959), reprinted by permission of Dr Alexander Matthews; **Philip Gourevitch**: from *We wish to inform you that tomorrow we will be killed with our families* (Picador, 1999), reprinted by permission of Macmillan, London; **Sir Ian Hamilton**: from *A Staff-Officer's Scrap Book* (Edward Arnold, 1905), reprinted by permission of the publisher; **Michael Herr**: from *Dispatches* (Picador, 1991), reprinted by permission of Macmillan, London; **Ernest Hemingway**: from a letter to Maxwell Perkins (October 1938), (c) Hemingway Foreign Rights Trust, and from *The Spanish Civil War: Dreams and Nightmares* (Imperial War Museum, 2001), (c) Hemingway Foreign Rights Trust; **James Hill**: for report from the war in Iraq (March 2003); **Alistair Horne**: from *Small Earthquake in Chile: A Visit to Allende's South America* (Macmillan, 1972), reprinted by permission of the publisher; **Gary Knight**: for his article and photograph from the war in Iraq (March 2003); **Don McCullin**: from *Sleeping with Ghosts: A Life's Work in Photography* (Jonathan Cape, 1994), reprinted by permission of The Random House Group Ltd; **Lieutenant Bernard Martin**: from *Poor Bloody Infantry: A Subaltern on the Western Front, 1916–17* (John Murray, 1987), reprinted by permission of the publisher; **Brian Moynahan**: from *The Russian Century* (Chatto & Windus, 1994), reprinted by permission of The Random House Group Ltd; **M. Moynihan**: from Petty Officer Ernest Francis, in *People at War* (David & Charles, 1973), reprinted by permission of the publisher; **James Nachtwey**: for his interview with Elizabeth Farnsworth (16 May 2000) and his experiences at the World Trade Center (11 September 2001); **Robert Sherrod**: from *Tarawa: The Story of a Battle* (1944), reprinted by permission of Admiral Nimitz Foundation; **John Swain**: from *River of Time* (Vintage, 1996), reprinted by permission of The Random House Group Ltd; **Julian Thompson**: from Alan Swanton, in *The Imperial War Museum Book of the War at Sea* (Sidgwick & Jackson, 1996), reprinted by permission of Macmillan, London; **Alexander Werth**: from *Russia at War* (Barrie & Jenkins, 1964), reprinted by permission of The Random House Group Ltd; **Richard West**: from *War and Peace in Vietnam* (Sinclair-Stevenson, 1995), reprinted by permission of the publisher.

Every effort has been made to trace or contact all copyright holders. The publishers would be pleased to rectify any omissions brought to their notice at the earliest opportunity.

Photographic credits

The photographs produced in this book are the result of extensive research in archives, museums and private collections. We are most grateful to all those kind people who willingly offered their support and advice.

We would especially like to thank Henri Bureau at Roger Viollet, Giovanni Cafagna at Corbis, Ferit Duzyol at Sipa Press, Linda Briscoe Meyers at HRHRC University Texas at Austin, Frances Dimond at The Royal Collection, Charles Merullo at The Endeavour Group, Fran Morales at Magnum, Ian Robertson at the National Army Museum, Press, Olivier Simoncellli at ECPAD Port D'Ivry, Ashley Woods at V11 Paris, and most importantly the photographers – David Douglas Duncan, Horst Faas, James Hill, Gary Knight, Kenneth Jarecke, Don McCullin, and James Nachtwey for their personal contributions to this book.

Photographers names, when known, are credited with the captions. Every effort has been made to trace the copyright holders. However if we have omitted anyone we apologise and will, if informed, make corrections in any future editions. The following have kindly granted us permission to reproduce the photographs on the pages listed below:

AKG, London: 54
Associated Press, London: 155 (Joe Rosenthal), 202 (Nick Ut), 206 (Horst Faas/Michel Laurent), 207 (Horst Faas/Michel Laurent), 281 (John Moore)
Associated Press/Requiem: 172 (Henri Huet)
Australian War Memorial, Canberra: 81 (AO20222)
Bettman/Corbis: 70
Black Star/Katz: 246
Bundesarchiv, Koblenz: 89
Larry Burrows/Time Life Pictures/Getty Images: 188-189, 190, 191, 194-195
Paul Christopher Collection: 123 (George Krainukov), 124-125 (George Krainukov)
Contact, Paris/Don McCullin: 198-199, 200, 201, 216-217, 241
Corbis, London: 10 (Roger Fenton), 36, 66-67, 71, 99, 102, 103, 112 left, 112-113, 148-149
The Daily Telegraph, London: 277 (Eddie Mulholland)
Defence Visual Information Centre/Getty Images: 50-51
ECPAD Ministere de la Defense, Port D'Ivry: 86-87, 93 (M. Emmanuel Gorce), 95, 184 (Jean Peraud), 185 (Jean Peraud), 228 (Mark Flament), 229 (M. Vandy), 230 top left (M. Kierzkowski), 230-231 (Mark Flament)
Endeavour Group UK: 84-85, 110, 111, 122, 144-145 (Georgy Zelma), 145 centre (Yevgeny Khaldei), 146-147 (Michael Savin), 162-163 (Richard Peters Jnr.), 169 (Yevgeny Khaldei)
Horst Faas/Requiem: 192 (Kyoichi Sawada), 186 (Tran Binh Khuoi)
Gamma: 220 centre left (Keith Burnstein)
Gamma/Katz: 205 (Sou Vichith), 251 (Laurent Van Der Stockt), 252 (François Lochon), 253 (Eric Bouvet)
Getty Images: 26, 35 centre right (Alexander Gardner), 48, 49, 59, 60 (Reinhold Thiele), 62-63 (Reinhold Thiele), 68 (Agustín Victor Casasola), 94, 132, 136, 181 (Bert Hardy), 209, 279 (James Hill)
The Guardian Newspaper, London: 283 (Sean Smith)
Imperial War Museum, London: 79 (Q49750 – Private F. A. Fyfe), 82 (Q28174 – G. P. Lewis), 83 (Q28314 – G. P. Lewis), 88 (SP1708), 91 (Q79501), 92 (Q32534), 96-97 (Q12182), 97 bottom right (Q50673), 98

(Q11586), 100-101 (Q2265 – William Rider-Rider), 130, 131, 139, 140 (Humphrey Spender), 141, 142 (Cecil Beaton), 214
Kenneth Jarecke/Contact, New York: 254-255
Katz, London: 203 (Jean-Claude Francolon)
Magnum Photos, London: Title Page (Raymond Depardon), 121 (Robert Capa), 126 (W. Eugene Smith), 143 (George Rodger), 150, 152 (W. Eugene Smith), 156-157 (Robert Capa), 159 (Robert Capa), 160 (Robert Capa), 161 (Robert Capa), 164 (Henri Cartier-Bresson), 180 (Werner Bischof), 182-183 (Robert Capa), 187 (Philip Jones Griffiths), 193 (Philip Jones Griffiths), 196 (Philip Jones Griffiths), 197 (Philip Jones Griffiths), 208 (Burt Glinn), 218-219 (Gilles Peress), 226 (Robert Capa), 227 (Robert Capa), 232 (David Seymour), 233 (Burt Glinn), 234-235 (Micha Bar Am), 236 (Leonard Freed), 237 (Leonard Freed), 238-239 (Raymond Depardon), 242 centre left (Raymond Depardon), 243 (Christopher Steele-Perkins), 256 (Bruno Barbey), 257 (Steve McCurry), 260 (Abbas), 261 (Paul Lowe), 288 (Robert Capa)
Annabel Merullo Collection: 106 (Alfonso, Madrid), 114 (Agustí Centelles), 115 (Agustí Centelles), 116, 117 (Agustí Centelles), 118-119, 119 top right
Lee Miller Archive: 165, 167
Minnesota Historical Society/Corbis: 52-53
National Archives, Washington: 29, 30-31, 33 (Timothy O'Sullivan), 34 (Timothy O'Sullivan), 133, 151, 153 (Kenneth E. Roberts), 170-171
National Army Museum, London: 20 (Felice Beato), 24 (Felice Beato), 41 (Sargeant Harrald), 58, 61
PA Photos Limited: 276 (Ramzi Haidar)
Photographic Collection Harry Ransom Humanities Research Centre The University of Texas at Austin: 176 (David Douglas Duncan), 177 (David Douglas Duncan), 179 (David Douglas Duncan)
Private Collection: 168
Reuters, London: 282 (Goran Tomasevic)
George Rodger/Time Life Pictures/ Getty Images: 166
Roger Viollet, Paris: 72, 77, 78, 104, 105
The Royal Collection HM Queen Elizabeth II: 17 (Roger Fenton), 18 (Cornelius Jarez Hughes), 19 (Cornelius Jarez Hughes), 43 (John Burke), 46, 47, 80
Royal Engineers Museum, Chatham: 44-45 (John Burke)
Sipa Press, Paris: 222 (Eric Durschmied), 248-249 (Grachtchenkov), 250 (Alexei Yefimov)
Humphrey Spender: 135, 138
Underwood & Underwood/Corbis: 51 (bottom right), 64-65
Wolf Suschitzky, London: 137
Victoria and Albert Museum Board of Trustees, London: 15 (Roger Fenton), 16 (James Robertson), 21 (Felice Beato), 22 (Felice Beato)
VII, Paris: 210-211 (James Nachtwey), 212 (James Nachtwey), 213 (James Nachtwey), 221 (Christopher Morris), 244 (Christopher Morris), 245 (Christopher Morris), 247 (Christopher Morris), 258-259 (Ron Haviv), 262 (James Nachtwey), 263 (James Nachtwey), 264 (Ron Haviv), 265 (Ron Haviv), 266 (Gary Knight), 267 (Gary Knight), 268-269 (James Nachtwey), 270 (James Nachtwey), 272-273 (James Nachtwey), 274-275 (Alexandra Boulat), 280 (Gary Knight)

Index

Figures in **bold** refer to illustrations, figures in *italic* refer to captions.

First published in the United Kingdom in 2003 by Weidenfeld & Nicolson

Text copyright in the Introduction © John Keegan, 2003
Text copyright in the Essays © Phillip Knightley, 2003
Design and layout copyright © Weidenfeld & Nicolson, 2003

A CIP catalogue record for this book is available from the British Library

ISBN 0 297 84311 7

Printed and bound in Italy

Design and art direction: David Rowley
Project managers and picture editors: Sarah Jackson and Annabel Merullo
Extract research and captions: Roger Hudson and Annabel Merullo
Copy editor: Claire Marsden
Design assistance: Austin Taylor and Justin Hunt
Picture administration: Emma Pattison

Weidenfeld & Nicolson
The Orion Publishing Group
Wellington House
125, Strand
London WC2R 0BB

Above: An Italian soldier and his companion in Sicily, July 1943.
Robert Capa

Title page: Vietnamese girl in the streets of Saigon, 1972
Raymond Depardon